AUGMENTED THINKING FOR A COMPLEX WORLD

T0402428

One of over five thousand
snowflake photomicrographs by
Wilson A. "Snowflake" Bentley,
1865–1931, the first person to
capture an individual snowflake
on film. Photo c. 1890, courtesy of
the Smithsonian Institution Archives.

THE NEXUS

1129

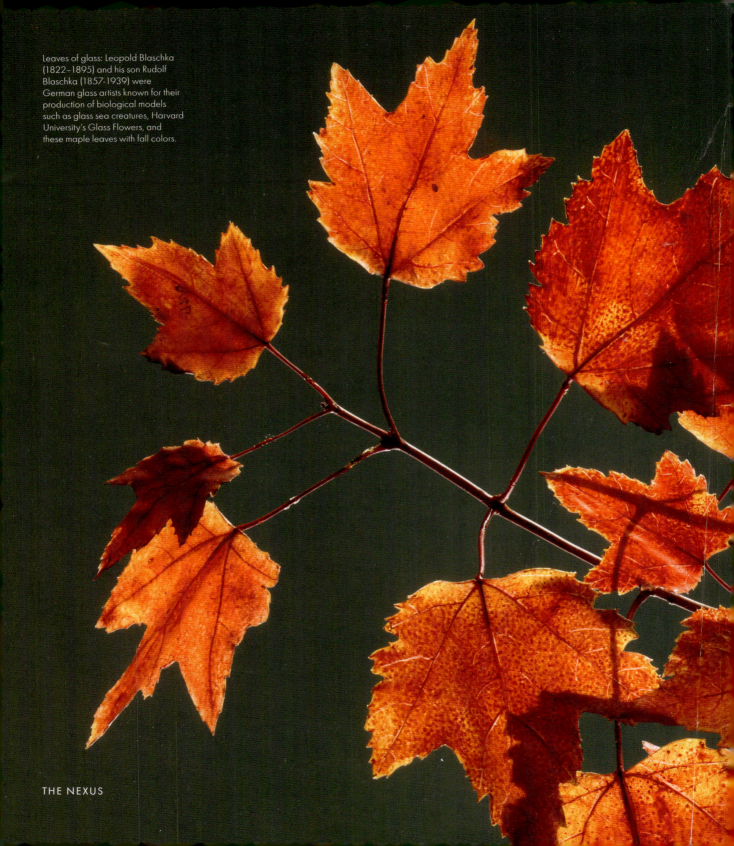

Leaves of glass: Leopold Blaschka (1822–1895) and his son Rudolf Blaschka (1857-1939) were German glass artists known for their production of biological models such as glass sea creatures, Harvard University's Glass Flowers, and these maple leaves with fall colors.

THE NEXUS

Designer Julia Koerner's work bridges the beauty of organic forms with synthetic processes and 3D printing to fashion and costume design. Koerner's Setae jacket mimics the intricate hairlike setae structures found on the wings of the Madagascan Sunset Butterfly. Koerner digitized microscopic photographs of the butterfly wings, developed algorithms to read the images which were then 3D printed, translating the colors and geometries, directly onto the fabric.

Thomas Edison's Menlo Park, New Jersey, Laboratory – the site of the invention of the light bulb – reconstructed in 1929 in Dearborn, Michigan at Greenfield Village, as part of The Henry Ford Museum.

Robot, assisted by a technician, working on a piece of Carrara Italian marble; a diamond-coated finger follows the instructions encoded in computer program to produce a sculpture. Florentine workshops employed many artisans who worked in relative anonymity, the final product receiving only the master's signature. Carrara's robots are now the anonymous artisans; many artists employing them want their identities to remain secret. Physical effort and health considerations have been factors in the decline of marble sculpting. But speed may be the critical factor; sculpting robots can be 160 times faster than their human counterparts.

Moving trains. Imaging time. Photographs by Celine Ramoni Lee of automated train tracks in Tokyo's Yurikamome line.

9 Evenings: Theatre and Engineering. A series of performances at the 69th Regiment Armory in New York City, October 13–23, 1966, the result of a ten-month collaboration between ten artists and thirty engineers from Bell Labs working together to develop technical equipment and systems to create a blend of avant-garde new technologies, dance, and theatre.

When we compare the NASA Command Module with the SpaceX Dragon interior shown here, we can see the central place of design in the culture of the Nexus.

AUGMENTED THINKING FOR A COMPLEX

Dedication:
To Alicia, Jules, and Bertrand
—Julio M.

To Bisi, Osunkemi, Omalola, and
Adeshola
—Bruce

The MIT Press would like to thank
the anonymous peer reviewers
who provided comments on drafts
of this book. The generous work
of academic experts is essential
for establishing the authority and
quality of our publications. We
acknowledge with gratitude the
contributions of these otherwise
uncredited readers.

This book was set in Futura
and Times New Roman by Vašek
Nunnelly Kokeš.

Printed in China

Library of Congress Cataloging-in-Publication Data
Title: The nexus: the new convergence of art, technology, and science / Julio Mario Ottino with Bruce Mau.
Description: [Cambridge, Massachusetts]: The MIT Press, [2022] | Includes bibliographical references and index.
Identifiers: LCCN 2021013272 | ISBN 9780262046343 (hardcover)
Subjects: LCSH: Science and the arts. | Technology and the arts. | Creative thinking.
Classification: LCC NX180.S3 O88 2021 | DDC 700.1/05—dc23
LC record available at https://lccn.loc.gov/2021013272
10 9 8 7 6 5 4 3 2 1

AUGMENTED THINKING FOR
A COMPLEX WORLD

NEXUS

THE NEW CONVERGENCE OF
ART, TECHNOLOGY, AND SCIENCE

JULIO MARIO OTTINO
with BRUCE MAU

Today, more urgently than ever, v
thinking. The world faces enormo
complexity—problems that intert
interdependent, and changing la
we must adopt new ways of think
the boundaries of classical knowl
must increase, and execution mus
our thinking spaces to increase cr
make those solutions real by mas
at the Nexus, where art, technolo

need to augment our

challenges of unprecedented

ne in a dizzyingly interconnected,

cape. The demands are clear:

g and working that cross

ge and practice; creativity

xcel. How can we augment

ive solutions? How can we

ing complexity? By working

, and science converge.

Above: Anatomical figure: Illustration from C.J. Rollinus in Albrecht von Haller's book *Icones anatomicae* from 1756

Below: A natural snowflake, one of the many photos taken by Kenneth Libbrecht, an expert on the properties of ice crystals. Lab-grown crystals tend to have sharper structural features; natural snowflakes, which sublimate as they fall, have a more of a travel-worn appearance.

THE NEXUS

CONTENTS

Cellular and Molecular Processes

Roche Biochemical Pathways
4th Edition, Part 2 — Editor: Gerhard Michal
www.biochemical-pathways.roche.com

Roche

THE NEXUS

Above: Beginning in the 1960's as a "hobby," Roche scientist, Gerhard Michal, developed this detailed poster of the cellular and molecular process of the human body. Every element of the diagram represents countless PhDs, and in many cases, a life's work.

CONTENTS

NASA engineer Ernie Wright striking a pose in front of the first six hexagonal mirror segments of the James Webb Space Telescope. JWST was designed to succeed the Hubble Space Telescope. Once completed, the 18 hexagonal mirror segments will combine to create a mirror seven times larger than Hubble's, providing improved resolution and capabilities that will enable the observation and study of the farthest regions in the universe, such as the formation of the first galaxies.

Above: Hubbard Glacier, Disenchantment Bay, AK, Alaska, United States.

Below: Embers fly across a roadway as the Kincade Fire burns through the Jimtown community of Sonoma County, Calif., on Thursday, Oct. 24, 2019.

THE NEXUS

Art inspired by the relationship between aesthetics and science. In Loris Cecchini's work, technology and design software, far from being in collision with the physical world, can create nearly perfect imitations of nature's process. This work, part of a series called, "Wallwave Vibrations," seems to bring the wall to life. Installed as part of the exhibition, "Turbulence," at l'Espace Culturel Louis Vuitton in Paris, the work models the intersecting impact of multiple sources of energy. The image, also used on the cover, perfectly captures the complex interactions and possibilities that happen when art, technology and science interact at the Nexus.

EVERYTHING

Above: Artist Tom Sachs, obsessed with the wonder of NASA's Apollo Program, produced his own full-scale replicas of the lunar module, mission control, and the lunar rover.

Below: "Everything," is a new class of video game by artist David O'Reilly, where the player interacts with a procedurally generated universe and can be anything, "from atoms to entire galaxies."

Origins of the Domains
Central aspirations and drivers
Age

Growth and Evolution
Methodology
Growth mode
Evolution of ideas
Chronology: the possibility of ordering events in time

Products
Uniqueness
Intellectual protection

Structure of Governing Systems
Role and character of talent pipelines
Domains
Fields
Relative importance of domain and field
Field size
Private/public support structure
Existence of formal nurturing and recognition systems
Role of external environment
Insiders and outsiders
Value of (and shifts in) reputations over time
Role and existence of constraints

People
Lines of succession and the role of mentors
Role of champions
Possibility of one-hit wonders
Degree of entrepreneurship

Communities and Groups
Role of groups or clusters in development of individuals
Cooperation among groups
Effect of increased connectivity and flow of information
Role of specific communities
Degree of control in the formation of groups and teams

THE NEXUS

Embodiment of a Nexus project: Jaume Plensa's 2004 Crown Fountain in Millennium Park, Chicago. Described as an extraordinary art object and public art at its best, the project had Plensa working with a large team of structural and mechanical engineers, experts in screen water engineering technology and image content production, glass block fabricators, and more. Two towers six meters high, made out of black granite and stainless-steel, with screens within the towers composed by over one million LEDs, show in carefully choreographed rotations, the faces of about one thousand Chicago residents – representing the diversity of the city in both ethnicity and age – spouting water from their mouths. A very thin layer of water covers the plaza area between and surrounding the towers. Images remain on the screen year-round but water features, function between mid-spring and mid-fall, computer programs determining when to turn the water on and off depending on weather conditions. Part art installation, part gathering space, the project elicited overwhelming public response, the ability to walk on water, being most welcome especially by children.

8 Spruce Street, a 76-story skyscraper in the Financial District of Manhattan, New York City – one of the tallest residential towers in the world – designed by architect Frank Gehry.

Above: Gowanus canal. One of a series of photos by artist William Miller of Brooklyn's Gowanus canal, one of America's most polluted waterways. Though significantly cleaner than it was 30 years ago it reflects more than a century of unfettered industrial abuse, followed by decades of bungled attempts to clean it up.

Below: The most perfect "Blue Marble." This high-resolution image of the Earth was taken from the VIIRS instrument aboard NASA's Earth-observing satellite, Suomi NPP. This composite image uses a number of swaths of the Earth's surface taken on January 4, 2012.

THE NEXUS

Rowan Cloud, 2012. Susan Derges's work, exposing images directly onto photographic paper – which goes by the name of camera-less photography – obviates the mediation of a camera between object and viewer.
"This is essentially more about print-making rather than photography," Derges has said.

Starlings above the village of Rigg, near Gretna, in the Scottish border.

THE SETTING

How we can identify ways for finding and implementing creative solutions.

When we augment our thinking spaces, we expand our potential for finding creative solutions. But to make creative solutions real through carefully orchestrated execution, we must understand the fabric of complexity that governs how every component of society and the world functions today.

The Problems We Face

Increased connectivity makes us more vulnerable to crises.

Why the imperative to augment our thinking spaces? Because we face problems of massive complexity. Few of them—especially those dealing with energy, environment, and social structures—admit clean solutions with clear end points. When particularly thorny problems suddenly appear ("wicked" problems in today's parlance), we treat them as crises—9-11 was one, the 2008 financial collapse was another—and respond with urgency. Yet in both these cases, people became increasingly impatient when confronted by the inconveniences associated with preparing for the next terror attack or the next financial debacle—and then superficially, in a year or so, everything went "back to normal." The year 2020 brought two crises. One was the COVID-19 pandemic; the second, a global explosion that brought recognition to racial inequalities. These two crises are hardly similar, and it is hard to predict what permanent changes they may produce. It is hard, however, to imagine clear end points. One thing is clear, though: more crises will follow.

Humanity has bounced back from terrible disasters. In Europe, the Great Famine in the early 1300s and the Black Death in the mid-1300s were followed by the Renaissance. World War I, immediately succeeded by the devastating Spanish flu epidemic, was followed by an amazing outpouring of intellectual creativity; World War II was followed by tremendous growth in the arts, sciences, and technology, things that make us proud to be human. Are future crises accumulating to be unleashed? Is the world in terrible shape? Opinions vary. Some have argued, as Steven Pinker does in *Enlightenment Now* (2018), that the world has improved across a wide number of metrics, a progress that can be traced back to the seventeenth and eighteenth centuries, when liberal humanism merged with scientific thinking to guide reason. But we can also argue that at no point in past history has it been so clear that the world is a wholly connected system, that physical distance is not a shield, and that there are no places to hide. Ours is a world where crises propagate and amplify. In such a world, networks rule.

Crises need not be triggered by people. Earth has always experienced mega disasters. Evidence of massive volcanic eruptions, which have had significant effects on climate, go as far back as 630,000 years ago, when the Yellowstone super-eruption covered half of the United States with ash. Evidence of Earth being impacted by life-changing asteroids goes back 56 million years, when a massive one hit the Yucatan peninsula. The event led to the extinction of dinosaurs and created what is now called the Chicxulub crater.

Disasters need not be mega to have significant impact. Connectivity is making us more vulnerable to events that in the past would have remained localized. A small volcanic eruption can disrupt interdependent supply chains and the entire transportation

system. But there are other risks that pose even more direct threats to our interconnected communicated world. One example is a coronal mass ejection (CME) in a geomagnetic solar storm, when the corona surrounding the sun throws out massive amounts of charged particles and creates disturbances on Earth's magnetosphere. CMEs can damage power grids, satellite systems, and communication systems. One significant CME, significant enough to have been given a name, was the 1959 Carrington Event; as it took down parts of what was then the newly created US telegraph network, this CME not only started fires but also sent electric shocks through some telegraph operators. Another CME, in 1989, caused power failures in Quebec, Canada. A significant CME could lead to months or years without reliable grid electricity. Recent reports estimate the chance of Earth being hit by a Carrington-class storm in the next ten years at about 10 percent.

The Two Themes of the Book: Creativity and Execution
We must develop a design methodology that can put good ideas into action.

Solutions to problems depend not only on good ideas but also on the ability to execute those ideas. The best way to come up with a good idea is to have lots of ideas. Just as important is generating diverse ideas from people with different experiences and backgrounds. Creativity is essential to finding the right idea, but so is the ability to execute an idea. Complex systems thinking can help us to plan, execute, and—when things do not go as planned—to perform forensics, uncovering concrete actions and plans we never considered as possible fixes to a particular problem. A wide-angled perspective has never been so important.

The problems ahead will not conform to the classical disciplines of knowledge or institutional boundaries of the past. The new challenges we face are of higher order of complexity. No problem of the twenty-first century will fit neatly into models of thinking, education, knowledge, and industry left over from twentieth, and in some cases nineteenth, century. As challenges cross domains we will we need to develop a design methodology that allows us to push our thinking to a higher order of complexity, to solve what are now ecosystem problems.

The plan going forward—the structure of this book—involves the parallel development of two components: (1) the augmentation of thinking spaces, and (2) the incorporation of complex systems thinking to complement those thinking spaces.

Augmenting Our Thinking Spaces

How can we develop a richer thinking space that synthesizes art, technology, and science, and what will arise when we do?

We can begin to augment our thinking spaces by blurring the boundaries between the three largest domains of human creativity—art, technology, and science—and converging them in a new space called the Nexus, a place where separate domains not only combine but synergize. When boundaries are removed, the whole becomes greater than the sum of its parts, and entirely new things can emerge.[1]

It is then somewhat paradoxical that our discussion starts with the stereotype of putting thinking in two camps. The first is the analytical, logical, methodical, sequential, and convergent camp, the kind of thinking normally associated with the sciences. The second is the creative, holistic, exploratory, metaphorical, and divergent camp, typically associated with the arts. This division is simplistic, of course. Extremes of both exist, as does thinking that crosses camps. We advocate the kind of thinking that fuses both. We call it Nexus thinking, or simply thinking at the Nexus; we refer to those who practice it as Nexus thinkers or whole-brain thinkers.

Though art, technology, and science grew apart after the Renaissance, they are now converging. Nexus thinkers who can understand this convergence and seamlessly navigate intersections will become the innovators of the future.

Context matters, and history enriches us. How do art, technology, and science grow? In what ways is creativity in these domains different, and in what ways are they similar? We need to understand how others think. Common belief has placed artistic creation on the highest plane, giving rise to a persistent myth: equating art with creation, and creation with inspiration. Reality is more complex and far more interesting. There are, in fact, creative processes and lessons that can be transferred across domains. Transferring lessons requires translators. But we cannot translate languages that we do not understand. Understanding the languages of art, technology, and science is the first task.

Incorporating Complex Systems Thinking

How can a complex systems framework help us to see commonalities that transcend differences, and what will happen when we do?

Understanding and crossing domains is not enough to drive innovation. Our world is increasingly complex and interconnected, and it is important to equip a new generation of innovators with a *conceptual framework* to help them navigate and thrive amid this complexity. Complex systems theory provides such a framework.

1. The word "nexus" may be one of the most versatile in the English language, and its use extends to a surprising number of other languages. The word appears in the names of fictional places; in the titles of novels (famously, as the third volume of Henry Miller's semi-autobiographical trilogy **The Rosy Crucifixion,** *following* **Plexus** *and* **Sexus***); in the names of journals and periodicals as well as rock bands and albums; in names of for-profit and nonprofit organizations; concepts in law and government; and in various contexts in computing, technology, and science—for instance,* **Nexus: Small Worlds and the Groundbreaking Science of Networks** *(Buchanan 2002). The word often bridges a whole array of domains as in, for example, the water-energy nexus and the humanitarian-development peace nexus. But a closer example of our use in this book, where the Nexus is the synthesis of three domains, may come from* **Star Trek Generations,** *a 1994 film that refers to Nexus as a place of supreme happiness, an extra-dimensional realm that exists outside of normal space-time, where time has no meaning, and where fantasy becomes reality.*

Before going further, it is important to distinguish between *complex* and *complicated*. We know how to deal with complicated systems, whose pieces can be understood in isolation; the whole system can be reassembled from its parts. Nothing magical or unexpected happens when the pieces are put together. The components in a complicated system work in unison to accomplish a function or series of functions. A nuclear submarine, for instance, is complicated: a single defect can bring its entire system to a halt, so redundancy needs to be built into the design in the form of multiple backups. Complicated systems do not adapt; they are designed to follow prescribed plans (Ottino 2004).

Complex systems are different. Ecological systems, traffic and transportation networks, the internet, the power grid, the propagation of epidemics, the brain, and financial networks are complex. Research results obtained over the last several years allow us to qualitatively and quantitatively understand the common principles that govern the collective behavior of seemingly different physical, biological, ecological, technological, and socio-technological systems. This is the first lesson emerging from complex systems research: seeing commonalties that transcend the differences.

Aims of This Book

We want to inspire, not just inform, so readers may emerge with an augmented perspective.

Our book is meant to be more than informative. We present our readers with lessons—with ideas that will enrich their thinking and eventually be useful. But we also aim to inspire, to have them emerge with an augmented perspective, a philosophy of thinking enhanced by the ability to function at the Nexus.

We do not pretend, though, to offer readily applicable solutions to current problems. Readers interested in ready-made solutions will be disappointed. We see this book as a guide, equipping individuals and teams—innovators and organizations—to traverse domains that appear unrelated. By teaching how to reach, understand, and operate in this augmented thinking space—and how to form the right teams who understand conceptual frameworks and tools to navigate complex environments—we can significantly increase creativity and innovation for individuals, organizations, and educational institutions.

Ever more complex problems need specially designed teams. Energy, security, epidemics, global health, income and racial inequities, and worldwide sustainability are all complex problems; they require thinking and approaches that span domains. Yet the total number of people who can navigate intersections while managing big teams with widely diverse skill sets is small. Our culture generally does not train people to operate at intersections. Nexus thinkers can be the connectors of the future, but teams will not be entirely composed of Nexus thinkers.

Instead, balance among team members is essential. Network theory has yielded insights into creative output and team performance: it shows that creativity requires divergent thinking, whereas implementation requires convergent thinking; teams must include experts at both. What may result in high creative volume and lots of novel ideas may actually hinder the desired goal of innovation. Studies of teams whose composition and outputs are thoroughly documented yield lessons about striking the right balance between idea creation and execution.

The ability to think more broadly and navigate complex environments results in lessons for individuals, teams, and organizations.

Designing The Nexus
Images and words embody two different worlds.
Design helps to fuse and synergize them.

A novel, symphony, or painting are each the result of a single mind.[2] An exhibit is not. An exhibit is an integration of images and objects with words, physical space, and sometimes sounds, that form a seamless coherent whole. It is the result of multiple decisions. If successful, the end result appears as the inevitable product of a single mind. A Broadway show, an architectural project, or a feature film are all the result of teamwork and complex design synthesis. And though we often assign credit to architects and film directors, the result is an amalgam of myriad inputs and contributions. The book we have designed is closer to an exhibit than a novel. But we want it to look like a novel, a seamlessly integrated experience of narrative and images.

Marshall McLuhan said that when a technology loses its utility, its functional relevance, it becomes an art form. In this digital information age of infinite access, there is no "need" for the physical book. Everything we have to say here could be easily distributed in digital form. But if we think about the cultural experience—the book as an art form—the physical book comes into its own. Something magical happens in the hands and minds of readers, which is hard to match in the digital domain (at least, so far).

Images and words embody two different worlds. We want our book to be a seamless integration of both, a Nexus blend. This is where design comes in. Design does more than fuse these two worlds. It shows how the worlds synergize and augment each other. When we consider the book from this perspective, it becomes the physical embodiment of the Nexus: a synthesis of art, technology, and science, with synergy between components; an immersive field composition laid down in multiple "tracks" that can be performed at different and unpredictable tempos, in whatever way individual readers decide.

A musical analogy conveys our aspirations. We think of the book's design as a physical environment with a bass line and jazz riffs that come in and out of the background,

2. It is important to qualify this statement when talking about sculptures, installations, and other creative endeavors. There are often entire Nexus teams working on contemporary art projects. In some cases, as in arts collectives and collaborative studios, the team elements may be reflected in the names themselves, as with *teamLab* or *Random International*, interdisciplinary groups that may involve large numbers of artists, animators (in film or computer graphics), engineers, architects, mathematicians, roboticists, lighting experts, and others. In some groups, elements of the team may stay in the background and contribute little to the aesthetic dimensions of the installation, but those elements may be critical to the launching of projects that may require years of political negotiations and environmental approvals. Christo and Jeanne-Claude's large-scale site-specific installations, such as *The Floating Piers* (floating walkways leading to an island in Lake Iseo in Italy) and *Running Fence* (a 24.5-mile cloth fence running through the California landscape and into the ocean), fall in this category.

3. The traditional (encapsulated) version of Eurocentric achievement is that science originated in Greece, was preserved in the Islamic Empire—with Islamic scholars acting as the caretakers and transmitters of Greek knowledge while European interest in science and mathematics declined—and it then spread northward via Spain. This view brings other oversimplifications as well, with China seen as distant and isolationist, if seen at all. The documentation of China's precedence on the famous trilogy of Renaissance inventions— printing, gunpowder,

at times performing solo on center stage, at others providing gentle background support for contemplative engagement. Participants (our readers) can take many personas: the Scanner, quickly dipping in and out, picking up ideas and insights here and there; the Grazer, landing on images or ideas in random sequence, sometimes from back to front; the Deep Reader, fully committed to the intimate experience of the long-form essay. The Nexus is designed to engage all of these, to create an immersive experience that can only come from the physical book.

The two of us, Julio Mario Ottino (JMO) and Bruce Mau (BM), have had conversations around the Nexus for well over a dozen years. Our first meetings took place shortly after BM's show "Massive Change: The Future of Global Design" at the Museum of Contemporary Art in Chicago (September through December 2006). BM's move from Toronto to Chicago resulted in both of us living on the same street, practically across from each other. Innumerable discussions followed. We both saw the benefits of seamlessly traversing the worlds of art, technology, and science. The goal became how to explain the Nexus and what follows from there. This book is the result of merging our two worlds, views blurring into each other, to reach this objective. One of us, JMO, is responsible for most of the text and structure and a good number of the figures that augment the text. JMO lives in the world of research, physical sciences, chaos and complex systems, incursions in art, and managing and creating academic units. BM lives in the world of design, responsible for the synthesis of ideas and images to create an experience, an immersive environment that not only contains the content—the ideas of the Nexus—but demonstrates that content as an embodied engagement. The outcome is different from an "illustrated" book. Our ambition is to produce a new world, a new way of experiencing the Nexus as a deeply holistic view that resonates with words and images working together like a multitrack composition.

A Guide to the Book from Julio Mario Ottino
We have built The Nexus *on an overarching lesson from history, that to operate successfully in the future we must understand the past.*

History enriches us: it teaches us how things got to be the way they are, and it offers us a glimpse of human creativity across domains. Thus, the book compares art, technology, and science across several levels, drawing occasional parallels that start from the Renaissance onward. In art, the focus is on Western art, and within art, the leaning is toward visual arts. In science, the emphasis is on physical sciences, with some detours to biological systems and math. But the final objective, the path forward, rests on comparisons across art, technology, and science, using modern and contemporary art as the reference point. The science view is Western based, as well.[3] Significant scholarship has been devoted to this topic, alluded to when we present the first examples from the Renaissance. It should be apparent that nearly all components covered in the book can be expanded significantly, and everything covered has more layers of complexity than depicted.[4]

the compass—is, in historical terms, recent. And although religion is often assumed to be hostile to science, Christianity was responsible for preserving knowledge in Europe. During the Middle Ages, there was no center of knowledge dissemination. Given distances, different versions of learning coexisted in relative isolation. The seemingly sudden emergence of the Renaissance boosted the notion of Europe as a cradle of civilization by linking directly to Greece, bypassing the time elapsed between Constantine and the fourteenth century.

4. It is manifestly impossible to capture the enormity—past and current conceptions—of the art, technology, and science domains. They have evolved in multiple ways over the arch of human history and continue to evolve at a faster rate than ever before. A view of science may start 4,000 years ago with Mesopotamian civilizations; of technology 100,000 years ago, with the beginnings of tool making; and, if a date is needed for art, 20,000 years ago with the Lascaux cave paintings. Science did not emerge as what we call science today until quite recently (Fara 2009), whereas the current centrality of technology prompts questions now that we never imagined in the past (Nye 2006). And today's contemporary art is broken down in so many strands that it is hard to imagine how art history may look thirty years from now. Entire academic careers and uncountable books have been devoted to specific components and subcomponents of the art, technology, and science domains. We advocate a convergence of thinking to address the domains as they exist today. But an understanding of the past may be crucial to imagining the future.

History teaches us an overarching lesson, that to operate successfully in the future we must understand the past. To build our case around this point, we begin the first chapter in the Renaissance—when art, technology, and science were one; we explain how these domains work in chapter 2. We move in chapter 3 to creativity and how our views of it are still shaped by the Renaissance and the Romantic periods. In chapter 4 we look at art/technology/science across a range of categories and metrics to show that, almost invariably, technology falls between art and science. We cover a somewhat idiosyncratic set of organizations and groups in chapter 5 that exemplify outpourings of creative products and ideas. In the sixth chapter we outline elements of complex systems theory and introduce the *complementarity*, a concept central to the Nexus and Nexus thinking. We get to elements of "how" and present lessons that cut across domains in chapter 7. These lessons, if internalized, provide a wide lens, a set of principles, to guide thinking and making decisions. Finally, in chapter 8, we discuss implications for organizations and leaders, and introduce the concept of the compass, a construct to help visualize the balancing of conflicting forces to guide organizations in periods of change.

We cover lots of territory; the challenge is to keep an even keel. Some readers may want more details in those areas where they are experts themselves; others may want less when they feel the exposition goes on too long.

With one exception, largely used to drive a metaphorical point, we refrain from connecting creativity with advances in neuroscience. Many have delved deeply into this field. Sophisticated tools already exist to observe brains in action; temporal and spatial resolution will continue to increase; and insights from this area will abound (Beaty et al. 2018; Kounios and Beeman 2009; and for popular accounts see Brandt and Eagleman 2017; Kounios and Beeman 2015). Early studies of hemispheric asymmetries often relied on 'split-brain" patients who had the corpus callosum—the neural fibers that connect the two hemispheres—severed as a treatment for severe epilepsy. We refer to one such study in chapter 8. The left-brain / right-brain metaphor—the left hemisphere being analytical and the right hemisphere being creative—is one of those ideas that has captured the broad public imagination. It is not, however, supported by contemporary research.[5]

The human brain is one of the most complex objects in the universe; we are just beginning to map the dynamic connections of the 86 billion neurons that make us human (Bassett et al. 2011). It is important to mention this here, as we would not want our readers to take literally what we present as a metaphor. In fact, scientifically assigning the labels *logical* and *creative* would require having to agree on how to quantitively measure logical and creative abilities. No generally accepted agreement exists at this point. Similarly, it is tempting to think of the brain as a highly optimized computer, but it is debatable whether (and how much) the computer metaphor is useful. Cognitive science has evolved from its origins of looking at brain processes through the lens of formal explicit analytic structures.

5. This two-ways-of-thinking division is manifestly coarse. Considerably more refined is the theory of multiple intelligences (Gardner 1983), grounded on the belief that humans have different ways of processing information (linguistic, logical-mathematical, musical, spatial, interpersonal, intrapersonal, and so on) that are relatively independent of one another. Not surprisingly the theory is popular with educators but somewhat controversial with psychologists.

With a few exceptions we also stay away from issues having to do with the role of creative thinking in personal lives. Scholars, researchers, and journalists have drilled into this topic via interviews with creative individuals—distilling advice, work habits, modes of inspiration, and the almost obsessive desire and need of creative individuals to constantly be seeking the new. There is some consistency, if not uniformity, in the advice this group offers: take an idea from one place and use it in another, surround yourself with lots of diverse of inputs, and constantly learn new skills. Then there is the fundamental counsel everybody in this space seems to agree with: do not be afraid of failure.

Absent as well is an explicit discussion of desirable characteristics of leaders. It is important to mention this because one of the central points of our narrative is complementarity—the ability to "embrace opposites"—and the capacity to do so may be considered an essential quality in a leader. This is also the appropriate time to mention empathy, which in this context can be regarded as the human attribute necessary for imagining the opposite of what we are certain about, another manifestation of complementarity. Nevertheless, we do not elaborate on this aspect or get into related issues such as tolerance, conflicts, and respect.

Finally, we need to comment about the future, since this book is essentially an argument on how to augment our thinking to deal with what has yet to happen. The past provides clues to the future, but so does the present. The past, however, provides examples that have aged well; it is hard to make such choices when operating in our cloudy present. This is especially true when bringing examples from the business world. Perspective is invariably lacking, underlying conditions change, and a good example now may turn out to be bad example a few years later. But this is not true when it comes to how businesses may be affected by circumstances facing us today. Supplychains disruption by epidemics and social unrest will sadly recur. Energy and sustainability will continue to be issues. It is manifestly hard to attempt for timelessness when addressing the future. Let us just say we are trying to avoid rapid obsolescence.

Paraphrasing a 1988 *Paris Review* interview with E. L. Doctorow seems appropriate here: *Life is like driving in an impenetrable fog. You can hardly see five feet in front of you, but in the rearview mirror everything is perfectly clear.* We hope that this book becomes a rearview mirror for our readers, offering a new way to look through fog and into all the possibilities the future holds.

About Julio Mario Ottino

Julio Mario Ottino is a researcher, engineering scientist, artist, author, and educator. Born in Argentina, he grew up with twin interests in physical sciences and visual arts, finding beauty in math and art, and seeing creativity as being one thing, rather that something living in compartments. Art provided a cathartic means of expression while growing up in turbulent times. He managed to mount a solo art exhibit while drafted as an officer in the Argentinian Navy. When he moved to the United States to pursue a doctorate, research achievements followed.

Most of the early attention Ottino received stemmed from work in chaos theory and mixing and a combination of scientific insight and visualization. His research work has been featured on the covers of *Nature, Science, Scientific American, the Proceedings of the National Academy of Sciences of the USA*, and other publications. He has supervised more than 65 PhD theses, written over 250 papers, 2 books, and given invited presentations at over 200 universities in the United States and around the world, as well as at organizations such as Accenture, Boeing, Google, 3M, and Unilever.

An academic entrepreneur, Ottino was the founding codirector of the Northwestern Institute on Complex Systems and educational and research initiatives in design, entrepreneurship, and energy and sustainability. As dean of Northwestern University's McCormick School of Engineering and Applied Science he also founded educational and research partnerships with Northwestern University's Kellogg School of Business, the Pritzker School of Law, the Medill School of Journalism, the Feinberg School of Medicine, the School of Communication, and the School of Education and Social Policy, as well as with external partners ranging from the Art Institute of Chicago to Argonne National Lab. In 2008, he was selected by the American Institute of Chemical Engineers as one of the "One Hundred Engineers of the Modern Era." In 2017, Ottino was awarded the Bernard M. Gordon Prize for Innovation in Engineering and Technology Education from the National Academy of Engineering for the concept of whole-brain engineering. He is a Fellow of the American Physical Society and of the American Association for the Advancement of Science. He has been a Guggenheim Fellow and is a member of both the National Academy of Engineering and the American Academy of Arts and Sciences.

About Bruce Mau

Designer, artist, entrepreneur, author and educator Bruce Mau is co-founder and CEO of the Chicago-based design consultancy, Massive Change Network. Born to Dutch and Polish/German Canadian immigrants, Mau grew up on a farm (without running water) outside of a mining town in northern Ontario. When he was a student, his first educational passion was science. He worked as the chemistry lab technician in his local high school. Mau traveled to the city for the first time to study art and design at the Ontario College of Art in Toronto but became a designer before he completed his studies. He worked in Toronto and then London before returning to Toronto, where he founded his first design studio, Public Good, in 1982.

Mau developed an international design practice, taking on diverse applications of his innovative methods of life-centered enterprise design to everything from carpets and cities, social movement and institutions, to brands and businesses, including the Oprah Winfrey Network, Arizona State University, MoMA, Coca-Cola, Panama Biomuseo, and the Holy City of Mecca.

Mau is the founder of the Institute without Boundaries in collaboration with George Brown College in Toronto. He is the curator and author of Massive Change, Life Style, and MAU: MC24, all published by Phaidon, London.

Mau has developed a globally recognized practice of creative collaboration, designing and coauthoring books with architects Rem Koolhaas (*S, M, L, XL*), and David Rockwell (*Spectacle and Drama*); the economist Minoru Mori (*New Tokyo Life Style Think Zone*); the artists Claes Oldenburg and Coosje van Bruggen (*Large Scale Projects*), and Terry Winters (*Perfection, Way Origin*); and the intellectuals Sanford Kwinter (*Zone 1|2 and Zone 6, Incorporations*), Mark Francis (the "fig–1" project), and Hans Ulrich Obrist (*Laboratorium*). For many years, he designed all the books published by Zone Books, The Getty Research Institute, and the Gagosian Gallery. Over more than three decades, Mau and his studio team have designed and produced more than 250 books, 200 of which were featured in an exhibition at the Philadelphia Museum of Art.

Mau is the recipient of the Smithsonian Design Mind Award from the Cooper Hewitt National Design Museum, and the recipient of six honorary degrees. He is a Distinguished Fellow in the Segal Design Institute at Northwestern University.

The deserted city of Wuhan China during the COVID-19 lockdown of 2020. The common denominator in our failed response was a shortcoming in our imaginative space. Even though we have been warned repeatedly of a coming pandemic, we could somehow not imagine solving a problem of this magnitude.

THE WORLD NOW

Facing enormous challenges with
great urgency

Problems—present and future—cannot be
solved with thinking from the past.

Any creative idea or endeavor must deal with the future. Yet what can we say about the future with any certainty? All we can do is predict that chaos and complexity will increase. What lies ahead will be messy when new ideas, if successful, take root and prosper. How best to prepare for challenges we cannot imagine?

Where do we start when listing problems that face the world now? Some have argued how the world has improved across a wide number of metrics, and this is undoubtedly true: longer life expectancy, fewer people killed in wars, increased literacy, more prosperity—the list of positives is long. But we live in a heightened state of anxiety. Views that start with "I feel that . . ." can rarely be changed by presenting data. Survey after survey of the biggest problems affecting humanity list climate change and destruction of natural resources, large-scale conflict and wars, religious fundamentalism, racial inequality, poverty, lack of education, lack of economic opportunity and unemployment, gender inequality, food and water insecurity, lack of political freedom, political instability, and—depending on who is surveyed—the future of the global financial system. Steven Pinker (2018) includes many of these problems in *Enlightenment Now*. Unsurprisingly, the ten we present below share some commonalities with the entries above.

(1) *Our modes of thinking are not suited to the problems we face.* Our thinking is still anchored in the past. For much of human history, we got by with linear thinking: A implies B, and B implies C, where small causes produce small effects. Now we understand that systems are much more interconnected and complex. We have access to amazing computational resources and analytics; we can quantify the connectivity that links world economies and supply chains; and we can measure things, unimaginably large and small, more precisely than ever before, things that were inconceivable even a few years ago. The toolkit that (in principle) can aid in our understanding has increased, but our intuition has not kept apace. There is now a dangerous gap between our intuition and the consequences of interactions of complex technologies with us and with the world.

(2) *Our wealth has never been greater.* We have greater and more broadly distributed access to technology, knowledge, and mobility than at any time in human history—but access in all three areas is inequitably divided between the richest and poorest among us. Racial inequalities are being magnified as well. We are seeing myriad unintended consequences of climate change and massive environmental degradation. Our success has now created one the greatest challenges in human history, and as such, the greatest opportunities for innovation and enterprise.

(3) *Knowledge is being democratized but, simultaneously, knowledge is fragmenting.* Access to knowledge—now available on a mass scale to people of any age—changes everything. Putting the tools of art, science, and technology into the hands of billions is fundamentally challenging the classical models in every domain. But domains of expertise—going deep in specific areas—are becoming narrower and narrower. Specialization rules.

(4) *Boundaries are blurring.* While this appears contradictory to (3) above, in fact, both conditions coexist. If we ask, "Where is creativity flourishing?" the answer is

at the intersections between domains. The boundary between art and technology is blurred, and the line between science and technology disappeared long ago.

(5) *The waves of innovation are becoming shorter.* The new feeds on the new. The process is autocatalytic and, therefore, accelerating. We are no longer experiencing a technological revolution but a cascading series of multiple mini revolutions crashing into one another, disrupting practically everything we do.[6]

(6) *Technology is permeating all areas of society.* Almost everything in our contemporary experience is connected in some way to media and technology. More and more of our time and attention are focused through a technological interface. Our most intimate experiences are subject to recording and global distribution. Barriers to entry are low, and the possibility for self-expression is increasing and will continue to increase.

(7) *Connectivity is changing all the rules.* Things that were once considered disjointed may now be combined, leading to spectacular new results. How we work and connect with each other, what we buy, what we do, where we shop, what we eat, how we live, how long we live, who we connect to—all of these are being redefined by connectivity, challenging models of business, governance, and culture. But connectivity comes at a price: disinformation, conspiracy theories, and crises propagate faster, and they reach more people.

(8) *Complex problems need bespoke teams.* Pandemics, energy, security, cancer, global health, and an increase in lifespans brings to the forefront a whole range of neuro-degenerative diseases, challenges to worldwide sustainability, and impacts of climate change. These are examples of big problems that require thinking and approaches that span a wide arrange of domains. Yet the total number of people able to navigate these intersections and function effectively in big teams with diverse skill sets is small. We generally do not train people to operate at intersections. Teams should be carefully designed for maximum creative output and faultless execution.

(9) *Massively interconnected challenges do not have clean solutions.* Environmental degradation, climate change, ocean pollution, global energy transitions, response to pandemics, and the need to balance privacy with effective public policy measures are all issues that cannot be solved in compartments or be declared to be solved in one swift blow. Massively complex problems do not have black or white solutions. We need to learn how to deal with problems that cannot possibly have perfect or finite outcomes.[7]

(10) *Technology-driven challenges will multiply.* How will artificial intelligence and robotics affect the future of work? Will privacy become a thing of the past?

6. Revolutions with a capital "R" are rare. But there is no question that technologies are combining with other technologies at an ever-increasing pace.

7. The highest order of complexity, in terms of sheer difficulty, are the so-called wicked problems: problems characterized by contradictory requirements, multiple causes, lack of information or conflicting data, ability to morph, and linkages with other problems that may be themselves wicked. Easy to list the symptoms; hard to agree on the complete syndrome. Examples may link urban planning with sustainability, energy, poverty, equality, political instability and terrorism, education, and health. The hardest components reside on the social complexity of the issues rather than pure technical barriers; the common denominator is that these are problems where one cannot possibly imagine a single solution or any solution at all. Wicked problems can be traced to a 1967 two-page editorial in the journal Management Science *(Churchman 1967). As of early 2020, the Institute for Scientific Information lists close to 2,000 papers with the term "wicked problems" in either the title or the abstract.*

Will we be able to distinguish what is real and what is not? Every vital sign can be measured; genes can be manipulated. Computers may seamlessly interface with brains. Do we want to design/edit people? How long do we want to live? Ethical frameworks must catch up with technology.

A common denominator among many of these entries? *Connectivity and lack thereof.* When increased connectivity takes place within specific sets, these sets become more and more disconnected from poorly connected ones. And as these highly exclusive connected parts become more efficient and interdependent, poorly connected parts become further disconnected and left behind. The COVID-19 crisis exposed this bifurcation. One could argue that part of the racial divide is due to lack of connectivity between improved sectors and those who do not share in the dividends.

Blurring Boundaries and Internalizing Lessons
Our biggest problems will persist unless we find viable ways
to implement creative solutions.

Imagination and creativity are needed more than ever. We need to be prepared to solve problems that we cannot imagine. Augmenting our thinking spaces is essential to this. Thus, a proposal:

First, *blur the boundaries* between the largest domains of human creativity—art, technology, and science. Synergies between these modes of thinking lead to a dramatic augmentation of thinking spaces and a wealth of possible ideas. Second, *internalize the lessons* from complex system research. We are operating in a dizzyingly complex world, where creative solutions must be followed by faultlessly planned implementation.

At its core, *the two components of the book are ideas and implementation.* Organizations, being able to balance teams in terms of left- and right-brain thinking strengths, may achieve excellence in both domains. But we should not regard these camps as disjointed. If anything, we are advocating for a much closer connection between the creative right-brain camp and the realistic, implementation left-brain camp. The path forward is not one where the creative team throws ideas to the implementation team and then waits for the ideas to become reality.

The path forward is full of hurdles. Our biggest problems persist because so many implementations, for myriad reasons, fail. Creative ideas presented without any context regarding possible implementation, blissfully unaware of reality, are set up for failure—and then there is the issue of resources and reality itself constraining lofty dreams. Nevertheless, money should not be the main obstacle. With clear objectives, we can build good economic plans. This is the territory of economic incentives and disincentives or incentives and rewards. The main things that conspire against

successful execution are political; then there is also the unavoidable fact that nearly all major innovations cause disruptions, creating winners and losers. So do apathy, uninformed opinions, and organized opposition, often materialized as lobbying groups. It is then hardly surprising that many creative ideas do not succeed.

The reflex today, in the face of increasing and immediate challenges, is to seek answers and solutions in hyper-specialization. There will always be a place in the world for people who master one topic; we need specialists to solve hyper-specific problems. But the path toward radically new insights to solve the massively complex problems we face can only come from the inverse—the integration of seemingly disjointed domains.

At a high level the differences between artists, scientists, and engineers begin to blur. The drivers dominate. They all rely on a singular need, craving, or obsessiveness to enjoy the process of creation for its own sake. The value in the intersection resides *in enriching how the other side thinks.* Why do we care? Because more fluid communication between the components will produce more unexpected ideas, and therefore more innovation. The opportunity is now. At no point in the past have artists been more entrepreneurial than they are today.

There is no better vantage point to appreciate the power of human creativity and imagination than being at the Nexus. A similar argument applies to the value of a humanistic education: not being aware of the Nexus would shield us from the enrichment of the broad landscape of human imagination, creativity, and innovation, and the outcomes it has produced. The Nexus is the space of convergence where the different modes of thinking stemming from art, technology, and science coexist and enrich each other—a broader thinking space from which to tackle today's problems and imagine futures that have not yet been imagined.

Here we make the case for how Nexus thinking benefits three different spaces.

Nexus Thinking for the Business World
What do we need to operate in this chaotic landscape?

The current business landscape is bewildering; nonstop emerging technologies, new market entrants, shifting customer demands. Everyone is struggling with how to innovate, how to scale innovation, and how to react to the changing ways of work. Organizational forms have changed —teams are very rarely together, except in the smallest of companies, and virtual teams are the norm not the exception; COVID-19 cemented this trend. Add to this an external, mazelike, regulatory environment and the social media amplification of constituencies, employees, and customers who are self-empowered when dealing with the companies they work for and buy from. Constant change and instability are the norm.

It is as though we need a new breed of "super-people" able to thrive and lead in this dizzyingly complex environment. What skills are we told that these superheroes must possess? A recent CEO survey from Accenture reports that future leaders need these essential abilities: to influence, coach, and empower others; to excel in creative thinking and experimentation; to synthesize diverse thinking and viewpoints; to inspire teams and create inclusive team environments; and to show empathy and self-awareness, all while being vigilant to the external environment. Also, they must be willing to embrace and enact change; be comfortable with data analysis and interpretation, critical reasoning, and understanding new technologies; to have a bias toward action and be able to make tough decisions, all while being grounded in the right tech.

In short, this new world needs people who have and can act on a clear vision and strategy amid the cloudiness and constant change in a dizzyingly complex environment. This a tall order. The list tells us that we need a mixture of divergent thinking and convergent thinking, of empathy and rationality, of logic and intuition; we need people who can deconstruct problems and who can put them together using a magical mixture of right- and left-brain skills. In fact, the complete title of Accenture's CEO report is "Striking Balance with Whole-Brain Leadership." The question then is: How can one produce these people? Where can you find them, and how can you hire them? Or, if they are already in our midst, how can you discover and promote them? Could people be converted into whole-brain thinkers? If so, how can we train them and what skills must they develop to advance along the whole-brain path? In short: How does one become a Nexus thinker?

First, people must want to become whole-brain thinkers. This is nonnegotiable; whole-brain thinking is not for everyone. Next, they must have the mental flexibility to traverse different domains and to broaden their thinking spaces. While this may sound daunting, it is possible, and it can be reached by those who are both adaptable and strongly motivated. Here is the starting point we suggest: understand the forces, motivations, and questions that drive art, technology, and science, the three receptacles of the accumulated creativity we humans produce. Though once unified, art, technology, and science separated after the Renaissance, but they are now converging again. Understanding these domains can provide the mental agility to cover the amazingly broad list of requirements to innovate and lead the organizations of the future.

On first viewing, however, art, technology, and science appear to operate very differently. This forces us to reframe long held assumptions, to questions beliefs never questioned. In what ways is creativity in these domains different, and in what ways are they similar?

Let us say you self-identify as a technologist and feel personally lacking in understanding art. What should you do? The answer is not to become an artist, but to really try to understand how artists think, how they come up with questions, and how they

see the world. The problem is that each side sees the other in terms of subject matter or the product of the thinking, rather than the styles of thinking themselves. The objective is to enrich our thinking.

The key to succeed in reaching the Nexus, the place where modes of thinking converge and synergize, is having the right mental framework: to be open to new ideas and to seek inspiration from domains outside our own. This may not suit those who prefer sanitized ideas, have little tolerance for ambiguity, and to tend to discard ideas that do not precisely fit in their existing mental libraries. The Nexus will be a fit for those who watch in amazement at a perfectly designed building, are moved by a great novel or an extraordinary work of art, admire the beauty in opposed arguments, love structuring imperfectly shaped ideas, see the beauty in an abstract theoretical concept—or wonder, having seen a piece of world-changing technology, old or new, "How on earth did someone imagine of this?" The entry point is clear: a mindset open to curiosity and connection is a must.

Long ago, in the Renaissance, people were generalists who easily traversed domains. The Industrial Age introduced the idea of a specialized workforce, and for many decades that remained the rule of law for organizations. Now, in startups, a smart generalist beats a smart specialist all the time; at a small company, every person needs to be able to do multiple things. This is often the essence of innovation that big organizations are trying to replicate. It is intuitively obvious that a group of pure specialists will be less creative than the same group with one whole-brain thinker in it. Nexus thinking is the unchaining of specialization, seamless integration within a functioning whole.

Nexus Thinking for Creative Professionals

Why do creative professionals need to understand how scientists/technologists think, as well as how science and technology work and intersect with art?

While exceptions no doubt exist, creative professionals and those operating in science and technology see each other differently.

The two groups are more similar than they think. Like artists and other creative professionals, engineers leave an aesthetic trail of ideas bifurcating and evolving through rough sketches, complex drawings, models, mockups, and all sorts of engineering artifacts. Today we have photorealistic computer renderings, virtual reality images, and 3D-printed working prototypes. We also see evidence of this trail in scientific and engineering publications. Stunning arrays of images of objects and natural phenomena generated by an array of ever more powerful and deep-probing scientific instruments. This may not be art. But many of these images are exquisitely beautiful and even artistic looking.

8. There is evidence that success in science correlates with interest and activities in arts. Root-Bernstein and colleagues (2008) found that "compared with other researchers, proportionally more Nobel prizewinners and members of the US National Academies pursued interests in activities such as arts, theatre, and creative writing." They further argued that a similar correlation exists between the subset of members of the National Academy of Engineering who are entrepreneurs and patent holders. The number of scientists whose work was influenced by artistic components is large. A brief and manifestly eclectic list may include George Washington Carver (1860–1943), the most prominent black scientist of the early twentieth century, who was able to balance his interests in natural sciences with arts. His fascination with developing paints and dyes from natural sources may have been influenced by his interests in painting. Dorothy Mary Crowfoot Hodgkin (1910–1994), who received the 1964 Nobel Prize in Chemistry for work in X-ray crystallography to determine the structure of biomolecules, was

These trails and products should resonate with people in both the design and art domains. The question is: Will these materials ever reach them? An industry of curated exhibits exists in art. No such organized structure exists in science and technology. Maybe we need more new museums of technology, very different from the ones we have. But even more, we must expand our circles. Unvarnished contact with scientific and technological output requires meeting scientists and technologists in their habitats. The same applies in reverse. Some may argue that a museum exhibit cannot replace contact with real artists, and they would be right. Direct personal contact is best. We must strive to increase our circle of collaborators and friends. This requires persistent effort.

Closing the gaps requires also overcoming stereotypes. Creative types, and artists particularly, often equate science and engineering with cold, methodical logic, and not with the human factors and passions that animate those fields. Misconceptions exist on the science side as well. Many scientists and engineers equate art with paintings, photographs, and sculptures, and leave out conceptual art, installations, and other creative endeavors. More importantly, they equate art with outcomes and not with the thinking process that led to them. Many in the science world still see art as something elitist and distant, a thinking still anchored on old romantic views of artists, views that are disconnected from current realities of how contemporary art works.

Similarly, most of the public, whether rightly or wrongly, have a narrow view of scientists. The perception of engineers—as designers/builders of machines, bridges, and (perhaps) software—is improving but still limited. Seldom does the public appreciate the thinking skills, especially the creative skills underlying engineering, and how the field interfaces and fuses with science.[8]

a gifted illustrator; her attention to detail through the creation of precise scale drawings gave her a crucial advantage in recognizing X-ray crystallographic patterns. Sir Harry Kroto (1939–2016), who was awarded the Nobel Prize in Chemistry in 1996, is known for his contribution to the discovery of "buckminsterfullerenes," popularly known as "buckyballs"—carbon atoms that form a nanoscale ball. Kroto's achievement may have been informed by his artistic side and a knowledge of graphic design. And then there are those who see value in fusing domains. Leonardo, a journal that covers the interactions between the contemporary arts with the sciences and new technologies, was founded in 1968 by the artist, entrepreneur, and true rocket scientist Frank Malina. The intersection of art/science is reaching mainstream science. A "Career Feature" in the journal Nature had this direct message as its subtitle: "Engaging in a creative pursuit can stimulate creativity and foster boldness and tenacity in the lab and beyond" (Dance 2021).

Design and architecture are domains where art, technology, and science never cleaved. But at the extremes, artists and scientists may still (and wrongly) equate design with superficiality. Misconceptions need to be corrected. An effort to understand each other will show that engineers and artists share significant aspects of modes of thinking. We have focused too much on differences; we should focus on commonalities. This book is about overcoming these barriers to reach the Nexus.

Nexus Thinking for Governmental Organizations

Now more than ever, how we act and make decisions as a society will depend, more than ever, on a careful balance between policy, science, economy, health, and public acceptance.

Broad thinking and balance—whole-brain thinking and complementarity—seem more relevant than ever for *leaders and teams* who govern cities, states, and countries. (And, on a smaller scale, universities.) Reopening research and education in the face a pandemic has tested university leaders like nothing before. How we act as a society

and make decisions in the wake of a crisis depends on a careful balance between conflicting objectives stemming from data, science and technology inputs, economic considerations, policy, and public perception. COVID-19 tested steady leadership to the max. In crises like pandemics, those who can transcend domains, who can act as translators between different spheres of knowledge and action, and who can translate left/right brain inputs into actionable outputs will be the most effective and impactful.

Balancing the inputs and outputs is essential: emotion, authenticity, and empathy on one side; control, rationality, and consistency on the other. Above all, there must be consistency. Panic and distrust may follow when there are changes in messaging. Prolonged silences do not help, either. Planning and thinking two steps ahead (left brain) to avoid the possibility of contradictions in further steps is key. Controlling the narrative (right brain)—the standard way to respond to public adversity—requires careful thought, since it can only work when it stays close to the underlying facts. This is one of many balances.

The level of command and control is another lever. We have seen various countries in different locations fall on this scale. There are benefits of decisive control, but top-down heaviness may lead to an erosion of trust—when people are afraid to come forward and tell the truth, problems may intensify down the line, posing a significant disadvantage if crises recur. Tracking entire populations may be an option; it is possible, for instance, to harness techniques originally intended for counterterrorism—including surveillance-camera footage, smartphone location data, and credit card purchase records—to help trace movements and determine how many people are obeying a government lockdown. Digital technologies may enable governments to exert more social control and enforce social distancing during a pandemic, but they also raise questions about when surveillance may go too far. Balance, balance, balance: this is the central concept to manage crises in our times.

In a time of increasing complexity and uncertainty, we need a new way of thinking to innovate and lead into the future. Blurring the boundaries between the largest domains of human creativity—art, technology, and science—leads to a dramatic augmentation of thinking spaces and a wealth of possible ideas. Myths and stereotypes in each field, however, have stood in the way of innovation. Lessons from complex system research—crucial to operating in a dizzyingly changing world—aid in implementation and converting ideas into reality. The key to succeed in reaching the Nexus, the place where these modes of thinking converge and synergize, is to be open to new ideas and to seek inspiration from domains outside our own.

Earthrise. While the Apollo program may have been an extraordinary feat of science and engineering, arguably its greatest impact came from the images produced by the mission astronauts. This iconic image, captured on December 29, 1968, by Bill Anders, showing the distant earth rising above the grey lunar horizon, became a catalyst for the environmental movement. Anders later said, "We came to explore the moon and what we discovered was the Earth."

THE EVOLVING DOMAINS OF ART, TECHNOLOGY, AND SCIENCE

Understanding how the domains work

In the popular view, art is about creation, technology about invention, and science about discovery. The reality is more complex.

The broad domains of art, technology, and science each operate under their own rules. At different points in history, they worked together, and at some points intertwined, but then they ultimately separated. Adjacent to this were breaks between visual thinking and analytical thinking and changes in the dynamic interplay between science and technology. Examples start in the Renaissance, end in the early twentieth century, and span architecture and engineering, astronomy, chemistry, physics, math, classical perspective training, and cubism.

9. We use the term "domain" in a loose sense here and define it more precisely in chapter 3.

10. *It is impossible to talk about the cultures of art, technology, and science without commenting on C. P. Snow's famous 1959 Rede Lecture at Cambridge, "The Two Cultures." In that speech, Snow posited a split between the worlds of "science" and "the humanities" in the British educational system which, in his view, had overemphasized the humanities (especially Latin and Greek) at the expense of scientific and engineering education. It is important to note that "the humanities" Snow referred to is a subset of the field: mostly writing and no art. This "battle"—advocating unity or split—has a long history. Though famous in this regard, C. P. Snow was a latecomer to the discussion; in fact, this split was at the very core of the founding of several universities (see chapter 8).*

11. We discuss the relationship between engineering and technology in chapter 4. The terms "engineering" and "technology," as understood today, barely existed before 1840 and 1910, respectively.

12. *The comments "breaking paradigms" and "self-expression" apply to modern and contemporary visual arts and avant-garde art. They may not apply to the past: for example, to the Dutch Renaissance or to other art areas, such as literature. "The great realist novelists—Jane Austen, Tolstoy, Dostoevsky, Henry James, George Eliot, Charlotte Bronte—did not*

Art, technology, and science are the largest domains of accumulated distilled creative thinking produced by humanity.[9] These three domains are routinely seen as different and disconnected, operating under different rules, values, and growth modes, with their own talent pipelines and recognition systems.[9] Yet by taking a broad view, focusing on underlying drivers and explaining key differences, it becomes clear that there is much to connect the three. Most importantly, art, technology, and science are the three large-scale domains of human activity in which creativity plays a central role. Technology is about invention: creatively making and building.[11] Science is about discovery: creatively unveiling, revealing what may already be here but has never been seen. Art now is about self-expression and breaking paradigms.[12] How do these domains grow and advance?[13]

Science builds on the past. Although science occasionally produces radical disruptions (like the Copernican worldview, evolution, quantum physics, and post-DNA molecular biology), the idea of incremental progress is wired into the very fabric of science. The biggest discovery of science is science itself; it is how science grows. In a normal mode, science is about methodically building and adding knowledge. In fact, the conservative culture of incremental scientific practice does not readily embrace innovators: Nobel Prizes often come decades and even lifetimes after the original accomplishment. Darwin, for example, refrained from publishing his world-changing insight until the very last moment for fear of personal attacks, which came in droves. Science now is the ultimate open-source enterprise.[14] The "open-source enterprise" and the idea that "the biggest discovery of science, is science itself" can both be connected to Galileo's contemporary, Francis Bacon (1561–1626). Bacon's key idea, way ahead of its time, was that if science were a shared enterprise, something that relied on a process or a method, it would not have to rely on occasional geniuses to advance.

Technology, on the other hand, is about both building and disrupting. In a way not dissimilar to science, most technology follows the pack and builds on what has already been accomplished. But disruption, in either minor or major scales, is essential for growth. The culture of technology embraces innovators and has developed a mythology of the garage—HP, Apple, Xerox Parc, Skunkworks, and others. Today the "start-up" is technology's paradigm of disruption.

Modern art's aspiration is uniqueness; disruption and progress has little or no meaning. The challenge for contemporary artists is not to extend an existing historical cultural line (that role has been handed off to craft) but to break from that line and create a territory not already occupied—a new form of expression that is not necessarily better, but different and distinct enough to be recognized as a new space. Today, artists need a "logo," a personal DNA, that they can own. At its best, art does not solve problems; it creates questions. There is no inevitability in art. The history of modern art appears to be driven by replacing and disavowing heuristics. If a heuristic exists, its purpose is to replace any semblance of continuity. Because modern

think this way. For them, the forms of the realist novel conveyed a set of assumptions about the world—about human psychology and its relation to the social world, for instance. And what made a novelist great was the insight he or she brought. James was not at all a form breaker, nor was Turgenev or George Eliot, but their greatness lies in the subtlety of their psychology and the depth of their wisdom. Tolstoy was a form breaker, but only to find a better way to convey novelistic ideas" (Saul Morson, personal communication to JMO).

13. Creation and invention may seem to go together, and occasionally they do overlap. We routinely put creation with art and invention with technology: art products are created; technological products are invented. Invention goes with inventor, and both are associated with devices, methods, processes, engineering, and technology. More bluntly: inventions can be patented because there is utility behind them; there need not be utility behind creation.

14. This was not always so. In Isaac Newton's time, before science developed into the scientific journal–publishing enterprise it is today, secrecy ruled and scholars taunted each other, or included riddles in their letters understandable to only a select group. How articles in scientific journals (instead of comprehensive books) became the central component of our current scientific enterprise is the result of a long, complex, and controversial historical process (Csiszar 2018).

ART
Constant reinvetion

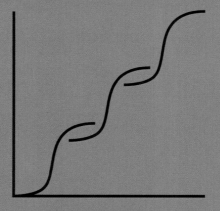

TECHNOLOGY
Continual adaptation with
disruptions

SCIENCE
Builds over past; infrequent
disruptions

Fig. 2.1 How art, technology,
and science grow. The diagram
labeled "ART" represents
the artworld from the beginning
of the twentieth century onward.
Which one of these domains
operates in mostly chaotic
environments?

and contemporary art is constantly looking for new spaces, art serves as an organizing principle for this book.

Science's edifice is built, layer by layer, on the foundation of previous science. Newton's remark, "standing on the shoulders of giants," is built into its fabric. In technology, however, the only reason to stand on the shoulder of giants is to crush the elder giants. A new technology appears before the older one has run its course (figure 2.1). And in art, now, it is bad idea to stand next to anybody. Derivative is not necessarily a bad word in technology; adaptations and remixes are good. But in art, *derivative* has a negative connotation.

Let now us state two important points, since they are relevant to everything that follows. One concerns terminology and labels, the other concerns perceptions of analysis and creativity.

First, the meanings of the words "art," "technology," and "science" have changed historically over time. Until the nineteenth century, "art/arts" was often a synonym for technology, and the distinction between "art" and "technology" was not clear until then. The word "technology" is relatively recent, arguably used for the first time in the very early twentieth century. (By most measures, technology is always between art and science.) We describe comparisons across different areas of the three domains in chapter 4.

The second point, in fact, permeates the entire book: *there is more analysis in art than perceived by science and more creativity in science than perceived by art.*

Historical Context for the Evolving Domains
The Renaissance in Europe generated astounding examples of creative fluidity.

The European Renaissance was a period of creative crisscrossing, especially in Florence, with artists as engineers and designers developing technology—sometimes practicing geometry, mathematics, urbanism and much more. At the same time, mathematically oriented thinkers moved into architecture and the arts. It is important to note that many of these labels did not exist at the time; people dabbled in things that we recognize in retrospect as cryptography. It is important to realize, as well, the tremendous variability among all these "geniuses" and the value system that pervaded their times. Filippo Brunelleschi (1377–1446), who trained as a goldsmith, played transformative roles in the fields of sculpture, painting, and engineering; through perspective and geometry, he contributed to key areas in what we today think of as "science." But Brunelleschi is remembered mostly as the preeminent designer of the duomo of Florence's cathedral. Almost concurrently Leon Battista Alberti (1404–1472) mingled geometry and optics with art and architectural theory while also practicing as an architect/designer. Leonardo da Vinci (1452–1519)—who did

Fig. 2.2 The Pantheor in Rome (above) and Brunelleschi's dome in Florence (left).

not overlap with Brunelleschi but did with Alberti—is often mentioned, along with Michelangelo Buonarroti (1475–1564) and Raphael (1483–1520) as the high artistic triad of the Renaissance. They were not of the same generation, however: Leonardo was twenty-three when Michelangelo was born and thirty-one when Raphael was born. Michelangelo outlived Leonardo by forty-five years.

Giorgio Vassari, arguably the first "art historian" and the first to use the term "Renaissance" in print, covers several hundred artists in "The Lives of the Most Excellent Painters, Sculptors, and Architects." Thinkers and doers certainly existed in other cultures and times, but in Europe during the late Middle Ages and Renaissance, there were specific sociocultural reasons for the emergence of so many such individuals. The fluidity between the arts, science, and engineering—though engineering did not yet exist as a discipline—is a model worthy of emulation. We claim this, and yet must acknowledge the exclusion of women and others from many of the realms of knowledge and practice during the European Renaissance.[15]

When Art, Technology, and Science Were Unified
Brunelleschi and Galileo, separated by two centuries,
exemplify the interplay between domains.

Florence's Daring Display of Confidence: Brunelleschi's Dome
Brunelleschi embodies a type of transformative and translational work that spans fields.

A little more than six hundred years ago, in 1418, those responsible for building the cathedral of Florence held a competition. The challenge was to enclose, with a dome, the cavernous space left open by the previous generation of planners and builders. Such was the self-confidence and ambition of Florentines that they had permitted the cathedral to grow so large with no clear plan or technological means to complete it. For designers, there was one prime model from the past: the dome of the Pantheon in Rome, built almost 1,500 years earlier (figure 2.2). Since then, no one had produced anything close to a dome of that span.

The two finalists and fierce competitors—they had faced off in two previous contests—were Lorenzo Ghiberti (1378–1455) and Filippo Brunelleschi (1377–1446).[16] Both had been trained not as builders or architects, but as goldsmiths. After Brunelleschi won and received the commission, he not only had to tackle aesthetic and engineering problems, but also had to invent and construct machines for transporting and maneuvering materials. The result was spectacular: the first octagonal dome in history built without a temporary wooden supporting frame. It is still the largest brick and mortar dome in the world.

15. In his book Vassari includes only one woman, Properzia de' Rossi, although in the section about her he briefly mentions three other women. Given the history of art, technology, and science, women appear very sporadically.

16. Ghiberti and Brunelleschi had faced each other in two competitions involving brass doors for Florence's Baptistery. Ghiberti won the first competition; in the second, the judges could not decide a winner and suggested that Ghiberti and Brunelleschi collaborate on the project. Brunelleschi was deeply offended, withdrew from the project, and left sculpture, switching his interests into architecture.

Brunelleschi embodies a type of transformative and translational work that spans fields: he transformed Italian architectural practice, wrote poetry, designed settings for theatrical performances, and conducted groundbreaking optical-geometrical experiments that were pivotal in the development of linear perspective.

Brunelleschi was amazing but far from alone in Florence; he died six years before Leonardo da Vinci was born. And Leonardo's death in 1519, a bit more than five hundred years ago, serves as a midpoint from our second example, which takes place almost two hundred years after Brunelleschi's dome.

The Importance of Surroundings: Galileo and the Surface of the Moon
Galileo's discoveries benefited from the knowledge of perspective gained in Florence.

Galileo Galilei (1564–1642), more than anyone, is responsible for the birth of modern science. Galileo and the Englishman Thomas Harriot (1560–1621) are at the root of one of the most celebrated near-simultaneous discoveries and one of the best examples of the interplay between art, technology, and science.

Europeans in the Middle Ages believed that the moon was a perfect sphere. It represented purity; the Virgin Mary was often represented standing on it. How then to explain the spots on the moon's surface, "the strange spottednesse," as Harriot called it? There were many speculative explanations. One was that the moon was a like perfect mirror that reflected Earth; another was that the moon was made of a transparent substance, like alabaster, with some internal matter giving off varying amounts of light.

A radical possibility presented itself, thanks to the most advanced technology of its day: perspective tubes, or what we now would call a telescope. Perspective tubes had been developed for military uses, like spotting invading ships. No one had used them they to observe the skies.

Harriot observed the moon with a Flemish-made perspective tube four months before Galileo. Galileo learned how to fabricate perspective tubes and became quite accomplished at it. Both recorded their observations—the irregularities on the surface of the moon (figure 2.3). Harriot made ink drawings while Galileo used watercolors (Edgerton 1984).

Drawing, in Renaissance Florence, was the foundation for all visual arts and architecture. And in Florence, the very center of drawing resided in the prestigious Accademia delle Arti del Disegno. This is where Brunelleschi's seminal perspective work ended up. Perspective—the idea that artists could render images on paper just as they are seen with the human eye—was central to the mission of the Accademia, which included within its staff a mathematician to teach elements of Euclidian geometry and perspective to aspiring artists. Galileo was familiar with the work of the Accademia;

Fig. 2.3 The moon's irregular surfaces: drawing by Harriot and watercolors by Galileo. Both men observed the same image of the moon, but Galileo had a "theoretical framework" to inform what he saw and what he needed to see to support his intuition. His training in perspective and his knowledge about the shadows projected by complicated objects gave him this edge.

Prototypical Renaissance Men
Alberti, Leonardo, and Michelangelo

Leon Battista Alberti, Leonardo da Vinci, and Michelangelo Buonarroti, at various moments in time, were each considered the very prototype of the Renaissance man. Broad as their interests were, they did not overlap. Alberti was the only one in the group to qualify as a humanist. He was one of the most influential figures in Renaissance architecture, but he was also an author of hugely influential treatises on art: *Della Pittura* (On Painting), *De Sculptura* (On Sculpture), and *De re Aedificatoria* (On Architecture). He was also a poet, linguist, philosopher, mathematician, and cryptographer; because of this breadth and depth of knowledge, many scholars consider him as the archetype of the Renaissance "universal man."

Leonardo was the ultimate polymath; the one who, from the perspective of our time, personifies "creative genius" and who most effortlessly seems to bridge drawing, painting, sculpture, architecture, music, engineering, anatomy, geology, astronomy, paleontology, botany, and cartography.

Michelangelo's artistic versatility as a sculptor, painter, architect, and poet was such that he is often considered a contender for the title of archetypal Renaissance man. Several scholars have described Michelangelo as the greatest artist of his age and even as the greatest artist of all time. All three were thus portrayed at various points as the personification of the Renaissance. They were far from similar. Alberti came from a wealthy family. Leonardo was born out of wedlock to a wealthy Florentine notary and a peasant woman. Michelangelo's father was a minor aristocrat. Of the three, Alberti is the only one who qualifies as a mathematician and a humanist. As the principal initiator of Renaissance art theory, his work lives to this day. But among the three, Michelangelo was the first—in fact he was the first Western artist—whose biography was published while he was alive. In 1553, when Ascanio Condivi published a second biography, *Life of Michelangelo*, the "high and noble creative genius" was nearly eighty years old.

Because most creative people begin their endeavors at young age, we have the tendency to ascribe genius with youth. But it was Michelangelo who embodied the idea that creativity does not have to dull with age. He sculpted two of his best-known works, the Pieta and David, before he was thirty. Yet at age seventy-four he took over as the architect of St. Peter's Basilica and, despite holding a low opinion of painting, he created two of the most influential frescoes in the history of Western art: the biblical

Leon Battista Alberti, view of the nave of the Basilica di Sant'Andrea and the English title page of the first edition of Giacomo Leoni's translation of Alberti's *De re Aedificatoria* (1452); Leonardo da Vinci, pages from *Codex Atlanticus*, a twelve-volume set of drawings and writings published from 1478 to 1519; Michelangelo Buonarroti, Sistine Chapel ceiling, 1512.

scenes he illustrated on the ceiling of Rome's Sistine Chapel and *The Last Judgment* on its altar wall. The Sistine Chapel dome was completed after his death (Wallace 2020).

Michelangelo's low opinion of painting may seem curious, considering that remarkably, during his lifetime, sculpture was deemed too physical and thus not held in high esteem. Architecture was at the pinnacle, since it included elements of drawing, painting, and sculpture itself; it was seen as shaping cities. But it was an older man's game. Most architects—in fact, all those named above, starting with Brunelleschi—had trained in another profession.

he was skilled in perspective drawing and was an accomplished watercolorist. In fact, he became an elected member of the Accademia based on his strength as an artist.[17]

A bit more than four hundred years ago, in 1609, Harriot and Galileo had the very same image of the moon in front of their eyes. But Galileo had in his toolkit the perspective knowledge accumulated in the Accademia, whereas Harriot was in London, then far behind Florence. Galileo's thorough training in perspective and *chiaroscuro*, with his knowledge about the shadows projected by complicated objects, was of immediate help.[18] One image was not enough: he had to see evolution. Changing shadows told Galileo about a surface pocked with craters, in what up until then had been regarded as a perfect sphere.[19] He even had the tools to estimate the craters' heights. Galileo had a theoretical framework to inform what he saw; Florence gave him that edge.

In Florence, the "left-brain" analytical, rational, and convergent coexisted with the "right-brain" creative, metaphorical, and divergent. Florence was the embodiment of the Nexus, a wholly connected network that connected to other city-states in Italy, a network that led to amazing creative insights. Galileo was part of it—he had lived in Pisa, Siena, Padua, and Venice, where he did his astronomical observations. He enriched the network and the network enriched him; the artistic atmosphere surrounding him was crucial to his thinking.[20]

Brunelleschi and Galileo do not stand as isolated examples. In the two hundred years separating these two examples, the Italian Renaissance saw many others, in multiple city-states, who explored the spheres of painting, mathematics, architecture, physiology, optics, and various branches of engineering. But Florence was in a class of its own. How could a city of some sixty thousand people produce such amazing intellectual output for more than two hundred years?

True, there was less knowledge to master than there is today, and labels mattered little, but the explosion of talent was remarkable. It also helped to have funding to dream up commissions and to support this talent. At the center of all this were the Medicis, Florence's banking family and ruthless political dynasty, the venture capitalists and angel investors of their day. The Medicis were patrons of the arts but, above all, investors in the glory of Florence and in their own family name. Their success rested on how to make the right bets. Who would assign a goldsmith with no record in engineering to construct a dome? Patrons in the Italian Renaissance asked people to stretch their potential, often expecting them to do things they had not done before. This practice was not restricted solely to Florence. In Vatican City, Pope Julius II "asked" Michelangelo— though demanded would not be too strong a word, considering that Michelangelo was then known mostly as a sculptor—to paint the ceiling of the Sistine Chapel.

This model of cooperation between art, technology, and science was hugely successful, and reached well into the sixteenth century. Why then, did art and science

17. Drawing was the foundation for all visual arts and architecture in Galileo's time; learning to draw included the study of composition, anatomy, and perspective, with a strong accent on the latter. This teaching was encapsulated in the prestigious Accademia delle Arti del Disegno, often referred to in shortened form as Accademia del Disegno. Giorgio Vassari, arguably the world's first art historian, founded the academy in 1563, one year after Galileo was born. Because perspective was so crucial to drawing, its staff included a professional mathematician to teach elements of Euclidian geometry to aspiring artists. We are told that Galileo applied for this post but was rejected; afterward he held a post as a mathematician in Pisa. A proof of his status within the art world of his times came later, when he was admitted as a member of the Accademia del Disegno.

18. Galileo's instruments had more magnification than Harriot's, but this appears to be unimportant to what happened, according to historians who studied the subject: Galileo could interpret what the images meant.

separate? Before addressing this question, let us look at one example where artistic training may have been central to a breakthrough scientific discovery.

Pasteur: The Hidden Importance of Mirror Images
Was chirality, a profound scientific concept, inspired by art?

Louis Pasteur (1822–1895) was a French microbiologist and chemist who made seminal contributions to science, technology, and medicine, a truly towering scientific figure of the nineteenth century. His mode of work, epitomizing the merging of basic and applied research, is now encapsulated in the concept of the Pasteur's Quadrant (Stokes 1997), the space where curiosity-driven and application-driven research coexist. Pasteur discovered that microorganisms cause fermentation and disease; he invented the process we now call pasteurization; and he pioneered the study of molecular asymmetry or chirality, something that connects him, in a deep way, with art. The art connection notwithstanding, by the time Pasteur was born, art and science had already bifurcated. People entered these fields by separate tracks.

In his teens, Pasteur was an average student but an accomplished artist (figure 2.4). As a teenager, he made several dozen portraits of family and friends: pastels, charcoals, and, significantly for our short story, lithographs. His artwork is now at the Pasteur Institute in Paris. At age twenty Pasteur stopped working in art, but he continued drawing figures for his scientific publications—representations of crystals and images for his microbiological work. He even made models of crystals from cork and wood. For the rest of his life, Pasteur remained closely connected to the fine arts; he attended salons, kept a diary of art that he saw during travels to museums, and taught classes at the École des Beaux-Arts on how chemistry could be used in fine art. As in many cases of visually gifted scientists, it is hard to know to what extent his visual imagination shaped and aided his scientific work. We must rely on their narratives for this, but Pasteur left none.

But we do know this: very soon after graduating from the École normale supérieure, where he wrote two theses—one in chemistry and one in physics—Pasteur became interested in optically active substances— substances that rotate polarized light, which moves in a plane, rather than in all directions (Gal 2011). When polarized light passes through an optically active substance, the light is rotated either in either a clockwise or counterclockwise direction.

In 1848, shortly after receiving his doctorate, Pasteur made the surprising observation that what seemed a homogenous mixture of crystals was in fact a mix of two kinds of crystals. When separated and dissolved in water, one kind of crystal rotated polarized light in one way, while the other kind of crystal rotated light in the opposite way (Pasteur 1848).

19. During his time as a professor of mathematics at the University of Padua (which was part of the Republic of Venice) Galileo had to teach Euclid's geometry and what was still the standard geocentric astronomy from Egyptian and classical Greco-Roman times. The description of the moon as a perfect sphere can be traced back to those times as well. The belief, which changed in the Renaissance, was that knowledge used to reside with the ancients. Book hunters searched for traces of that knowledge in manuscripts preserved in monasteries. One such account is described in Greenblatt (2011)

20. Many perspective books were published during Galileo's time, the bulk of these in Italy and Germany; they included entire sections on irregular solids and complicated exercises in perspective and shadows. The topic was equally important to artists and mathematicians. But during Galileo's lifetime no comparable dialogue took place in England.

Fig. 2.4 Louis Pasteur, lithograph of Charles Chappuis, made when Pasteur was nineteen years old. The text under the image reads: "Portrait of my philosophy classmate Ch. Chappuis made in Besançon in 1841," followed by his signature, "L. Pasteur."

Fig. 2.5 Discovering chirality: from 1848, Louis Pasteur's drawings of chiral crystals of paratartaric acid and models of crystals he later made, while working on crystallography, to demonstrate his discovery of molecular asymmetry.

How did Pasteur discover this? Using tweezers, he separated crystals and saw that the mixture of crystals was in fact a 50–50 mix of two non-superposable mirror-image forms (figure 2.5). In today's terminology, the crystals were chiral images of each other.

This is quite remarkable. How could Pasteur have possibly seen this? Imagine a heap of crystals, like pieces in a puzzle thrown on a table, and somehow picking two crystals and discovering that, when orienting them properly, they are mirror images of each other. Human hands are the most universally recognized example of chirality; the left hand is a non-superimposable mirror image of the right hand. But seeing chirality in a jumbled collection of right-handed screws and left-handed screws, for example, seems to be a far easier proposition than seeing it in the crystals Pasteur observed.

Chirality is one of most profound concepts in chemistry, something that has a molecular basis. But Pasteur did not know this at the time; twenty-five years had to pass before this fact was established. Chirality is at the very basis of life; for example, all regular DNA is right-handed. Chirality has also deep-reaching consequences. The molecular structures of some drugs are chiral: one kind may treat a disease while the mirror image can bring terrible side effects. The most notable example is Thalidomide, a drug initially prescribed for anxiety and morning sickness, and initially deemed to be safe in pregnancy. The other chiral form of the molecule, however, gave rise to terrible birth defects.

Pasteur discovered chirality at age twenty-five, just eight months after earning his doctorate. Some have argued that this discovery was the result of his earlier work in crystallography. But a compelling argument—although Pasteur left no notes of his thought process—can be made that his artist's mind, still fresh from his work with lithographs, may have been prepared to see mirror images where others could not (Gal 2017).[21]

Lithography exploits the immiscibility of oil and water. An image is drawn with a greasy substance—oil, fat, wax—onto the surface of a smooth limestone plate. An acid treatment follows, which etches the portions of the stone that were unprotected by the grease-drawn image. The stone is then moistened, and an oil-based ink is applied, which repelled by the water, sticks only to the original drawing. A blank sheet of paper, pressed on the stone, produces a printed page. The same general concept is used in etching and woodcuts, where a design is made in a metal plate or wood. In all cases, the resulting image is the mirror image of the original image. An artist will notice differences between the original and the printed image; mirror images magnify differences, for example, in a human face. Pasteur's experience with mirror images in his lithographic work may have facilitated his recognition of the chirality in crystals that had eluded many others. As in the cases of Harriot and Galileo, having the same image in front of our eyes does not mean that we "see" the same thing.

21. We suggest a larger point, that a fascination with symmetry could have factored in Pasteur's thinking. Scientists have long been obsessed with finding beauty and symmetry in nature; a classic book on this subject is Hermann Weyl's *Symmetry* (Weyl 1952). In fact, much of scientific work involves a creative effort to read nature in this way; it guides physics theorizing to this day (Zee 2016).

Poincaré, Duchamp, Metzinger, and Bohr: Intertwining Mathematics, Cubism, and Quantum Mechanics
What we learn from thinkers at the frontier of intersecting domains.

Our example of early twentieth-century interconnections brings together some of the top names in mathematics and physics with the top names in art. It shows how those connections were made possible by translators who could bridge camps. As the Harvard historian of science Gerald Holton (2001) declared, "A culture is kept alive by the interaction of all its parts." His statement aptly encapsulates this kind of intertwining as a Nexus of minds at the frontiers of math, science, and art. Holton is the main reference in our next story about the interdigitation of art and science. Many people are part of this story and, and while we mention several, others will undoubtedly remain hidden from view.

The beginning of the twentieth century was a period of rapid change: electricity, cinema, radio, cars, and airplanes entered our culture alongside abstract notions of hyper-dimensional spaces, spacetime, and baffling concepts stemming from the new world of quantum mechanics. Educated classes in Europe were fascinated by some of these concepts. At the beginning and center of this cultural spreading was Jules Henri Poincaré (1854–1912), one of the greatest mathematicians of all time referred to by his contemporaries as the last complete mathematician: the "last of the universalists."

Poincaré contributed fundamental insights to mathematics, physics, astronomy, and philosophy. He was one the founders of topology, the father of chaos theory, and the first to propose gravitational waves. Many concepts in mathematics are named after him, including the Poincaré conjecture, which took nearly a century to prove. Unusual for a mathematician, Poincaré was an essayist who made deep incursions into the psychology of creativity. He was an influential intellectual and a gifted writer who was elected to the French Academy for his literary achievements. Not only did he become director of that preeminent French literary institution, but he also served as president of France's Academy of Sciences—an unmatched combination. Poincaré's 1902 book *La science et l'hypothèse* (Science and Hypothesis) was required reading for any cultured person, especially in France.

Popularizations of Poincaré's mathematical work spread the concepts further. One such work was the *Traité élémentaire de géométrie à quatre dimensions* (Elementary Treatise on the Geometry in Four Dimensions), published in 1903 by Esprit Jouffret (1837–1904), a French artillery officer, actuary, and mathematician.[22]

And then they were the translators, people who fluidly bridged the camps of math and arts. Maurice Princet (1875–1973), known as "le mathématicien du cubism," was such a connector. Princet brought Jouffret's work, most notably the concept of the "fourth dimension"—an extension to our everyday perception

22. A cube exists in our everyday three-dimensional space. We can imagine how an augmented version of a cube, a hypercube, may exist in a four-dimensional space. Jouffret's book explains, among other things, how to project a hypercube onto a two-dimensional space.

of the three-dimensional space—to the most influential artists of the day. He was a close associate of Pablo Picasso (1881–1973), as well as several now-famous artists including Jean Metzinger (1883–1956) and Marcel Duchamp (1887–1968). Duchamp and Picasso are arguably the most influential pair of artists of the twentieth century, Metzinger less so, but he has a crucial role in another part of this story. There seems to be no question that Poincaré's work influenced Duchamp, since we have his notes referring to Princet's book (Holton 2001). The influence on Picasso and other cubists is compelling, as well.

Jean Metzinger's influence comes into play via his direct connection with Niels Bohr, one of the giants of physics of the twentieth century, who made groundbreaking contributions to atomic structure and quantum mechanics. Metzinger was also a writer; he coauthored, along with Albert Gleizes in 1921, *Du Cubisme* the first book on cubism. Bohr kept up with cubist and modern art, although it is unclear if he ever read this book. But we do know that Bohr owned one of Jean Metzinger's cubist paintings, and Bohr's relationship with this painting is worth telling.

Bohr was revered by the Danish government and beloved by the Danish people. With the help of the Carlsberg Foundation and the Danish government, Bohr founded the Institute for Theoretical Physics in Copenhagen in 1921. After he won the Nobel Prize in 1922, the Carlsberg Foundation gave him a house where he could host visitors in style. It was a remarkably good investment; Bohr was an outstanding mentor, and a record number of scientists who spent time with him at Carlsberg mansion in Copenhagen were awarded the Nobel Prizes (notably the list includes one of his sons, Aage Bohr).

An account of Bohr's connection with art—and specifically with Metzinger—comes via Mogens Andersen, a friend of Bohr's eldest son, Christian Bohr. Andersen, who went on to become a painter, wrote a short piece titled "An Impression" for a book edited by Stefan Rozental, who was Niels Bohr's assistant for fifteen years. In this book, *Niels Bohr: His Life and Work as Seen by His Friends and Colleagues* (Rozental 1967), Mogens explains the physicist's relationship with La Femme au Cheval, the 1911 cubist painting by Metzinger (figure 2.6). It hung in the drawing room—or music room—in Carlsberg mansion. Mogens tells us, "I have often seen Niels Bohr, full of life, explain his views and interpretation of the picture. In his eyes there was the pleasure of giving form to thoughts to an audience unable to see anything in the painting… Bohr was engrossed with the ambiguity of the motif… that an object could be several things."[23] This idea undoubtedly meshes with the principle of complementarity proposed by Bohr to explain concepts in quantum physics. Complementarity, the concept that something can be two things at once, is far from intuitive. We further discuss complementarity in chapter 6, "Thinking at the Nexus in a Complex World." Bohr had a series of famous debates with Albert Einstein, who was reluctant to accept the ideas of quantum mechanics. One such exchange, from Bohr to Einstein, captures the difference between these two men: "You are not thinking, you are merely being logical!" Complementarity defies logic based on our observable world.

23. The principle of complementarity was announced in 1928; Bohr moved into the Carlsberg mansion in 1932. It appears that complementarity came first, and explanations based on *La Femme au Cheval* came second.

Art Illuminating Science
Santiago Ramón y Cajal

Santiago Ramón y Cajal (1852–1934) is regarded as the father of modern neuroscience. He (along with Camillo Golgi) received the 1906 Nobel Prize in Medicine "in recognition of their work on the structure of the nervous system." Cajal's experiments demonstrated that the nervous system is made up of millions of separate nerve cells, "neurons," and that the relationship between neurons was not continuous—forming a single system as proposed by others—but rather contiguous, that there were gaps between neurons. His scientific insights are inseparable from his artistic eye, for he was truly as much an artist as a scientist. Cajal's drawings not only guided his thinking—his 1906 Nobel Prize Lecture, "The Structure and Connexions of Neurons," includes twenty-three figures— but also have helped innumerable others to extract the right insights from the images. As proof of this, many of his more than three thousand drawings are still in use today. It is important to note that the drawings are not exact reproductions of what he saw under the microscope; today a photograph would capture that, and in Cajal's time a camera lucida, which projects images on paper for tracing, would have served a similar purpose. But Cajal rarely used a camera lucida; instead, he drew freehand, sometimes combining insights from multiple observations in a single drawing, as he did when encapsulating his hypothesis about brain connectivity. His Nobel Prize biography characterizes him as a rebellious teenager who had decided to become an artist, but who eventually moved into medicine. A man of many passions, he was also an accomplished photographer who made several self-portraits, including some with his family, and wrote several books for wider audience. His passion for drawing and his sensitivity to visual aesthetics were the hallmarks of his scientific activity.

Histological drawings by Santiago
Ramón y Cajal: Cerebellum-Purkinje
Cell, astrocytes—infant cerebral
cortex, degeneration-regeneration.

Fig. 2.6 Jean Metzinger's *La Femme au Cheval* (1911); Niels Bohr's drawing room in Copenhagen, showing where the painting was hung. Bohr used this cubist work to explain the idea of complementarity to visitors.

Much has been written about the cubism-quantum mechanics parallelism. Some of it may overexplain the underlying thinking attributed to both camps. In his book *Einstein, Picasso: Space, Time and the Beauty that Causes Havoc*, Arthur Miller (2001) writes: "If cubism is the result of the science in art, the quantum theory is the result of art in science." Nicely symmetric phrasing, but probably an oversimplification. It is nevertheless hard to imagine another time where the foundations of science and art changed in parallel at such rapid pace. The fact remains that interconnections existed, and that both art and science together changed forever.

Art and Science Separate

Science and technology become useful and worthy of patronage.

The sixteenth century includes many examples of cooperative enterprises between scientists and artists, and of scientists who were also artists, like Galileo. But—notwithstanding the intertwining of art and science of the examples following Brunelleschi and Florence—art and science had started to diverge. In fact, Galileo also marked the beginning of the end of that era.

Signs of this shift can be glimpsed a hundred years before Galileo.[24] An example is Niccolò Fontana Tartaglia (1497–1557), a mathematician, military engineer, and surveyor—someone who bridged the gaps between military architecture, ballistics, and geometry. People like Tartaglia had useful knowledge that was valuable to the rulers who were constantly battling with other city-states. Tartaglia's skills could be used to calculate the trajectory of projectiles—he wrote an entire book on it—and he developed plans for fortifying cities and changing the course of rivers. City-states started supporting these kinds of activities. It was their edge. Money drove change.[25]

Examples abound: Galileo secured the financial backing of the Doge of Venice by touting the military uses of his telescopes. Leonardo de Vinci was hired by Ludovico Sforza, the Duke of Milan, because of his strengths in military engineering. Notably, in his application letter, Leonardo described the many things that he could achieve in the field of engineering and mentioned parenthetically that he could also paint.

Hard to draw an approximate dividing line, but up to Galileo and Francis Bacon's times, what we now regard as science and art were seen as complementary rather than oppositional. It was perhaps at the early stages of the Industrial Revolution when these two practices become separated

Prior to this shift in power, the intellectual prestige had been associated with the philosophers; knowledge resided in the past. There was no concept of progress or innovation; if anything, innovation was thought of as undesirable.[26] But after city-states started investing in people like Tartaglia, the balance of power shifted to mathematics and engineers.

24. We associate Galileo, more than anyone, with birth of the scientific method and credit him for launching experimental physics. None other than Stephen Hawking said, "Galileo, perhaps more than any other single person, was responsible for the birth of modern science." He is also responsible for putting physics in the language of mathematics—and this is at the root of the separation because mathematics became useful, which in turn produced a shift in power.

25. A parallel break was the one between science and religion. This is an amazingly complex topic that we cannot possibly cover in any detail here.

26. The idea of innovation as something good is, in terms of human history, a rather recent concept. So is the idea of progress. In fact, it can be argued that the root of modernity is when people started seeing knowledge as cumulative, and the idea of progress as something positive (Mokyr 2016). Worth noting that the use of the word innovation in print media has increased by almost a factor of seven in the last hundred years.

By the time we reach Isaac Newton (1632–1727) and his magnificent *Principia* (co-incidentally, Newton was born the year that Galileo died), the change was in full force, and art was left behind. The transformation was complete by the time we reach Joseph-Louis Lagrange (1736–1783), Pierre Simon Laplace (1749–1827), and others.

Lagrange and Laplace personify analytical thinking at its apex, the point when determinism ruled.[27] This is when the accent was clearly on the analytical, and the creative, intuitive aspects aspect of science became hidden from view. Alexander Pope's proposed epitaph for Newton captures this mode of thinking magnificently: "Nature and Nature's laws lay hid in night: / God said, Let Newton be! and all was light." Men could predict the motions of heavens: the metaphor of the solar system was a clock. What then was the use of art? Determinism and rationality ruled, and art separated from science. It was as if the two sides of the brain, seamlessly connected during the Renaissance, split. Analytical, rational, convergent, deductive, logical, and quantitative thinking on one side; divergent, inductive, metaphorical, creative, and artistic thinking on the other. The Nexus was no more. Art, technology, and science evolved in separate paths.[28]

When Science Became Analytical and Divorced from Art
Anything that was perceived to weaken purely analytical thinking became suspect.

The Poincaré/Duchamp and Bohr/cubism vignettes represent linkages of art and visualization, math, and science (Henderson 2013). To many of us they are truly inspiring. The examples, however, are slightly misleading in that they represent notable exceptions; examples belonging to this crisscrossing of art and science after the Renaissance are less than plentiful. For much of the eighteenth to twentieth centuries, images and analytical thinking did not mix. In fact, if something was perceived to weaken purely analytical thinking, it became suspect. Figures aiding in explanations or representing concepts fell in this category. We have already mentioned the two towering figures bridging the eighteenth and nineteenth centuries who encapsulate this divorce. The first is Joseph-Louis Lagrange (born Giuseppe Luigi Lagrangia), an Italian mathematician and astronomer who worked in Berlin and then in France. His *Analytical Mechanics* (1788)—the most influential work on classical mechanics since Newton's Principia—charted the course of mathematical physics in the nineteenth century. The second is Pierre-Simon Laplace, who pioneered work in mathematics, physics, astronomy, and statistics. His 1799 *Traité de méchanique céleste* (Celestial Mechanics), a five-volume tour de force set, established him as the prince of celestial mechanicians. It is said that when Napoleon asked him why he did not mention God in his work, Laplace replied, "Sir, I have no need of that hypothesis." And Lagrange, in his *Analytical Mechanics*, boasted proudly that the book "contains no pictures." The accent was on the analytical and rational.

27. Neptune's discovery in 1846 captures the unbounded faith in determinism. Uranus, the last planet known at that time, at was not behaving as predicted by Newtonian mechanics; a 30-second of arc deviation from Newtonian predictions was deemed unacceptable, and the idea of a trans-Uranian planet, a body that somehow could account for the deviations in the predictions, took shape. The discovery of the reason for these deviations—after dispensing with various explanations, such as an incorrectly calculated mass for Uranus—took the form of finding an as yet undiscovered, trans-Uranian planet. This laborious task was completed almost simultaneously by Jean Le Verrier in France and John Couch Adams in England and resulted in the discovery of what we now call Neptune. This was a crowning triumph of determinism, and in some sense, it would be its last. The solution of the two-body (Sun-Earth) problem was known, but no one knew how to solve the Sun-Earth-Moon problem. Propelled by an unbounded belief in the existence of an analytical solution for the motion of planets, a race of sorts took place to solve the three-body problem. The King of Sweden established a prize. The answer, as it turned out, was anticlimactic, and it was most clearly not what people were looking for. Poincaré, whom we encountered earlier, showed that no closed-form solution could possibly be written down; three bodies interacting via gravitational forces were enough to produce chaos. The story is worthy of a book (Barrow-Green 1997).

Physics and mathematics have been held as primary examples of domains where images play no role. But this view is far too narrow—visual imagination is a central element of scientific imagination. Beauty, balance, and symmetry are often invoked in describing scientific and mathematical concepts (Weyl 1952). Seeing and representing are inextricably linked to understanding. Visual imagination, of course, was always there, but sometimes hidden below the surface. Figures may have helped in the elaboration of ideas but were eliminated in the final presentation of results. Holton (1996) wrote on the topic of scientific imagination and identified those who were on the side of it and those who were not. We already encountered his first and most eloquent example: Thomas Harriot (1550–1621) representing the "no" side, and Galileo Galilei (1564–1642) representing the "yes" side.

Holton's proponents of visual imagination include Albert Einstein (1879–1955) and Richard Feynman (1918–1988). To this list we may add the German mathematician David Hilbert (1862–1943); commenting on one of Hilbert's books, the French mathematician Jacques Hadamard (1865–1963) said, "Diagrams appear in every other page." The German physicist Werner Heisenberg (1901–1976) is squarely on the "no" side ("the progress of quantum mechanics has to free itself from all these intuitive pictures"), as is the mathematician Karl Weierstrass (1815–1897). "You may leaf through all his books without finding a figure," Poincaré said of Weierstrass (Hadamard 1945, 111).[29] Michael Faraday (1791–1867) and Bernhard Riemann (1826–1866) are prominent examples of the visual side. Faraday had little mathematical training, but he was an amazing physical and visual thinker who can be rightfully regarded as a theorist. It is said that Einstein had a framed copy of Faraday's portrait over his desk.

Nevertheless, after Galileo, rationality started to dominate science: intuition and creativity went with art. Scholars commented on the imbalance. At some points in time, the strands connected, some in real ways, and some in imagined ways (as in the mostly imagined connections of quantum mechanics and relativity with cubism). But in the early 1900s, art became more abstract; and science, which up until that time had been focused on precision, quantification, and numbers, was revolutionized by quantum mechanics and relativity, and became about concepts and structure.[30] And then the frontiers of science diverged from technology, as well. Science's goal became a quest for understanding.

Science Driving Technology or Technology Driving Science?
The evolution of progress and innovation depends on the ability to switch places.

While science and technology began to diverge, they were sporadically interconnected; one leading, the other following, and constantly switching places. The popular view, however, is of science driving technology: a breakthrough in science can lead to technological innovation. Sometimes this happens, but invariably progress is slow and almost never linear.

28. This applies, with some disclaimers, to science and visual arts. But less so if arts include poetry and writing in general. Johann Wolfgang von Goethe (1749–1832), widely regarded as the greatest German literary figure of the modern era, considered his scientific theory of color as his greatest achievement, not his poetry. A magisterial presentation of the so-called Romantic age of science is presented in Richard Holmes's *The Age of Wonder* (2008). This is the age that gave rise to Mary Shelley's *Frankenstein*.

29. Figures can be inseparable from the discovery and thought process. This seamless integration is more than a quaint sentimental point. A drawing communicates the voice of the author: "This is what I think happens," "This is how I imagine this mechanism works," or "This is how I imagine this." A drawing allows us to see a mind at work. It is hard to argue that replacing Leonardo's drawings in the codices with more precise computer-generated images would improve the impact of the presentation (Ottino 2003a).

30. Albert Abraham Michelson (1852–1931), the first American to receive a Nobel Prize in Science, said, "An eminent physicist has remarked that the future truths of Physical Science are to be looked for in the sixth place of decimals." This statement was made in 1894 upon the dedication of the Ryerson Lab at the University of Chicago. Nine years later, Michelson and this quoted eminent scientist were proved decidedly wrong, with Einstein and the "miracle year" in physics. Physics became dominated by concepts and ideas rather than measurement and precision.

First, an example of science driving technology: After Evangelista Torricelli and Otto von Guericke demonstrated the existence of the atmosphere in 1654, von Guericke demonstrated dramatically the consequences of this fact in 1657 with his famous experiment in which teams of horses—sixteen on each side—were unable to separate two metal hemispheres that had had the air between them pumped out. After this, many others began to explore the possibility of harnessing this atmospheric force as a source of power. After more than a century of improvements and iterations, the result was James Watt's steam engine, which went into production in 1774. Watt's impact was incalculable. But we should not fall in the trap of one-individual/one-invention and give all the credit to Watt.

No one could have imagined that the Torricelli and von Guericke experiments would help unleash the Industrial Revolution. And certainly no one could possibly have imagined that studies on steam engines by Nicolas Léonard Sadi Carnot (1796–1832) and others would give birth to thermodynamics, one of the pillars of modern physics. In the picture where science drives technology, Carnot would have been first and steam engines second.

Another somewhat more recent example: Uber depends on GPS, and GPS systems calculate positions using highly accurate clocks in space and on Earth. To make these clocks work precisely, we need to factor in relativistic corrections, which come from Einstein's general relativity (1905). But to build his theory of relativity, Einstein had to make use of what was then a new geometry invented by the German mathematician Bernhard Riemann, whom we encountered when discussing visual imagination. Of course, GPS depends on satellites, and what makes satellites possible stretches back to Galileo and Newton. Science/technological links are rarely of the type "A leads to B and B leads to C." It is more like a complex system of braided interconnecting paths.

Like the case of the steam engine, there are many examples of science leading technology: the transistor, lasers, LEDs. But in many respects the steam engine case is atypical. In fact, until the later part of the nineteenth century, technological progress did not generally rely on scientific progress. This was true across the entire range of eighteenth-century industries. Innovations in food processing, mining, shipbuilding, and metallurgy were the fruit not of scientific progress but of relentless and inspired tinkering, guided by experience and craft tradition. Improvements in machines used to spin cotton and other fibers that would revolutionize the British economy—from Arkwright's spinning machine to Crompton's spinning mule—had not been held up by waiting for scientific breakthroughs.

Here is a more typical example from the period. At the start of the nineteenth century, a Frenchman, Nicolas Appert, discovered that food could be preserved in bottles that had been boiled and sealed airtight. Within twenty years, tin-coated cans came

into use. Storing food in this way was a crucial innovation for the development of urban society and the military. Only later did Louis Pasteur's studies show the role of microorganisms in spoiling food. First came inspiration, then lots of tinkering, and then luck. After that came biology.

Science/technology linkages rarely follow a straight line, as we see in the next two examples from aviation: (1) William Thomson (better known as Lord Kelvin), who made many now-recorded pronouncements, declared in 1895 that "heavier-than-air flying machines are impossible" and, in 1896, declared also that "I have not the smallest molecule of faith in aerial navigation other than ballooning." Somewhat ironically, Kelvin's circulation theorem (published in 1869) is important in the concept of calculating lift in airplanes wings. And (2), the Wright brothers and others flew first, the theory and all the calculations made possible by fluid dynamics, came second. In fact, few of the inventors responsible for the wave of innovations that took place between 1750 and 1860 were "scientists" or "engineering scientists." Their goal was not understanding but, as Watt said of his own efforts, to make machines that worked better and at lower cost.[31]

Remarkably, even in the middle of all this, Victorian engineers were still seen as socially below scientists, and labor well below intellectual speculation. James Watt's steam engine made Britain the leading industrial nation, but it took time before fashionable Londoners could admit that their wealth stemmed from northern factory owners. Even today the public has an idea of what scientists do but know much less about the broad spectrum in which engineers operate. There is still a tendency to equate engineers with end products instead of the underlying thinking processes driving engineering or the overlap of science and engineering.[32] Today we associate steam power with Stephenson and Watt and mechanical engineering, Goodyear with rubber and chemical engineering, Bell and Nikola Tesla with electrical engineering, and Hargrave and the Wright brothers as pioneers in aeronautical engineering. But classification is largely retrospective: none of these inventors were engineers as we think of them today, with engineering firmly grounded in science. It is impossible now to separate engineering and science in terms of how together they generate technology.

Science as an Established Field
New players bridge science and government, while chemistry becomes the first science-driven technology.

Before the middle of the seventeenth century, intellectual activity in science took place in private rather than public settings. But in the second half of the seventeenth and well into the eighteenth century, the new experimental investigators formed associations and formal scientific societies, and a new class emerged. Newton himself benefited tremendously from the London Royal Society (founded in 1660): it advertised

31. After their 1903 flight went largely unnoticed, Orville and Wilbur Wright relentlessly pitched their "flying machine" for six years. They eventually sold one plane to the US government by focusing on a truly ambitious goal for their invention: ending wars. Small aircraft in hands of democratic governments, they said, could be used to observe the movements of troops from afar, rendering surprise attacks impossible. World War I quickly killed these idealistic dreams. It took until the late 1920s for commercial aviation to emerge.

32. The names of the various branches of engineering are based on the markets they served and the products they produced. The story starts with Rome's military engineering, from which emerged Rome's amazing achievements in civil engineering—think of roads, bridges, aqueducts, and buildings like the Coliseum. Mechanical engineering is tied to the Industrial Revolution, electrical engineering to the advent of electricity, chemical engineering to the emergence of the chemical industry, computer engineering to the invention of computers, and so on.

his books, papers, and experiments. During the eighteenth century, scientific entrepreneurs—lecturers, publishers, writers, instrument makers—devised ways of selling science for profit. Scientific discoveries were now marketed to the public. Competition was fierce. Knowing about science became fashionable; the Christmas lectures at the Royal Institution in London, started in 1825 by Michael Faraday, who presented a nineteen of those lectures himself (a record number), were a social event. Electrical experiments were a hit. Science had become a public venture; people dressed up for the occasion.

By the nineteenth century, governments were investing heavily in scientific research, which led to the emergence of scientific administrators, individuals able to bridge the worlds of science and government. Joseph Banks, who presided over the Royal Society of London for forty-one years, is a prototypical example. Another set of individuals emerged as well, those who brought government, science, and industry together. Lord Kelvin was one of the first people who succeeded remarkably well in the science/engineering/corporate world nexus. He is today remembered as a great physicist. But during his lifetime he earned fame and wealth from his work as an engineer: he was active in industrial research and development, was the vice-chairman of the board of the British company Kodak Limited, affiliated with Eastman Kodak in the United States, and successfully laid the trans-Atlantic telegraph cable linking the New and Old Worlds. He was the first British scientist/engineer to be elevated to the House of Lords.

Now we make two important points. The first is that the role of governments in funding science was quite limited until the very late nineteenth century, *except in the case of military needs*. This exception deserves highlighting. Many significant innovations can be traced to investments in military needs. The second point, also quite important, is that creativity leading to innovation in technology comes about when the *technology needs to be integrated with existing systems and made to work in practice* (not just in isolation or in theory).

When the government began to invest outside military needs, science began to play a crucial role in industry. The first industrial science was chemistry. Chemistry, of course, had always existed, but throughout the eighteenth century; it was a practical rather than a theoretical subject. Theories came after, not before, practical applications. Extracting metals from ores, creating pottery and glazes, and fermenting beer and wine were all possible without knowing the underlying theory. But things exploded with the development and success of the Haber–Bosch process, which allowed for large-scale production of ammonia and the refinement of petroleum, which lead to the production of gasoline and diesel, as well as solvents, lubricants, and plastics, and the foundations provided by the emergence of industrial chemistry and chemical engineering.

When government investment reached physics, the results were startling: electricity and communications. But even then, science and tinkering—engineering encompasses

both—exchanged leads back and forth. The interplay is fascinating. This is the time we find Thomas Edison, Nikola Tesla, and George Westinghouse (1846–1914). Westinghouse, someone who got his first patent at the age of nineteen, and who saw the potential in alternating current as an electricity distribution system, was in direct competition with Edison's direct current. This was a technological battle. Another example of technology/science interplay, and lack thereof, is Guglielmo Marconi (1874–1937) and his approach to the invention of wireless telegraphy versus the more scientific route taken by Oliver Lodge and others in the elucidation of Hertz's work on "Hertzian waves." Lodge demonstrated the feasibility of wireless communication over short distances. But he did not elaborate further or pursue practical use based, in part, on his perception of infeasibility, perhaps shaped by the theoretical understanding at the time. Marconi's approach was entirely empirical but made huge strides toward proving the validity of the concept. We will encounter Edison and Tesla later, when we address examples of remarkable productivity. But for the purposes of the present discussion, Edison was a transitional figure; someone not trained in either engineering or science but the founder of the first research industrial laboratory, a place that congregated scientists and engineers and whose goal was relentless innovation. This alone would have been enough to get Edison a place in history books.

Origins and Intersections

The gap between frontier science and technology narrows.

The 1962 Nobel Prize in Medicine was awarded to James Watson and Francis Crick (and Maurice Wilkens) "for their discoveries concerning the molecular structure of nucleic acids and its significance for information transfer in living material." Nine years before, in 1953, their nine-hundred-word paper in *Nature*, which resulted in their Nobel Prize, ended with this sentence: "It has not escaped our notice that the specific pairing we have postulated immediately suggests a possible copying mechanism for the genetic material" (Watson and Crick 1953). The verb "suggests" and the adjective "possible" make for a twice-tentative ending. It took three decades, but this is the paper that launched all biotechnology.

A 2012 Science paper by Jennifer Doudna and Emmanuelle Charpentier (Jinek et al. 2012), resulted in the 2020 Nobel Prize in Chemistry "for the development of a method for genome editing." Tellingly, the Nobel announcement also said: "This technology [CRISPR-Cas9] has had a revolutionary impact on the life sciences, is contributing to new cancer therapies and may make the dream of curing inherited diseases come true." Nobel recognition took nine years for Watson and Crick and eight for Doudna and Charpentier. But Doudna and Charpentier were aware of the technological consequences of their work—and so was the Nobel committee. Watson and Crick's work allowed us to read our genetic code, while CRISPR-Cas9 has made it possible to rewrite it. Doudna and Charpentier ended their paper with the sentence: "We propose

an alternative methodology… that could offer considerable potential for gene-targeting and genome-editing applications." It is important to compare this ending with Watson and Cricks DNA's ending; here, the word "applications" is the last word of the sentence. As to the "considerable potential," the prediction was on the mark. There has been an explosion of companies based on the CRISPR-Cas9 technology.

The 1956 Nobel Prize in Physics was awarded jointly to William Shockley, John Bardeen, and Walter Brattain "for their researches on semiconductors and their discovery of the transistor effect." It is safe to say that in 1956, no one fully envisioned the implications of transistors and how they would go on to completely dominate our lives.

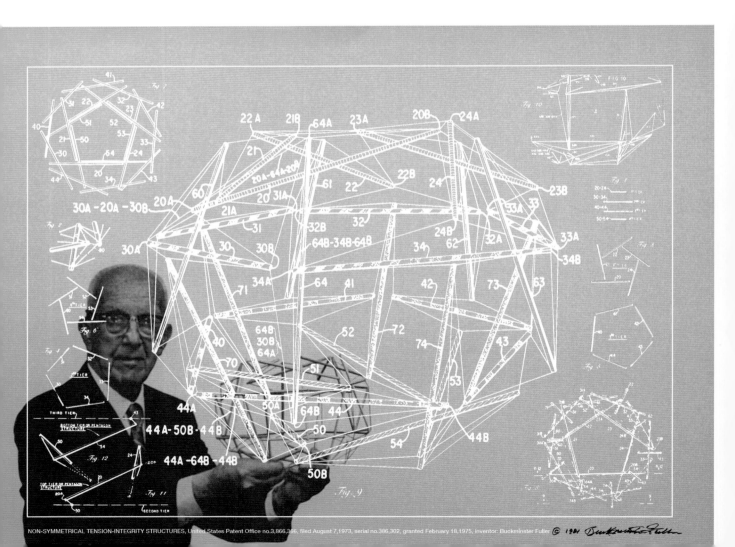

NON-SYMMETRICAL TENSION-INTEGRITY STRUCTURES, United States Patent Office no.3,866,366, filed August 7,1973, serial no.386,302, granted February 18,1975, inventor: Buckminster Fuller © 1981 *Buckminster Fuller*

Not long ago, art, technology, and science were unnamed components of the same whole, leading to extraordinary innovation. Their transformation into separate domains is remarkably recent. Today, science is about analysis, decomposing problems in parts, rational thinking, logic, convergence and, whenever possible, quantification. Art is about metaphorical thinking, divergence, emotion, creativity. Technology has elements of both. Only by understanding this separation can we bring them back together in the name of innovation.

Non-Symmetrical Tension-Integrity
Structures, shown by Buckminster
Fuller in 1981.

Dreamscape Immersive is a social entertainment technology company that exemplifies Nexus thinking. This image, from *Alien Zoo*, the first Dreamscape VR production, portrays a group of explorers floating through an alien landscape where endangered species from around the universe have been preserved by the Intergalactic Wildlife Federation. The group of travelers interacts with the alien lifeforms in a mind-altering synthesis of digital and physical experience.

CHAPTER THREE

CREATIVITY AT THE NEXUS

Our views of creativity, shaped by
the renaissance and the Romantic period

Myths of the lone creative genius
and the burst of inspiration remain
with us today.

In what ways are creativity in art, technology, and science different, and in what ways are they similar? A view stemming from philosophy, placing the emphasis on uniqueness, declared that science is ephemeral, and that art is permanent, placing artistic creation on the highest plane. Others have had the same view. Is this actually true? There is more analysis in art than perceived by science and more creativity in science than perceived by art. In fact, somewhat paradoxically, we can often see the evolution of ideas in art, whereas the scaffolding that leads to the final result in science is nearly always removed from sight.

33. Many have attempted a broad definition of creativity. Taking an idea from one context and applying it to another is a common one. Jacob Bronowski's definition is eloquent and particularly forceful: "There exists a single creative activity, which is displayed alike in the arts and in the sciences; the scientist or the artist takes two facts or experiences which are separate... finds in them a likeness which had not been seen before, and... creates a unity by showing the likeness" (Bronowski 1958). This is a relatively recent view. The word "creativity" itself barely appears in English until the early twentieth century. And for a while it was reserved exclusively for art.

34. True revolutions in science are rare. Some have names: heliocentrism, Newtonian mechanics, evolution, plate tectonics, quantum mechanics, relativity, and the birth of molecular biology. Others, which may have been even more sweeping, do not, like the invention of chemistry or the adoption of Arabic numerals. Thomas Kuhn (1962), in a remarkably influential book, *The Structure of Scientific Revolutions*, outlines a theory of how revolutions occur.

35. Mathematics is unique. On one hand, mathematics could be thought of as invention. On the other, Platonists among mathematicians will argue that mathematics is discovering what it is already there. This duality extends to other domains such as visual arts and writing. "The marble not yet carved can hold the form of every thought the greatest artist has," said Michelangelo. Jorge Luis Borges, in a 1939 essay titled "La Biblioteca de Babel," took a similar, if somewhat more disheartening, view about writing: "La certidumbre de que todo está escrito nos anula y nos afantasma" ("The certainty that everything has already been written annuls us").

W̲hat does it mean to be creative in art, in technology, and in science? An all-encompassing definition of creativity across domains is elusive. Ideally, at some abstract level it may be possible to argue that creativity is the same no matter what the domain.[33] In reality, however, the fields—the collection of arbiters who decide what is creative and what is not—operate under very different rules.

Art is about breaking paradigms and the search for the new, whereas science is about building and exhausting paradigms, and technology is about building and disrupting paradigms.[34] In science it is good to "stand on the shoulders of giants." In technology, the only reason to stand on older technology is to crush the elder giant. And in art, especially now it is a bad idea to stand close to anybody. Although combining and meshing what exists to create something new is good in technology it is frowned up in art.

Science is about unveiling, revealing, and (sometimes) explaining what is already there.[35] A clear method exists for questioning and deciding what can stay in the edifice of science. The standard view of the scientific method starts with collecting information or data about the phenomenon being studied. On the basis of that information, a preliminary generalization, or hypothesis, is formed, usually by inductive reasoning; this in turn leads by deductive logic to a number of implications that may be tested by further observations and experiment. If the conclusions drawn from the original hypothesis successfully meet all these tests, the hypothesis becomes accepted as a scientific theory or law; if additional facts disagree with the hypothesis, it may be modified or discarded in favor of a new hypothesis, which is then subjected to further tests.[36] This scientific method underlies the growth of science. A few people at the edge of science—a minority in fact, the philosophers of science—worry about how science works. Most scientists do science and do not question its underlying assumptions.[37]

Looking at a few other comparisons across art, technology, and science is also revealing. Start with models of growth. Science builds on the past; progress is wired into the very fabric of science. In a normal mode, science is about methodically building and adding knowledge (though disruption certainly happens, and it is essential as well). Massive revolutions are rare. Technology, on the other hand, is always about building and disrupting—constant disruption is necessary for growth. Art, especially as we move into the twentieth and twenty-first centuries, is all about disruption. Mannerist giants were replaced by baroque, then rococo, then neoclassical painters. And, in the early twentieth century, the modern movement turned the neoclassical academic giants William-Adolphe Bouguereau, Ernest Meissonier, and Jean-Léon Gérôme into forgotten figures in less than twenty-five years (figure 3.1). More recently, the modern, postmodern, and post-postmodern may have been the last recognizable periods. Peter Schjeldahl, the art critic for the *New Yorker*, put this in vivid language: "Then those movements, too, disintegrated, and it's been pretty much one damn thing after another ever since."

Michelangelo says you can create/invent anything with stone; Borges tells us that everything that can be written has already been written.

36. The scientific method has penetrated human consciousness. But it is not how all science really works. On the theoretical side, the method is one of sweeping generalization and induction; much more like how math works rather than a hypothesis-driven method. In inductive thinking, one begins by observing the variety of phenomena and derives general principles to explain those observations, often guessing that the application of the principles goes way out of the observed or known phenomena. Once the theory is formulated, the first drafts are usually rough; the key is to deduce consequences. The value of the theory rests on usefulness and prediction; on how many things can the theory explain. How the theory came into being in the first place may be not traceable at all. Deciding on which phenomenon to study is half the battle. In fact, the ability to identify rich phenomena for inquiry distinguishes a great scientist from an average one.

37. It is probably fair to say that scientists, if at all aware, are ambivalent about the value of philosophy of science as a discipline. Mathematics may bring an extreme point to the discussion: "The function of a mathematician is to do something and not to talk about what other mathematicians have done.... There is no scorn more profound, or on the whole more justifiable, than that of the men who make for the men who explain. Exposition, criticism, appreciation, is work for second-rate minds," declared G. H. Hardy (1941) in his book *A Mathematician's Apology*.

Fig. 3.1 William-Adolphe
Bouguereau (1825–1905), The Birth
of Venus (1879). Bouguereau was
one of the neoclassical academic
giants. His near-contemporary, Paul
Cézanne (1839–1905), formed
the bridge between late nineteenth-
century impressionism and the early
twentieth century's new line
of artistic enquiry that rendered
Bouguereau and his neoclassical
colleagues into forgotten figures in
less than a quarter century.

It would be a stretch to consider science as completely algorithmic, something that can be executed following a series of prescribed steps—though mistakenly, in the popular imagination, the scientific method comes close to this.[38] But when compared with art and technology, it appears to be so. Art is the least algorithmic, unless the algorithm is that there is no algorithm. This is heightened as we approach the present; anything smelling of derivative is bad, and originality is a must.

Ordering Developments in Art, Technology, and Science

Science is inevitable, technology less so. What then is art, as we approach the present?

Assume that we are given a collection of milestones in art, technology, and science: paintings, examples of working prototypes of various technologies, research papers, all spanning two hundred years but unidentified by specific dates. Would it be possible to put them in the right chronological order?

We would contend that this is possible, in principle, for developments in science. Science often follows a clear path in time. Theories become more sophisticated, with new ones containing older ones as special cases. The same can be said within branches of mathematics; the n-theorem follows logically from a subset of n−1 previous theorems.

Technologies can be ordered as well: the iPad came after the Macintosh and the Macintosh after the IBM 360; CDs came after the record player. But here we must make an important point: these are all *successful* technologies. Many *seemingly* successful technologies do not make it: there are many dead branches in the network of evolution of technologies. Technologies can be forgotten, but more often they are combined and embedded into new technologies.[39] GPS is now embedded in phones, and motion sensors are found in cars and video games.

In aesthetics and design-dominated fields, however, ordering becomes less clear. One would have to be well trained to put in the right chronological order chairs designed in the span of a hundred years (figure 3.2). A similar observation can be made about paintings, especially as we get closer to the present. Without some training in art history, it would be nearly impossible to put in the right order a hundred randomly selected paintings done by well-known artists in the twentieth century (figure 3.3.) There is an intrinsic arrow of time in science; there is no arrow of time in art, especially now. And—as in the previous comparisons and several of the ones to follow—*technology falls between art and science*. The science component within technology can be ordered (figure 3.4). The design and aesthetic components less so.

38. Everything looks tidy in retrospective; the scientific method portrayed as process neatly organized as observation, hypothesis, prediction, experiment, and confirmation. But it is worth noting that other orderings are possible. For example, the sequence hypothesis followed by prediction, with observation next, followed by confirmation and refinement, seems to be better suited to theoretical or modeling work. Labels are assigned retrospectively as well: Darwin is seen today as a prototypical scientist, but he never mentioned the term in any of his writings (Cowles 2020).

39. History shows that technologies may seemingly disappear. Cement is largely a Roman invention; the dome in Rome's Pantheon is a beautiful example. Cement almost disappeared during the Middle Ages, though masons and what we would now call military engineers used it in canals and fortifications. It was rediscovered by British and French engineers in the eighteenth century. Another example is firearms. Although the Chinese invented a gunpowder weapon called the fire lance in the ninth century, credit for inventing firearms is given to the Japanese in the thirteenth century, years before the Europeans. Japan used the guns in the Japanese invasion of Korea in 1592. It is estimated that about a quarter of the invasion force of about 160,000 people were gunners. But then Japan seems to have completely abandoned firearm production. The use of firearms in Japan would start again after 1854 with the resumption of contacts with the West. One explanation is that firearms did not fit the Japanese culture. The reality is likely much more complicated.

Fig. 3.2 Iconic chairs designed over a hundred years. Who can order these chairs chronologically?

Eames, Lounge chair and ottoman

Henry Glass, Cylindra plywood chair

Harry Bertoia, Armchair

Edgar Bartolucci, and Jack Waldheim, Barwa lounge chair

David Adjaye, Washington skin nylon side chair

Frank Gehry, Wiggle side chair

Ludwig Mies van der Rohe, MR 20 armchair

José Albers, armchair

Richard Meier, Armchair

Lina Bo Bardi, Bowl chair

Joseph Hoffman, Side chair

Gerrit Rietveld, Red-blue chair

Eileen Gray, "Transat" armchair

m) David Adjaye, Washington skin nylon side chair, 2013
l) Richard Meier, Armchair, 1982
k) Frank Gehry, Wiggle side chair, 1972
j) Harry Bertoia, Armchair, 1967
i) Henry Glass, Cylindra plywood chair, 1966
h) Eames, Lounge chair and ottoman, 1956
g) Lina Bo Bardi, Bowl chair, 1951
f) Edgar Bartolucci and Jack Waldheim, Barwa Lunge chair, 1946 g)
e) Ludwig Mies van der Rohe, MR 20 armchair, 1927
d) Eileen Gray, "Transat" armchair, 1927
c) Josef Albers, armchair, ca. 1927
b) Gerrit Rietveld, Red-blue chair, 1918
a) Joseph Hoffman, Side chair, 1906

Fig. 3.3 Paintings from 1910 to 1988. Who can order these paintings chronologically?

Jean-Michel Basquiat, *Untitled*

Lyonel Feininger, *Village Street*

Helen Frankenthaler, *Mountains and the Sea*

Vasily Kandinsky, *Landscape with Factory Chimney*

Gerhard Richter, *Betty*

Charles Sheeler, *Rolling Power*

Helen Saunders, *Abstract Multicoloured Design*

Gerhard Richter, *St. John*

Lee Krasner, *Gothic Landscape*

David Hockney, *Portrait of an Artist (Pool with Two Figures)*

a) Vasily Kandinsky, Landscape with Factory Chimney, 1910
b) Helen Saunders, Abstract Multicoloured Design, ca. 1915
c) Lyonel Feininger, Village Street, 1927–29
d) Charles Sheeler, Rolling Power, 1939
e) Helen Frankenthaler, Mountains and the Sea, 1952
f) Lee Krasner, Gothic Landscape, 1961
g) David Hockney, Portrait of an Artist (Pool with Two Figures), 1972
h) Jean-Michel Basquiat, Untitled, 1981
i) Gerhard Richter, Betty, 1988
j) Gerhard Richter, St. John, 1988.

Fig. 3.4 Lighting technologies. Who can order chronologically all these technologies to produce light?

First-generation light emitting diode (LED)

Candle

Incandescent light bulb

Corn cob / candelabra bulb, LED

Fluorescent tube

Round clear bulb with yellow filament, LED

LED halogen-equivalent bulb

Compact fluorescent bulb

Whale oil lamp

Incandescent light bulb.

a) whale oil lamp
b) candle
c) incandescent light bulb
d) compact fluorescent bulb
e) first-generation light emitting diode (LED)
f) round clear bulb with yellow filament, LED
g) corn cob / candelabra bulb, LED
h) LED halogen-equivalent bulb
i) fluorescent tube
j) incandescent light bulb.

Domains and Fields

How do new ideas get accepted in art, technology, and science?

Creative ideas do not happen in a vacuum. Creativity is not a private enterprise but involves the interaction of three things: (1) a person or a group, (2) a domain—say, any of the branches of mathematics or physics or visual arts or history or sociology—and (3) the field, the set of people who are gatekeepers of the domain (figure 3.5).[40] For an idea to be judged as truly creative, it must affect a domain and become a permanent part of that domain. (Permanent is probably too strong a descriptor; we will show in chapter 7 that revisions do occur.) The character of a domain limits the claims. In some instances—for example, in mathematics—the domain trumps the field; a theorem is either proved or not. In physics, the idea cannot violate the first or second laws of thermodynamics.

Altering the content of a domain in transformative ways is very difficult. People see things through the lens of their times. To accept something new we may have to expand or, more crucially, alter our knowledge base and abandon deeply held beliefs. This is not easy. Even in the fact-driven domains of science, such as physics, people are slow to accept new ideas.[41]

Publications associated with scientific revolutions look momentous to us. A list may include books: Niclaus Copernicus, *On the Revolutions of the Heavenly Spheres*, published just before his death in 1543; Isaac Newton's *Principia* in 1687; and Charles Darwin's *On the Origin of Species* in 1859. The list may also include papers: Einstein's first paper on relativity in 1905 and Watson and Crick's *Nature* paper in 1953. But Darwin did not triumph overnight. Neither did Copernicus: even though *On the Revolution of Heavenly Spheres* was dedicated to the Pope, the Pope took little notice of it, written as it was by a minor Polish functionary. In fact, there were few converts even fifty years after its publication. None of these works received instant acclaim; ideas took time to sink in. Sometimes, a long time: Niclas Léonard Sadi Carnot wrote *Reflections on the Motive Power of Fire* in 1824, when he was twenty-seven years old. We know now this short 118-page book lay the foundations of an entirely new discipline in physics: thermodynamics. But it was not appreciated for close to a hundred years.

By the time of Newton's death in 1727, Newtonian ideas had yet to conquer continental Europe. But when they did, by the end of the eighteenth century, Newtonian ideas took over the intellectual life of Europe and America. Newton had become the God of the Enlightenment, the period that brought inspiration to the French Revolution and the founders of the United States. To have something taken seriously, it had to be labeled Newtonian. But once acceptance sets in, so does a new normal and the inertia that accompanies it. Newtonian ideas became orthodoxy, and dominated physics for close to two centuries—until relativity and quantum mechanics came into

40. *A domain (or area) comprises all the accumulated recorded knowledge and the implicit rules that govern the addition of new knowledge in the domain (theories, models, methodologies, principles). Art, technology, and science are domains. So are components (such as physics, mathematics, anthropology, philosophy, art history) and subcomponents (condensed matter physics, cultural anthropology, Renaissance history, and more). Domains would exist even if people did not. The field represents the people who practice in the domains (Csikszentmihalyi 1996). Fields make collective decisions via gatekeepers (for example, article referees in sciences; curators, critics, museums, and collectors in art) as to what becomes part of the domain: what goes in, what stays out, and even what gets rediscovered.*

41. *"A new scientific truth does not triumph by convincing its opponents and making them see the light, but rather its opponents eventually die, and a new generation grows up that is familiar with it." This gloomy view comes from Max Planck (1858–1947). Planck's view is especially significant; he is considered one of the founders of quantum mechanics. But even though he set the foundations of quantum mechanics, he did not quite believe in it. He had to solve a problem; he got to his solution by assuming quantization of energy and by using Ludwig Boltzmann's statistical mechanics formalism. He did not see himself setting a revolution. Also, oddly enough, he disapproved of Boltzmann (1844–1906) and his work. There are many great figures in science who opposed ideas, even after it became clear that the tide was turning toward acceptance. Lord Kelvin and Henri Poincaré did not accept the atomistic ideas of Boltzmann either. Sadly, Boltzmann did not live to see the acceptance of his ideas. He hanged himself during a period of depression in 1906.*

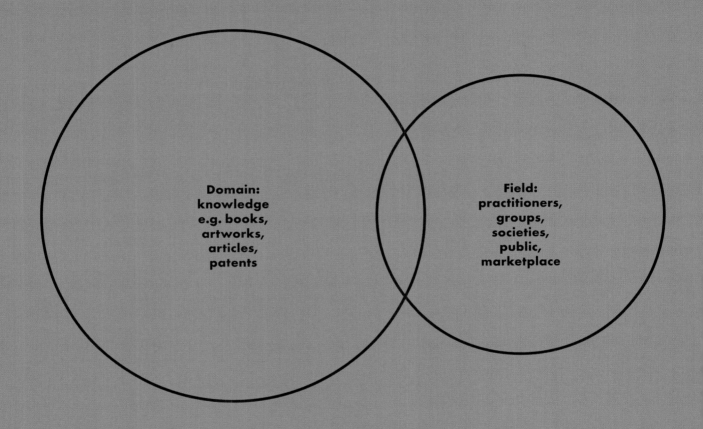

Domain:
knowledge
e.g. books,
artworks,
articles,
patents

Field:
practitioners,
groups,
societies,
public,
marketplace

Fig. 3.5 Interaction between domain
and field.

the picture, bringing with them one of the biggest disruptions in physics and the establishment of a new normal.

At the other end of the spectrum in art, the field trumps the domain. Gatekeepers—critics, museum curators, galleries, art collectors, and the like—collectively decide what gets in. Judging which works of art are worthy of inclusion in the canon of art brings to mind the concept of emergence in complex systems, something we discuss in chapter 5. Here, though, let us say that judgments are not final and are rarely unanimous; ups and downs in artistic reputations occur as a function of time. When we say that Van Gogh was unrecognized in his lifetime or that Bouguereau was overrated, we are, in essence, overriding the judgment of the field in their time.

In general, the rules of acceptance by a field are clearest in math and in physical sciences. We could also add theoretical computer science into the mix. There are ways to check and verify results; there is a methodology for moving forward. Today the bar for possible acceptability is having work published in prestigious peer-reviewed journals or presenting work at the right conferences. But even in these fields, things are not always that clear-cut, and anonymity does not preclude bias.[42]

Style also matters. This is important: clean, clear, elegant presentations will typically prevail. There may be two different styles of doing something, and this is true even in mathematics. The word "beauty" often appears in discussions of math. "There is no place in the world for ugly mathematics," G. H. Hardy said. An elegant proof is always better than an inelegant one. But sadly, for purists, mathematics is starting to accept computer-assisted proofs. And few will label such proofs "elegant."

We compare the structures of art, technology, and science in chapter 4. But let us consider here three aspects that cut across the three domains: (1) the talent pipeline, (2) the role of groups or communities, and (3) the transparency of the creative processes.

The talent pipeline (1) in science today is a well-oiled machine consisting of a predictable sequence—undergraduate degree, followed by graduate degrees and, often, postgraduate studies. Research takes place in universities, institutes, and corporate and national labs.[43] Science and engineering faculty positions in research universities almost always require a PhD. There are now virtually no outsiders in science. The pipeline in technology, however, is far less formal, and the pipeline in art, though becoming professionalized, is less clear as well. With a weak support structure, there are still outsiders in art.[44]

Groups and communities (2) are central to the acceptance of ideas in a domain. In terms of the sheer number of components involved, the most "democratic" (and complicated) system is the one underlying the acceptance of a new technology: an invention that results—via knowledge transfer—in an innovation. This is an area where active collaboration takes place between universities and federal labs and organizations

42. Getting a paper accepted in a science journal today depends on the recommendation of anonymous peer reviews. Anonymity does not seem to eliminate issues having to do with diversity. The question has attracted scrutiny because it is something that can be quantified. Using data from 2014 to 2018 gathered from close to a hundred journals, a lengthy report produced by the Institute of Physics, titled "Diversity and Inclusion in Peer Review," found that papers with female corresponding authors had a slightly lower chance of being accepted. It also found that authors from the United States and Europe were more likely to have their papers accepted than authors from China or India, and male reviewers were invited more frequently than female.

43. Universities did not exist in Europe until the end of the eleventh century, although learning did thrive in monasteries. But by the year 1200 there were three universities, one in Bologna, Paris, and Oxford. Research was nevertheless a private activity and took place outside the universities well into the eighteenth century. Determining which university is the oldest depends on how one defines "university." Our current conception stems from Europe, but the Alexandrian Museum in Egypt, established about 300 BCE, nevertheless qualifies as an institution of higher learning. So does the University of al-Qarawiyyin, which started as a mosque and was incorporated into Morocco's modern state university system in 1963. UNESCO lists al-Qarawiyyin as the oldest continually operating higher-learning institution in the world.

44. There are many labels for art produced having little or no contact with the mainstream components of the art world or art institutions: raw art, marginal art, naïve art, outsider art. These kinds of labels have always existed, but outsider art, now probably the most recognized among them, goes back only to the 1970s. Outsider art is now a recognized art category, with its own marketing, annual fairs, and publications.

Fig. 3.6 The very first academic journal was France's *Journal des sçavans*, established in January 1665. In London, the *Philosophical Transactions of the Royal Society (Philos Trans)* started less than a year later, in March 1665. *Philos Trans* was the first journal devoted exclusively to science; it is also the world's longest-running scientific journal. The Royal Society was founded in 1660 to promote open exchange of ideas backed by experimental evidence. In 1752, *Philos Trans* became its official society publication, in some ways anticipating modern scientific journals. Prior to this, academic publishing was rare, and it was not unusual that results were announced in anagrams, all but indecipherable for anyone not in on the secret. Newton and Leibniz used this approach. The method did not work well as an adjudicator of priorities, the Newton-Leibniz dispute regarding the invention of calculus being of the most famous example (Bardi 2006). Robert Merton, a sociologist at Columbia University, found that 92 percent of cases of simultaneous discovery in the seventeenth century ended in dispute. This dropped to 72 percent in the eighteenth century, 59 percent by the latter half of the nineteenth, and 33 percent by the first half of the twentieth (Merton 1973). The decline in contested claims for priority in research discoveries can be attributed to the rise of modern academic journals and, especially, the practice of peer review. Enlisting external anonymous reviewers started in the mid-nineteenth century but did not become the standard practice until the twentieth.

with business-sector researchers via joint research and publications. In the United States, both the number and share of joint articles have increased since the 2010s. The innovation system environment is complex. Nowadays, at least in the United States, this involves an inventor, a system of funding (federal funding agencies, venture capitalists, and angel investors, for example), tax and regulatory policies, and a system of laws for intellectual property protection. Added to this are national and international interests, battles about intellectual property protection, issues of public policy, marketing, and social attitudes toward risk, among other concerns. Products now regarded as an integral part of society took years if not decades to develop. In many cases, public acceptance defies the opinion of experts, and so a clearly inferior idea continues to live.

The degree of cooperation within communities can be quantified in science and, to some extent, in technology. This interfaces with issues concerning the transparency of creative processes (3). There are established ways by which we investigate the output of teams in science (papers published) and in some aspects of technology (patents and licenses).[45] To a large extent, it is easy to know who worked with whom, because listing references to prior scientific work is part of the established practice of science (figure 3.6). Some academic disciplines are meticulous in this area: mathematics is at the top of the list.[46]

But despite transparency, the path leading to the final product may not be always clear. In science and technology, we generally see the result and not all the steps in the evolution that may have led to it. The result is important, but the documentation of the evolution is not valued—except a posteriori, by historians of science and technology.

In fact, in science, all dead ends are concealed in the final presentation of results.[47] This happens more so now than in the past. Space in the most prestigious scientific journals, including *Nature, Science, Proceedings of the National Academy of Sciences of the United States of America*, even in this era of digital content, is at a premium, and presentations are highly condensed. Supplementary materials—easy to include in web versions of articles—are often much longer than the publications themselves. First-person description of results, something that was common in the early 1900s and used by many renowned scientists until the 1960s and 1970s, is discouraged in most top journals covering science and engineering. It is unclear if the emergence of a new field could alter norms in the synthetic biology community (an emerging field we mention in chapter 6), there is an increasing emphasis on the value of publishing positive and negative results (albeit the negative results are often relegated to the online supplement).

On the other hand, the degree of cooperation in art (literature, music, visual arts, for example) is more subtle—coauthorship is rarer—and operates more at the level

45. The literature from the field of economics on technical change has increasingly relied upon patent citation data to measure knowledge flows. But some doubt whether patent citations really reflect the knowledge of inventors in their technical fields. Citations may stem from patent examiners and, especially in large corporations, from the patent applicant's lawyers, rather than from the inventors themselves.

46. The Mathematics Genealogy Project, carried out by the Department of Mathematics of North Dakota State University and the American Mathematical Society, traces the academic lineage of all mathematicians in the world. As of March 2021, it listed at about 265,000. Mentoring is critical in science (Malmgren et al. 2010) and also in organizations. Not being aware of bias in mentee selection, and/or the limited bandwidth of mentors, can lead to suboptimal mentoring.

47. Of course, in theoretical work or in mathematics, ideas that lead to nowhere are discarded. In biological, medical, and social sciences, records matter, and strict regulations govern their upkeeping. Even within highly curated and enforced reporting structures—such as the outcomes of clinical trials—there may be biases, and negative results may remain unpublished even when publication is ostensibly required.

of influence.[48] Often a movement is seen in retrospect; alliances are informal. Entire careers in art history and criticism are based on dissecting these facts.

The Adjacent Possible—A Recipe for Creative Output
We can learn to access and extrapolate from existing cutting-edge knowledge.

Can there be a methodology for coming up with new ideas? What ideas and knowledge could emerge if we were to curate connections of individuals at the vanguard of a domain? What new knowledge could be accessed by relatively small steps and extrapolations from existing cutting-edge knowledge? The theoretical biologist Stuart Kauffman (1995), motivated by his work in preboitic chemisty, coined a suggestive name for what could be called first-order combinations reached from the boundary of this edge: "the adjacent possible."

The adjacent possible can be thought of as a forever-expanding house—opening a door from a room at the boundary of the domain leads to another room, which will have new doors that may lead to other new rooms with yet other doors. In the case of prebiotic chemistry, the adjacent possible defines all the molecular reactions that were directly achievable in the primordial soup. From those chemicals, other molecules formed, and from those, others more complex still, until they hit upon something that could self-replicate. Plants, trilobites, and sponges exist outside the circle of possibility of the primordial soup. The opening of very large number of doors and the visiting of many rooms would be needed before reaching something resembling a brain.

The adjacent possible, being accessible to the prepared mind, is at the root of so-called multiple discoveries—when different individuals independently come up with significant new ideas at virtually the same time.[49] Though this also happens with teams, the case of individuals is the clearest and provides the best examples. Earlier in the book, for instance, we encountered Lord Kelvin, a towering figure in physics known for many achievements, including his work on the development of the second law of thermodynamics; Kelvin had several ideas that others had as well, almost at the same time: the sociologist Robert K. Merton (1910–2003) and his collaborators examined 400 of Kelvin's 661 scientific communications and addresses and found that at least 32 qualified as multiple discoveries (Merton 1961). Kelvin's co-discoverers were an illustrious set—some on par with Kelvin, others a notch below on the prestige scale. This does not diminish Kelvin's greatness. It indicates a considerable number of other top scientists were required to duplicate only a subset of the discoveries that Kelvin made. Many others were with him at the boundary. But Kelvin was a master in opening doors in the adjacent possible.

We can find numerous documented multiple discoveries in both science and technology. The invention of calculus by both Newton and Leibnitz is a famous example.

48. True artistic collaborations, where two great names are associated with a painting, are rare but do exist. And some are old. One example is Peter Paul Rubens (1577–1640) collaborating with Jan Brueghel the Elder (1568–1625). They worked together frequently over the course of twenty-five years. So did Pablo Picasso and Juan Gris during the cubist period, their styles blending so seamlessly that only experts can tell their paintings apart. More common, however, were art enterprises like Rubens's operation in Antwerp, which involved many assistants. Between the two world wars, many great artists worked alone. Things changed considerably from 1970 onward, with no prevailing mode. Large studies, like that of Jeff Koons, coexist with individuals who have one assistant, with artists working alone, and with people working in pairs. There are also true associations of artists. The Bauhaus School, which combined crafts and fine arts, serves as an extremely influential example.

49. The concept of the adjacent possible qualifies as a multiple discovery as well. This idea can be traced back to the English mathematician and philosopher Alfred North Whitehead (1861–1947) with his 1927 book *Process and Reality*, and to the Russian psychologist Lev Vygotsky, who called it "The Zone of Proximal Development." Steven Johnson (2010) popularized the concept in his book *Where Do Good Ideas Come From? The Natural History of Innovation*.

Charles Darwin and Alfred Russell Wallace having similar ideas about the theory of evolution is another. Possibly the clearest example, in terms of documented timing, may be Elisha Gray and Alexander Graham Bell filing patents for the invention of the telephone the very same day. Yet another, less well-known example, but nevertheless central to our understanding of the world, is Brownian motion, named after the botanist Robert Brown. Using a microscope, Brown observed the seemingly random motion pollen particles suspended in a liquid. Einstein explained this phenomenon in one of his famous string of papers in 1905; the Polish physicist Marian Smoluchowski (1872–1917) came up with a similar model in 1906. Einstein moved to other matters; Smoluchowski kept working on these ideas, using them as a basis for his theory of stochastic process (one central equation bears his name. It is important to see the consequences of Brown's discovery.

Why does Brownian motion happen? The pollen particle is hit by molecules of the liquid, but given its small size, the number of hits will not balance out; more hits will come from one side than the other, and the particle will move in what is a seemingly random motion. In fact, random motion and Brownian motion may be considered synonymous. Neither Einstein nor Smoluchowski knew conclusively about the existence of atoms, but their explanation of Brownian motion became the bases of the experiments by Jean Perrin proving conclusively the existence of atoms and molecules, for which he received the 1925 Nobel Prize in Physics. It is no exaggeration to say that we could not possibly understand the world without understanding that the world is made up of atoms.

In a New Yorker article titled "In the Air," the popular author Malcolm Gladwell argued that if you put together, in one room, people who were a notch below Kelvin on the prestige scale, you could get a large subset of Kelvin's discoveries without Kelvin being in the room with them. The point being that there are more people a notch below Kelvin and much fewer at the level of Kelvin. But Gladwell also argued that this does not apply to artistic genius. "You can't pool the talents of a dozen Salieris and get Mozart's 'Requiem,' he wrote. "You can't put together a committee of really talented art students and get Matisse's 'La Danse.'... A work of artistic genius is singular" (Gladwell 2008a). This may be true, though some will disagree, especially regarding the tendency to elevate some people to the genius category and separate them from what were somewhat comparable peers. Not that Mozart doesn't deserve this label, but there seems to be now some motion to diminish the talent gap between Mozart and Salieri (Ross 2019).

The Myth of Genius and Primo Persieri

History has taught us to believe in epiphanies and eureka moments.

Retrospective analyses show that artistic masterpieces do not suddenly appear from thin air. A "final" painting can be deceptive when presented without context.

Fig. 3.7 An example of *primo pensieri*. Two studies of male figures by Jacopo Pontormo (1494–1557). Genius is popularly associated with the belief that an idea emerges fully formed. Equating creative inspiration and genius comes largely from visual arts and the Renaissance, where significant value was given to initial sketches or *primo pensieri*.

50. We rarely get the chance to peer into the creative insights of scientists and mathematicians. Occasionally, though, we get to see a seminal book with annotations and markings of a towering figure: think of Newton's **Principia** *with the markings by Leibniz or, more recently, the internet pioneer Doug Engelbart (1925–2013) and his notes on Vannevar Bush's "As We May Think" article. Mathematics is one area where a few of its greatest practitioners have written extensively about their own creative processes and into the creative processes of others. Jules Henri Poincaré was one of those who documented his own thinking. Another example is the French mathematician Jacques Hadamard. In his book* **Psychology of Invention in the Mathematical Field** *(Hadamard 1954), he described his own mathematical thinking and surveyed one hundred of the leading mathematicians and physicists of the day asking them how they did their work.*

51. Pontormo's sketches, however, are now exhibited as discrete, independent works. In 2009, the Block Museum at Northwestern University mounted an exhibition of seventy Renaissance drawings (*primo pensieri*) to explore the working methods of Italy's most important artists—including Michelangelo and Annibale Carracci among others—during a time of unprecedented patronage.

52. Eureka moments cover a broad spectrum. The chemist August Kekulé said that he had discovered the ring shape of the benzene molecule after having a daydream of a snake biting its own tail; no molecule had been imagined as a ring before this. On

Paradoxically, even though bursts of inspiration are strongly associated with visual arts, it is the domain in which the evolution of an idea—the painstaking process that goes on behind what may appear as flashes of genius—is the most transparently and meticulously documented. This is far from uniform across other domains. There are visible fragments of the evolution of creative thought in music and literature, such as surviving book manuscripts or annotated copies of musical scores. And once in a great while we see the editing processes of a great scientific paper (for example, the manuscript of Einstein containing the celebrated $E = mc^2$).[50] By far, visual arts provide the most complete records of creative processes and exploration of ideas. Two examples serve to make the point. Picasso, for instance, did forty-three sketches for Guernica (figures 3.8). Another notable example of elaboration of an idea, is Picasso's Las Meninas, a series of fifty-eight paintings done between August and December 1957. The series has Picasso reinterpreting, reconstructing, and recreating the original *Las Meninas*, the 1656 painting by Diego Velázquez, one of the most widely analyzed works in Western painting.

We popularly associate "genius" with the initial burst of an idea—and often we assume that the idea emerges fully formed. There is a historical underpinning associated with equating creative bursts and genius, and this comes largely from art and the Renaissance.

In the Renaissance, the first ideas—the initial sketches, or *primo pensieri*—were highly prized (figure 3.7) These sketches, when sufficiently evolved, were called *il modelli*. They served as templates for say, altarpieces, larger paintings, or frescoes, but they were not intended to be works of art in themselves.[51] Rather they were functional drawings and an integral step in planning compositions for paintings. But they carried a legal force; *primo pensieri* were the Renaissance version of copyrighting an idea, capturing it at the very moment of creation.

The *primo pensieri* concept has a parallel in science, not in reality but in popular imagination. The falling apple hitting Isaac Newton's head? A myth popularized by Voltaire and Disraeli. What about Archimedes running out the bathtub shouting "eureka!" or Darwin conceiving the theory of evolution after a brief visit to the Galápagos islands in 1835? Probably myths, as well. Some eureka moments are more believable than others, but there clearly is a continuum, with the fully formed idea at one extreme.[52] The reality is that epiphanies are an occasional by-product of single-minded attention devoted to difficult problems. The brain is working on an idea without being consciously engaged (figure 3.9). The epiphany is then the last piece that solves a puzzle, though the last piece is often no more special than any of the others. The electric light bulb is often used as a metaphor for inspiration or great idea, but it would be hard to come up with a worse example in the history of technology. Edison worked on thousands of ideas for filaments before hitting on one that worked. Inspired tinkering, yes; sudden burst of creativity, most definitely no.[53] And even more than in art and science,

the mathematics side, Jules Henri Poincaré told of how an idea came fully formed after a period of inactivity. After working extremely hard on a vexing mathematical problem, he decided to board a bus, just for the ride. "I entered an omnibus to go to some place or other. At that moment when I put my foot on the step, the idea came to me, without anything in my former thoughts seeming to have paved the way for it, that the transformations I had used to define the Fuchsian functions were identical with non-Euclidean geometry." On the other hand, the writer Jorge Luis Borges described a process of an idea revealing itself, rather than a specific example or a moment of a fully formed discovery. "Walking down the street or along the galleries of the National Library, I feel that something is about to take over in me. That something may be a tale or a poem. I do tamper with it; I let it have its way. For afar, I sense it taking shape. I dimly see its end and beginning, but not the dark gap in between. This middle, in my case, is given me gradually. If its discovery happens to be withheld by the gods, my conscious self has to intrude, and these unavoidable makeshifts are, I suspect, my weakest pages" (from "Afterword" in Borges 1970, written directly in English).

53. Tim Berners-Lee's invention of the Web developed not as a sudden flash of inspiration but as a slow hunch: "a problem of accretion, not a linear solving of one problem or another." Steven Johnson coined the term "slow hunch" (and included this quote from Berners-Lee) in his book *Where Good Ideas Come From* (Johnson 2010).

Fig. 3.8 Pablo Picasso's *Guernica*
(above), preparatory sketches
(over), and photo of *Guernica* during
its execution at his studio, located
on Rue des Grands Augustins,
Paris. Remarkably, of the forty-three
preparatory sketches Picasso
did for *Guernica*, all survive.

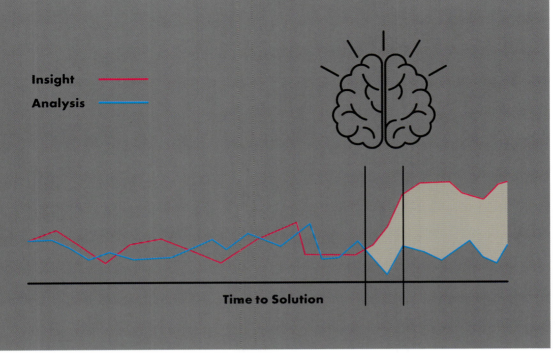

Insight ———
Analysis ———

Time to Solution

Fig. 3.9 Experiments from Mark Beeman at Northwestern and John Kounios at Drexel investigated the moment of insight and how tasks are processed, in real time, consciously and unconsciously, by different parts of the brain (Kounios and Beeman 2009, 2015). The techniques used in these studies involve a blend of fMRI, a scan which measures blood flow, and which gives a spatial picture but is relatively slow, and electroencephalography (EEG), which measures waves of electricity and is very fast but does not capture spatial information. Subjects were given verbal puzzles that could be solved with insight, a flash-type of solution, or—more laboriously, methodically—by an algorithm. Beeman and Kounios showed that although the experience of insight appears sudden and disconnected from previous thoughts, the insight is the end of repeatable sequences of brain states and processes operating with very different timescales. Shifting activity in different nodes of a cortical network creates brain states that are conducive to solving with sudden insight. Even before people see a problem,

their brain state in the "preparatory phase" can ready them for insight. Concentrated activity in certain regions of the prefrontal cortex, involved in executive control of brain processes, indicates a readiness to be flexible and eventually solve with insight. Next, in the "search phase," the brain starts looks for answers in all relevant places; for example, in the case of verbal puzzles, in areas connected to speech and language. If no solution emerges, people may get frustrated and be ready to give up. But the executive control area may engage processes to help search for weaker signals, by attenuating input entering through the visual cortex, suppressing distractions, and allowing detection of weak solution candidates. This is when, seemingly out of nowhere, an answer may appear.
The Kounios and Beemen studies reveal a spike is what is called a gamma rhythm, which is the highest level of electrical activity associated with the brain, occurring in the right temporal lobe. Although the solution feels sudden to the person solving the problem, it is anticipated by and dependent on the series of events described above. Related to these studies are

the investigations of how prefrontal cortex controls the rest of the brain by Earl Miller at MIT and Jonathan Cohen from Princeton (Miller and Cohen 2001). The prefrontal cortex operates as a sort of director who is responsible not only for focusing on the task at hand but also for figuring out what other players must be engaged in solving a problem—without actually knowing the answer. This theory suggests why we can instantly recognize an insight, even when it seems surprising; the brain has been concertedly pursuing the answer in several ways, even if we did not know it. When the obscure circuit in the right hemisphere finally generates the right association to bring all the pieces together, the previously subthreshold idea emerges into awareness and the prefrontal cortex is able to instantly identify it as the solution, in a sudden Aha! moment.

54. There is usually a long, far from linear, backstory behind the most successful technologies. For example, it took decades before Xerox released its first copy machine. Its inventor, Chester Carlson, started with a degree in physics in 1930, and worked in Bell Telephone Laboratories as a research engineer and as an assistant to one of the company's patent attorneys, all while writing more than four hundred ideas for new inventions in his personal notebooks. This was followed by night studies leading to a law degree in 1939. From 1939 to 1944, more than twenty companies turned down his funding requests. The Department of the Navy and International Business Machines (IBM) turned down his copy machine invention.

55. Mathematicians are all too sure of the role of imagination in mathematics. The famous German mathematician David Hilbert reputedly made this comment about one of his students, who abandoned mathematics: "You know, for a mathematician he did not have enough imagination. But he has become a poet and now he is doing fine."

56. *A mathematical proof is, by definition, flawless: once constructed, we can follow the logical argument (though it may take a team of mathematicians quite a long time to verify all the steps). But this hardly means that the idea behind the theorem, how it came into being, can be traced at all. Mathematics is wholly inductive, not deductive (Polya 1954). We guess a theorem— this has nothing to do with logic and everything to do with informed intuition—and then we go on to prove the theorem, or not. This is where the logic goes, post facto. Most guesses go nowhere, but a very small number of very good guesses may acquire mythical status. Those are the ones that become conjectures, statements that cannot be proved or disproved. Some have remained unproved for a century: Fermat's last theorem took much longer—*

in technology the first idea is just the beginning of a long and often tortuous process.[54] The beginning idea is never close to the end in technology.

We normally get sanitized narratives of creative and scientific outputs; a distilled and cleaned-up view leading smoothly to an end point: perfect buildings with no hints of the scaffold. The reality is that trajectories leading to what is seen as a creative end-point are messy—and learning about this messiness is good. Knowing some of the history behind creation and discovery may increase creativity rather than diminish it.

The Deception of Final Pictures
Do not be misled by the removal of scaffolds.

"The secret of creativity is knowing how to hide your sources," Albert Einstein reputedly said. Scientists, philosophers, and mathematicians have commented on this, what we call the "deception of final pictures." Many of the highest exponents of creative thought have left no trace of the scaffold. Ludwig Wittgenstein's (1889–1951) phrase "kicking the ladder" after climbing it is apt, even if he used the metaphor in a different context. Mathematics provides rich examples. Karl Friedrich Gauss (1777–1855) and Bernhard Riemann (1826–1866) left no trace of the scaffold that led to their final result.[55] "I did not succeed in compacting the proof as to make it publishable," Riemann said, simply stating four properties of the "Riemann" function. It took thirty years to prove Riemann's first three conjectures.[56]

And even if final results do not look magical but solidly logical, they can hide what may have been myriad tentative steps and dead ends. The physicist Hermann von Helmholtz (1821–1884) captured this point when he described the two roads to research:

(1) the shaky ladder every researcher must climb to get to the results and
(2) the smooth royal path when the results are presented to an audience (as told by von Békésy 1961).

The idea of final pictures also helps perpetuate the myth of lone genius. Exceptions do exist; some people create in relative isolation.[57] But as human myths go, it is a relatively recent one. The Greek embodiment of creative powers resided with the Muses, attendant spirits who inspired creation in literature and the arts. Creativity touched humans from unknowable and distant sources and for unknowable reasons. This went beyond the Greeks. It was not until the 1500s that Western cultures grew comfortable with recognizing individual accomplishment.[58] The turning point is when *primo pensieri* mattered and the pendulum began to move in the direction of individual human achievement. The idea of genius, as we understand it today, comes from the Renaissance—Giorgio Vasari, history's first art historian, is partially responsible for this. Leonardo, Michelangelo, and Raphael were seen as having talents seemingly

conjectured by Pierre de Fermat in 1637, it was not proven fully until 1995 by Andrew Wiles.

57. Grigori Perelman is a recent extreme example of "the lone genius" type. Perelman is a Russian mathematician who proved one of the outstanding open problems in mathematics, the Poincaré conjecture, initially posed in 1904 and regarded as one of the most important and difficult open problems in topology. In November 2002, Perelman posted the first in a series of papers on arXiv and gave a series of talks about the proof. Eventually, three independent math groups verified that Perelman's papers contained all the essential elements for a complete proof of the conjecture—though discussion and controversy marked the road to acceptance. In August 2006, Perelman was awarded the Fields Medal (the highest award in the world for a mathematician, only two to four medals are awarded every four years). Perelman declined to accept the award or to appear at the congress. In December 2006, Science magazine named Perelman's proof of the Poincaré conjecture as the scientific "Breakthrough of the Year," the first such recognition in the area of mathematics. In 2010, the Clay Institute announced that Perelman had been awarded the first $1 million Clay Millennium Prize Problems award. Perelman declined the prize and has since stopped working on mathematics. As Perelman explained to the BBC in March 2010, justifying his refusal to accept these awards: "I'm not interested in money or fame; I don't want to be on display like an animal in a zoo."

58. We do not know who designed the Egyptian pyramids, the pantheon in Rome, or the Great Wall of China. We may know who commissioned them, but not the names of the architects or engineers. There are no names we can attach to the sword, the compass, the plow, the bow, kites, or the gun.

beyond human limitations. The idea was perfected in the Romantic period and migrated from art, music, and poetry to science and mathematics.

The genius myth is still in full force today. The label is sometimes assigned by others, but often the "geniuses" themselves help market the myth. Legend has it that Jack Kerouac wrote *On the Road* in three weeks, typing it almost nonstop on a 120-foot roll of paper (figures 3.10 and 3.11), which was sold on May 22, 2001, for $2.2 million. It is a nice legend, but the truth is much more complicated.[59]

Critics love to discover unrecognized geniuses. A somewhat recent case is the German physician and writer Hans Keilson. Two of his novels, written more than sixty years ago, were declared to be "the work of genius" in a *New York Times* book review (Prose 2010).

Associating one idea to one person is convenient, but it is rarely the whole story. Yet the idea is deeply ingrained in the popular consciousness and now extends even to organizations: Google did not invent the search engine, Nintendo did not invent the video game, and Netflix was not created because of a late fee at Blockbuster.

Creativity in Technology
The Rule of Three: balance three or more elements to create something unique.

We quoted earlier Jacob Bronowski's definition of creativity: "the scientist or the artist takes two facts or experiences which are separate;... finds in them a likeness which had not been seen before, and... creates a unity by showing the likeness." The individual ideas may be not be breathtaking, but the combination is. We also said that, in technology, derivative is not necessarily a bad word: adaptations and remixes are good. This fact alone makes creativity in technology different from creativity in science and art.

Combining two things to create a third is relatively common. Combining three balanced elements at the same time to produce something unique, something that could not be glimpsed by the components that go in the mixture, is much less so.[60] There is nothing magical about the number three; it could be four, or even five. Nevertheless, it is useful to think of inventions in terms of triads. When seen through this lens, a rule-of-three seems to underlie much of technology.[61] Consider the following illustrative examples:

> William Morse, credited with inventing the telegraph. This involved combining the electromagnet, battery, and cable making.

> Louis Daguerre, forerunner of photography: camera obscura, one chemistry to record images, and another chemistry to fix images.

59. Kerouac typed fast, at about a hundred words a minute; replacing paper in his typewriter interrupted his flow (hence the reason for the scroll). "Three weeks" is what Kerouac answered in an interview when asked how long it took to write *On the Road*. The myth was seeded. Kerouac's brother-in-law and executor said that the word "write" should have been "type." The reality seems to be that between 1951 and 1957, while trying to get editors to accept the book, Kerouac worked on as many as six drafts, pieced together from journals he kept of his cross-country travels. And after typing the scroll, he made revisions and line edits in pencil.

60. This observation recalls that, in statistical mechanics, the probability of triple collisions is for all practical purposes, zero.

61. This concept comes from the energy and tech expert Mark Mills, who reaches back to Aristotle for inspiration: *omne trium perfectum*, or "Everything that comes in threes is complete."

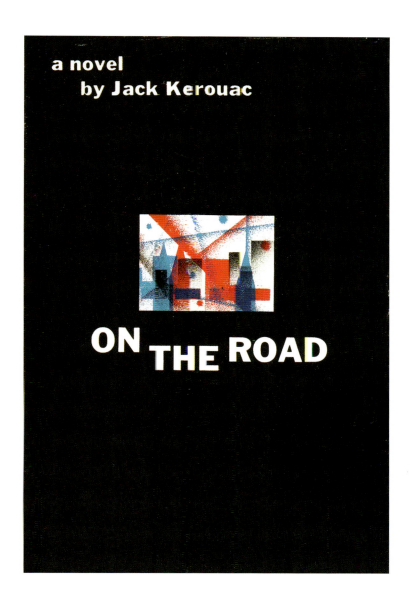

Fig. 3.10 The myth of the genius and the burst of creativity: cover of first edition of *On the Road* by Jack Kerouac; portrait of Jack Kerouac; preceding page, *On the Road's* manuscript scroll.

Fig. 3.11 Kerouac typed fast,
at about a hundred words a minute;
replacing paper in his typewriter
interrupted his flow (hence
the reason for the scroll). "Three
weeks" is what Kerouac answered in
an interview when asked how long it
took to write *On the Road*. The myth
was seeded. Kerouac's brother-in-
law and executor said that the word
"write" should have been "type."
The reality seems to be that between
1951 and 1957, while trying to get
editors to accept the book, Kerouac
worked on as many as six drafts,
pieced together from journals he
kept of his cross-country travels.
And after typing the scroll, he made
revisions and line edits in pencil.

easy chair to smoke a waterpipe loaded with tea. These were his coming-home pleasures; together with a deck of dirty cards. Have you noticed where her other hand is?...

The Wright brothers and the airplane: gliders, aluminum, and the wind tunnel.

Carl Benz and the Benz Patent-Motorwagen, regarded as world's first production automobile: carriage, bicycle, and the internal combustion engine.

Guglielmo Marconi and the invention of the radio: the telegraph, telephone, and radio frequency vacuum tube.

Henry Ford and the development of the first affordable automobile: the maturation of the gasoline engine, petroleum refining, and the concept of the assembly line.

Willis Carrier and the first useful air conditioner system: the centrifugal compressor (which he invented), the electric motor, and the distribution of cheap electricity.

RCA's David Sarnoff and the development of television: the cathode ray tube, the radio, and the idea of a scanning technique to collect and transmit images.

IBM's Thomas Watson and the first practical modern computer: silicon transistor, magnetic tape, and the concept of computer logic, a.k.a. software.

Vinton Cerf, who is closely associated with the invention of the internet: pervasive computing, pervasive telecommunications, and the concept of coded packet routing of information

Like in much of technology, other names could be associated to many of these inventions. Also, the list could be longer. As a final example, consider the iPhone. The concept could be traced back to George Gilder's prediction of the "teleputer." The iPhone is a triumph of design but involves pieces that were already there: the large scale integrated (LSI) circuit, the gallium arsenide (GaAs) radio chip, and the lithium battery. And each of them can be traced much further back.

The common denominator in all these? Three enabling technologies, the combination of which yielded something fundamentally different. It is also useful to imagine how entire disciplines—not just technologies—may be combinations of three components. Consider one example out of many. Modern medicine could be imagined as the combination of information in the form of medical science and knowledge (all the underpinning science, beginning with germ theory and moving into molecular biology, genomics), new classes of machines (X-rays, MRI, robotics, diagnostics), and new kinds of materials (pharmaceuticals would fall in this bucket, as well as implantable and surgical materials). Where would AI fit into this picture? Underpinning knowledge? Such questions are what makes this a useful exercise.

Creativity is essential in art, in technology, and in science. But in what ways are creativity in these three areas different, and in what ways are they similar? The fields determine what is creative, what becomes part of the domains. Science builds on the past, methodically adding knowledge, with radical disruptions happening rarely. Technology is about both building and constant disruptions—disruptions, in either minor or major scales, are essential for growth, and combining things is both necessary and good. Art is all about uniqueness and disruption, and progress has little or no meaning. A common creative signature encompassing all domains is thus elusive. What is permissible in one domain may be frowned upon in another. But there are still lessons that can be extracted across domains. How can we use creativity from another domain to innovate in our own domains?

Enhanced color image taken by the
High Resolution Imaging Science
Experiment camera on board the
Mars Reconnaissance Orbiter,
which has been orbiting and
studying Mars since 2006 (two-
color dunes in Meridiani Terra).
Interpretation of HiRISE images is
far from simple. One is HiRISE's use
of enhanced color, which operates
in long infrared wavelengths; light-
toned surfaces being those with thin
coatings of global dust, nanophase
ferric oxides. The second is the
combination of two factors that
make the physics of sand dunes in
Mars different from Earth, resulting in
patterns which are different as well.
The first is that the Mars atmosphere
is thin – about 6 percent of Earth's
air pressure at sea level; unless there
are hurricane level winds there is
not enough wind energy to move
grains of sand away from surfaces
on Mars. The second is gravity,
which is only about 38% of the
surface gravity on Earth. Therefore,
once motion starts, grains move
long distances, for far longer than
on Earth. Also when particles hit
surfaces, particles splash, which can
then move as well. Under normal
conditions dust persists on lower
dune areas because there is not
enough wind energy to remove it,
whereas higher-lying dune crests,
which are subject to more intense
winds, become dust free, resulting in
the appearance of two-color dunes.

THE STRUCTURES OF ART, TECHNOLOGY, AND SCIENCE

Incentives, aspirations,
and ambition of the domains

Almost invariably, technology falls
between art and science.

Much is revealed when we compare art,
technology, and science by analyzing
their various drivers, recognition systems
and pipelines, uniqueness of products,
and more. To master the practice of the Nexus,
we will need to understand the language,
culture, and motivations of the three domains.
Without knowing the incentives, aspirations,
and ambitions of each, it would be almost
impossible to connect across them to produce
the synthesis we need.

We compare each domain across these categories:

Origins of the Domains
Growth and Evolution
Products
Structure of Governing Systems
People
Communities and Groups

Each of the domains has had hundreds and even thousands of years of development that has pushed them apart into their own language, governance, and culture. To build bridges and work across these domains will take extraordinary insight, commitment, and discipline. But first we must understand the structures we are working with and against.

We start below with two charts that indicate the origins of the domains—their central aspirations, and their age. In these and all comparisons within the charts that follow, entries are ordered as ART (left), TECHNOLOGY (middle), SCIENCE (right).

Origins of the Domains

	ART	TECHNOLOGY	SCIENCE
Central aspiration driver	Creation	Creation	Creation

Science is explaining and unveiling, technology is inventing and building, and art is creating and expressing. The inside view, especially in art, is more complex.

At the very highest level, art, technology, and science appear to have very different drivers and aspirations. The inside and outside views, however, may be quite far apart, and that is a reason for the schism between domains: domains and their practitioners do not understand each other.

Art is seen primarily to be about self-expression; most outsiders equate art with creation and often with beauty. Most artists, however, will use other terms instead of creation: challenging, reframing, provoking, reflecting, and transforming. Creation and beauty may be by-products. Equating art with beauty is for amateurs.

Technology, at its root, is about invention, making, and building. More generally, it involves a dizzying continuum that goes from an idea to an eventual innovation. It is rarely the product of a single mind.

Science is about unveiling, revealing what may already be there. It relies on a clear method for questioning and deciding what belongs in the edifice of science.

Fig. 4.1 Art is as old as the paintings in the caves of Lascaux; technology and engineering are in full display in the Roman aqueducts of Segovia in Spain. The tower of Pisa, where Galileo reportedly conducted his falling bodies experiments, can be associated with the birth of modern science.

Introspective questions abound in art. They range from "What is art?" and "What is the purpose of art?" to more practical matters, such as "What is the role of art in society?" and "What is the purpose of museums?" Technology is different. A few people, usually from the outside, think about the big questions: "Is technology good?" or "Is technology necessary?" But by and large technology is not introspective it just ruthlessly moves along. A few people in science, a minority in fact, the philosophers of science, worry about how science works. Most scientists do not question its underlying assumptions.

Age	As old as humanity itself	As old as humanity itself	Five centuries old (since Galileo's times) and 350 years old since the birth of scientific societies

Art and technology are as old humanity. By this measure, science is quite young.

Art is as old as humanity (think of the paintings in the Lascaux caves, from 17,000 years ago); so is technology (think of the paints used in the Lascaux caves). Arguably, engineering thinking is among the oldest types of codified thinking: a way to pass information from one generation to another in projects that lasted multiple generations. Think of building Roman aqueducts (figure 4.1) or medieval cathedrals.

The word "technology" comes from *techne*, which implies knowledge gained though practical work. Long before industry existed, *techne* referred to manual skill rather than efficiency and manufacturing; in this sense, technology is closer to crafts and art, as practiced today, than current technology. Technology as an activity is much older than engineering. Humanity has been creating technology since the beginning of time. The emergence of engineering as a discipline with clear foundations—for example, using all available scientific knowledge in the pursuit of objectives—is relatively recent. Roman engineers were doing engineering without the scientific basis of mechanics having been established. But somewhat paradoxically, the word "technology" is even newer. The first use of the word in the modern sense was likely in the 1829 book by Jacob Bigelow, *Elements of Technology* (reprinted and expanded in 1831); based on a course given at Harvard between 1819 and 1829, which was titled "Application of the Sciences to the Useful Arts" (figure 4.2).[62]

Bigelow (1831) writes: "I have adopted the general name of Technology, a word sufficiently expressive, which is found in some of the older dictionaries, and is beginning to be revived in the literature of practical men at the present day. Under this title is attempted to include an account... of the principles, processes, and nomenclatures of the more conspicuous arts, particularly those which involve applications of science." In his book Bigelow tried to summarize all the knowledge of the day about materials and processes for making things.

62. The association of the word "technology" with institutions in the United States may be traced back to the Rensselaer Polytechnic Institute, which started as the Rensselaer School (1824–1834) for the "application of science to the common purposes of life," and which became the Rensselaer Institute in 1834. The charter for the establishment of the Massachusetts Institute of Technology goes back to 1861. The origins of the California Institute of Technology date to 1891.

ELEMENTS

OF

TECHNOLOGY,

TAKEN CHIEFLY FROM

A COURSE OF LECTURES

DELIVERED

AT CAMBRIDGE,

ON THE

APPLICATION OF THE SCIENCES

TO THE

USEFUL ARTS.

NOW PUBLISHED

FOR THE USE OF SEMINARIES AND STUDENTS.

BY JACOB BIGELOW, M. D.

Professor of Materia Medica, and late Rumford Professor in Harvard University ; Correspond-
ing Secretary of the American Academy of Arts and Sciences ; Member of the American
Philosophical Society ; of the Linnæan Societies of London and Paris, &c.

BOSTON.
HILLIARD, GRAY, LITTLE, AND WILKINS.

1829.

63. Let us look at the origins of the words "art" and "technology." Art derives from the Latin ars, which means something akin to skill, method, or technique; it also carried a connotation of beauty. But the word "artist" emerges much later. We think of painters and sculptors as artists, but that was not always so; sculptors in ancient Greece were regarded as craftsmen. And even though the word "artist" existed in Italy in the Middle Ages, its meaning was still associated with craftsmanship. An artist was a craftsman with better skills than other craftsmen; the accent was on the skill rather than the activity itself. The importance of the underlying intellectual skills rather than the manual skills dates back to Leon Battista Alberti and his treatises on architecture, painting, and sculpture. The word "technology" is made of two parts. The first part, its root, goes back to the Greek word techne which means both art and skill; it was what painters, goldsmiths, cabinet makers, or glassblowers might do. Its suffix (-ology) means the study of, theory of, or science of something. Thus, technology is the knowledge (or the science) of techne—and thus encompasses the knowledge of making and doing. Engineering, which is intertwined with technology, comes from the Latin word ingeniare, which means "to devise." Several English words are related to it: ingenuity and engine, for example. The word "engineer" (Latin, ingeniator) also derives from the Latin ingeniare (to create, generate, contrive, devise) and ingenium (cleverness). Its origins are even clearer in Spanish (ingeniero/ingeniera) and French (ingénieur ingénieure), showing masculine/feminine forms). Taken together we may equate an engineer with someone who gives give birth to ideas.

64. Science becomes organized with the creation of scientific societies. The Royal Society of London (initially called the Royal Society of London for Improving Natural Knowledge) was founded in 1660

Bigelow defines all knowledge as either science or arts (note the plural *arts*). In his terminology, science is everything that exists whether people are here or not and whether they are thinking about it or not; it is independent of human intervention. Arts is everything that emerges from the human mind. Thus, science is about discovery (not creation) and arts is about creation (not discovery). Into arts goes everything from art (drawing, engraving), architecture, writing, craftsmanship, music, engineering, and so on. In Bigelow's view, engineering is closer to arts than it is to science because it is about creation—a surprisingly modern view from someone living two hundred years ago.

On the other hand, the word "science" comes from *scientia*, meaning knowledge.[63] But science, as understood today, is young: about 400 years old if one uses Galileo Galilei (1564–1642) and the birth of the scientific method, somewhat older if one uses 1543, when Copernicus published that the sun—not Earth—is at the center of our planetary system, and 350 years old, if one uses the birth of the Royal Society in London as another benchmark.[64] But science is remarkably young, possibly 170 years old, still if we go by the emergence of what may resemble modern scientific journals.

The Oxford English Dictionary dates the origin of the word "scientist" to 1834. It is one of those rare instances where we know exactly when and who coined the term: William Whewell (1794–1866), an English polymath, used it in his review of *On the Connexion of the Physical Sciences*, by Mary Fairfax Somerville (1780–1872; figure 4.3).[65] Whewell wrote a glowing, if somewhat patronizing, review of her book (Sommerville 1834) but did not want to refer to Somerville as a "man of science." He was looking for a term to reflect the interdisciplinary nature of Somerville's expertise. As the book demonstrated, she was more than a mathematician, astronomer, or physicist; she possessed the intellectual capacity to blend these areas seamlessly. Whewell used a word of his own invention: scientist.[66]

The term was slow to catch on. Many Victorians preferred older expressions such as "natural philosopher," "naturalist," or "experimental philosopher." Darwin, Faraday, and Lord Kelvin refused to use the term to describe themselves. But "scientist" caught on in the United States. It was only in the early twentieth century that the term was fully accepted.

The past informs the present; next we compare the domains as they are now.

and chartered by King Charles II; the Accademia del Cimento (Academy of Experiment), was founded in Florence in 1657; the Accademia dei Lincei, another Italian science academy, was founded in 1603. The Leopoldina, the German academy, was founded in 1652. The French Academy of Sciences (Académie des sciences) was founded in 1666 by Louis XIV. Many consider the Royal Society to be the oldest academy. The time of its charter is used as a benchmark. Yet the history of all these academies is complex, involving reestablishment after periods of inactivity. It should be pointed out that people were doing "science," in the sense of trying to understand the functioning of the world, prior to science. The tools may have been different. For example, in pre-Galilean times, perspective and drawing were methods to investigate the reality of the world.

65. Mary Sommerville's book quite possibly represents the first connected view of science. It was published in 1834 by John Murray (a company founded in London in 1768). Few books are reviewed 180 years after publication. Somerville's is an exception; a review of it appeared in *Nature* in 2014 (Holmes 2014). Still in print today, it is often thought of as the book that launched popular science writing. It was Murray's best-selling scientific publication for twenty-five years until Charles Darwin's *On the Origin of Species*.

66. Whewell was a gifted wordsmith and invented many scientific words now in common use: physicist, linguistics, consilience, astigmatism, and others. Quite remarkably he suggested the words "electrode," "ion," "anode," and "cathode" to Michael Faraday, the leading figure in electromagnetism and electrochemistry in his day. Whewell invented the word "scientist" in 1833, responding to a challenge by the poet Samuel Taylor Coleridge, but he first used it in print in the 1834 Sommerville review.

Methodology	No prescribed method	Driven by desired results and aided by all available knowledge, including all available science; if gaps, it uses any available heuristic	Largely scientific method in experimental realms; induction in theoretical realm. Theoretical disruptions driven by inductive reasoning

Fig. 4.3 Portrait of Mary Fairfax Somerville (1780–1872) by Thomas Phillips.

Growth and Evolution

The biggest discovery of science is science itself; how science evolves. Technology uses all available knowledge, from older technologies, from science, and even art, via design.

It would be a stretch to consider the evolution of science as algorithmic but, when compared with art and technology, it appears to be so. Art is the least algorithmic of the three, unless the algorithm is that there is no algorithm or, that in approaching the present, anything that smells of derivative is bad.

Growth mode	Constant reinvention; no underlying arrow of time or concept of progress.	Builds on past – constant growth by nearly continual adaptation and disruptions; major disruptions are rare	Progress wired into the fabric of science. Builds steadily over past. Big disruptions shaking foundations happen rarely but are very much desired to either unify or simplify knowledge

Technology is about both building and disrupting; art is disruption and uniqueness. Progress has meaning in science and technology but little or no meaning in contemporary art.[67] "Standing on the shoulders of giants" is a good strategy in science; in technology, its only purpose is to crush the elder giant; and in art, it is a bad idea to stand near anybody.

Dynamics of evolution of ideas	Constant resetting; branching. Substantive branches preserved	Opportunistic; builds on combination of existing technologies. Many non-growing branches	Builds on existing ideas to point of exhaustion. Few dead branches.

It is possible to trace the evolution of ideas in visual arts even though, externally, the ideas are sometimes associated with epiphanies. Externally ideas in visual arts are associated with epiphanies. It is possible, however, to trace their evolution. Evolution in technology—often an interplay of interconnected networks—is less clear and may leave parts unseen. In science, especially in theoretical work a laboriously built scaffold may be removed (and thus invisible) when unveiling the final result.

Many equate art with a burst of inspiration, but any art retrospective will show the evolution of ideas and progression and the contrasting of styles.

Chronology? Possibility of time-ordering of events	Many possible parallel but asynchronous strands; temporal arrangement only possible with historical hindsight	Within classes, events can be ordered roughly in time, but not always; parallel paths possible and plenty of dead ends	Events can largely be ordered in time; final structure contains few dead ends; in fact, the very nature of science is successful trimming of dead branches

67. This assessment of progress in art does not apply to the beginning of the Renaissance, when the foundations of perspective were established and, subsequently, reaching into the late nineteenth century, when realism was a goal.

Singapore Art Museum

Frist Center for the Visual Arts

Galerie Rudolfinum

Haus der Kunst

Ludwig Museum im Deutschherrenhaus

MET

Galerie Simon Blais

MNAC Anexa

Centre for Contemporary Art Ujazdowski Castle

Franche-Comté Frac

Galerie Ludorff

Gagosian Gallery

Neue Nationalgalerie

MoMA Whitney

MUMOK

Moscow Museum of Modern Art - MMOMA

Victoria and Albert Museum

Guggenheim

Pace Gallery

Galerie Thaddaeus Ropac

Carreras Mugica

Mori Art Museum

MuHKA Museum of Contemporary Art Antwerp

Galerie Wolfgang

Frissiras Museum

Zentrum Paul Klee

Musée d'art contemporain de Montréal

Taipei Fine Arts Museum

Ma Galerie

Michael Rosenfeld Gallery

Tel Aviv

De Sarthe Gallery

Kunstmuseum Bochum

Reina Sofía

Galería Cayón

MACRO - Museo D'Arte Contemporanea Roma

Paul Kasmin Gallery

Centro Atlántico de Arte Moderno

Mayoral

Grosvenor Gallery

Connaught Brown

Museo de Arte de Lima - MALI

Centro de Arte Moderna

National Gallery of Victoria

Haus a

Leila Heller Gallery

The Israel Museum

RHA Gallagher Gallery

Istanbul

Galerie Sophie Scheidecker

National Gallery of Australia

Gallery One

Museum für Neue Kunst

Galerie Tamé

La Maison Rouge

Kolumba

Sudley House

Kunsthalle Basel

Louisiana Museum of Modern Art

Pomona College Museum of Art

Hiroshima City Museum of Contemporary Art

Art Gallery of Hamilton

Museion

Stadtgalerie Altötting

Katonah Museum of Art

Tampere Art Museum

Gladstone Gallery

Parrish Art Museum

Elizabeth Leach Gallery

Opera Gallery

Hosfelt Gallery

Kathleen Cullen Fine Arts

Elizabeth Dee Gallery

Daniel Weinberg Gallery

George Adams Gallery

Garage Museum of Contemporary Art

Carl Solway Gallery

Galerie Lena Brüning

Jacobson Howard Gallery

Marlborough Gallery

Orange County Museum of Art

National Gallery of Arts - Tirana

Eli and Edythe Broad Art Museum

Vanderbilt University Fine Arts Gallery

La Triennale di Milano. Design

Galerie Bugdahn und Kaimer

Zabludowicz Collec

Fondation Louis Vuitton

Madelyn Jordon

Villa Croce Museo d'Arte Contemp

Círculo de Bellas Artes

MARTa Herford

Galerie Clairefontaine

Bonnefantenmuseum

Galleria Torbandena

Museo Fortuny

WIMMERplus

Kunstmuseum Mülheim an der Ruhr

Erfurt

Antiguo Colegio de San Ildefonso

nsthaus Kaufbeuren

Motel Gallery
sammlungen Chemnitz Museum Gunzenhauser

KUNSTHAUS& GALERIE KEIM

LEVY Galerie

rari

Turner Contemporary

Museum im Kulturspeicher

Highpoint Center for Printmaking

nstmuseum Bern

Art Attitude Hervé Bize

The Museum/Gallery Network
of Contemporary Art

Two institutions—for example, a museum and a gallery—
are connected if an artist whose work was exhibited
at the museum is also exhibited next at the gallery, or vice
versa. The dataset for this network combines information on
497,796 exhibitions in 16,002 galleries, 289,677 exhibitions
in 7,568 museums, spanning 143 countries all during
the years from 1980 to 2016. The image captures the largely
invisible network of influence and trust between thousands
of institutions worldwide. At its core is a dense community
of major European and North American organizations; they
appear as large nodes, the largest among them are New
York's Museum of Modern Art (MoMA), Guggenheim in
New York, the Gagosian Gallery in New York, and Reina
Sofia in Madrid (Fraiberger et al. 2018).

One can argue that results in science are inevitable; they are there to be found. Technology is not inevitable. There is an intrinsic ordering to the fabric of science.[68] There is evolution in technology but also haphazard bifurcations (figure 4.4). Progress has little or no meaning in contemporary art. The challenge is not to extend an existing historical cultural line, but to break from that line and create a territory not already occupied, different and distinct enough to be recognized as a new space.

Products

	ART	TECHNOLOGY	SCIENCE
Uniqueness of products	Generally, one of kind; products have mark of the creator	Multiple copies a must; patented. But "products," objects, processes, systems, business models, may have clear imprint of creator-inventor	If something is discovered, it means it was there all the time; but one can rightfully say that theories are created and that they have the imprint of the creator

Art is all about uniqueness. The result is independent of the discoverer in science; but the path the led to it is not. A theory in science has the imprint of its creator. In technology, the more the design elements are involved, the more unique the result.

	ART	TECHNOLOGY	SCIENCE
Intellectual protection	Copyright	Patents; trade secrets	Largely open source; intellectual protection is publication in open literature[69]

Science's progress hinges on publication in the open literature, and credit for discovery hinges on priority in publication; often, several people will arrive at an idea at the same time. Technology depends on intellectual protection via patents and trademarks. Copyrights affect scientific publications as well as artistic works.

Structure of Governing Systems

	ART	TECHNOLOGY	SCIENCE
Role and character of talent pipeline	Very informal	Informal	Well developed; universities and national labs

Complex balance exists between domains and fields (for an early view of this interplay see Becker 1982). Pipelines in science are well structured; apprenticeships and PhDs, for example, are part of the system. Technology is both structured and unstructured: structured in pipelines feeding from science and engineering but unstructured on the entrepreneurial side. Amateurs/outsiders are rare in science but still possible in technology and art.

68. If Isaac Newton had not established the foundations of classical mechanics, someone else would have done it, though probably in a different style (Lagrangian mechanics? Hamiltonian mechanics?). Same goes for discovering the photoelectric effect, unraveling the structure of DNA, uncovering the relationship between electricity and magnetism, or establishing the foundations of thermodynamics.

69. *Open communication and peer review are central both to the identity of academic scientists and to the public legitimacy of science itself; a cornerstone of how science is supposed to work. But this is relatively recent, a bit more than a hundred years old. Academies and scientific societies, such as the Royal Society of London, have been associated with the creation of scientific journals as if scientific journals had been an unavoidable step in the evolution of learned societies. The real story of societies and journals is quite complicated (Csiszar 2018). For a long while journals were a marginal feature of the academic world, and often the subject of disdain and suspicion.*

	ART	TECHNOLOGY	SCIENCE
Domains	Collections in museums, individuals, catalogue raisonnés, books, critical reviews	Artifacts, products and processes, patents, trade secrets	Refereed papers, books, patents
Fields	Museum directors and curators, auction houses, collectors, dealers, art schools, influential art fairs and biennales, art prizes, trend-setting magazines. On longer time scales: art historians	Markets, government subsidies, public at large, social media reviews	Faculty at universities; national and industrial labs; foundations, peer review processes,[70] journal editors, significant recognitions and awards
Relative importance of domain and field	Field dominates.	Neither field nor domain critical.	Domain dominates field in physical sciences.

70. Research universities contribute disproportionally to the number of articles published in refereed journals. In the United States, 16 percent of all scientists are employed in universities but account for about 75 percent of all articles published (National Science Board 2020).

71. The picture in art is possibly the most complex of all. The thinking of art historians has evolved through time. A review of two books in this area (Woods 2020 and Michaud 2020) by Susan Tallman (2020) with the apt title "Who Decides What's Beautiful," is especially revealing.

72. Stigler's law, proposed by statistician Stephen Stigler (1980) states: "No scientific discovery is named after its original discoverer." Stigler named sociologist Robert K. Merton as the discoverer of "Stigler's law," consciously exemplifying "Stigler's law."

73. Compare this with the artworld. The size of New York City's artworld, at its reputational height, was estimated to be about three thousand people.

74. Technological evolution is haphazard. The appearance of the video format VHS was not inevitable—we could have jumped straight to DVDs, or passed from Betamax to DVDs, or even to flash drives. Technological innovation is like playing with an ever-growing Lego® set—some pieces are already there, and combinations of these lead to the creation of new pieces, which lead to yet more. New technologies generate surrounding technologies. When cars first appeared, there were steam cars, electric cars, and combustion engine cars, but the combustion engine became dominant the technology. Would the development of batteries have been different if electric cars had coexisted for a longer time?

The character of a domain limits the claims for acceptance. Conditions for acceptance are strict in the most codified aspects of science—physical and biological sciences—but revolutionary or even simply contrarian ideas may not be accepted overnight.[71]

Being right and first, however, is sadly not enough. The field must also "see" that the idea is right. A new idea can have many parents. Science is full of ideas anticipated by someone else; attributions are a result of an amalgam of interest, promotion and self-promotion and even veiled national interests—to the point that there is even a law, Stigler's law, making this very point.[72] At the other end of the spectrum, in art, where the concept of "right" does not really apply, the field collectively decides. Judgments may be revised, however, when reevaluations take place in the course of time. The most "democratic" (and wildly complicated) system, in terms of the sheer number of components involved, is the one underlying the acceptance of a new technology.[73] In many cases public acceptance defies the opinion of experts; in others a clearly inferior technology prevails.[74] Products now regarded as an integral part of society have often taken years to develop.

	ART	TECHNOLOGY	SCIENCE
Field size	Small	Huge	Small or large, but sharply defined according to areas
Private/public support structure	Loose or minimal institutionalized structure	Combination of informal structures and public policy; lose adaptable, capital support structure.	High degree of formal institutionalized structure; pillars are universities, national agencies

Fig. 4.4 An example of evolution in technology: 1912 and 1913 models of Harley-Davidson motorcycles. The 1912 model has a one-cylinder engine and a leather belt; the 1913 model has a chain belt, and significantly, the two-cylinder engine that has characterized Harleys to this day.

Sophisticated structures, many of them government-run, drive science; public/private partnerships often drive technology. There are minimal such structures, by comparison, in art.

	ART	TECHNOLOGY	SCIENCE
Existence of formal nurturing and recognition systems	Limited number of significant awards. Recognition by being selected for specific shows.	Unclear in initial stages	Formal, clear and thorough; clear pipelines to nurture emerging talent

Significant recognition systems exist in science, ranging from fellowships to prestigious memberships to prizes; many forms of recognition are emerging on the technology side. Recognitions affect careers in science; awards beget more recognition, influence, and further awards. No such clear positive feedback loop on the technology side. A few awards, such as the Guggenheim and MacArthur fellowships, cover the spectrum from science to art.

	ART	TECHNOLOGY	SCIENCE
Role of external environment	Typically, minimal.[75] May thrive under adverse conditions	Unclear in initial stages	Formal, clear and thorough; clear pipelines to nurture emerging talent

The external environment is critical in science and even more so in technology, since it depends on public policy for funding, and on a system of laws for technology investments and rewards. Art, however, can survive and even flourish under adverse conditions.

	ART	TECHNOLOGY	SCIENCE
Insiders or outsiders?	Accepting of outsiders	Meritocracy; accepting of outsiders	Virtually all insiders

Science is now almost completely professionalized; "gentlemen scholars" have vanished.[76] Technology provides examples of outsiders and has even created a mythology of entrepreneurs, populated by people of remarkable vision and insight (think Steve Jobs). And although elements of professionalism have emerged, artists and the ultimate entrepreneurs are outsiders.

	ART	TECHNOLOGY	SCIENCE
Value of (and shifts in) reputations over time	Reputational value is high. Shifts are possible.	Low aspirational value.	Reputational value is high. Changes depend on strands within domains; unlikely in physical sciences; most unlikely within mathematics.

75. A notable contrary example could be the Federal Art Project during the New Deal, which employed about ten thousand artists and craft workers in the United States during the Great Depression to create murals, sculptures, paintings, graphic art, photography, with little restriction as to content or subject matter.

76. As late as 1859, when Charles Darwin wrote *On the Origins of Species*, one of the most influential books in science, he could do so with no academic credentials whatsoever, no professorship or academic affiliations. He was wealthy and could work from his home study.

77. Reputations are subject to revision. One significant revision occurred with Robert Hooke (figure 4.5). In many aspects Hooke was on par with Newton. It appears that it was Hooke who suggested (well before Newton) the principle of universal gravitation. There is ample evidence that Newton tried to destroy Hooke's reputation— he is quoted as saying that Hooke was "a man of strange, unsociable temper" when, in fact, the same could have been said about Newton, who was both vengeful and antisocial. And it has been argued that the famous Newton quote about "standing on the shoulder of giants" was a putdown of Hooke's physical stature, which was reputedly short and stooped. Newton famously "lost" the only known portrait of Hooke that hung at the Royal Society when Newton was its

In the art world, it is possible for reputations to shift over time; the myth of increased reputation after death still exits. And reputations may be long-lived. Changes in reputations in science, though possible, are somewhat rare.[77] Technology looks forward; its history, to its practitioners, matters less.

	ART	TECHNOLOGY	SCIENCE
Role and existence of constraints	Existence critical in public art. Otherwise non-important. Constraints may drive creativity	Hugely important; many constraints; positioning is critical	Not critical; often only constraint is funding (and, depending on area, compliance and public policy)

The main sources of constraints in science are funding and public compliance; constraints in technology are capital. There are few or no visible constraints in art, though constraints may appear in commissioned and public work. All this changes if the political climate is included among the list of other constraints.

People

	ART	TECHNOLOGY	SCIENCE
Definition of lines of succession; role of mentorship	Informal influence	Unclear; system is constant state of flux	Very clear; defined academic trees; dynasties possible

Clear mentorship lines exist in science, especially in modern times, with formal supervision through university training. Mentorship paves the way in science but does less so in art.

	ART	TECHNOLOGY	SCIENCE
Role of champions	Extremely high	Moderate	Small or large, but sharply defined according to areas

Academic pedigree and pipelines matter in science. Fewer formal and visible pipelines exist in technology. Champions, collectors, critics, and museum directors matter significantly in art.

	ART	TECHNOLOGY	SCIENCE
Possibility of one-hit wonders	High in literature, low in visual arts	Moderate	Possible but low

A body of work matters in science and in visual arts. Reputations may rest on this body of work.

	ART	TECHNOLOGY	SCIENCE
Degree of entrepreneurship	Extremely high[78]	High	Relatively low

president. The Royal Society was then a collection of aristocratic philosophers who talked more than experimented; Hooke, who grew up relatively poor and needed the money, did many of their experiments for them. He was central to the success of the Royal Society, and as more than one Newtonian scholar has noted, without the Royal Society, there would have been no Newton's Principia.

78. The practice of art has changed significantly since the time of apprenticeships and masters, whether they literally worked side by side in large studios or just labeled their art as being from a master's workshop: the "workshop of Rubens," for example. The Romantic period, in the late eighteenth and early nineteenth centuries, gave us art that was breaking from craft: the cult of the artist breaking rules and overthrowing tradition and the emergence of the term "fine arts." Modernism, the age that gave us Picasso, Virginia Woolf, and Igor Stravinsky, made artists the new cultural aristocrats. After World War II, and in America in particular, MFA programs emerged and, after that, some artists became entrepreneurs, something in full force today. Several modern practices may involve workforces of more than a hundred people with multiple skillsets, not only artists but also others with skills in finance, marketing, and IT. Downsizings events in such practices make the news in the art world.

Fig. 4.5 Robert Hooke's *Micrographia*, published in January 1665, was the first major publication of the Royal Society of London and, arguably, the first scientific bestseller in the world. The book was lavishly produced with finely detailed copperplate engravings and fold-out plates of insects, slices of cork, and a few man-made objects, such as the tip of a needle, presumably to contrast man-made objects with the precision of the biological world. *Micrographia* includes the first known use of the word "cell" as a biological term.

	ART	TECHNOLOGY	SCIENCE
Communities and Groups			
Role of groups or clusters in development of individuals	Small	High	Small in beginning stages (due to tenure-driven considerations); important at end but highly dependent on area

Clusters, university labs, and centers are at the very core of science, and organized clusters, often formed to respond to specific opportunities that may emerge in science and technology, blur the lines between the two. Artistic clusters may emerge organically, with no central command (figure 4.6).

	ART	TECHNOLOGY	SCIENCE
Cooperation among groups	Minimal to noncritical, but depends on endeavors.	Targeted cooperation balanced with competition. Efforts to protect results.	Some competition, but substantial cooperation. Results protected by placing them in open literature.

A rich dynamic of cooperation and competition underlies progress in science; the emergence of numerous scientific meetings is a way to explore the frontiers.

	ART	TECHNOLOGY	SCIENCE
Effect of increased connectivity and flow of information	Non-critical	Critical	Critical
Role of specific communities	Relatively minor	Important within subsets, for example VC communities	Important in credibility of emerging areas
Degree of control in the formation of groups and teams	Minimal	Among organizations, driven by mixture of cooperation and competition. Within organizations, degree of control is high	Driven by combination of funding and complementarity of knowledge and techniques

Funding structures, and the response to opportunities, drives the balance of cooperation-competition underlying progress in science. There may be tight control at the level of a single individual or a single lab, but less control over who cooperates with whom at the level of a university as a whole; researchers freely connect with colleagues at other universities and across countries. In technology, the level of cooperation/competition is hugely dependent on the size of the firm. As opposed to a university, large firms act with a single voice. All the above changes in totalitarian regimes;

think of Nazi Germany and the exhibits of Degenerate Art, of multiple controls in Soviet Russia and postwar Eastern Europe.

Contemporary avant-garde art embodies a widespread avalanche of mind-bending, challenging, thought-provoking, puzzling (at times baffling), unclassifiable, and perplexing works, without any discernable mainstream and geographical centrality. It is enough to make the world of technology seem almost sluggish. No longer is it possible to talk about the art world only in terms of the West. There is a constantly changing center of gravity and a blurring of art, education, and commerce. Artists, entrepreneurs, collectors, museums and galleries, critics, academic institutions, and impresarios intersect in ever-evolving ways. New York City was once at the center of everything; now the center could be Houston, Ghent, Antwerp, Sao Paulo, the Middle East, or anywhere from Doha to Dubai to Africa. It seems like yesterday when Beijing and all of China were superhot, and now they are almost passé. There is constant string of biennials—Basel, Miami, Frieze—and some triennials, monumental exhibits and amazing building investments in new museums by renowned architects. PhD students writing dissertations on twenty-five-year-old artists, bypassing the test of time; MacArthur genius grants providing instant credibility and celebrity; markets making stars and then quickly abandoning them; the art world morphing into the art market. The avant-garde art world can be its own worst enemy in the way it projects an air of exclusivity. Paradoxically, in the middle of all this, the degree options for artists have largely remained stagnant for decades (sculpture, painting, ceramics, for example), even though artists have mixed and matched all those subjects into new disciplines. The distinction between art and other creative industries is becoming increasingly subtle. Some changes are visible, such as distributed creative networks, a resurgence of artist collectives, and a reemphasis on community building. In the past decade, a new category has emerged: social practice. This approach to artmaking has so solidified around a new generation of artists that some schools have responded by offering degree programs in it, a professionalization of art that has resulted even in a burgeoning push for PhD degrees.

Fig. 4.6 Random International, a London-based art collective and collaborative studio founded in 2005, installed the site-specific experiential artwork *Rain Room* at the Barbican in London in 2012. Visitors to the exhibit could walk through its downpour without getting wet.

The Reach of Contemporary Art
Michael Rakowitz

Michael Rakowitz (b. 1973) is often referred to as a sculptor, but his body of work defies classification. He is known for conceptual projects, shown in non-gallery contexts, that span a wide range of topics. One exhibit unveils how the *Star Wars* film series influenced the Iraqi military during Saddam Hussein's regime in the design of monuments, uniforms, and helmets inspired by Darth Vader. Another project, *Return*, unconventionally re-creates the import-export business run by his grandfather—a Jew who fled persecution in Iraq— by setting up shop in New York and selling imported dates and date syrup, nostalgic items for the émigré community.

Rakowitz's custom-designed *paraSITE* homeless shelters, inspired by Bedouin tents, respond to an individual resident's needs. Built from plastic bags, polyethylene tubing, and tape, they require a host to function, as do actual parasites. The shelters attach to the air outtake ducts of buildings, which simultaneously inflate and heat the double membrane plastic film structure, creating a warm space.

In 2018, Rakowitz was awarded the Fourth Plinth commission in London's Trafalgar Square, possibly England's most important space for public art. He re-created one of the stone statues—a winged bull with human features— that had guarded the gates of the ancient city of Nineveh until it was destroyed in 2015 by ISIS militants. Connecting with his project *Return*, the construction of the replica involves more than 10,000 empty Iraqi date-syrup cans.

Michael Rakowitz, *The Invisible Enemy Should Not Exist (Lamassu)*, 2018, on London's Trafalgar Square's Fourth Plinth, and *paraSITE*, one in a series of inflatable homeless shelters.

A Final View: What Is Art? What Is Technology? What Is Science?

Technology and science have clear objectives. Art today is exciting because it is hard to define.

What exactly is art? Or, as Marcel Duchamp demonstrated by essentially positing that everything thought by an artist can be art, "What is not art?"[79] Contrast this with science. Science is about making the unrecognizable recognizable, turning the unfamiliar familiar, and seeing a thread of unity behind dissimilar phenomena: seeing in a moving pendulum the workings of the solar system; seeing milk mixing into coffee and capturing insights into chaos theory and the seeds of understanding of how regions can remain unmixed in oceans or why Jupiter's red spot persists. This is the essence of science: finding the simple picture that contains many pictures.

We could argue that art, especially modern and contemporary art, is the opposite. It is seeing something that we may have seen a hundred times before but now see in a different light, a new viewing that makes the familiar become unfamiliar. This is "bestrangement," as the Russian formalists called it, or "perplextion." Sometimes described as the moment of awe, it is the first step toward a critical engagement with art. Now more than ever, art is far from just the aesthetic concerns of shape, color, and composition—it is about the why's and how's of a thing. Its "utility" is in bestowing upon us, as viewers, the role of completing the work and inviting us to participate in a change of perception. It asks us to make distant and perhaps implausible connections that could not exist without a confrontation with the art itself. And that is why we want it at the Nexus: to bring the dizziness of art as a catalyst.

Technology is about invention; science is about discovery. Art need not be driven by a purpose, at least not one that can be captured in a verb or a compact phrase. Objectives in art are as varied as artists: provoke, incite, irritate, challenge, reframe, shock, upset, document, nauseate, reveal, and maybe even educate. The phrases "shake things up" and "force confrontation," in one way or another, appear often.[80]

Art exists essentially for its own sake, but it is not always self-referential. And it is most clearly not driven by beauty, though beauty can be an outcome. We could argue that art is about self-expression, a form of human response to the world, an attempt to capture something about it—to put a lens to some *thing*, or creature, or feature of reality—or conversely to turn a mirror back on us. An alternative rich set of compelling and persuasive arguments about "What is art?" is possible. Inevitably some of the arguments will contradict each other. Therein, we could argue, lies the value of art: the ability to function within an ever-evolving structure that allows it to flourish amidst chaos.

79. *The very meaning of what "art" is has evolved through time. Plato saw art as imitation of beauty in nature and classified it under techne, meaning a craft or a skill. Georg Hegel (1770–1831) placed "Art" much higher in the list of human achievements, art with cap "A," above what we now call science. He connected Art squarely with aesthetics and beauty, but he saw Art as existing in a higher plane than beauty in nature. The "end of art," as some saw Hegel suggesting—Arthur Danto (1924–2013) subsequently expressed it in decidedly clearer terms (Danto 1997)—is when art was seen as liberated from the constraints of imitation theory. Art, especially as we move into the twentieth and twenty-first centuries, is all about disruption. As shown in chapter 3, the modern movement in the early twentieth century forced three neoclassical academic giants—William-Adolphe Bouguereau (1797–1851), Ernest Meissonier (1815–1891), and Jean-Léon Gérôme (1824–1904), the most revered artists of their time—into the back pages of art history in less than twenty-five years. By the middle of the twentieth century, with the modern, postmodern, and post-postmodern movements, we see what may have been the last succession of recognizable periods in art.*

80. *One-word descriptors fail, of course, to capture both scope and ambition. The ways that contemporary artists see themselves, what they do and why they do it, cannot be easily condensed. Consider how the sculptor Nancy Rubins characterizes her view of what it means to be an artist (video studio visit, Gagosian Quarterly, January 25, 2019): "I also think of an artist in a way as an explorer, and as a researcher, as a scientist, in a way, because we're looking for a place that we can discover and learn about and share with the rest of the world, that hasn't really been seen before."*

Art, technology, and science operate under different rules, goals, values, education/talent pipelines, and recognition systems. A broad view reveals similarities and differences. By almost any metric, and we have described many, technology is always bracketed by art and science; there are elements of both arts and science in how the domain operates. Extracting a meta-lesson that encapsulates the essence of all comparisons—reaching the Nexus—is essential to individuals and organizations whose goal is seamless movement across domains and the integration of thinking that leads to breakthrough ideas and innovation.

Surface Tension is an interactive installation by the electronic artist Rafael Lozano-Hemmer. A giant human eye in a plasma or rear-projection screen follows the observer with Orwellian precision. This work was inspired by the deployment of camera-guided "intelligent bombs." The installation was originally developed in 1992 at the Universidad Complutense de Madrid.

CONVERGING DOMAINS TO ENCOURAGE CREATIVITY

Bringing together (parts of) art, technology, and science

Intense collective outpourings of creative products and ideas emerge from cities, organizations, and groups.

Throughout history the world has witnessed attempts to generate creativity by bringing (parts of) art, technology, and science together. An admittedly eclectic list includes examples from the Lunar Society, the Bauhaus, Black Mountain College, Bell Labs, and the Office of Scientific Research and Development. These examples provide a foreword to explain how art, technology, and science intersect today, how that connectivity is threaded by design, and how crossovers happen when technologies are new.

Creative output has sometimes emerged without a visible master plan. It is as if a rare combination of ingredients magically clicked. This has happened in cities and regions—Florence, Athens, Edinburgh, Paris, Vienna—as well as in organizations and groups of all sizes, such the Bauhaus and Bell Labs. Some groups benefited from a clear leader: Niels Bohr's group in Copenhagen—a group that produced more than two dozen Nobel Prizes among its visitors—served as a remarkable catalyst for the emergence of new physics. Others, like the Lunar Society, were essentially flat. Some were remarkably short-lived: the Bauhaus lasted fourteen years and Black Mountain College a decade longer, twenty-four years. Others, like the Italian Renaissance, lasted a remarkable three hundred years. But they all seem to contain hidden kernels of answers to the question: How can we design organizations for the emergence of creativity?

One of the best-known examples of this emergence, the European Enlightenment, shows what happens when different groups share ideas and the barriers of communication disappear. The Enlightenment was the period when, for the first time, two types of knowledge merged: the "what knowledge" and the "how knowledge." The "what knowledge" came from the natural philosophers (who became of scientists of today). The "how knowledge" came from the engineers and industrialists of the day, the knowledge associated with "know-how" techniques. Interactions between the two groups were rare before 1660, but their fusion lay the groundwork for our economies of today. Joel Mokyr, a historian and economist at Northwestern University, argues that the growth and diffusion of useful knowledge—science, engineering, and mathematics—is at the very foundation of modern economic growth and is the basis of our historically unprecedented prosperity (Mokyr 2016).

This diffusion of knowledge created positive feedback loops that resulted in the Industrial Revolution. Lower access costs—printing presses, encyclopedias, and institutions to report scientific results—allowed for increased communication between these sets.[81] The GDP per person in Western Europe, had hovered around $1,000 until the mid–1800s (given in 1990 prices for comparison) and then skyrocketed by 1990 to about $18,000.

The Lunar Society
This archetypal society of the Enlightenment sparked innovation.

The Lunar Society was a dinner club and informal association of prominent scientists, engineers, and industrialists—and more generally, intellectuals—who met in Birmingham, England. It serves as an archetype of successful communication between the natural philosophers (the scientists of the day) and the engineers and industrialists of the time.

The group would meet during the full moon—hence the name—as the extra light made the journey home easier and safer in the absence of street lighting.

81. Contrary to popular belief, several crucial technical inventions happened in the Middle Ages, including gears that enabled mills to tap wind and waterpower, developments in metallurgy, and the horse harness. It could be argued that the horse harness had an impact similar to that of steam power during the Industrial Revolution. But defined structures and connectivity between the equivalents of the "what knowledge" and the "how knowledge" had yet to emerge as they did in the context of the Lunar Society.

An Art Component in the Heart of Engineering James Watt

James Watt (1736–1819) was a member of the Lunar Society, an elected fellow of the Royal Society of London, and a central figure in the Industrial Revolution, mostly remembered for his contributions to the development of the steam engine. The commercialization of this technology, with his Lunar Society fellow partner Matthew Bolton, made him a rich man. But he was much more than simply a brilliant engineer who perfected the development of the steam engine. Watt had another side, one that represents a now-lost connection between the practice of engineering with the world of artisanship. The contents of his workshop in the attic in his home in Birmingham remind us that Watt began his career as an instrument maker in Glasgow. This workshop had remained unseen until the Science Museum of London unsealed it more than a century after Watt died (Russell 2014). In this workshop we see that Watt applied his knowledge and skills to devise new technologies, one of the most interesting being his connection with sculptures. He invented and constructed a pair of machines—3D pantographs: one made copies of sculpture; the other made reduced-size copies. What comes across from Watt's workshop is the capability to take an idea and evolve it through a development process and turn it into an actual product, arguably typifying an ability that led to Britain's emergence as the first industrial nation.

The Lunar Society lasted about fifty years—from sometime before 1760 to about 1790 or as late as 1810—and was always informal. The interests of its members spanned geology, medicine, education, engines, electricity, chemistry, botany, ceramics, and silverware; the overriding goal was progress. There are no publications or membership lists, and the evidence of its existence and activities comes only from the correspondence between members. In fact, while the society's meetings provided a social focus, most activity and communication took place outside the meetings themselves. It was a progressive group. Evidence shows that the Lunar Society championed a more democratic educational system, one that would make intelligence, not birth, the route to success. It also advocated better education for girls.

The Lunar Society included a core group of fourteen members who attended meetings over a long period during its most productive years: Matthew Boulton, Erasmus Darwin, Thomas Day, Richard Lovell Edgeworth, Samuel Galton Jr., Robert Augustus Johnson, James Keir, Joseph Priestley, William Small, Jonathan Stokes, James Watt, Josiah Wedgwood, John Whitehurst, and William Withering. To many people in science and technology, these names are still recognizable today. But the circle was far wider—a loosely defined group who attended meetings occasionally and who corresponded or cooperated regularly with multiple other members. All in all, the group was composed of about fifty individuals and was notable for including in its circle people based in other countries, such as Benjamin Franklin in the United States, Jean-André Deluc in Switzerland, and Louis Joseph d'Albert d'Ailly in France (who became a member of the Royal Society of London).

Although we do not know what was said among the group, we do know what kinds of innovation many of its members sparked. Consider what they accomplished:

Joseph Priestley (1733–1804) was an English natural philosopher (now he would be classified as a chemist), educator, and political theorist who published more than 150 works. He is usually credited with the discovery of oxygen.

James Watt (1736–1819) was a Scottish inventor and mechanical engineer whose improvements to the Newcomen steam engine were fundamental to the Industrial Revolution. He developed an interest in the technology of steam engines while working as an instrument maker at the University of Glasgow. Universities had yet to become the research engines we know them to be today.

Erasmus Darwin (1731–1802), an English physician, natural philosopher, physiologist, inventor, and poet, was a member of the Darwin-Wedgwood family, which includes his grandsons Charles Darwin and Francis Galton.

Josiah Wedgwood (1730–1795), an English potter, founder of the Wedgwood company and credited with industrializing the manufacture of pottery, was the grandfather of Charles Darwin and Emma Darwin.

Matthew Boulton (1728–1809) was an English manufacturer and business partner of James Watt. In the final quarter of the eighteenth century, the Boulton-Watt partnership installed hundreds of steam engines in the United Kingdom.

And one, similarly accomplished, outside the inner circle: John Smeaton (1724–1792) an English civil engineer responsible for the design of bridges, canals, harbors, and lighthouses, was the first self-proclaimed civil engineer. He is often regarded as the "father of civil engineering."

The Bauhaus

The short-lived German art school created a disproportionate and remarkably lasting influence.

The German art school known as the Bauhaus was founded in 1919 by the architect Walter Gropius (1883–1969). It lasted fourteen chaotic years between World War I and World War II—1919 to 1933—but had an amazing influence, given its short life. Founded upon the idea of creating Gesamtkunstwerk, or "total works of art," in which all the arts would be brought together under the same umbrella, it influenced design, art, architecture and architectural education, graphic design, interior design, industrial design, and typography. The Bauhaus broke the barrier between fine art and applied arts. Its influence in architecture may have waned, but Bauhaus influences can still be seen everywhere, from furniture to graphic design (figure 5.1). The success of Bauhaus furniture, for example, has become so ubiquitous as to be invisible. Scandinavian, industrial, and midcentury modern are unmistakable in their Bauhaus influences.

The school existed in three German cities—Weimar (from 1919 to 1925), Dessau (from 1925 to 1932, see figure 5.2), and Berlin (from 1932 to 1933)—under three different architect-directors. In 1933, the Nazis shut it down. There is a lesson here. Many of the school's faculty left Europe, spreading its idealistic precepts all over the world, but primarily in the United States. Key figures went to Harvard, Yale, and the Illinois Institute of Technology in Chicago. A few settled at Black Mountain College in North Carolina—most notably Josef Albers, who was selected to run the art program with his wife, Anni Albers. The Bauhaus influence is even more remarkable given its short, tumultuous history involving relocations and changes of leadership. It is doubtful that such a spreading of ideas, worldwide evangelizing, and the dispersing of accomplished acolytes all over the world would have happened without the 1933 closing. Some have argued that the school's closing only increased its mystique. Bauhaus influence lives on.

Political speeches do not age well, but they capture the spirit of the times and, sometimes, the allure of the past. Ursula von der Leyen, the president of the European Commission, after listing all the challenges facing the world during her state of the union address in September 2020 at the European Parliament Plenary, said,

Fig. 5.1 Posters from the Bauhaus. Joost Schmidt, pamphlet for the City of Dessau, 1930; Herbert Bayer, *Research and Development of Universal Type*, 1927.

Fig. 5.2 The Bauhaus building
designed by Walter Gropius
(1925–26), commissioned by
the city of Dessau, Germany.

Fig. 5.3 Black Mountain College, located in Black Mountain, North Carolina, and logo. An amazing amount of talent passed through and emerged from the school in its twenty-four-year existence.

"This is why we will set up a new European Bauhaus—a co-creation space where architects, artists, students, engineers, designers work together to make that happen.... This is *NextGenerationEU*. This is our opportunity to make change happen by design—not by disaster or by diktat from others in the world." Her words echo the 2018 *Baukultur* Davos declaration. Though centered on the built environment that declaration called for the synthesis of art, technology, and science. Unity is in the air, at least in Europe.

Black Mountain College

This unconventional organization in North Carolina attracted and generated talent.

Walter Gropius tried to reconstruct the Bauhaus at Harvard, with less than spectacular results. In terms of influence, though of a different kind, Black Mountain College in North Carolina was the closest thing to the Bauhaus in the United States (figure 5.3). It was founded the same year that the Bauhaus closed and lasted a bit longer, twenty-four years, from 1933 to 1957. It was conceived by John A. Rice and was centered on the study of art as central to a liberal arts education. There were no course requirements, grades, or degrees. Students were left in charge of deciding when they were ready to graduate, and notoriously few ever did. Graduates were presented with handcrafted diplomas as purely ceremonial symbols of their achievement. It was as if, out of controlled chaos, creativity emerged.

The Bauhaus defined a style, a philosophy, and a recognizable identity. Black Mountain College left no such recognizable footprint. Its influence spread through those who taught there and the students who were educated there. A remarkably large number of faculty and students became prominent in the arts, including Ruth Asawa, Robert Motherwell, Cy Twombly, Robert Rauschenberg, Merce Cunningham, Willem de Kooning and Elaine de Kooning, Josef Albers, John Cage, Buckminster Fuller, and Franz Kline. Guest lecturers included Albert Einstein, Clement Greenberg, Bernard Rudofsky, Richard Lippold, and William Carlos Williams. By any measure this is an amazing list: talent attracted talent. Many "firsts" took place at Black Mountain: Buckminster Fuller and his students installed the first large-scale geodesic dome, Merce Cunningham formed his dance company, and John Cage staged his first musical happening.

Bell Labs

Freedom and resources drove an unparalleled output of scientific and technological innovations.

From the late 1940s through the late 1970s, the research and development company Bell Labs was the most innovative technological and scientific organization in the world. The huge resources of its parent company, AT&T, a monopoly at the time, allowed Bell Labs employees to conduct research that had limited immediate use and tenuous ties to the telephone business.

Fig. 5.4 Centerpiece of the Bell Labs campus, abandoned in 2007. Constructed between 1959 and 1962, the complex in Holmdel Township, New Jersey, served as a research and development facility to over 6,000 engineers and researchers, and was one of the final projects of architect Eero Saarinen before his death in 1961.

Such freedom is unheard of today, and the output from Bell Labs during that period was remarkable. A list of inventions and breakthroughs includes the transistor, the first patent for a laser, and communications satellites. Researchers also developed the first cell phone systems, the technology that provides the basis for digital photography and solar-powered devices, the Unix operating system and programming languages C and C++.

But beyond technology, Bell Labs researchers also expanded the boundaries of physics, chemistry, astronomy and mathematics. In 1964, two Bell Labs researchers discovered cosmic microwave background radiation, which resulted in a 1978 Nobel Prize for a discovery that pointed to the origins of the Big Bang. Nine Nobel Prizes have been awarded for work done at Bell Laboratories.

Bell Labs mathematicians also helped improve business processes by creating the foundations of the statistical methodology known as "quality control"—now widely used in manufacturing around the world.

How can we explain this amount of success over a period of a bit more than three decades? The man most responsible for creating the Bell Labs culture was Mervin Kelly, president of Bell Labs from 1951 to 1959. Kelly gave several talks distilling the ingredients essential to innovation:

Form multidisciplinary teams of smart people; mix thinkers and doers, and engineer ways for them to exchange ideas. Kelly was convinced that physical proximity was everything. Quite intentionally, Bell Labs housed thinkers and doers under one roof. He personally helped design the building in Murray Hill, New Jersey, to ensure that everyone would interact. One innovation—its long hallways—increased the chance of serendipitous encounters: to travel through the building without encountering several colleagues, ideas, problems, and diversions was almost impossible (figure 5.4). Having scientific luminaries on board—"the guys who wrote the book," as they were called in Bell Labs—was a must, but it was also essential to put them into the mix. A new hire, faced with a difficult problem, could be directed by a supervisor toward "the guy who wrote the book." The culture demanded that office doors remain open and that experts would always help newcomers.

Present them with real-world, challenging problems to solve, but do not force them to be anchored to the problems. Bell Labs was sometimes depicted as an ivory tower, but a more apt description would be an ivory tower with a factory downstairs. Many researchers were tasked with inventing ways to save money and coming up with better products and services—by replacing fragile vacuum tubes with transistors, for example. Even researchers in pursuit of pure scientific understanding realized that their work could ultimately, in some way, be put to use. But ideas evolved in highly nonlinear ways, and Kelly allowed them to pursue ideas even if no obvious applications were at hand.

Provide them the best technological tools, time, and a stable source of funding. Kelly believed that freedom was crucial, especially in research. He trusted people to create and often gave his researchers years to pursue what they felt was essential—such a luxury stemmed from serving a parent organization that had a large and steady income ensured by its monopoly status. Nobody had to meet benchmarks to help with quarterly earnings; nobody had to rush a product to market before the competition did.

The Office of Scientific Research and Development
A blending of two dissimilar cultures led to a remarkable output of working innovations.

Vannevar Bush (1890–1974) was the legendary dean of engineering at the Massachusetts Institute of Technology. He was an inventor (with several patents under his belt), an entrepreneur (he founded the company that now is Raytheon), but most notably he was a remarkably gifted science administrator who could seamlessly navigate the cultures of academic research and the military world. He was a master in bridging cultures and making them achieve things that would have been impossible on their own.

During World War II, with the endorsement of President Franklin Delano Roosevelt, he created the organizational structure that resulted in the Office of Scientific Research and Development (OSRD). OSRD merged the research and military worlds and guided all wartime military R&D. It was responsible for the development of radar and created deployment strategies for therapies such as penicillium, plasma transfusion, and vaccines for malaria and tetanus. OSRD's objective was to create the technologies that did not yet exist from ideas that were in embryonic form in some academic lab (as radar had been), or to come up with technologies that needed to be invented. In this role Bush was, in effect, the first presidential science advisor. Bush's efforts led to the initiation and early administration of what became the Manhattan Project. His report "Science, the Endless Frontier," presented to Harry Truman in 1945, called for an expansion of government support for science and led to the creation of the National Science Foundation in 1950 (Bush 1945b).

This connecting ability, the ability to bridge the worlds of the military and science and engineering, was his genius. His obituary in the New York Times captures this beautifully: "a master craftsman at steering around obstacles, whether they were technical or political or bull-headed generals and admirals."

Organizational structure is often unrecognized and unseen as innovation. None other than Steve Jobs told his biographer Walter Isaacson: "The whole notion of how you build a company is fascinating.... I discovered that the best innovation is sometimes the company, the way you organize." This idea of how creative organizations are assembled (and how they are run) is important, but it is apparent that no single answer

exists. The Lunar Society had no central commanding authority and left no products that can be quickly identified with the it. By design, it connected populations of people who up to that point had been disconnected. Its influence was in terms of connectivity. The Bauhaus had some towering figures as leaders, a clear philosophical viewpoint, and a structured curriculum that was predicated on the holistic intersection of all arts. Black Mountain College had little in the way of central guiding authority, and almost no visible organizational structure, but it produced an amazing legacy in terms of the people who were formed there by emphasizing creative ideas, attracting talent, and ignoring labels. Bell Labs produced an unparalleled output of scientific and technological innovation, and expanded the boundaries of physics, chemistry, astronomy, and mathematics by artfully mixing thinkers and doers. Hands off managing was the strategy. The Office of Scientific Research and Development bridged two worlds as well—the military world and the science and engineering world—domains that operated with completely different value systems but were able to synergize in ways that could not have been anticipated by looking at them separately. And again, it did so with light top-down management.

None of these examples perfectly balance and synergize art, technology, and science in the way we envision for the Nexus. The Lunar Society was proto-science, technology, and no art. The Bauhaus was art and design accompanied by technology, whereas the Black Mountain College was driven by primarily art. Bell Labs was a magic blend of scientific and technological innovation, as was the Office of Scientific Research and Development. But what cuts across all these examples? The key denominator, if there is one, is the power of intersections.[82] In our current culture we would be lucky to reach the heights of any of these examples.

Harry Holtzman's trans|formation
This pioneering journal attempted to bring art into the science-technology mix.

A notable, brilliant, but little-known example of trying to merge art, technology, and science was a project driven by the artist Harry Holtzman. In 1950, Holtzman founded a cross-disciplinary journal called *trans|formation*. The list of people he assembled was remarkable, a who's who of art and science. Contributors and collaborators included Marcel Duchamp, Stuart Davis, Buckminster Fuller, Werner Heisenberg, Merce Cunningham, Sibyl Moholy-Nagy, Alberto Giacometti, Le Corbusier, Albert Einstein, Ad Reinhardt, Piet Mondrian, Pierre Boulez, John Cage, Willem de Kooning, and Jose Luis Sert. The new synthesis attempted by *trans|formation* resonates. One can hardly improve on Holtzman's "manifesto," appearing in the first inside page on the magazine; it is worth savoring every word:

82. Many have commented on the value of mixing people with different ideas to produce new ideas. Steven Johnson (2010) has argued that the outpourings of creativity in the European Enlightenment is directly connected with the switch from drinking alcohol to coffee and the proliferation of coffee houses, where different groups of people socialized. It is hard to resist adding one specific coffee-driven artistic example: in the 1730s Johann Sebastian Bach shifted his focus from liturgical music to compose a short comic opera, his *Coffee Cantata*, based on the famous Leipzig coffee house called Zimmerman's.

trans | formation :

arts
communication
environment

a world review

1¹
1950

trans | formation :

arts
communication
environment

a world review

1²
1951

trans | formation :

arts
communication
environment

a world review

1³
1952

Figure 5.5 An insufficiently known landmark in Nexus thinking.

Left: Covers for the entire run of Harry Holtzman's journal, *trans|formation*, each featuring a rich diversity of artists, scientists, architects, educators, composers, and designers.

Right: Four spreads from the first edition of Holtzman's journal, including his manifesto, along with contributions from Buckminster Fuller, Le Corbusier, and the diagrammatic centerfold, illustrated in every issue by Ad Reinhardt.

trans|formation affirms that art, science, and technology are interacting components of the total human enterprise... but today they are too often treated as if they were cultural isolates and mutually antagonistic.

Lack of time, misinformation, and specialized terminology make it hard to keep pace with advances in all fields. It is difficult enough to keep pace with a single one.

trans|formation will cut across the arts and science by treating them as a continuum.

trans|formation will provide authentic glimpses into the emerging forms of the "now."

trans|formation will present unifying views. Specialization is a condition for progress, but we are opposed to mutual ignorance, prejudice, cultural civil war.

trans|formation will emphasize the dynamic process view as against static absolutes ... open as against closed systems ... culture under transformation. (Holtzman 1950)

The journal's run lasted for only three issues; the final one appeared in 1952 (figure 5.5). Did Holtzman fail? Yes. Were Harry Holtzman's goals unrealistic? No. Such unification is now not only possible but necessary.

How Art, Technology, and Science Intersect Today
Extracting lessons from the unanticipated reveals surprising ways that art, technology, and science collide, collaborate, and compete.

It did not happen in one step, but after sixty years Harry Holtzman's vision is becoming a reality. Art, technology, and science intersect now in multiple ways, creating a dizzying triangle of ever-changing collaboration, competition, and collusion. The belief is that more fluid communication between these domains will produce more interesting, radical ideas—and therefore, more innovation. This will be essential to innovation going forward.

It is now common to talk about "artscience" as a thing; avant-garde individuals operate in this space, but it is far from being an established culture. Technology is the real bridge between art and science. Since the very beginning, art has appropriated technology as a means to an end. But art now wants technology's ubiquity and power, its leading-edge processes, and its materials; on the other side, technology wants art's inventiveness, its untethered thinking, and its built-in innovation.

The art-science link is different. What art desires is the respectability of science. But this longing is unreciprocated. Many in the science world still see art as something elitist and distant, a thinking still anchored on old romantic views of artists, views that are disconnected from current realities of how the contemporary art world works.

The science-technology relationship is blurred and fluid. Sometimes science drives technology, but science also needs technology and, in many ways, is driven by it. Examples abound on both sides. Many technologies are a direct consequence of fundamental science—those technologies known by acronyms (radar, for RAdio Detection And Ranging; lasers, for Light Amplification by the Stimulated Emission of Radiation), initialisms (GPS, for global positioning system; PCR, for polymerase chain reaction; CRISPR, for Clusters of Regularly Interspaced Short Palindromic Repeats), and word combinations (transistors, for transfer + resistance). But technologies do not wait for the underpinning science. The steam engine was invented before the laws of thermodynamics were established; Roman aqueducts emerged before the laws of statics and the foundations of fluid dynamics were in place. Now we live in a constant state of resonance, of synergistic science and technology co-evolution. The very cornerstone of science—hypothesis-driven research—is being expanded, and some think replaced, by technology-driven research. "Inelegant, brutalistic," the orthodoxy will claim, but the march toward a technology-driven future appears inexorable.

How can the art-technology-science triangle function better? By understanding how the other sides think, and by not equating domains with the products they produce but rather by the thinking that led to them.

To connect these different sides of the triangle, some have attempted education, putting everything that matters in one location. Harry Holtzman's *trans formation* attempted this. Other attempts have included placing artists in the middle of top-notch scientific organizations, forcing intersections, and waiting to see what happens. The European Organization for Nuclear Research known as CERN—which operates the largest particle physics laboratory in the world, with more than 2,500 scientific, technical and administrative staff members, and one of the highest concentrations of talent in the physics world—has tried this. During the last few years it has included artists-in-residence on that roster.

The output has not been spectacular. Many interesting artworks come out of art/science collaborations, but many art residency programs seem to focus solely on predictable products. Equating art with products, and products solely with objects, is a narrow view. Such programs have had varying level of success because they are not really integrating thinking in provocative and unexpected ways; they are stuck at the level of referencing each other's domains.

Artists do not need total immersion to be inspired by science.

Fig. 5.6 Joseph McElheny's *An End to Modernity* (2005) exemplifies how art can be aided by science. The artist built this representation of the Big Bang and the expanding universe with advice from the astronomer David Weinberg. Nearly every single aesthetic decision McElheny made during the creation of this piece has a one-to-one relationship to the scientific information available about the history of the universe.

Other types of collaboration are possible. Josiah McElheny's 2005 stunning floor-to-ceiling sculpture *An End to Modernity*, which represents the Big Bang and the expanding universe, is an example of what an artist can do with a concept by using a scientist as an advisor. Everything has a meaning in McElheny's sculpture. In the center hangs a 28-inch sphere of chrome-plated aluminum. From this sphere emanate 230 chrome-plated aluminum rods. Of these, 75 terminate in lamps, which represent quasars. The remaining 155 terminate in clusters of hand-formed glass discs and hand-blown glass globes, which represent clusters of galaxies. There are 932 galaxies and a total of more than 2,500 parts (figure 5.6). The result is beautiful, but in terms of collaboration, it is one-sided. It is wholly science inspired, but it is science serving art, and does not directly use cutting-edge technology.

Technology appears prominently in many works of art. Opera provides two clear examples. First is Karlheinz Stockhausen's massive seven-opera cycle *Licht* (subtitled *The Seven Days of the Week*), performed as a seven-day, twenty-nine-hour extravaganza in which controlled and choreographed helicopters beam the live performance of a string quartet to a central stage. Second is Tod Machover's 2010 opera *Death and the Powers*, which tells the story of Simon Powers—an inventor who "downloads" himself into a digital world as a way to live forever—and uses robots on stage playing a central role as the chorus. Creation of this piece depended on the dialogue between the artist and the technology, but not the kind of dialogue most could have imagined taking place the opera world. Some may disagree with the value of the results, be unmoved, or consider the experiments gimmicky and overshot. But the value resides in exploring connections, bringing new tools to new camps. Some things will fail. But expanding the palette is good.

Some works achieve a rare balance between art, technology, and science. The nineteenth-century saw the advent of pulse-wave recording via mechanical instruments designed to replicate, and possibly enhance, the sensitivity of a human pulse reader. These were delicate mechanical instruments; some involved a stylus made of a single hair, which traced a path through a thin layer of soot deposited on a moving paper uncoiled from a cylinder. There were numerous studies made, and the "recordings" involved many parts of the body—chest, forearms, and, in one celebrated example, in a subject who had an accident that exposed part of his brain, a "cerebral pulse." The subjects ranged from newborns to senior citizens. In some cases, the objective was to visually capture a range of emotional and sensory experiences—sleep, dreams, anger, the pleasure of eating chocolate, and so on. The idea of a recording today immediately implies the possibility of playback. That was not in the realm of possibilities when these experiments were carried out. "Make a record of" was the objective.

The scientific experiments that emanated from "making a record of" coalesce in the work of the artist Dario Robleto in a perfect example of balancing art, technology, and science (figure 5.7). In collaboration with the sound archaeologist Patrick Feaster,

Unknown
and
Solitary Seas

(Dreams and Emotions of the 19th century)

Name softly called while sleeping, 1877

Fear, 1896

Ear lightly touched with feather while sleeping, 1877

"Undulation", or dream state, 1877

Being scolded; shamed, 1876

Religious guilt, 1878

Anger, 1874

Fig. 5.7 Dario Robleto, *Unknown and Solitary Seas (Dreams and Emotions of the 19th Century)*, 2018. Earliest waveform recordings, 1874–1896, of blood flowing from the heart and in the brain during sleep, dreaming, and various emotional states, rendered and 3D printed in brass-plated stainless steel; lacquered maple, 22k gold leaf; video, waveform audio processing by Patrick Feaster.

Robleto managed to retrieve the sound from fragile soot-coated documents that pre-date Edison's invention of the phonograph in 1877.

Another beautiful example, something that goes to the essence and power of the Nexus, is an older, one-of-a-kind event that happened more than fifty years ago, fifteen years after Harry Holtzman's *trans|formation*. It was called *9 Evenings: Theatre and Engineering*, and it ran from October 13 to 23, 1966. This was arguably the first large-scale partnership between artists and engineers to create a blend of avant-garde theater and dance. Sadly, we do not have comments of what Harry Holtzman may have thought of this collaboration among ten artists (led by Robert Rauschenberg) and thirty engineers (led by Billy Klüver from Bell Labs—Klüver and the place itself may be the unsung heroes of this alliance). The enormous space of the 69th Regiment Armory in New York City, made famous by the 1913 show that scandalized New York and introduced modern art to America, was the perfect venue for the event (figure 5.8).

The two teams worked together for ten months to develop technical equipment and systems that were used as an integral part of the artists' performances. Their collaboration produced many "firsts" in the use of new technology for theater, including using closed-circuit television and television projection on stage. A fiber-optics camera showed the audience objects in a performer's pocket, while an infrared television camera was able to record action in total darkness; a Doppler sonar device translated movements into sound, while wireless FM transmitters and amplifiers allowed speech and body sounds to be broadcast through loudspeakers in the facility.

What has happened since? Have we moved forward? Are there works of art-technology today in which we cannot separate the artist from the technologist? Yes, there are. One example, first mentioned in chapter 4 (figure 4.6), is Random International, a group founded in 2005 that creates art installations focusing on the relationship between man and machine and audience interaction. They hit it big with *Rain Room*, first shown in London in 2012, and subsequently in New York, Shanghai, and Los Angeles. In this installation, visitors walk through a downpour without getting wet. Motion sensors detect visitors' movements as they navigate through the darkened space, becoming performers in this intersection of art, technology, and simulated nature. The installation uses 2,500 liters of self-cleaning recycled water, controlled through a system of 3D tracking cameras placed throughout the ceiling. The cameras detect the movement of the visitors and ensure their space is dry. Participant response is a crucial part of the installation; it becomes part of the artwork. Do *Rain Room* and Random International pave the way for the Nexus?

Looking back, *9 Evenings* was a singular almost non-repeatable event.[83] It is hard to see places today with the broadness, concentration of talent, and the amazing degree of freedom of Bell Labs. It is hard to imagine Google, Microsoft, Amazon, Facebook—who have yet to produce Nobel Prize winners—letting thirty engineers and scientists work alongside artists for a ten-month exercise with an uncertain outcome.

83. The *9 Evenings* event gave birth to Experiments in Art and Technology (E.A.T.), which was officially launched in 1967 to facilitate connections between artists and engineers. It is generally agreed that the high mark of E.A.T. was the Pepsi Pavilion at Expo'70 in Osaka, Japan, which involved a group of more than seventy-five artists and engineers from the United States and Japan. The exhibit included an immersive dome that "housed" the world's first atmospheric fog sculpture, by the Japanese artist Fujiko Nakaya.

9 evenings: theatre & engineering

OCTOBER 13·14·15·16 18·19 21·22·23 8:30 P.M. $3 each evening
25th STREET ARMORY NYC TELEPHONE 689-3315

PERFORMANCES OF DANCE·MUSIC·FILM·TELEVISION·TECHNOLOGY BY CAGE·CHILDS·FÄHLSTROM·

Fig. 5.8 Above left: Robert Rauschenberg, poster announcing the opening of 9 Evenings: Theatre and Engineering, at the 69th Regiment Armory in New York City, October 13–23, 1966 (above right). A larger view of this image appears on pages 12–13.

How can we use these examples as a path forward? Undoubtedly, there will be many more Random Internationals and *Rain Rooms*. But the goal is not just to do astonishing things to affect the theater world or any other specific world. The goal is to scale up and to affect everything, to produce people and organizations who have the capacity to expand their thinking spaces and catalyze innovation. Can we extract the thinking skills central to art—the inventiveness, untethered thinking, and built-in innovation—and transfer them to the science and technology worlds? And can we transfer some of these skills to the people who can make things happen, the people who are in the business of solving problems and who run organizations? Conversely, can we transfer the ability to innovate, not just to create, to those operating in the realm of ideas so that some of those ideas can be become real? This book is based on the belief that we can. In fact, the opportunity now is better than it has ever been in the past. At no point have artists been so open to outside influences and shown the levels of entrepreneurship that we see today.

The Ultimate Connector

Design bridges the domains of art, technology, and science.

Design has evolved; it is now something different than the "design" in the Accademia delle Arti del Disegno. In the Renaissance the Italian word *disegno* meant both the *intellectual capacity* to invent the design and the ability to make the drawing. This ability to invent, or create, is what raised the status of painting and sculpture from craft to art. *Disegno* underlined all painting, sculpture, and architecture; it was the unifying component of all visual arts. Now, the word "design" means something else; it means to conceive, create, fashion, execute, and build according to a plan, with the plan driven by "design thinking."[84] Today's design landscape is broader. It may intersect with art but the finished "design" of something could mean the specification for the construction of objects, processes, or systems. And, importantly, it is something that functions in the context of reality, that satisfies goals and constraints. There will be user considerations—functional, aesthetic, economic—as well as considerations of interactions with various types of environments, sociopolitical considerations, and much more. For a design to exist, there must be a user.

We can argue that that everything we see, everything we use in our daily lives— the utensils we eat breakfast with, our cell phones (and everything that goes inside them), cars and other means of transportation, clothing, the environments we live in, and our places of work—all of it has been engineered and designed. We can also argue that design enters in every piece of technology we use. There need not be objects; they can be environments, processes, or systems. The places where we get educated and the content of the curricula that is taught in them, and all our interactions with technology, have been designed as well.

84. There is no single "design thinking" process—hardly surprising since there is no unique, generally accepted, scientific method—although it is a subject of current study. Some have attempted to add structure to the design process as it moves forward. But it is also possible to see design thinking as the encapsulation, looking backward, of all the processes by which design projects have been developed across different contexts involving objects, processes, and systems.

Everything can be designed. But this does not mean that everything has been designed well. There is good design and bad design, and in the last several years the importance of good design and design thinking has come to the forefront. Human-centered design is currently at the center of design.[85] And how we interact with technology (human–computer interaction) is an active area of research. Design thinking has invaded management consulting and been placed at the center of many businesses. By its very nature, design bridges areas and uses everything at its disposal; design has elements of science and technology, psychology, and art. Beauty is not the goal of design, but creating beauty is often a way of achieving the goal, or sometimes merely a by-product. In fact, it is hard to draw a clear boundary between art and design. This is a vast territory, with many camps and subcamps. But design is perfectly positioned to bridge analysis and emotion, rational thinking, and empathic thinking: in short, left- and right-brain thinking.

Charles and Ray Eames were an American married couple who made significant contributions to the development of design in the broadest sense, spanning modern architecture and furniture, graphic design, films, and much more. They influenced design thinking for decades to come. They were also prolific filmmakers; the iconic 1977 film *Powers of Ten* is one of their creations. The superb 1972 film *Design Q&A*, which reduces design to its minimal essence, captures Charles and Ray Eames's view of their craft. In the film Charles (speaking for the pair) answers twenty-nine questions from the French curator Madame L'Amic about what design is and how it works (Eames Official Site n.d.). Three years earlier, in 1969, the Eames's answers to L'Amic's queries were the inspiration for part of the exhibition *Qu'est ce que le design? (What is Design?)* at the Musée des Arts Décoratifs, Palais du Louvre. It is hard to imagine that more content could be encapsulated in five and a half minutes; as with Holtzman's manifesto in *trans|formation*, it is important to savor every word.

What is your definition of "Design," Monsieur Eames?
One could describe Design as a plan for arranging elements to accomplish a particular purpose.

Is Design an expression of art?
I would rather say it's an expression of purpose. It may, if it is good enough, later be judged as art.

Is Design a craft for industrial purposes?
No, but Design may be a solution to some industrial problems.

What are the boundaries of Design?
What are the boundaries of problems?

Is Design a discipline that concerns itself with only one part of the environment?
No.

85. For a design to exist, there must be a user. Human-centered design, which makes people its focus, has been remarkably successful. But one cannot solve systems problems connected with environmental degradation or climate change with a human-centered lens alone. A broader viewpoint is needed: life-centered design. A glimpse of what this entails appears in chapter 8.

Is it a method of general expression?
No. It is a method of action.

Is Design a creation of an individual?
No, because to be realistic, one must always recognize the influence of those that have gone before.

Is Design a creation of a group?
Very often.

Is there a Design ethic?
There are always Design constraints, and these often imply an ethic.

Does Design imply the idea of products that are necessarily useful?
Yes, even though the use might be very subtle.

Is it able to cooperate in the creation of works reserved solely for pleasure?
Who would say that pleasure is not useful?

Ought form to derive from the analysis of function?
The great risk here is that the analysis may be incomplete.

Can the computer substitute for the Designer?
Probably, in some special cases, but usually the computer is an aid to the Designer.

Does Design imply industrial manufacture?
Not necessarily.

Is Design used to modify an old object through new techniques?
This is one kind of Design problem.

Is Design used to fit up an existing model so that it is more attractive?
One doesn't usually think of Design in this way.

Is Design an element of industrial policy?
If Design constraints imply an ethic, and if industrial policy includes ethical principles, then yes—design is an element in an industrial policy.

Does the creation of Design admit constraint?
Design depends largely on constraints.

What constraints?
The sum of all constraints. Here is one of the few effective keys to the Design problem:

the ability of the Designer to recognize as many of the constraints as possible; his willing-
ness and enthusiasm for working within these constraints. Constraints of price, of size, of
strength, of balance, of surface, of time, and so forth. Each problem has its own peculiar list.

Does Desig obey laws?
Aren't constraints enough?

Are there tendencies and schools in Design?
Yes, but these are more a measure of human limitations than of ideals.

Is Design ephemeral?
Some needs are ephemeral. Most designs are ephemeral.

Ought Design to tend toward the ephemeral or toward permanence?
Those needs and Designs that have a more universal quality tend toward relative
permanence.

**How would you define yourself with respect to a decorator? an interior architect?
A stylist?**
I wouldn't.

**To whom does Design address itself: to the greatest number? to the specialists or
the enlightened amateur? to a privileged social class?**
Design addresses itself to the need.

**After having answered all these questions, do you feel you have been able to prac-
tice the profession of "Design" under satisfactory conditions, or even optimum
conditions?**
Yes.

Have you been forced to accept compromises?
*I don't remember ever being forced to accept compromises, but I have willingly ac-
cepted constraints.*

**What do you feel is the primary condition for the practice of Design and for its
propagation?**
A recognition of need.

What is the future of Design?
[No answer. The video turns to images]

Why the emphasis on design? Because design is a bridge that connects right-brain thinking
and left-brain thinking (figure 5.9). Design is central to the arguments of the Nexus.

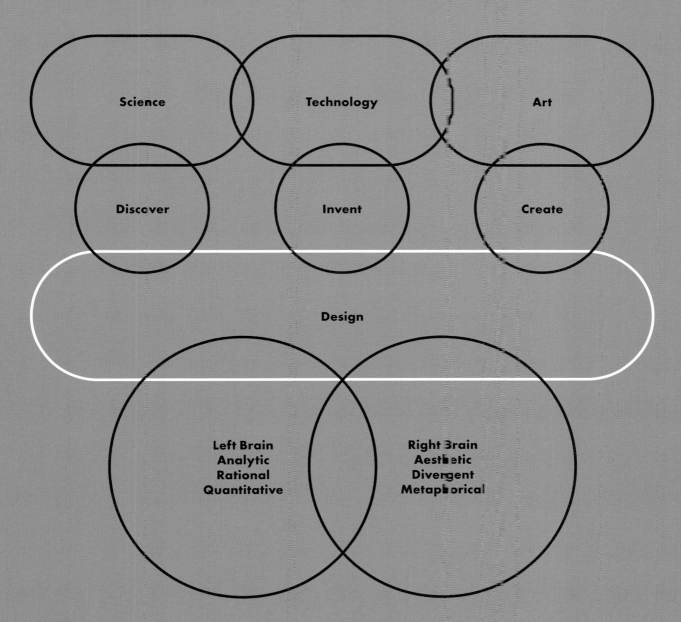

Science Technology Art

Discover Invent Create

Design

Left Brain
Analytic
Rational
Quantitative

Right Brain
Aesthetic
Divergent
Metaphorical

Fig. 5.9 Design as the bridge between right- and left-brain thinking. By its very nature, design links areas since it uses everything at its disposal: psychology, engineering, anthropology, graphic art, and much more. It is hard to imagine components of technology that could not be used by design. Design it thus serve as a connector of the domains of art, technology, and science.

Two Bounds of Design

SpaceX's Falcon 9 rocket and Dragon spacecraft are shown here being launched on NASA's SpaceX Crew–1 mission to the International Space Station. Astronauts Doug Hurley and Bob Behnken were aboard the SpaceX *Crew Dragon* as it approached the International Space Station on May 31, 2020; the open nose cone shows the spacecraft's docking mechanism that connects to the International Docking Adapter. The images capture bounds of design. Falcon 9 is engineering design par excellencvve, with hundreds of thousands of parts working together to accomplish one function. The tens of thousands of parts that make up Dragon (without counting electronics) represent a substantial and visible change from previous NASA designs.
Dragon is a blend of human-centered design and pure engineering prowess. Shown as well are the *Dragon* interior and the SpaceX Demo–2.

Fig. 5.10 Samuel F. B. Morse, *Gallery of the Louvre*, 1831–33. Morse, now known primarily as the inventor of the telegraph, was formally trained as a painter. *Gallery of the Louvre* was his last painting, started while he was in Paris. It is large work, approximately 6 feet by 9 feet, and shows over forty paintings Morse believed the American public should be familiar with, a sort of condensed version of the great paintings housed in Musée du Louvre. Morse had hoped that the exhibition of this work would attract large audiences, but success did not follow. He stopped painting altogether, switching his attention to successful experiments with daguerreotypes and the telegraph.

New Opportunities Emerging from Crossovers

Training in art contributed to technologies whose scientific bases were still evolving.

When technologies are new opportunities emerge. This is happening now. But it has happened many times in the past as well. At some points in time some people had feet in two camps: people trained in art made substantial technological contributions when new technologies appeared, and the scientific basics of those technologies were still evolving. Four examples make the point. Two represent success: one with the advent of electricity and the invention of the telegraph, the other with the new chemistries that gave rise to photography. Two represent ideas that failed to catch on: one that could be imagined as precursor of 3D printing, the other with the goal of reproducing human voice using mechanical means.

These are two that succeeded:

Louis-Jacques-Mandé Daguerre (1787–1851) was a French artist who apprenticed in architecture, theater design, and panoramic painting. Though he became a celebrated theater designer and invented the diorama, he is best known for developing the daguerreotype process of photography. When Daguerre unveiled his results in January 1839 to members of the French Académie des Sciences, it may have looked as if his invention had come from nowhere. But he had worked for years on sophisticated chemistry involving the light-sensitive properties of silver salts. Some of the technology needed to produced images had been known, but they required very long exposure times; Daguerre discovered that a faint "latent" image, obtained with short exposure times, could be "developed" into a visible image.

The case of Samuel Morse (1791–1872) is possibly even more interesting. Today, Morse is associated with the invention of the telegraph and the Morse code. But before he moved into pursuits involving electricity, Morse was an accomplished painter, good enough to gain admittance to the Royal Academy in England (figure 5.10).

As a student at Yale, Morse attended some lectures on electricity, but focused his efforts on painting. In 1825, the city of New York commissioned him to paint a portrait of the Marquis de Lafayette. They offered him $1,000, a very rich commission for the times, and the job took him from New Haven to Washington. In the middle of painting Lafayette's portrait, he received a note from his father, delivered by horse messenger: "Your dear wife is convalescent."

Morse immediately left Washington, abandoning the unfinished portrait. But by the time he arrived home in New Haven, his wife had already been buried. In his grief Morse switched from painting to conceiving methods of rapid long-distance communication. The end point of this switch was the telegraph. As in nearly every case involving technological innovation, Morse's ideas fermented in a sea of other people

Fig. 5.11 Illustration of François Willème's photosculpture. Page from the 1864 US patent application (Willème had previously been awarded French patents in 1860 and 1861). A ring of twenty-four cameras surrounds a central subject producing simultaneous photographs every 15 degrees; the set of photographic profiles provided data for a representation of the subject in three dimensions. Willème's studio, which opened in 1861 near the Arc de Triomphe in Paris, was 40 feet wide and 30 feet high. Similar studios opened in London in 1864, and in New York in 1866.

and ideas. Some of these people were prominent inventors and scientists on both sides of the Atlantic, like Charles Wheatstone and Joseph Henry. Developing the idea to the point of acceptance was far from immediate. The idea for the telegraph, like most other innovations, took decades to be accepted. Along the way, Morse remained interested in painting. In fact, he was the founder and first president of the National Academy of Design, which he established in reaction to the conservative American Academy of Fine Arts.

And these are two that failed to catch on:

The first example is the 1860 "photosculpture" system developed by the French sculptor, painter, and photographer, François Willème (figure 5.11). Silhouettes extracted from the images taken simultaneously by numerous cameras functioned as profiles for the semi-automated construction of sculptures traced in clay. This system predates 3D scanners and stereolithography by a full century. Despite financial support and royal patronage—Willème was invited to Madrid to make portraits of the royal family of Spain—photosculpture had a short life and never caught on.

The second example of a technology that never caught on is Joseph Faber's 1845 Euphonia, an attempt to reproduce human speech. Faber's device was based on human vocal anatomy, broken down into parts, and then reorganized mechanically. It was driven by pumping air with bellows, which then drove combinations of keys to manipulate a series of plates, chambers, and other apparatuses, including an artificial tongue. Faber demonstrated various versions of Euphonia in Vienna, London, and New York. But even after being promoted by P. T. Barnum in the United States, Euphonia generated little profit and received minimal respect. One of Euphonia's few devotees was a Scottish professor of speech named Melville Bell, whose son was the famed Alexander Graham Bell, credited with the invention of the telephone. Faber died in obscurity in the 1860s, first destroying Euphonia and then taking his own life. Faber could not possibly have imagined that the way to reproduce human voice needed the development of digital technologies. And even less, that a company called Google would launch a program called Euphonia to improve speech recognition software to make it more accessible to people with disabilities.

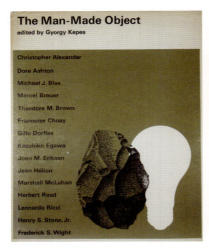

The Man-Made Object

edited by Gyorgy Kepes

Christopher Alexander
Dore Ashton
Michael J. Blee
Marcel Breuer
Theodore M. Brown
Francoise Choay
Gillo Dorfles
Kazuhiko Egawa
Joan M. Erikson
Jean Hélion
Marshall McLuhan
Herbert Read
Leonardo Ricci
Henry S. Stone, Jr.
Frederick S. Wight

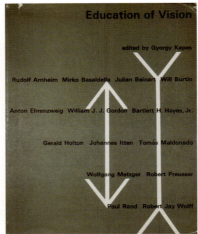

Education of Vision

edited by Gyorgy Kepes

Rudolf Arnheim Mirko Basaldella Julian Beinart Will Burtin

Anton Ehrenzweig William J. J. Gordon Bartlett H. Hayes, Jr.

Gerald Holton Johannes Itten Tomás Maldonado

Wolfgang Metzger Robert Preusser

Paul Rand Robert Jay Wolff

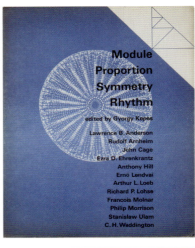

**Module
Proportion
Symmetry
Rhythm**

edited by Gyorgy Kepes

Lawrence B. Anderson
Rudolf Arnheim
John Cage
Ezra D. Ehrenkrantz
Anthony Hill
Ernö Lendvai
Arthur L. Loeb
Richard P. Lohse
Francois Molnar
Philip Morrison
Stanislaw Ulam
C. H. Waddington

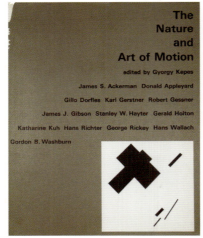

**The
Nature
and
Art of Motion**

edited by Gyorgy Kepes

James S. Ackerman Donald Appleyard

Gillo Dorfles Karl Gerstner Robert Gessner

James J. Gibson Stanley W. Hayter Gerald Holton

Katharine Kuh Hans Richter George Rickey Hans Wallach

Gordon B. Washburn

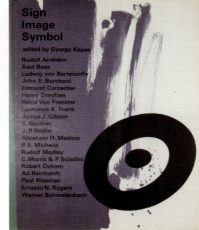

**Sign
Image
Symbol**

edited by Gyorgy Kepes

Rudolf Arnheim
Saul Bass
Ludwig von Bertalanffy
John E. Burchard
Edmund Carpenter
Henry Dreyfuss
Heinz Von Foerster
Lawrence K. Frank
James J. Gibson
S. Giedion
J. P. Hodin
Abraham H. Maslow
P. A. Michelis
Rudolf Modley
C. Morris & F. Sciadini
Robert Osborn
Ad Reinhardt
Paul Riesman
Ernesto N. Rogers
Werner Schmalenbach

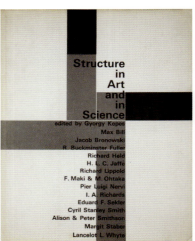

**Structure
in
Art
and
in
Science**

edited by Gyorgy Kepes

Max Bill
Jacob Bronowski
R. Buckminster Fuller
Richard Held
H. L. C. Jaffe
Richard Lippold
F. Maki & M. Ohtaka
Pier Luigi Nervi
I. A. Richards
Eduard F. Sekler
Cyril Stanley Smith
Alison & Peter Smithson
Margit Staber
Lancelot L. Whyte

The best way to have a good idea is to have lots of different ideas. Fusing thinking spaces—merging domains—is the first step toward augmenting the set of possible solutions. This is especially true at the level of organizations where the goal is innovation. Successful examples from the past are both revealing and inspirational. There is no algorithm for the perfect balance between art, technology, and science. But try we must.

An early, comprehensive vision of the Nexus. The complete six volume set of the *Vision + Values Series*, edited by György Kepes, and published by George Braziller in 1965–66. Kepes assembled an extraordinary who's who of artists, scientists, architects, mathematicians, and designers around six cross-disciplinary themes. Kepes himself was a painter, photographer, educator, designer, and art theorist. He was Professor of Visual Design and the founding Director, in 1967, of the Center for Advanced Visual Studies at MIT, after having taught at the New Bauhaus in Chicago.

THINKING AT THE NEXUS IN A COMPLEX WORLD

Complex systems–based thinking that reveals new insights

We know the challenges posed by complex systems. We need to internalize the lessons.

IBM Q quantum computer cryostat; nearly a dozen companies are developing quantum computers. There is much promise in the field; theory indicates that quantum computers can solve certain computational problems substantially faster than today's classical computers. Classical computers store information in two states; a bit can be either on or off; quantum computers use qubits, which in addition to being possibly on or off, can be simultaneously on and off. This opens unprecedented possibilities. But for quantum computers to function in practice atoms need to be near motionless, and for this to happen systems need to be cooled to close to absolute zero; zero degrees Kelvin or −273.15 on the Celsius scale, a difficult issue from a practical viewpoint.

We live in a complex world. Having a framework to guide thoughts is essential. It is important to recognize the difference between complicated and complex before distilling relevant lessons that stem from complex systems theory and the concept of complementarity. Network science gives insights into teams; complexity serves to highlight the differences between engineered systems and biological systems, a powerful metaphor in understanding organizations.

Models and Complex Systems

Concepts to navigate the Nexus include reductionism, emergence, and complementarity.

When we talk about the Nexus, we talk about a place, a frame of mind, where separate domains are not only combined but augmented. When boundaries are removed, thinking spaces expand and entirely new things can emerge.

To better understand how this is possible, we look to two important concepts in science and engineering: complex systems (how systems connect and foster emergence in open, out-of-equilibrium environments) and quantum physics (where something can be two things at once).

Many systems that appear wildly different—sand dunes, an colonies, the brain, cities, the internet, power grids, travel networks, ecologies, and the metabolic pathways within a cell—are complex systems. Complex systems have been a subject of significant study over the last several decades. The field draws significantly from several technical components: nonlinear dynamics (chaos theory is part of this), agent-based modelling (ABM); cellular automata, network science, and statistical mechanics (Ottino 2003b; Amaral and Ottino 2004). Central to complexity is the concept of emergence.

Emergence is what happens when elements—"agents" in the terminology of complex systems theory—interact with each other to produce outcomes that could not have been predicted by examining the agents in isolation. No amount of knowledge about a single starling can explain the mesmerizing flocks that form when several thousand of them fly together; studying one termite does not give us a clue as to how they form mounds; no amount of knowledge about a neuron can explain consciousness. Something seemingly magical happens when many elements interact together.

The Game of Life, a deceptively simple two-dimensional cellular automaton invented by the mathematician John Conway in 1970, provides an excellent example of the magic of simple elements interacting via simple rules (figure 6.). It beautifully illustrates a fundamental lesson we will encounter later: how to go from *simple to complex and from complex to simple*. The game starts by placing filled cells on a two-dimensional grid; it advances according to three rules that depend on the state of the eight cells surrounding any given cell: (1) any live cell with two or three live neighbors survives; (2) any dead cell with three live neighbors becomes a live cell; and (3) all other live cells die in the next generation. Similarly, all other dead cells stay dead.

An amazingly rich taxonomy—in fact, we could say an entire industry—has emerged out of these simple rules. We find stable systems, patterns that repeat, oscillations with a wide range of periods, and cohesive patterns that move across the grid. The game was

Boat

Tub

Blinker
(period 2)

Pulsar
(period 3)

Glider

Toad
(period 2)

Beehive

Block

Loaf

Beacon
(period 2)

Light-weight
spaceship
(LWSS)

Middle-weight
spaceship
(MWSS)

Heavy-weight
spaceship
(HWSS)

Fig. 6.1 Life forms generated by
the Game of Life.

shown to be *undecidable* in the sense that if we are given an initial pattern and a later pattern, there is no algorithm that can tell whether the later pattern is ever going to appear. Unsurprisingly, variations of the original game have appeared: three-dimensional square grids; two-dimensional triangular and hexagonal variations. Could anyone anticipate the rich results that would have emerged by simply examining the rules (*going from simple to complex*)? And as to the reverse, if we are shown the outcomes, could we have inferred the rules (*the complex to simple reason*)? Yes, with enough training, our intuition could have been prepared for this. But the central point is that this training is still rare. And, therefore, our intuitions often fail us.

Accepting the ideas stemming from complexity research has been far from easy, because they went against reductionism, a remarkably successful dogma deeply embedded in science: a cornerstone of science, in fact. In 1972 the physicist Philip Anderson (1923–2020, winner of the Nobel Prize in Physics in 1977), wrote a very influential short paper in *Science* titled "More is Different," in which he emphasized the limitations of reductionism (Anderson 1972). Reductionism, explaining things from the ground up, is a central idea in physics that migrated to chemistry, biology, and, through economics, to the social sciences. Every discipline wanted to be like physics, to build understanding emerging from a small number of laws (Ball 2004). And as in Newtonian mechanics, the belief was that there had to be laws to be discovered.[87]

The central tenet of reductionism is that if one understands the elementary building blocks of a given discipline—particles, atoms, and molecules in physics; DNA in biology—that discipline can formulate problems and infer consequences marching upward in scale.

It has become clear, however, that this approach, although eminently successful since Newton's times, has severe limitations. Once we reach the ultimate simplicity (Newton's laws in physics, for example), how do we manage to put things back together? Many times, we can. But there are limits, and those limits, and surprises, open an entirely new world. This was the point of Anderson's short paper: *More is different*. More implies emergence.

For example, even if we were to know much more than what we know now, the basic building block in social sciences (humans) could in principle be understood in terms of the laws uncovered by psychology—which, in theory, could be understood through the laws of neuroscience and physiology, arriving to molecular biology, then chemistry, and then to particle physics. So, the idea is that if we master particle physics, then we master all chemistry; and with chemistry we get all of biology and so on, marching upward in scale.[88] A far simpler proposition is that by understanding a grain of sand we can understand sand dunes. But even this is simply not possible. A complex system must be understood as a whole.

86. Another example that challenges our intuition, taking place also on a grid, is the model of segregation in cities that appears in chapter 7.

87. Ideas did not fly solely in one direction. The belief that Newtonian ideas could extend to societies was strong. August Comte (1798–1857), a French philosopher who is widely regarded as the founder of sociology, defined social physics as the "science which occupies itself with social phenomena, considered in the same light as astronomical, physical, chemical, and physiological phenomena, that is to say as being subject to natural and invariable laws, the discovery of which is the special object of its researches." Adolphe Quetelet (1796–1874), a Belgian statistician, proposed that society be modeled on the basis of probability and statistics. Quetelet's 1835 book, Essay on Social Physics: Man and the Development of his Faculties, *outlines the development of social physics. Upon hearing the term "social physics" from Quetelet, Comte invented a new one: sociologie (sociology). A movement began, advocating that the social sciences adopt mathematical and physical concepts. But the reverse happened as well. For example, to get his ideas about constancy of averages accepted by the physics community, James Clerk Maxwell (1831–1879) drew inspiration from Quetelet, who had been using statistics to try to describe social interactions with the same level of rigor as Newtonian mechanics (Ball 2004).*

88. Marching up in scales is a worthwhile goal; but it may be wholly unnecessary. A central concept in physics is separation of scales, using the right level of description to capture the phenomena of interest. Goldenfeld and Kadanoff (1999) remind us of this when they state: "Don't model bulldozers with quarks."

Complex systems cannot be understood by studying each part in isolation. The very essence of the system lies in the interaction between parts and the overall behavior that emerges from the interactions. Seemingly magical things happen when elements interact with each other. It is not fanciful that something similar may happen when different modes of thinking interact with each other. The modern challenge for reductionist approaches is that complex systems are now everywhere.

Complex systems thinking went against reductionism; and reductionism was everywhere in science. *Complementarity*—a concept emanating from quantum mechanics, that something can be two things at the same time, two opposites in fact—stayed largely within physics.

Invoking complementarity was the only way, during the initial development of quantum mechanics, to reconcile two perfectly acceptable but ultimately contradictory descriptions of one thing: light. Light can be described in two ways: as a wave when it travels and as a particle when it interacts with matter. Each of the descriptions is useful, but they are mutually incompatible. This does not mean that we do not know what light is. Quantum mechanics tells us that the ultimate fundamental description of a system is in its wave function. The wave function is not something that can be directly observed. But the wave function can be *transformed into something that can be observed*; and in this we have a choice. But once it is observed in one way it cannot be observed in another. Thus, when observed, light can be either a wave or it can be a particle. But in essence—and this is the very essence of complementarity—it is both. As we saw in chapter 2, this is the idea that Einstein found hard to accept, which led to memorable discussions with Niels Bohr.

Complex systems thinking and complementarity both represent augmentations of our thinking. We said that complex systems thinking was perceived to go against reductionism, but that may be a narrow view. In fact, we could argue that complex systems thinking *augments* reductionism. Complex systems thinking does not mean abandoning the basic laws of physics. Reductionism has limits, and that is where complexity comes in. Complementarity has not had the same staying power in the way humans think, but we believe that it should. Human limitation is what causes us to perceive many things as opposites. In his short story "The Crack-Up," F. Scott Fitzgerald famously wrote: "The test of a first-rate intelligence is the ability to hold two opposed ideas in mind at the same time and still retain the ability to function." This most certainly applies to the present discussion.[89]

In fact, the Nexus itself encompasses complementarity, which within it, contains versions of diametrically different, even opposite, ways to think about an idea.[90] And the idea of complementarity is at the very center of complexity, for chaos and order are not opposites. Chaos and order coexist within complexity.

89. F. Scott Fitzgerald's quote is encapsulated in an earlier term, negative capability, coined in 1817 by the Romantic poet John Keats (1725–1821), when referring to the ability of the greatest writers to pursue artistic visions even if they may lead to intellectual confusion or uncertainty. We can thus think of negative capability as the ability to be comfortable with ambiguity and embrace multiple, seemingly conflicting ideas or concepts at the same time. Keats captured the essence of complementarity.

90. Albert Rothenberg, a psychiatrist who carried out long-term research on creative processes in literature, art, and science, coined the term "Janusian Thinking" to characterize the ability to conceive multiple opposites simultaneously, a capacity that he found to be a central component of creativity (Rothenberg 1971 and 1979).

Complex and Complicated: An Essential Distinction

Jetliners, tall buildings, and nuclear subs are complicated, whereas ecological systems, cities, and the brain are complex.

Complex is different from complicated (Ottino 2004). A complicated system is designed top down. A Boeing 787 is complicated; so is a nuclear submarine and a moon-phase mechanical watch. The pieces in complicated systems can be understood in isolation; the whole can be reassembled from its parts. The components in a complicated system work in unison to accomplish a function; a single defect can bring the entire system to a halt. Redundancy needs to be built in when system failure is not an option. Complicated systems do not adapt. There are no surprises in how they will behave. It is not like we put the very last small gear in a complicated watch and somehow, spontaneously, the watch will spring out legs and walk. There is no emergence. In essence, the difference between complicated and complex is the same as the difference between engineering systems and biological or social systems, or between performing from a score and jamming (figure 6.2).

Up to now, engineering has typically dealt with complicated systems. But now, more than ever, engineering must deal with systems that were not designed with a single blueprint.[91] These may be systems where engineers designed all parts but not the system, or where human input is crucial to how the system behaves. The internet falls in this category; so do power grids, global transportation systems, worldwide supply chains, and synthetic biology.[92] Others are systems that are "out here" and must be dealt with. Social systems are one example (Miller and Page 2009). Complex systems represent some of the biggest problems facing us today. They all involve a subtle, intricate, and yes (the word cannot be avoided) *complex* balance between the "system" and our actions: ecosystems, and how they are affected by human actions; geosystems and actions intended to mitigate climate change; and measures and policies to respond to a pandemic.

The natural world has always been complex, but now the human-made parts are an increasing source of complexity. Speed and connectedness give rise to headline making crises: rapid propagation of epidemics, worldwide economic collapse, cyberterrorism, and much more.

How do we know when we are dealing with a complex system? A complex system can be identified by what it does: It displays organization without any organizing top-down principle being applied (in other words, behavior emerges bottom up) and by how it can and cannot be analyzed. Decomposing the system and analyzing each part in isolation does not give any clue as to the potential behaviors of the whole. Looking at the parts does not capture the whole; in fact, focusing on the parts misses the whole.

91. The distinction between complicated and complex is becoming increasingly blurred. While it is true that every component in, for example, a Boeing 747 MAX has been designed, it is very hard to consider all possible interactions between components. Every specific model of an Apple computer emerges from the factory as being identical, but once it reaches a consumer and settings are chosen or apps installed, it is unlikely that two computers are the same; it is manifestly impossible to predict the consequences of all possible settings. Adding elements of machine-learning algorithms to engineered systems to build adaptation will make these two extremes get closer and closer to each other and make complicated systems behave more like complex systems.

92. In synthetic biology the parts are engineered, typically considering some limited set of designed interactions between the parts (a synthetic gene network, for example), but then these engineered parts are deployed in a system that is not engineered (for instance, a cell). It is the integrated system—the combination of engineered and non-engineered systems—which is of interest and of use, and such efforts to impose prosthetic functions upon complex systems may indeed lead to emergent behaviors.

Fig. 6.2 Examples of complicated and complex systems. Left side (complicated): astronomical clock, nuclear sub, Airbus A380, integrated circuit board. Right side (complex): school of fish, neurons, brain, ecology. Watches and clocks typify complicated systems. The most elaborate mechanical watches are called *très compliqué*; they are, as their French name implies, complicated (in horology, a "complication" refers to the ability of a mechanical timepiece to go beyond indicating hours, minutes, and seconds). Some recent wristwatches have over 1,300 components and can display moon phases, time of sunset and sunrise, and calendars that account for leap years. Pocket watches can do even more. The watchmaker Vacheron Constantin created a piece in 2015 with 2,800 parts. Building complications is hardly new. The Prague astronomical clock, installed in 1410 and the oldest astronomical clock still in operation, can predict the movements of the stars, sun, moon, planets (as known in the 1400s), as well several other astronomical details. Counting parts in purely mechanical systems is relatively easy. Counting parts in other engineering systems is more complicated. A typical car, down to the last screw, has about 30,000 parts; an Airbus A380 is made up of about 4 million individual parts. But both these numbers do not include electronic parts. The number of transistors in an integrated circuit can reach into billions; computer systems, composed from multiple integrated circuits, can have trillions. A benchmark: the human brain has about 86 billion neurons.

An ant colony, a school of fish, an ecology, or the human brain are complex. The number of parts—for instance, the number of fish—is not the critical issue. The key characteristic is *adaptability*. Complex systems respond to external conditions. A food source is obstructed, and an ant colony finds a way to go around the object; a species becomes extinct, and an ecosystem may adapt. Complicated systems do not adapt. Parts must work in unison to accomplish a function; a key defect in a critical part may bring the entire system to a halt. For this reason, redundancy (as well as a backup to a backup) is built into a design when system failure is not an option.

THINKING IN A COMPLEX WORLD 203

Synchronization and Networks
The spontaneous emergence of order reveals ways of seeing the world.

A visible manifestation of complex systems behavior is the spontaneous emergence of synchronization. Examples of synchronization dynamics appear in physics, engineering, biology, and social sciences (Strogatz 2003). Synchronization can be both good and bad. The examples of fish organizing in schools, birds in flocks, and fireflies firing in unison fall in the "good" category. It allows them to fend off predators in the cases of schools and flocks and to attract mates in the case of fireflies. Another example in the good category: the coordination of the 10,000 cells in the cardiac pacemaker to fire in unison to govern our hearts. There are many cases where we want synchronization: The functioning of a power-grid network requires that its power generators remain synchronized (Motter et al. 2013); the loss of synchronization resulting from disturbances can lead to power outages. But synchronization can sometimes be the cause of bad outcomes. A celebrated example is the closing of the Millennium Bridge in London on its opening day, when the unexpected synchronization of the crowd walking on the bridge generated oscillations (Eckhardt et al. 2007). It took nearly two years before the bridge could be retrofitted with viscous dampers to prevent synchronization.

Until recently, the prevailing view had been that homogeneity in the dynamics is facilitated by increased homogeneity in the population. Recent work by Adilson Motter and his group identifies scenarios in which complete synchronization is not stable for identically coupled identical oscillators but becomes stable when, and only when, the oscillator parameters are judiciously tuned to nonidentical values (Nishikawa and Motter 2016; Molnar et al. 2020). Although results are at the level of basic research, they suggest that in numerous systems, heterogeneity may be required for stable synchronization. This adds a new dimension to the advantages of diversity: consensus and other convergent behavior may occur because of (not despite) differences.

We can link these results to social systems as complex systems and networks. Organizations and cities can be thought of as complex systems, interacting networks of individuals, communities, and institutional structures. At times, these interactions can give rise to something akin to emergence—behavior that goes above the individual parts, a sort of a higher order intelligence. Think of the explosion of creative output in Renaissance Florence, the amazing output of the short-lived Bauhaus and the equally short-lived Black Mountain College, the output of Vienna's modernist era, Edinburgh and the Scottish Renaissance, or the remarkable intellectual and technological output of Bell Labs. These dissimilar examples represent moments of confluence, of an almost autocatalytic production of creative ideas. Major organizations and universities aspire to this kind of emergence. Many would like to know the magic recipe.

Confluence goes beyond the purely metaphorical. One aspect is conceptual: an anchoring perspective, a thinking platform that serves to highlight crucial differences of how to

see and run organizations. Another aspect is practical: providing tools for quantification. Lessons emerging from network science are particularly relevant in this regard.

A network is a system of discrete objects (nodes) with connections (links) (Newman 2010). If artists A and B (nodes) exchanged correspondence, or participated in the same exhibit, we can say that they are connected (linked). In food webs, species are connected if one preys on another; airports are connected by traffic routes.

Two papers, published in 1998 and 1999, launched the explosion in the study of networks.

The first was the *small-world* networks identified by Watts and Strogatz (1998). This is the case where most nodes in the network are not neighbors of one another, but the neighbors of any given node are likely to be neighbors of each other, and most nodes can be reached from every other node by a small number of hops or steps. The famous "six degrees of separation" is an example of this class of network. Further examples appear in electric power grids, food webs, metabolite processing networks, voter networks and, of particular interest to us, social influence networks. This class of networks appears when we discuss the formation and performance of teams.

The second was the discovery of *scale-free* networks by A-László Barabási's group (Albert et al. 1999) in their study to measure "the diameter of the World Wide Web." The prevailing thinking at the time was that nodes of real networks are randomly linked to each other. Barabási and colleagues measured the probabilities $P_{out}(k)$ and $P_{in}(k)$ that a document in the Web has k outgoing and incoming links, respectively, where k is referred to as the degree of the node. A large degree (k) denotes a highly connected node. They found that both $P_{out}(k)$ and $P_{in}(k)$ follow power laws over several orders of magnitude. This was not what was expected if the nodes were randomly linked to each other. A *scale-free network* has distinct hubs with an exceptional number of links that hold the network together but also, at the same time, a large number of small degree nodes that are virtually absent in a random network. Scale-free networks form by preferential attachment, a sort of "rich get richer" scheme; there is an advantage to connect to a node that is already highly connected. A few websites are highly connected; the vast majority languish with few connections. The real discovery, of course, was what followed next: that many other networks—from some social networks to air routes to protein interactions in our cells—follow the same, nonrandom pattern (Barabási and Bonabeau 2003). It is good to connect to websites that are already highly connected; it is good to add travel routes to significant hubs.

There now exists a large body of work, produced over the last two decades, that studies the distinguishing categories of networks, breaks them in classes, and uncovers generic laws that govern their formation and robustness. Once we recognize how to see the world as networks, we find them everywhere (Barabási 2002).

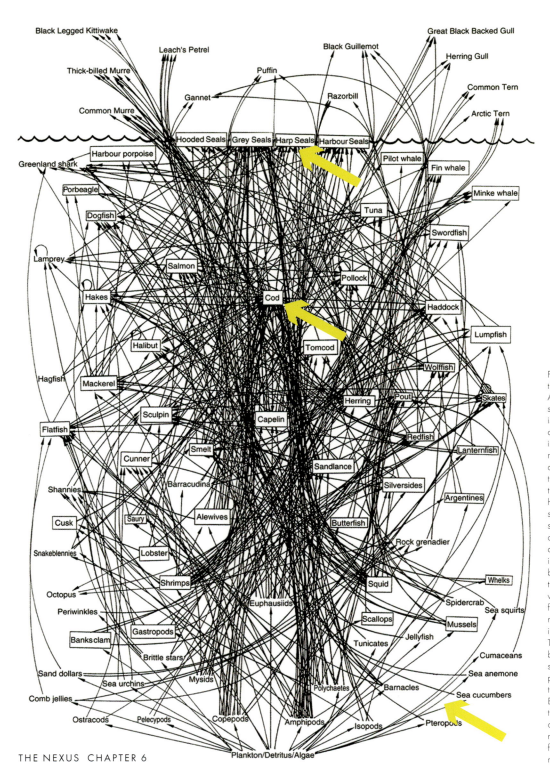

Fig. 6.3 A partial food web for the Scotian Shelf in the Northwest Atlantic off eastern Canada. A simplistic model of this food web is harp seals eat cod and cod eat crustaceans, indicated with arrows in the figure. There are several reasons why the real ecology is considerably more complex. First, this food web is incomplete because the feeding habits of all components have not been fully described; second, all species—including some of the marine mammals—do not spend the entire year in the area, and third, species enclosed in rectangles are also exploited by humans. An upper bound of the possible complexity of a food web is given the number of different food webs N, for a system having a number of species n, each of which interacts with every other species. The simplest case corresponds to binary interactions, i.e., for two species A and B, the list is four possible states: A eats B, B eats A, they both eat each other, and A and B do not eat each other. In general, the number is $N = 2^{n^{(n-1)}}$. Numbers can get astronomically large. For nine species the number of possible food webs is 4.7×10^{21}, more that number of stars in the universe.

Conceptual Implications of Complexity

Lessons are applicable across domains.

Complex systems adapt. Within bounds, complex systems are resilient. Failures take place all the time: servers fail, weather closes airports, species disappear, but the overall system manages to adapt. In complex systems, there is no single controlling unit; they display emergence. How can an ecosystem reassemble after a devastating fire or a volcanic eruption? How does a run-down neighborhood emerge as a new whole from an initially disconnected series of shopkeepers, art galleries, restaurants, and real estate developments?

Living systems are complex. Cells, organisms, and ecosystems (figure 6.3) are robust, in the sense that they tolerate imperfect components and can recover from the brink of death. Living systems are modular, and perhaps because of this, these systems evolve to tolerate diversity (as much as imperfection). Outcomes enabled by this feature include horizonal gene transfer (the movement of genetic information between organisms, even between distantly related species) and genetic capture (such as the viral gene that was captured in our own genome and enabled the evolution of the mammalian placenta; Quammen 2019). They are adaptable and can "learn" to solve new problems. They evolve. They are also highly contextual (stem cells, for example) and depend on circumstances to take on any of their many functions. The standards for performance are also less rigidly defined than in engineered systems: "good enough" may pass the test. This is an important point, important enough that we will revisit it later in the book. All these characteristics make biological systems very different from engineered systems, where precision and consistency are the rule. Imperfections in a single screw can put at risk an entire jetliner.

We do not live in a wholly engineered world. Components may have been engineered, but how they connect with each other has not. Everything is more connected—linked supply chains, telecommunication, and transportation networks—but often we cannot foresee the consequences of connectivity. An important example is the propagation of epidemics via air transportation routes (figure 6.4).

Access to data and information is not the problem. We can measure things more precisely than ever before: pico to femto quantities on the small side, as in the spread of pollutants; mega to zeta on the large side, as in the amount of information exchanged and generated in the world. But apart from experts, we do not know how to process information dealing with the very small and very large, or even grasp those scales, since those extremes are so far removed from our normal experiences. Add in connectivity and issues of emergence, and it is easy to see that our thinking has not yet adjusted to this new reality. Further, combine all this with how many such systems interact with our lives, and the outlook is concerning.

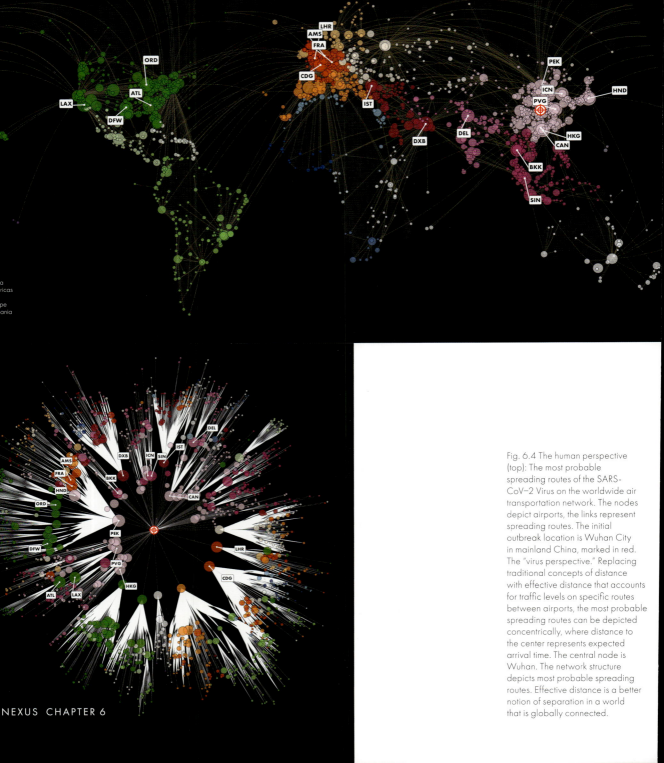

Fig. 6.4 The human perspective (top): The most probable spreading routes of the SARS-CoV–2 Virus on the worldwide air transportation network. The nodes depict airports, the links represent spreading routes. The initial outbreak location is Wuhan City in mainland China, marked in red. The "virus perspective." Replacing traditional concepts of distance with effective distance that accounts for traffic levels on specific routes between airports, the most probable spreading routes can be depicted concentrically, where distance to the center represents expected arrival time. The central node is Wuhan. The network structure depicts most probable spreading routes. Effective distance is a better notion of separation in a world that is globally connected.

We rely on systems that are both ubiquitous and invisible, and we take them for granted. More ubiquitous systems will appear in the future; dependencies will not stop. We rely more and more on systems that we understand less and less, and the gap between dependency and understanding is growing wider. Many problems that we have not imagined will surely appear, taxing our imagination as never before. Problems, even if very difficult, come with possible solutions. The question is how to find solutions. But solutions are increasingly defined by trade-offs: Do we opt for convenience, security, or personal freedom? An increase in standard of living or environmental impact? Continual growth and unlimited rewards or mitigation of economic inequalities? Dilemmas are about unavoidable choices. We are now faced with a stream of dilemmas that may determine the future of our species.

Valuable lessons to help us face these dilemmas can be extracted from complex systems research. These lessons apply to organizations and even to how the world functions. But the broader lesson may be in augmenting the Nexus and the constant interplay of the thinking modes of art, technology, and science.

Here we encapsulate the lessons that emerge from understanding complex systems:

Respect and Prepare for Emergence
Seeing the limits of control and top-down actions helps us understand the world and helps us organize our own systems. Organizations, for example, should be thought of as biological systems rather than engineered systems.[93] Those that do not adapt and evolve disappear.

Recognize the Possibility of "Hidden" Connections
Be unsurprised by seemingly unexpected linkages and recognize the possibility of hidden connections.

Be Prepared for Failures
Be unsurprised by large consequences stemming from small actions.

Embrace Complementarity
Chaos and order are not opposites. See both: the details and the whole.

These lessons are conceptual; we examine them in greater detail in the next chapter. But some tools have emerged from the toolkit of complex systems, specifically network science, to help us analyze problems and ask questions that until recently no one had imagined asking. This proves once more that asking the right questions is as important, if not more important, than finding the right answers. One such example is how complex systems thinking can yield insight into creative output and innovation in teams.

93. Artificial intelligence will make these two extremes get closer and closer to each other and make complicated systems behave more like complex systems.

Lessons from Network Science about Forming Teams
Research supports the right mix of expertise and network connections.

Solving big problems requires a team effort, but teams rarely form spontaneously. Someone must form them. Are there lessons on how to form teams? More specifically, which kinds of teams produce successful outputs? Research teams at Northwestern University have done pioneering work in this area (Uzzi and Spiro 2005; Guimerà et al. 2005). They have explored these questions in terms of network science using data sets from both artistic and scientific fields: the century-long record of Broadway musicals and the massive publication records of several fields of science.

Using Broadway is a particularly inspired choice since documentation is precise and goes to the very beginning of this famous New York City theater district. We know who contributed to the creation of a play and exactly how successful the play was. The size of the team needed to produce a Broadway musical has fluctuated at around six or seven contributors for the past ninety years: a composer, a librettist, a lyricist, a choreographer, a director who manages the team's collaboration, and a producer who manages the financial backing (possibly the least artistic person in the team, but someone who brings a different type of creative skill). Sometimes, a single person can play two roles (composer and lyricist, for example, both on the right-brain side), or two different individuals might collaborate on a single role. In truly exceptional cases, an individual could simultaneously play the roles of producer and director. Hal Prince, who received twenty-one Tony Awards, often had both roles. A whole-brain individual indeed.

On the scientific team side, publication datasets are massive. Everything is documented, especially now since quantitative metrics of research impact (Wang and Barabási 2021) are linked to reputation and levels of funding. At the very beginning, when the word "scientist" had not yet been coined, science started with individuals, and it was not unusual for scientists to announce their results in terms of riddles; being the first to announce a result or solve a problem was important. But this was not to say that people worked in isolation. They exchanged correspondence, forming what has been called an invisible college. They often challenged each other, but in the end, they published alone; publications involving even pairs of scientists were remarkably rare. To a large extent, the history of science is still told as the stories of individuals working alone: Galileo, Newton, Darwin, Einstein, Heisenberg, and Bohr.[94] Today, however, the picture is dominated by teams. Ease of collaboration makes coordination easy. The number of coauthors in many scientific fields has increased monotonically; from pairs, like Watson and Crick in the 1950s, to papers with several dozens of authors in experimental fields, like biology, chemistry, and physics; papers in astrophysics may involve massive teams and publications exceeding a thousand authors. This trend does not show signs of leveling off.

94. The propensity in science and technology to eponymously name principles, constants, mathematical concepts, theories, dimensionless numbers, electrical units, and much more, lasted until about World War II. A short list of examples may include the Heisenberg uncertainty principle after Werner Heisenberg, the Avogadro's number for Amedeo Avogadro, Gaussian distributions for Carl Friedrich Gauss, Mertonian theories for Robert Merton, the Reynolds number after Osborne Reynolds, and the volt and ampere electrical measures for Alessandro Volta and André-Marie Ampère, respectively. Algorithm, named after the medieval Muslim astronomer and mathematician Muḥammad al-Khwārizmī, whose Latinized surname was Algorismus, is in a category of its own, since there are named algorithms nested in this category. Notable relatively recent exceptions: the 1965 Moore's Law and the 1970s Mandelbrot set.

Using these two datasets, the Northwestern team was able to analyze the collaborative history of the individuals who contributed to a particular Broadway show or to research that resulted in a publication, with impact measured in terms of how long a show ran, or how impactful a paper was in terms of how many citations it received (meaning, how many other researchers mention a particular paper in their own work).

To understand the nature of collaboration in teams, we must understand the kinds of experiences people bring to teams. This is easiest to see in the case of the Broadway data. The Northwestern team distinguished between veterans who participated in collaborations before and rookies who were about to see their names appear in print for the first time. Two parameters were key: one is the fraction of veteran members in a new team; the second, the degree to which veterans involved their former collaborators.

They found that the 'small world" component of the team affected the financial and artistic performance of the musicals they produced in short, how successful the play was. This effect was quantified in terms of the fraction of new collaborations among experienced participants. The small-world network effect on this fraction was non-monotonic; performance increased up to point, after which performance started to decrease. Everybody knowing each other was not good, a team of strangers meeting for the first time as part of a team was not good either. Of course, everybody wants to know what the best ratio is. A rough encapsulation of Uzzi and Spiro's findings? First, it is better to have an odd sized group; it makes decision-making easier. For a team of five, have two or three experienced domain incumbents who have successfully worked together on two or more recent projects and one or two experienced domain incumbents who have no prior experience with the incumbents. Scale appropriately for larger teams.

Scientific Teams That Innovate
Research supports the need for diversity and a grounding in prior work.

The results of scientific publishing mesh well with the Broadway findings. The results of the study by Guimerà and colleagues show that teams that publish in high-impact journals have a high fraction of veterans—people who have already published there. But, as in our Broadway example, diversity matters: teams with many former collaborative links offer inferior performance. Best advice? When forming a "dream team," try to include experienced people, especially individuals you have worked with before. But bring in new players as well. The temptation to work mainly with your friends will eventually hurt your team's performance.

There has been a significant rise in interdisciplinary research since the early 2000s. The causes are many—ease of communication, the complexity of problems being

attacked, and more. It could be argued that the discipline of "the science of science" emerged as a consequence of this tilt—to uncover patterns in the production of science, to assess the effectiveness and composition of teams and their ability to innovate, and so on. For example, a science-for-science team analyzed more than 65 million papers (as well as patents and software products) in the period from 1954 to 2014. The title of their paper says it all: "Large Teams Develop and Small Teams Disrupt Science and Technology" (Wu et al. 2019). Smaller teams have tended to disrupt science and technology with new ideas and opportunities, whereas larger teams have tended to develop and evolve existing ones. There is one area, however, where the accent is still placed on the specialization side. Consider the top science and engineering awards. Nobel Prizes cannot be shared between more than three people and are awarded across classical disciplinary lines: physics, chemistry, and medicine. Election to prestigious academies, such as the National Academy of Engineering, relies on evaluation of candidates by a peer committee within traditional disciplinary fields such as materials sciences, chemical engineering, aerospace engineering and more. It has been noted, however, that recognition in one area does not translate into impact in the same area. For example, a Nobel Prize in Chemistry, in terms of citations, may be more impactful in areas like physics and engineering. Are labels too rigid and becoming obsolete? And, if so, are recognition structures anachronistic? Some have argued so (Szell and Sinatra 2018).

There is one additional component that can be investigated in scientific publishing: bringing novelty into the picture. It has been said that the best way not to produce a masterpiece is by trying to produce a masterpiece. There is quantitative backing for this dictum. Not all ideas in a high-impact papers have to be 100 percent new; in fact, meshing old and new may be the best route to high impact. Ground ideas in something that is well understood, then add the piece that is unusual. This strategy goes back to Newton, who uncharacteristically gave Galileo more credit than Galileo deserved so he could smoothly present new radical ideas.

This concept carries unaltered to our times. Communication, if anything, is more important now than ever. A great innovation, poorly communicated, will not catch on. On the other hand, an incremental idea that is well publicized can become enormously successful. From this perspective, balancing atypical knowledge with conventional knowledge may be the crucial link between innovation and impact, as measured by citations. An analysis of 17.9 million papers spanning all scientific fields suggests that science conforms to a nearly universal pattern (Uzzi et al. 2013): The highest-cited science is primarily grounded in combinations of prior work which, at the same time, feature a component of unusual combinations. Papers of this type were twice as likely to be highly cited works. Novel combinations of prior work are rare, yet teams are 38 percent more likely than solo authors to insert novel combinations into familiar knowledge domains.

Teams dominate, but there are still domains where creativity is assigned to individuals. The perception of individual creativity is strongest in plastic arts where true collaborations are rare. We see Picasso, Matisse, Vassily Kandinsky, Kazimir Malevich, Marcel Duchamp, and Marina Abramović as singularities, not parts of teams. The reality, however, is more nuanced. A remarkable interactive network of artist's interactions was produced for the show called *Inventing Abstraction, 1910–1925*, which ran at the Museum of Modern Art in New York City from December 23, 2012, to April 15, 2013. It shows connectivity between artists whose acquaintance could be documented—they either exhibited together or exchanged letters—and identifies those with the most connections (figure 6.5). The network is quite complex, and many artists are highly connected; those highlighted in orange have more than twenty-four connections. This makes visible the invisible college that exists in the art world.

The Importance of Seeing the Mechanical (In)side of Things

*Surrounded by complexity, we still long for a world we can experience
and intuitively understand*

Arthur C. Clarke, one of the most acclaimed science fiction writers of the twentieth century, said, "Any sufficiently advanced technology is indistinguishable from magic." The invisible systems that now rule our lives fall under this category. For some, the combination of magic with rate of change is too much. Most of us want functionality in the things we interact with: cars, software, household appliances. We want the convenience of automated services and the ability to carry our electronic lives and information in the palms of our hands. But we also want this technology to be understandable and intuitive. This is the challenge of human-centered design. The problem is that, too often, technology frustrates and confounds—not because of its inherent complexity, but because of poor design that does not account for human behavior. People routinely and successfully operate inherently complex devices—we drive cars, fly airplanes, and use complex graphics and audio software. We know that the complexity is there, and at the same time recognize that it is way beyond our ability to grasp it.

We want to interact with technologies in successful, intuitive ways; we want the proper human–machine interfaces. As we build out more complex artificial intelligence systems, a clear focus will be on having the machine communicate to us in a way that we can understand. The machine would need to be able to express ideas in terms of examples, metaphors, experiences, and analogies. It should refer to things we have emotional commitments to. Having systems that can only present ideas as rational arguments will not help us. People "want" to see the inner mechanisms. Could we ever "see" the inside of an artificial intelligence (AI) algorithm?

Going back to the 1820s illustrates the "seeing" side of things. Charles Babbage (1791–1871) was an English mathematician, inventor, and mechanical engineer who is

Artists who have over 24 connections within the network

Artists who have fewer than 24 connections within the network

This diagram maps the nexus of relationships among those artist represented in the exhibition Inventing Abstraction, 1910—1925, all of whom played significant roles in the development of a new modern language for the arts. Vectors connect individuals whose acquaintance with one another during these years could be documented.

LAWRENCE

HENRI GAUDIER-BR

PATRICK HENRY BRUCE

PAUL STRAND

MARCEL DUCHAMP

STANTON MACDONALD-WRIGHT

MAN RAY

GEORGIA O'KEEFFE

MORGAN RUSSELL

FRANCIS PICABIA

ALFRED STIEGLITZ

MORTON LIVINGSTON SCHAMBERG

JOSEPH STELLA

EDGARD VARÈSE

ARTHUR DOVE

MARSDEN HARTLEY

MAX WEBER

Fig. 6.5 Still image of the interactive network of artist's interactions, from the show *Inventing Abstraction*, 1910–1925, which ran at the Museum of Modern Art in New York City from December 23, 2012, to April 15, 2013.

LANGDON COBURN

DUNCAN GRANT

GUSTAV KLUTSIS

HELEN SAUNDERS

VANESSA BELL

ALEKSEI KRUCHENYKH

VILMOS HUSZAR

WYNDHAM LEWIS

MIKHAIL LARIONOV

KAZ MIR MALEVICH

GEORGES VANTONGERLOO

BART VAN DER LECK

JOSEF ALBERS

KATARZYNA KOBRO

IVAN KLIUN

THEO VAN DOESBURG

LÁSZLÓ MOHOLY-NAGY

WŁADYSŁAW STRZEMIŃSKI

NATALIA GONCHAROVA

PIET MONDRIAN

ALEKSANDR RODCHENKO

SONIA DELAUNAY TERK

SÁNDOR BORTNYIK

WACŁAW SZPAKOWSKI

KUPKA

ROBERT DELAUNAY

VIKING EGGELING

WERNER GRAEFF

HENRYK BERLEWI

EL LISSITZKY

MIKHAIL MATIUSHIN

VASLAV NIJINSKY

HANS RICHTER

CLAUDE DEBUSSY

KSENIIA ENDER

PABLO PICASSO

VASILY KANDINSKY

KURT SCHWITTERS

CONSTANTIN BRANCUSI

VLADIMIR TATLIN

LÉOPOLD SURVAGE

AUGUST MACKE

RUDOLF VON LABAN

LIUBOV POPOVA

CENDRARS

FRANZ MARC

MARY WIGMAN

GUILLAUME APOLLINAIRE

HANS ARP

CHRISTIAN SCHAD

FERNAND LÉGER

PAUL KLEE

SOPHIE TAEUBER-ARP

AUGUSTO GIACOMETTI

TRISTAN TZARA

FORTUNATO DEPERO

ARNOLD SCHÖNBERG

ANTON GIULIO BRAGAGLIA

UMBERTO BOCCIONI

LUIGI RUSSOLO

CARLO CARRÀ

FILIPPO TOMMASO MARINETTI

FRANCESCO CANGIULLO

GIACOMO BALLA

EMILIO PETTORUTI

ARDENGO SOFFICI

GINO SEVERINI

Fig. 6.6 Portrait of Ada Lovelace by Margaret Sarah Carpenter, 1836. Detail of Babbage's Difference Engine No. 2. The calculating section of the engine weighs 2.6 tons and consists of 4,000 separate parts. The Difference Engine No. 2 was never built in Babbage's lifetime. The London Science Museum began its construction in 1985; the calculating section was completed in 1991 for the bicentennial of Babbage's birth.

regarded as the "father of the computer." But the first computer, the computer that put us at the doorstep of scientific computing, information technology, the digital economy, and everything that followed, was purely mechanical. In Babbage's time, numerical tables were calculated by humans who were called "computers," meaning the "ones who compute," in as much as a conductor is the "one who conducts." Babbage thought the process could be made automatic. In 1822, Babbage started working on what he called the Difference Engine, which was designed to compute values of polynomial functions. It was never built. It was supposed to be composed of around 25,000 parts, weigh 15 tons (13,600 kg), and be 8 feet (2.4 m) tall. Babbage later designed an improved version, the "Difference Engine No. 2." It was built 150 years later, using Babbage's plans and nineteenth-century manufacturing tolerances. It performed its first calculation at the London Science Museum, returning results to 31 digits, a precision way beyond that of the average modern pocket calculator.

Soon after the attempt at making the Difference Engine crumbled, Babbage started ed designing a another even more complex machine called the Analytical Engine; he tinkered with a succession of designs until his death. This was not just an incremental improvement of the Difference Engine. The Analytical Engine represented a major conceptual advance by foreshadowing modern computers. It could be programmed using perforated cards[95] to control a mechanical calculator which could formulate results based on the results of preceding computations.

Ada Lovelace (1815–1852), an impressive young mathematician and one of the few people in the world who fully understood Babbage's ideas, created a program for the Analytical Engine to calculate Bernoulli numbers, a series of numbers that are of interest in number theory (figure 4.6). Based on this work, Lovelace is now widely credited with being the world's first computer programmer. But Babbage's ideas never took root. If anything, Babbage's example shows how complicated it is for a truly innovative technology to take hold and to be implemented before there is a recognized need for it.

But there is also a second reason we use Babbage as our example for the "seeing" side of things. Babbage's mechanical ideas still fascinate us, possibly because mechanics gives us the illusion of visualizing how something works. Shortly after 1945, mechanics lost its exalted role, and lost the ability to see. We are now decidedly in the information age. But there is a palpable and an almost unfulfilled longing for things we can understand. Many people are still creating art and technology to fill this void. The fascination with mechanical things continues to this day.

François Delarozière (b. 1963) has been described as an "engineering genius." He is the artistic director of La Machine, a French company operating as a collaboration between artists, designers, fabricators, and technicians, and which specializes in producing giant performing machines. One of its creations, a very large elephant, is 12 meters high and weighs 50 tons, and can take fifty people aboard. The company has also

95. The Analytical Engine would have used loops of Jacquard cards, named after Joseph Jacquard (1752–1834), a French weaver and merchant who automated his loom by using perforated pasteboard cards, the forerunners of the punch cards used in computers in the 1960s and 1970s.

Fig. 6.7 Theo Jansen *strandbeests*, built with PVC plastic tubes, wood, and fragile-looking sails. These whimsical animal skeletons that "walk" using the wind are a fusion of art and engineering.

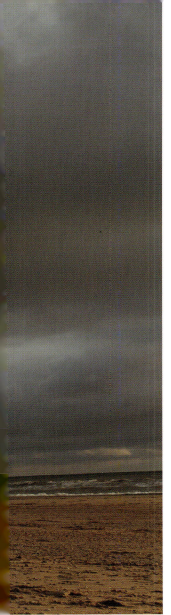

created fish, insects, and spiders. Delarozière's pieces all start with hand-drawn blueprints and are built of materials that age with time: wood, copper steel, and brass.

Theo Jansen (b. 1948) is a Dutch kinetic sculptor who builds large works called *strandbeests* ("beach animals" in Dutch) using stiff PVC plastic tubes, wood, and fragile-looking sails (figure 6). These whimsical animal skeletons "walk" when propelled by the wind. They have legs, which, according to Jansen, "prove to be more efficient on sand than wheels... they don't need to touch every inch of the ground along the way, as a wheel has to" (Jansen 2007). Jansen's kinetic sculptures are a fusion of art and engineering; he often says that he does not know if he is a sculptor or an engineer: "The walls between art and engineering exist only in our minds," he has said. Jansen equips the *strandbeests* with rudimentary "intelligence" to manage avoiding obstacles or going into the sea. Over the years, successive generations of his creatures have evolved into increasingly complicated animals (according to our definition of complicated and complex) Our fascination is that we can see their insides, everything is in the open, and get a sense of how they work.

Why do Jansen's and Delarozière's creations appeal to us? When we see mechanics, we think that understanding is within our grasp. Jansen's and Delarozière's work could have been done any time in the past fifty to seventy years, if not more, but it is only now that this kind of work resonates with people at an emotional level as it satisfies a longing for the past.

To a large extent, we still frap our understanding in mechanical terms; witness the fascination for astonishingly elaborate (and expensive) mechanical watches and the relatively recent addition of seeing mechanisms through sapphire case backs.

But the reality is that we hardly understand a Newtonian universe. Studies show that many people who took university physics courses have pre-Newtonian, Aristotelian, views on how the world works (Halloun and Hestenes 1985). Conventional instruction does little to alter these beliefs.

But as imperfect as this understanding is, mechanics is a clear anchor to comprehend large components of our world; seeing things in mechanical terms can take us far. Richard Feynman (1918–1988) one of the giants in twentieth-century physics, asked himself: "If, in some cataclysm all of scientific knowledge were to be destroyed, and only one sentence passed on to the next generation of creatures, what statement would contain the most information in the fewest words?" (Feynman et al. 1964). Feynman's answer? "I believe it is the atomic hypothesis that all things are made of atoms—little particles that move around in perpetual motion, attracting each other when they are a little distance apart, but repelling upon being squeezed into one another. In that one sentence you will see, there is an enormous amount of information about the world, if just a little imagination and thinking are applied." A mechanical

picture—balls bouncing, attracting, and repelling each other—coming from one of the towering figures in quantum mechanics.

How to comprehend the world we live in, surrounded by smartphones and computers, a world based on electronics and quantum mechanics? A mechanical to electrical to digital progression did happen. It is interesting to see aspects of this transition and how ideas were presented.

Vannevar Bush's visionary essay "As We May Think" was published in 1945 in The Atlantic, just before the advent of digital computers (Bush 1945a). This piece was visionary and has had a cult following among the cognoscenti; it created multiple fields of study, such as human–computer interaction, and inspired not only a generation of computer scientists and computer engineers but also writers and artists. It predicted many aspects of our digital world. The article in *The Atlantic* was quickly followed, also in 1945, by an abridged version in *LIFE magazine*, the highest circulation magazine at the time, which condensed the main points Bush made. *LIFE* understood the value of the original article, adding this note to the piece: "*LIFE* is indebted to the editors of the *Atlantic Monthly* for permitting to bring a condensed version of their important article to its larger audience." And the importance of the article was made transparently clear in the article's long subtitle: "*A top U.S. scientist foresees a future in which man-made machines will start to think.*"

We cannot overstate the importance of how this reframing captured the imagination of the broader public. The article in *The Atlantic* was only words; the article in *LIFE* broke the piece into understandable components with short explanations. A sidebox mentioned futuristic technologies: a *Cyclops Camera*, which (worn on the forehead) would photograph anything the user would see; *Microfilm* that "could reduce the *Encyclopaedia Britannica* to volume of matchbox"; a *Vocoder*, a machine that could type when talked to; a *Thinking Machine*—"Give it premises and it would pass out conclusions, all in accordance with logic"; and, somewhat more abstractly, a memory aid called a *Memex*, a device/process that would file material linked by association. Notably, the *LIFE* article added illustrations—meant to look like actual working designs—of the proposed *Memex* desk, a thinking machine, and, crucially, an automatic typewriter.[96] The piece made it possible to imagine the mechanical-digital transition; seeing possible designs and the immediacy of an automatic typewriter was key in terms of selling the idea to the public.

We cannot resist bringing in another connection, one that beautifully bridges the invisible world of information with the visible and tactile mechanical world. Like with many things, the origins of one part of this connection, the mechanical part, is murky. In the 1930s, the Italian artist Bruno Munari created what he called "useless machines" (*macchine inutili*). Munari was initially associated with Futurists, the group of Italian artists who declared love for speed, cars, airplanes, and technology. This

96. Somewhat bafflingly, the *LIFE* editors added a staged picture of Vannevar Bush wearing a lab coat and examining glassware, as if he were a chemist, thus stereotyping him as a "scientist," not as the engineer that he was.

enthusiasm eventually translated into a love for war and Fascism, which led Munari to distance himself from the group and to counter the threat of the rule of technology by building machines that were artistic but utterly useless. This idea seems to have inspired Marvin Minsky, a graduate student at Bell Labs in 1952, to make a useless machine of his own, which he called an "ultimate machine." Minsky's mentor at Bell Labs was Claude Shannon (1916–2001). And then Shannon took on this idea as well.

Why is this connection to Claude Shannon important? Because Shannon as well seems to have had the sensitivity of an artist. In 1937, as a twenty-one-year-old master's student at MIT, he wrote a thesis demonstrating that an electrical application of Boolean algebra could construct and resolve any logical, numerical relationship; some have claimed that this was the most important master's thesis of all time. Shannon is rightly regarded as "the father of information theory," which he launched with one landmark paper, published in 1948.[7] Shannon actively engaged in making things that we would now classify as machine-artworks. He kept his own version of the Minsky-designed "ultimate machine" on his desk; Arthur C. Clarke saw it there and later commented: "There is something unspeakably sinister about a machine that does nothing—absolutely nothing—except switch itself off." Had Shannon or Minsky actively pursed variations of this idea, their names would be now in the annals of art history. One final point: Shannon's advisor at MIT was Vannevar Bush.

The Rewards of Building Things from the Ground Up
Lessons emerge from unexpected quarters: synthetic biology.

Today, we are witnessing what happens when engineers, artists, designers, and craftspeople join forces, and the "handmade" world intersects with electronics. This collision of worlds that was so carefully curated in years past is now possible with tools that let people integrate the physical and digital worlds simply and cheaply. This is the realm of the maker's movement.

The underlying philosophy of the maker's movement is making inroads in science as well. Feynman's dictum, "What I cannot create, I do not understand," is invoked often by practitioners of synthetic biology.

One strand of synthetic biology brings concepts from engineering—primarily electronic engineering—to cell biology, acting as a sort of isomorphism between cells and electronics, and seeing gene functions as components in a circuit. Employing the metaphors and concepts of electrical engineering and other fields of engineering serves to anchor a new field on an established ground. The field is still very much learning *how* to reduce an abstract functional goal (the behavior of the genetic program, for example) into a concrete physical object (such as a specific DNA sequence that is loaded into a cell, like software loaded onto a computer).

97. Information theory is at the root of signal processing and data compression. Without it we would not have the internet or mobile phones.

Early Attempts at Human–Machine Interaction
Edward Ihnatowicz

Edward Ihnatowicz (1926–1988) was a Polish cybernetic sculptor who, in the late 1960s and early 1970s, explored the interaction between robots and audiences. His first cybernetic work was the *Sound Activated Mobile*, a piece that moved in response to sounds around it; an analog circuit controlled the hydraulics to move the robot to face the direction of the predominant sound. His most significant work was The Senster, a large hydraulically actuated robot that followed both the sound and motion of the people around it, giving the impression of being alive. To detect the direction of the sound around it, the Senster used an array of four microphones. Doppler radar arrays allowed it to sense the motion of people, and a computer program controlled the hydraulic actuators to move the body. The Senster was designed such that it was attracted by sound and movement, loud noises and violent motion repelled it. The Dutch electronics giant Philips commissioned it, but it was wholly designed and built by Ihnatowicz with war surplus parts of radar technology and servo-hydraulic actuators. The Senster advanced the concept of a robot as a sensing organism; it was the first robotic sculpture to be controlled by a digital computer and the first instance of behavioral autonomy in art. Ahead of its time, it anticipated many subsequent technical research agendas.

The goal is to design and fabricate biological components and put them together—sort of like Lego® pieces—to create cells and systems that do not already exist in nature. Recombinant DNA technology can make cells express a foreign protein in large amounts, but it cannot make cells respond to stimuli in a desired manner. Synthetic biology allows creation of synthetic gene circuits and programmable cells that can perform novel functions, like detecting stimuli and reporting the event or modify the environment.

Like any emerging area, the synthetic biology field is far from monolithic, and there are several coexisting and competing strands of thought.[98] But the central idea is to think of biology as an interacting collection of parts, as engineering and hardware. The approach goes roughly like this: First, characterize the genetic sequences that perform needed functions. These are the "parts." Then, combine the parts to create small systems, or "devices," which can achieve more complex functions. Next insert these devices into cells. The idea is that since all life is based on roughly the same genetic code, synthetic biology could evolve into a toolbox of reusable, almost interchangeable genetic components—very much like electronic devices made of transistors and switches. The goal would be to have the biological equivalents of transistors and switches that could be plugged into biological systems to achieve a prescribed objective. Following this line of thought, synthetic biology could be thought of as microchip design or electrical wiring. We would then be able to program cells to produce biofuel from renewable sources, to detect toxins, to release insulin as needed, and much more. We would be limited only by our imagination.

That is the plan, but there are questions, of course. Every revolution goes too far. Invariably early promises overshoot and must be scaled down, and synthetic biology may be no exception. Can an engineering approach work that well with living systems?

Components of this approach are taking off. Synthetic biology was used to speed the development of vaccines to deal with COVID-19; a large number of companies pursuing a broad range of commercial opportunities have been formed. But another impact is at a grass root level. The International Genetically Engineered Machine (iGEM) competition is a worldwide undergraduate synthetic biology competition started at MIT in 2003. Like the maker movement, iGEM is too big to ignore. Student teams get a kit of biological parts at the beginning of the summer from the Registry of Standard Biological Parts (called BioBrick). The teams, working at their own schools over the summer, use these parts and new parts of their own design to build biological systems and operate them in living cells. In 2004, five teams from various schools participated; by 2019 it grew to 3,500 people on more than three hundred teams from forty-two countries. Thirty-two startups around the world began life as iGEM teams. This may qualify as a revolution.

98. We described one major strand of synthetic biology—that which focuses on construction of new biological programs and is metaphorically related to electrical engineering. Another strain is synthetic chemistry, which focuses on harnessing biological systems to create new molecules, materials, and substances.

Engineered Systems and Biological Systems
The ability to adapt (or not) limits analogies between systems.

There are very few molecular operations understood as clearly as a transistor. But even in this case, difficulties multiply as the networks get larger, limiting our ability to design more complex systems. Can this approach scale to biology? Biological components are far more complex. Context matters. The parts—say, a DNA sequence that encodes a specific protein to a promoter, a sequence that facilitates the expression of a gene—could have performances that change with different cell types or under different laboratory conditions.

The Registry of Standard Biological Parts has more than 5,000 parts available to order, but MIT does not guarantee their quality. About 1,500 registry parts have been confirmed as working by someone other than the person or group who deposited them, and 50 or so have reportedly failed. The concept that biological parts work like a Lego® set—the popular press portraying synthetic biology as simple design and construction—is a bit oversimplified. The broad point is seeing the birth of a new discipline and how it self-regulates. The role of standardization, which is so essential to established engineering fields, remains unclear in the new engineering discipline of synthetic biology.

The Importance of Context
Parts change roles in some systems, but not on others.

When putting together a watch, a gear is a gear no matter what watch it goes into. We can build many watches from a set of parts with well-defined roles. But context matters in biology. In mammalian cells, for example, it may happen that genes introduced into a cell may integrate unexpectedly into the cell's genome; neighboring regions can often affect expression as well. Another set of challenges appears upon integration. Even if the function of each part is known, the parts may not work as expected when put together, and this makes the design procedures in synthetic biology completely different than those practiced in other engineering disciplines. Also, many parts may be incompatible. Once constructed and placed into cells, synthetic genetic circuits can have unintended effects on their host, and variability may crash the system. Molecular activities inside cells are prone to random fluctuations, or noise. And over the long term, randomly arising genetic mutations can kill a circuit's function altogether. The complexity can become unwieldy; as circuits get larger, the process of constructing and testing them becomes more daunting. But despite all the challenges, synthetic biologists have made considerable progress.[99]

There is larger point in all this. The many difficulties facing synthetic biology offer a metaphor for the difficulties we face when translating lessons from complex systems thinking into organizations.

99. One of the most celebrated successes comes from Jay Keasling's lab at the University of California Berkeley, which uses about a dozen genes to produce a precursor of the antimalarial compound artemisinin in microbes. Keasling estimates that it has taken roughly 150 person-years of work, including uncovering genes involved in the pathway and developing or refining parts, to control their expression.

The Outsize Impact of Unconstrained Thinking
Claude Shannon

No scientist or engineer has had an "impact-to-fame ratio greater than Claude Shannon, the creator of information theory," declared *Scientific American* in 2017. This is no exaggeration. Claude Shannon (1916–2001) was the digital pioneer who developed the foundations that underlie the communications networks spanning the planet. He is known as "the father of information theory," having launched the field in 1948 with a landmark paper, "A Mathematical Theory of Communication," published in The Bell System Technical Journal. It was subsequently seen as "the Magna Carta of the Information Age" and was later republished as a book titled "The Mathematical Theory of Communication," thus replacing "a" with "the" to emphasize the importance of the work. The word "bit" appears for the first time in this work. The path for his amazing feat of creative insight had been set eleven years earlier, when as a student in MIT, he wrote the most influential master's thesis of all time, which in one sweeping blow provided the foundations of digital circuit design theory.

Shannon was trained as a mathematician and electrical engineer. He always had his feet in two camps, the theoretical and the applied, the playful and the serious. In his technical work, he combined abstract thinking with a practical approach. A man of many sides, he was a constant tinkerer; he delighted in building machines—an electronic mouse that could run a maze, chess-playing machines, the first three-ball juggling robot (he was a juggler), a flame-throwing trumpet for his daughter, and customized unicycles (he was an accomplished unicyclist, famous for combining unicycling and juggling along the long halls of Bell Labs at night). His efforts to make machines that think helped create the field of artificial intelligence, but at the same time, he was fascinated by useless machines. Shannon's publications covered topics ranging from communications to computing to juggling to "mind-reading" machines. People who do something truly fundamental are usually known for leaving a mark in one of two areas. But Claude Shannon has one of the longest "known for" lists, spanning information theory and processing, data compression, and digital electronics; his name appears in foundational concepts, like the Shannon limit, entropy, and capacity, as well as in laws and theorems. Shannon defies classification; he was a unique type of Nexus thinker.

Shannon's electromechanical mouse would move around in the maze until it found the target. If placed anywhere it had been before, because of prior experience, it could go directly to the target; if placed in a new location, it would move until it reached a location it had visited before, and then it would proceed to the target, adding this new path to its memory. This experiment is regarded as one of the first conducted in artificial intelligence.

A watch, being the archetype of a complicated system, can be designed piece by piece, with each part locked rigidly in the design function established by the master designer. Typical engineered systems are designed with a blueprint. Every part fulfils a function, and there are instructions for assembly, a guide for repairs, ways to diagnose and even to predict failures. But engineered systems can fail all at once. That is why they may have backup systems. They are not designed to adapt.

Biological systems, on the other hand, are robust; they can fail gracefully, tolerate imperfect components, and are adaptable. They can "learn" to solve new problems and evolve. They can be also highly contextual. Stem cells, for example, can take on any of many functions. There is no analog for this in the classical engineered world.

It is educational to map these qualitative concepts of engineering systems and biological systems into the design of organizations. At the heart of the Nexus thinking argument is that Nexus thinkers—people capable of bridging art, technology, and science—are an essential part of a creative system by being able to catalyze change in a network of multiple interacting parts. We want them to operate in the context of the network itself, and we want creative output to emerge. But, as in the case of synthetic biology, we should be prepared for surprises. Complex systems and planning do not work exactly well together. Unplanned behavior, sometimes good, sometimes bad, may occur; that is how emergent behavior works. We need to understand all these nuances. We need to guide behavior. What type of thinking within the Nexus is best for handling chaos and surprises?

Complex systems–based thinking is becoming essential to operate in today's world. Thriving under complexity requires us to internalize lessons that will prepare us to deal with the highly connected systems that make up world around us. Studying complex systems can reveal new insights and provide useful tools, but the main value is in shaping our thinking; being able to seamlessly view and reconcile what may appear as diametrically different perceptions of realities. The lesson of learning to see simplicity in complexity, and complexity in simplicity, contains the kernel of complementarity, the ability to synthesize opposing viewpoints.

Mariko Mori – Wave UFO,
1999–2002. Art and science
come together in an immersive
fiberglass space where a blend of
neuroscience, computer graphics,
and sound blend to create an
interactive immersive experience for
up to three participants connected
to electrodes. The brainwaves of
the participants are transmitted and
projected on to a screen that allow
them see their thoughts come to life
in color and shape.

CHAPTER SEVEN

LESSONS THAT CROSS DOMAINS

Why we benefit by extracting lessons
from art, technology, and science

We learn from the way others think.

In what ways do the lessons we learn from domains intersect and enrich each other? Artistic creativity, for example, reveals lessons for scientific and technological creativity. Our thinking spaces expand when we learn how others think.

The most memorable lessons in terms of forming mental pictures, may be those that emanate from visual arts, as the first eight lessons in this chapter do. The ninth, though visually exemplified in terms of art, could function equally well as coming from the science and technology side. The last five emanate from science/math. The important point is that these lessons be remembered and become routine thinking.

Start with a Solid Grounding and Equate Creation with Hard Work
Creative products will eventually emerge.

100. Herbert Simon (1916–2001), a political scientist, economist, sociologist, and psychologist, was uniquely qualified to comment on creativity (Simon 1983). His research ranged across the fields of cognitive psychology, cognitive science, computer science, economics and management theory, philosophy of science, sociology, and political science. He won the Turing Award in 1975 (considered the Nobel Prize in Computer Science) and the Nobel Prize in Economics in 1978. In his 1983 PNAS article Simon encapsulated three attributes that creative individuals possess: (1) a willingness to accept vaguely defined problem statements and gradually structure them; (2) a continual preoccupation with problems over considerable periods of time; and (3) extensive background knowledge in relevant and potentially relevant areas. Attribute (1) is critical, often lacking in people overtrained with analytical tools. And (3) is the one connected with the 10,000 hours popularized by Gladwell in his book Outliers, that is, working three hours per day, every day, for ten years. It is worth noting that the ten-year rule holds for child prodigies (Bobby Fischer, Mozart, Picasso) as well as for people who begin the ascent to expert later. Some individuals, however, appear to be exceptions to this rule and in a class by themselves. Évariste Galois (1811–1832) died at age twenty after penning some of the seminal ideas in mathematics, and Arthur Rimbaud (1854–1891), a towering figure in poetry, stopped writing verse at twenty.

101. The 2010 show Yves Klein: With the Void, Full Powers, organized by the Walker Art Center and the Hirshhorn Museum and Sculpture Garden (Washington, DC) in collaboration with the Yves Klein Archives in Paris, exhibited two hundred pieces. Klein died when he was thirty-four years old.

Creativity requires effort.[100] This becomes clear when we assess the evolution of a work, the arc of creation that generates the final product, especially in visual arts. Things are surely changing now, but up until the 1930s or so, even the most revolutionary artists learned by copying the classics; consider the "early" and "late" works of Willem de Kooning (1904–1997) in figure 7.1, of Pablo Picasso, or any great artist. This evolution is transparent in art but is a hidden part of science and technology. We rarely get to see the dead ends or the failed ideas of great scientists: the endpoint is all that matters. And we almost never get to see how an idea evolves in mathematics, where the final piece is stripped of unnecessary details in the scaffolding that supported the breakthrough result.

Visual arts make evolution easy to follow, and along with it, the point of hard work. At one extreme we have painters with small productions. Leonardo has just a dozen or so undisputed attributed paintings. Johannes Vermeer has 35, and Rembrandt, more typically, has 630 attributed paintings. High production is the usual rule, even in short careers. Van Gogh produced 900 paintings in the last 2.5 years of his life. Picasso's lifetime output is about 13,500 paintings and 300 sculptures; this works out to 2.2 days to produce a piece of art. The career output of Andy Warhol (1928–1987), despite 2 years of inactivity after he was shot by a deranged fan, averages to about 1.25 paintings/objects per day. René Magritte (1898–1967), in just a single year, 1928, produced more than 100 paintings. Yves Klein (1928–1962), an innovator across domains who embraced painting, sculpture, performance art, photography, music, theater, film, architecture—and whose career lasted only 8 years—produced a piece every 1 or 2 weeks.[101]

Even artists with borderline medical conditions produced prodigiously. When Edvard Munch (1863–1944) died, his bequest of works to the city of Kristiania (now Oslo) included 1,000 paintings, 15,400 prints, 4,500 watercolors, 6 sculptures, 92 sketchbooks, and thousands of letters and manuscripts. This works out to about one piece a day. The important point is that this level of production is far from rare. Many of the highest exponents in most creative fields—ranging from Freud to Stravinsky—produced prodigiously.

Fig. 7.1 An early de Kooning, *Portrait of Elaine* (1950), and a late de Kooning, *Excavation* (1960).

The picture in technology is similar. Thomas Alva Edison (1847–1931) and Nikola Tesla (1856–1943) are often compared as fierce competitors and polar extremes. But both produced a lot; Edison aided by a large group, Tesla alone. Edison is famous for inventing the phonograph, the incandescent light bulb, cement-making technology, the motion picture camera, DC motors, and electric power generation systems. Tesla, an eccentric and more solitary inventor, but more in the model of a modern electrical engineer, invented radio, fluorescent light, AC motors, and electric power generation systems. With over a thousand patents, Edison, who died at eighty-four, produced one patent every three weeks. What was behind this prodigious inventive output? Edison's biggest creation, the modern research laboratory. The organizational structure behind him left 5 million pages of organized records: that works out to about 270 pages per day in a sixty-year career span. Tesla, who died at eighty-seven, produced about three hundred patents. This works to about one patent every 2.5 to 3 months.

Quality is essential to lasting fame, but production and prestige are undoubtedly correlated, and there is lots of evidence that volume correlates with fame. As early as 1967, it was noted that Nobel Prize winners in science publish more and were more apt to collaborate than a matched sample of non-Nobel scientists. One off-scale example makes the point of amazingly high productivity clear: Bertrand Russell, mathematician-logician-philosopher, had a long and productive life (he died at ninety-eight). Along the way, he collected the Nobel Prize in Literature and published 125 books (more than 60 of these were in print when he died). This amounts to about 1.7 books per year and an astonishing production of 28 books in the nine-year period from 1951 to 1960.

Learn the craft and then set it aside.

I decided to start anew, to strip away what I had been taught. —Georgia O'Keeffe

The word "breakthrough"—a sudden advance, an important discovery—brings to mind something that pierces the boundary of a domain. But to truly represent something new, "break-with" may be a more apt term: a conceptual advance that breaks with ideas that were central to the old domain.

To truly appreciate a "break-with" requires context. We may not need to know the entire evolution of automobiles or cell phones to appreciate a new car or the latest smartphone upgrade (car enthusiasts may dispute this). It is hard to appreciate the value or novelty of end results in many areas without knowing something about the evolution of an idea, how that something came into being. Knowledge of the trajectory is essential to understanding the "break-with." In the case of Kazimir Malevich, one of his black square paintings, say, means nothing without context (figure 2).[102] From his earlier paintings, we can see the leap he took and appreciate it. We must first learn the craft, learn the background. This observation applies to nearly anything that it is novel. It is the beauty and pleasure we derive from being cognoscenti.

102. Malevich's black square paintings were followed by his *Suprematist Composition: White on White* (1918), a barely visible white square on an imperceptibly different (also white) background. This might seem to be the endpoint of pure abstraction. But we will never know if there was more to come. Joseph Stalin, a brief prison term, and modern art falling completely out of favor in the Soviet Union, got in the way. In the last seventeen years of his life Malevich abandoned abstraction; in a mild act of rebellion, he signed his paintings with a black square and went back to a representational style until his death at age fifty-six. Knowing this gives context to his work.

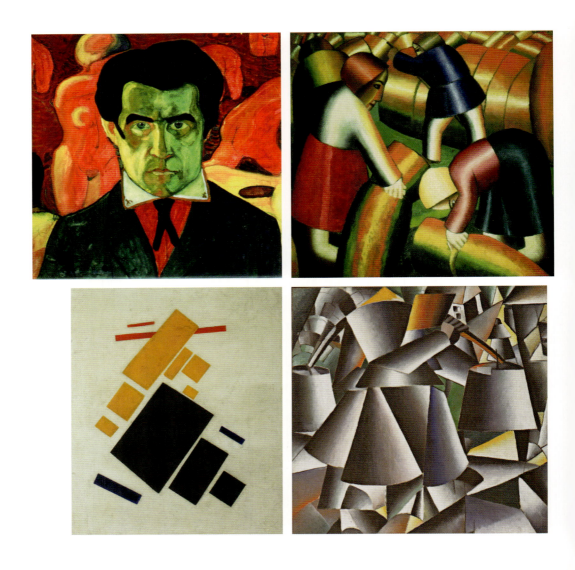

Fig. 7.2 Works that illustrate the evolution of Kazimir Malevich's (1879–1935) artistic production: *Self-Portrait*, 1910; *Taking in the Rye*, 1912; *Woman with Pails: Dynamic Arrangement*, 1912–13; *Supremacist Composition: Airplane Flying*, 1915 (dated 1914 on back); and *Black Square*, 1915.

Fig. 7.3 Pablo Picasso (1881–1973),
Baboon and Young. Picasso made
the sculpture using two toy cars for
the head, ceramic pitcher handles
for the ears, and large pot for
the belly. So assembled, the objects
cannot be seen independent
of the whole.

Learn How to Adapt and to Thrive with Constraints

Bad artists copy, great artists steal. —Pablo Picasso
The absence of constraints is the enemy of art. —Orson Welles

Adopt and adapt. Edison put it this way: "An idea has to be original only in its adaptation to the problem at hand." Picasso put it more strongly "Bad artists copy, great artists steal." Copying involves no new ideas; stealing involves picking an idea and transforming it or making it part of a much larger whole. Often a new idea is a combination of several existing ideas. This is a common occurrence in science. In fact, it is how science works: every idea is built on older building blocks. It is also the way that technology moves forward. It happens less transparently in art, and again Picasso serves as an apt metaphor. For his *Baboon and Young*, an assemblage of manufactured objects cast in bronze, he used two toy cars for the head of the baboon, ceramic pitcher handles for the ears, and a large pot for the fat belly (figure 7.3). Once combined, the objects cannot be seen independent of the whole. Thus, a theory or a technology may be the combination of several ideas or technologies. The individual ideas or pieces may be not be breathtaking, but the combination is. Like the "Rule of Three" mentioned at the end of chapter 3: combining two things is relatively easy, combining three to produce something new is much less so.

It is hard to come up with a better example of thriving within constraints than Frank Lloyd Wright's Fallingwater (figure 7.4). Edgar Kauffmann, a wealthy Pittsburgh businessman, and his wife Liliane wanted to build a house on a wooded lot that had a stream and waterfalls. Nine months after their initial meeting with Wright, Kaufmann called Wright and told him that he would be visiting later in the day to see the plans. Wright had done nothing. But after breakfast that morning, Wright drew the plans in two hours, the time it took Kaufmann to arrive at Wright's studio. Wright placed the house on top of the waterfall, rather than below, as the Kaufmanns had expected. In 1991, the American Institute of Architects named Fallingwater the "best all-time work of American architecture." Wright saw the cascade as an opportunity and part of the design rather than as a constraint.

Do Not Converge Too Quickly—Step Back and Look at the Entire Picture
Force yourself to look at the problem from afar—everything can be improved by removing unnecessary details.

It is possible to solve a problem correctly but end up solving the wrong problem. Most failures belong in this category. It is important not to fall in love with the "final" product; be willing to completely rethink and modify things at the end. We must ask, "Is this the best we can do?"

Although a great masterpiece may appear effortless, it likely involved numerous unseen sketches. The amount of time spent doing those sketches may be much greater

Fig. 7.4 Frank Lloyd Wright (1867–1959), Fallingwater (1935), Mill Run, Pennsylvania.

than the time it took to execute the final piece. But once a project is finished, we must still be willing to completely rethink and modify things. Once again, a Picasso vignette provides a great example of this lesson.

William E. Hartmann, who was a senior partner at the architectural firm of Skidmore, Owings & Merrill, was visiting Picasso in Mougins, France, when he presented the artist with a catalog of a 1968 Chicago exhibit, where Picasso's *Mother and Child* appeared. "The painting was originally different," Picasso reportedly said. "There was a bearded man holding a fish over the baby's head." He proceeded to give Mr. Hartmann the fragment he had cut off from the left side of the painting (figure 7.5). Both the fragment and the painting are now at the Art Institute of Chicago, though rarely shown together. Can we take drastic action when things appear to be finished?[103]

Take Time to Reflect, but Do Not Wait for Divine Inspiration

La inspiración existe, pero tiene que encontrarte trabajando (Inspiration exists, but it has to find you working). —Pablo Picasso

"Inspiration is overrated," said the artist Chuck Close. Masterpieces are the occasional result of a commitment to continual work. But how can you force yourself to work? If ideas do not come, we should follow this dictum about painting from Jasper Johns (b. 1930): "Do something, then do something else to it." Do not wait for "the idea," but also know when the waiting has gone on long enough. The painter Robert Motherwell (1915–1991) gives clear limits: "If you cannot find your inspiration by walking around the block one time, go around two blocks—but never three." Advice in this area is plentiful: "The secret of getting ahead is getting started," Mark Twain said. John Cage (1912–1992), one of the most influential composers of the twentieth century, has even stronger advice: "It does not matter where you start as long as you start."

Two points connect the seemingly contradictory admonitions "take time" and "do not wait." The first is having a routine. A reoccurring daily routine, as the next examples suggest, seems a prerequisite for long-lasting productivity; nearly all great artists and creative people had some type of routine (Currey 2013).

The English Victorian-era writer Anthony Trollope (1815–1882) was amazingly prolific. He wrote forty-seven novels, eighteen works of nonfiction, twelve short stories, two plays, and large number of articles and letters. He achieved this astonishing productivity by writing in fifteen-minute blocks, and he demanded of himself three thousand words every morning. Buckminster Fuller catnapped for approximately thirty minutes after each six hours of work; Ernest Hemingway wrote every morning as soon after first light as possible, standing with the typewriter at chest level on a makeshift "desk" in his bedroom. Thomas Wolfe of *Look Homeward, Angel* fame, wrote standing in the kitchen.

103. Despite their popularity, "less is more" and "keep it simple" do not seem to be the mottos most people live by. And most people do not heed this advice from the sixth-century BCE Chinese philosopher Lao-tse (Laozi): "To attain knowledge, add things every day. To attain wisdom, remove things every day." It appears that the standard human reaction, when confronted with change, is to add rather than subtract. This subject is explored in the journal *Nature* by Adams et al. (2021).

Fig. 7.5 Pablo Picasso (1881–1973).
Maternity on the sea side, 1921 and
*Fragment of Maternity on the sea
side*, 1921.

Igor Stravinsky worked on his compositions daily, with or without inspiration, but needed complete isolation. Descartes and Truman Capote wrote in bed, and Rossini composed in bed. And even though he completed around forty operas in less than twenty years, Rossini was a legendary procrastinator who operated on impending deadlines. Charles Dickens needed absolute quiet; Nikola Tesla worked best in the dark. Picasso forbade anyone from entering his studio without his permission. Maya Angelou could not write at home; she did so in hotels and motels. "Cannot work in pretty surroundings," she said. John Updike had an office above a restaurant and wrote every morning, three or four pages a day, except Sunday. Others needed stimulants. Honoré de Balzac's frantic writing schedule was fueled by coffee, up to fifty cups a day, according to one estimate. Paul Erdős, an amazingly prolific and eccentric mathematician, was powered by strong espresso. "A mathematician," he liked to say, "is a machine for turning coffee into theorems." Less worthy of emulation were Ayn Rand, who pushed herself with Benzedrine, and Jean-Paul Sartre, who worked three hours in the morning and three hours in the evening, somehow also consuming lots of amphetamines, pipes stuffed with black tobacco, and more than a quart of alcohol daily—wine, beer, vodka, and whiskey. Many creative people, with or without stimulants, are remarkably structured. Roy Lichtenstein, for example, liked to have two or three projects going at once, but structured his day with a morning session from 10 a.m. to 1 p.m., a second session, after lunch, from 2:30 to 6 p.m., and often a third in the evening. Henri Matisse (1869–1954) left behind a vivid visual directive: you go to the study, and you paint (figure 7.6).

The second admonition—take time to reflect—is more about deciding when to start a project, how to tackle a new non-routine problem, and what constitutes the optimal amount of knowledge to tackle a problem. This is a delicate balance of knowing enough and knowing the right things, but also of not knowing too much and not being too influenced by the past. The "not knowing too much" part may sound surprising, but it has two clear implications. One is to not second-guess your ideas, the notion that "if things were that simple, someone would have done this before." The second aspect has to do with being fearless, with being unimpressed and uncontaminated by the past.[104]

It is hard to divide the entire spectrum of human creative output in two clean buckets, but a binary classification serves to anchor some ideas that touch on the "unimpressed and uncontaminated by the past" component of this issue. So here we turn to a classification of innovators and experimenters as, respectively, young geniuses and old masters. This idea originates with the economist David Galenson (Galenson 2007).

Young geniuses can be thought of as "conceptual innovators," those who are fearless and make their best work while young. These are the people that popular imagination equates with genius. Experimenters evolve more slowly; the later works of these mature artists are often the most highly innovative; their genius takes years to develop.

104. A notable example is Maya Lin's Vietnam Veterans Memorial, designed while she was an undergraduate at Yale.

Fig. 7.6 Do not wait for divine inspiration. One of Henri Matisse's most famous paintings is *La Danse*, which is housed at the State Hermitage Museum in St. Petersburg. *Dance I*, or the first version of *Dance*, a large oil on canvas at New York City's MoMA, is the most famous of the many preparatory sketches that Matisse did for this painting. When Matisse was short in inspiration, he made paintings of his paintings; being in his studio and not painting was not an option. Versions of La Danse appear in the background of his studio in more than one of his paintings, as in *Les Capucines (Nasturtiums with The Dance II)*.

F. Scott Fitzgerald wrote *The Great Gatsby* at twenty-nine. Giorgio de Chirico may have peaked at twenty-six. Orson Welles made *Citizen Kane* at twenty-six. Edvard Munch, Herman Melville, Andy Warhol, Frank Stella, and Jasper Johns hit high marks while young.

On the other hand, Auguste Rodin, Mark Twain, Alfred Hitchcock, Willem de Kooning, Mark Rothko, and Robert Motherwell are examples of old masters, or what Galenson calls "experimenters." Frank Lloyd Wright created Fallingwater when he was seventy and designed the Guggenheim in New York City several years after that; those two works are among the most famous of his career.[105]

Louise Bourgeois (1911–2010) finished her last pieces a week before she died. Experimenters keep learning and improving through their lifetimes.

In visual arts, the archetypical counterparts to Picasso are Paul Cézanne and Henri Matisse. Picasso's *Les Demoiselles d'Avignon*, regarded by critics as the most important painting of the past hundred years, was completed when Picasso was twenty-six. The highest-priced paintings of Cézanne are those he made shortly before he died at age sixty-seven. Cézanne is the third-most-illustrated French artist of the twentieth century; he appears copiously in art books. But just 2 percent of what is in art books represents what he created in his twenties. Cézanne seemed to accelerate with age; 60 percent of his work was completed after he turned fifty, and more than one-third during his sixties. Another interesting Picasso/Cézanne observation: Picasso signed nearly everything he did immediately, whereas Cézanne signed less than 10 percent of his work. It is as if experimentalists never know when their work is finished.

The same two bucket classification may apply to poets. T. S. Eliot, Ezra Pound, and Sylvia Plath were early achievers and thus fall into the conceptual category. Eliot wrote "The Love Song of J. Alfred Prufrock" at twenty-three and "The Waste Land" at thirty-four. Pound published five volumes of poetry before he turned thirty, but by the time he turned forty he had essentially exhausted his creative output.

On the other hand, experimental poets like Wallace Stevens, Robert Frost, and William Carlos Williams took years to mature. Both Pound (a conceptual) and Frost lived into their eighties, but of Pound's anthologized poems, 85 percent are from his twenties and thirties. Frost, an experimenter, got a late start. He has more poems in anthologies than any other American poet. More than 90 percent of them were written after his fortieth birthday. One could argue that the Renaissance artist Raphael was conceptual. He died young, at thirty-seven, so we do not know if he could have aged into becoming an experimenter. But we do know that Leonardo, Michelangelo, and Rembrandt were experimenters. The divide is often unclear. What to make of Picasso and *Guernica*, which he painted at fifty-six and which remains one of his most famous works?

Counterexamples are also at play in physics, a place where conceptual innovators reign (Chandrasekhar 1987). James Clerk Maxwell, Sir George Stokes, and Einstein did their best work while young. (Einstein published his amazing series of papers at twenty-six; Niels Bohr did his at twenty-eight.) But then we have Lord Rayleigh, who won the 1904 Nobel Prize in Physics, at sixty-two, and who produced steadily for over fifty years.

Nevertheless, the young person's creative mystique in science is etched in our brains. G. H. Hardy, one of the greatest mathematicians in the early part of the twentieth century, declared in his short but influential book *A Mathematician's Apology*: "No mathematician should ever allow himself to forget that mathematics, more than any other art or science, is a young man's game" (Hardy 1940). Isaac Newton made most of his discoveries in his twenties (Brodetsky 1942). And Einstein is quoted as saying that "a person who has not made his great contribution to science before the age of thirty will never do so."

Yet a 2011 analysis of 525 Nobel Prizes awarded between 1900 and 2008 in physics, chemistry, and medicine—182 in physics, 153 in chemistry and 190 in medicine—shows that this is not quite right (Jones and Weinberg 2011). With the notable exception of the quantum mechanics discoveries in the 1920s and 1930s, the trend across all fields is toward researchers being older when they produce their greatest work. Comparing before 1905 with after 1985 is revealing: The average age in physics went from thirty-seven to fifty; chemistry from thirty-six to forty-six, and medicine from thirty-eight to forty-five. A shift from theoretical work, toward experimental work, may be one explanation; another that is that scientists may now be required to have more basic knowledge. The anomaly of quantum physics may simply be that when there is a scientific revolution, the old, accumulated knowledge ceases to be an advantage; in fact, it becomes a disadvantage. There does not seem to be a comparable study for mathematicians (where the Abel Prize and the Fields Medal serve the role of the Nobel Prize).

Pick a Style and Own It, but Be Conscious of Repetition
I have forced myself to contradict myself in order to avoid conforming to my own taste. —Marcel Duchamp

Style matters: it is what makes artists, scientists, and engineers stand out in a crowd of generic sameness. Aesthetic appeal is as important in science as it is in art. The way an argument or theory is put together in science is crucial to the idea's acceptance. Same for mathematics; many top mathematicians have commented on this. "Beauty is the first test: there is no permanent place in the world for ugly mathematics," G. H. Hardy said.

The ultimate in style is being recognized by a word. Somewhat paradoxically, a one-word description captures many innovators in visual arts. Consider how these pairings demonstrate lifetimes of work encapsulated by a single word.[06]

Yves Klein and blue
Piet Mondrian and geometry
Lucio Fontana and slashes
Kazimir Malevich and squares
Yayoi Kusama and dots
Jackson Pollock and drippings
Christo and wrapping
Alexander Calder and mobiles
Andy Warhol and pop
Jasper Johns and the US flag
Joseph Cornell and boxes
Cy Twombly and scribbles
Dan Flavin and fluorescent tubes
Donald Judd and boxes
Roy Lichtenstein and cartoons

One-word descriptions can encapsulate styles. Style, however, should never get in the way. There is an unavoidable, all-too-human tendency to stick with a style, a way of doing things, long past its useful limit. Success, especially early success, has two diametrically opposed drawbacks: One of them is repetition, turning out work all in the same mold and becoming a self-caricature. The other is the inability to live up to our vision of what we should do, and therefore become paralyzed or fall prey to "importantitis," a word coined by the arts and culture critic Terry Teachout.[107] "The best way to make a bad work of art is to try to make a great one," he declares (Teachout 2008). This dictum extends beyond art.

When Robert Rauschenberg (1925–2008) won the first prize in the Venice Biennale in 1964, he telephoned a friend in New York and asked him to destroy his silk screens, thereby ensuring that he would not repeat himself and would be forced to move on to something new.

Johannes Brahms (1833–1897), an uncompromising perfectionist, destroyed many more works than he published, and some he never published. He began to compose quite early in life but later destroyed most copies of his first works. This is one outcome of imposing on oneself too high a standard.

More tragic is the case of constantly shooting for the stars after an initial big success and producing much less. Teachout (2008) points to the immensely talented composer and conductor Leonard Bernstein, who may fit in this mold when it comes to his

106. Inspired by the poster "Art History" by Vuk Vidor.

107. Teachout, describing the tendency of certain successful artists to fail, mentions Ralph Ellison, who was "strangled by self-consciousness" in his unsuccessful efforts to write another novel as worthy of praise as his 1952 work *Invisible Man.*

theatrical career. Bernstein set Broadway on fire in 1957 with *West Side Story*. His next show, *1600 Pennsylvania Avenue*, produced nineteen years afterward—an interim marked by stellar conducting for the New York Philharmonic and international orchestras—closed after seven performances. Orson Welles made the cover of *Time* magazine at twenty-three for playing an octogenarian in a George Bernard Shaw play, just five months before he narrated the radio adaptation of H. G. Wells's *War of the Worlds*. Two years later, RKO gave Welles a near-blank check, which he used to make *Citizen Kane*, a film acclaimed as a masterpiece. After that, he was convinced he could do no wrong. The result? Movies that wanted desperately to be masterpieces but fell short of the mark.

At the other extreme, Teachout (2008) mentions the lifelong productivity of the great choreographer George Balanchine, who turned out a ballet or two every season. Most were brilliant, a few were not, and whether they received critical acclaim or not, he moved on to the next one, never looking back. "In making ballets," Balanchine said, "you cannot sit and wait for the Muse."

Be Ready to Prepare the Ground
Every innovator is a self-promoter.

To add new ideas to the canon is to innovate, and innovation is never easy. Having an idea accepted by a field depends on how the new idea connects with the canonical knowledge of the times. This requires work: the innovator must prepare the ground, connecting the idea to previous ideas, diminishing the shock of the new. This was said best by William Wordsworth (1770–1850) in the context of literature: "Never forget what I believe was observed to you by Coleridge, that every great and original writer, in proportion as he is great and original, must himself create the taste by which he is relished" (de Selincourt 1969).

Be prepared to prepare the ground. Self-promotion has mattered since the beginning of time. Galileo was one of the greatest physicists who ever lived. But he was also an astute campaigner who sold his inventions—telescopes—to the Venetian navy. When Galileo wanted to persuade his readers of the validity of his viewpoint, he created his controversial *Dialogue* and included a fictional opponent, a straw character called Simplicio, patterned after a medieval scholar. At some point, Galileo crossed the line with the Church; Simplicio had become the Church. And we all know what happened: public repentance and house arrest.

The list of famous creative people who were inveterate self-promoters is long. Michelangelo, Freud, and Walt Whitman were notorious self-promoters. Self-promotion may even involve changing the past. In fact, only by reframing the past can one change how others see the present. Jorge Luis Borges captured this point in his essay "Kafka and his Precursors" when he wrote: "In the critic's vocabulary, the word

'precursor' is indispensable, but... the fact is that every writer creates his own precursors. His work modifies our conception of the past, as it will modify the future."

Be Conscious of the Judgment of the Times (and Possible Revisions)

Reputations do not last forever; obsessing about reputation can be paralyzing.

The art historian Gregory Hedberg, director for European art at Hirschl & Adler Galleries, said that with metronomic regularity, the dawn of each new century has seen a collapse of one reigning taste and the establishment of another. William-Adolphe Bouguereau was one of the victims of these collapses. In the summer of 1985, Tom Wolfe, the author of *The Painted Word*, gave a lecture at the Parrish Museum in Southampton, New York, titled "Picasso: The Bouguereau of the Year 2020." This prediction did not come to pass, but revisionism in art is always a possibility.

Music provides many examples. Revered figures are forgotten, and others emerge (Gustav Mahler was "discovered" by Leonard Bernstein; Georg Philipp Telemann was better known than his contemporary Johann Sebastian Bach; Charles Ives was mostly unrecognized during his lifetime). There are numerous examples supporting the romantic notion of the unrecognized genius. But clear examples notwithstanding—Van Gogh in painting, Évariste Galois in mathematics—the unrecognized genius is mostly a myth.[108]

The converse seems closer to the truth; reputations diminish after death. Carlo Maratta (1625–1713), the last of Raphael's line—and after the death of Giovanni Lorenzo Bernini (1598–1680), possibly the most important European artist of his time—is an early example. Victor Vasarely (1908–1997), the "grandfather" of Op art, is a somewhat more recent one. The jury is out for the work that Willem de Kooning (1904–1997) created in the last few years of his life. It happens in science as well, though on a smaller scale. Johan Poggendorff (1796–1877) was arguably one of the most influential physicists of his time. But that influence was tied to his being editor and gatekeeper (for fifty-two years) of the most important scientific journal of its time, *Annalen der Physik und Chemie*. His influence waned after his death. It takes hard work to make an idea stick, but often an idea dies with the creator. The cases of posthumous recognition are few. Death is not a good career move.

Learn to See Simplicity in Complexity and Complexity in Simplicity

Develop the ability to see the patterns and implications of simple pictures and the simplicity hidden in complex ones.

A lesson that many theorists immediately understand is the ability to see simplicity in complexity and complexity in simplicity. This is possibly the most significant lesson, and we illustrate it with *The Bull*, a series of eleven lithographs by Picasso.

108. Few stories of early genius match that of the young French mathematician Évariste Galois (1811–1832). While still in his teens, he solved a problem that had gone unsolved for 350 years, yet his papers were rejected, and he was twice denied admission to the prestigious École Polytechnique. A fiercely independent spirit, Galois became heavily involved in political protests and was sentenced to six months in prison for illegally wearing a uniform. While in prison, he continued to develop his mathematical ideas until released in April. In May he died from injuries sustained in a duel; he was twenty years old. Much romanticism colors accounts of his life. The night before the duel he wrote feverishly, composing a letter that would become his mathematical testament. The famous mathematician Hermann Weyl described it: "This letter, if judged by the novelty and profundity of ideas it contains, is perhaps the most substantial piece of writing in the whole literature of mankind." Galois's papers were officially published eleven years after his death.

Reassessing the Past
Sophie Gertrud Taeuber-Arp

Reputations in art are not static, but revisions are slow. The past is constantly reexamined: champions may emerge as critics, art historians, museum directors, and galleries collectively identify artists who were not sufficiently recognized in their lifetimes. Sophie Gertrud Taeuber-Arp (1889–1943) was a Swiss artist who did it all, and her reputation is now ascending. Taeuber-Arp was a central figure in many of the most important avant-garde movements of the first half of the twentieth century; she spanned a wide range of mediums as a painter, sculptor, dancer, and teacher—as well as a designer of textiles, fashion accessories, and interiors. She designed marionettes, puppets, costumes, and sets for her performances as a dancer, choreographer, and puppeteer at the Cabaret Voltaire, the birthplace of Dadaism. She was married to Jean Arp, who got her into inner art circles. But even though many museums around the world include her work in their collections, her reputation was eclipsed by her more famous husband. After she died of accidental carbon monoxide poisoning, Jean Arp organized a catalog of her work and tried to promote her legacy, even producing a number of posthumous "re-creations" of her artworks. Only after World War II did she begin to gain substantial recognition. She was the only woman depicted on the eighth series of Swiss banknotes; her portrait was on the 50-franc note from 1995 to 2016, and her artwork appeared on Swiss postal stamps. Nevertheless, even though scholarship on her work still lags behind those of her contemporaries (Mair 2018), she is now generally accepted as being in the first rank of classical modernists.

Pictured here are *Self-Portrait with Dada Head*, 1920; *Dada Head*, painted wood, 1920; the marionettes *König Hirsch: Wachen (King Stag: Guards)*, and *Composition of Circles and Overlapping Angles*, 1930.

Picasso made these lithographs between December 5, 1945, and January 17, 1946. Figure 7.7 shows how eight of the eleven bulls in the series reveal the evolution of an idea, a beautiful example of the concept "going from complex to simple" or its reverse, "going from simple to complex." Figure 7.8 distills the idea. This example may have more than a passing connection with seeing details and the big picture and how the left and right brain handle information about the world.

We use the terms "right-brain / left-brain" as useful metaphors.[109] But we should point out that in general, this is a very active area of research in cognitive neuroscience with studies spanning from the evolutionary origins of hemispheric specialization (speech, right handedness, and facial recognition seem to be traceable back to brain asymmetries in early vertebrates), to plasticity and adaptation (cognitive development following injury). The fact that the two cerebral hemispheres are differently specialized with respect to speech was observed as early as 1865 by Pierre Paul Broca. Studies further demonstrating that the left and right hemispheres are each specialized in some different tasks can be traced back to Roger Sperry's experiments in the 1960s at Caltech, for which he received the 1981 Nobel Prize in Medicine. Sperry studied "split brain" patients, patients with a special kind of epilepsy (epilepsy as a result of excessive signaling of nerve cells) that had been treated by severing the main connection between the two hemispheres of the brain, the *corpus callosum*. Severing the connection prevented seizures from spreading from one hemisphere to the other and from reverberating and strengthening across both. Thus, although this surgery is a severe treatment, it is also very effective.

After surgery, the two halves of the brain have a reduced capacity to communicate with each other. Each hemisphere is still able to learn, but since there is no connection between hemispheres, information is carefully presented to one hemisphere at a time, and each hemisphere knows little of what the other hemisphere has experienced or learned. The studies showed that the left and right hemispheres are specialized in different tasks; until then, the prevailing wisdom, extrapolated from the language results of Broca and many others, was that most "high-level" functions, such as language, resided in the left side. Importantly, these researchers found that the right hemisphere was capable of rudimentary language processing. Later studies show that, despite the left-hemisphere advantage for many linguistic tasks, the right hemisphere contributes to processing emotional context, gist, and more. Left-hemisphere processes are particularly adept at denotation—understanding and storing the primary or definitional meanings of words. Nonetheless, the right hemisphere contributes to understanding connotation, everything associated with words beyond what may be covered in a dictionary: nuances, poetic meaning, and emotional content in a sentence or a metaphor.

Research in this area moves fast, and what was once new may quickly become dated. But we cannot resist pointing at studies from over thirty years ago that focused on visual perception and using them as a visual anchor to the metaphor. Dean Delis

109. *Analogies and metaphors both have supporters and critics. In the most successful cases the inspiration of the initial analogy gets forgotten, except by a few scholars. For example, the word "cell" in biology was used first by the British physicist Robert Hooke when looking at cork under his microscope, in reference to the small rooms, or cells, that monks had in monasteries. Few would argue with the various references to the solar system depicted as a clock, but some would regard as needlessly poetic the descriptions of universe as "elegant," cosmos being equated with "a string symphony," depicting thermodynamics and gravity as being in an "endless battle," and characterizing genes as "selfish." No one in economics seems to have taken Adam Smith's "invisible" hand as more than a metaphor for the unseen forces that move a free-market economy. Right-brain and left-brain are shortcuts, ways to aggregate different modes of thinking, not unlike the fast, intuitive, and emotional traits encapsulated as System 1, and the slower, deliberative, and logical behaviors ascribed to System 2, employed by Daniel Kahneman in his bestseller* Thinking, Fast and Slow *(Kahneman 2011).*

and others at the University of California, San Diego, studied adults and children with massive unilateral [one-sided] brain damage. Like many other studies in the field, this one involved showing the subjects a picture, a visual hierarchical stimuli, consisting of larger forms constructed from smaller forms—for example, a large letter H that is drawn from many small letter As. (These types of images are referred to as Navon patterns, after David Navon [1977], an Israeli psychologist.) The right-hemisphere-damaged patients made more errors in remembering the larger forms relative to the smaller forms, leading them to recall a group of As without any particular structure, whereas the left-hemisphere-damaged patients made more errors in remembering the smaller forms relative to the larger forms, as evidenced by them remembering a single large H (figure 7.9). This seems to suggest that the left-hemisphere sees the trees, whereas the right-hemisphere sees the forest.[110]

Now back to Picasso. Picasso was a pioneer but, by his own admission, also a thief. "Bad artists copy, great artists steal," he said, and steal he did. Theo van Doesburg (1883–1931), with his Cow series, was thirty years ahead of Picasso (figure 7.10). Was Picasso aware of this? But similarly, was van Doesburg, in this last image shown here, influenced by Piet Mondrian (1872–1944) or Malevich? It is hard to be definitive on matters of influence.

Understand How Models Help Us to See Simplicity in Complexity
Simple caricatures of reality yield considerable insight.

We have given complex systems theory a central role in our narrative. Other elements of physics, such as models of phase transitions and self-organized criticality, could have been powerful aides in the story we have developed as well. But before making one more point regarding complexity—in this case, how large consequences can stem from small actions—we ask the question: *What are models?*

Models exist along a spectrum: from those capturing the essential aspects of phenomena to those realistically representing engineered systems, such as the models that can simulate, in almost complete detail, the fluid dynamics and performance of a jet plane. When models can capture details, they become simulations. These 'hyper-realistic' models can mimic reality. Planes, for example, can be flown on a computer (a flight simulator) before a pilot is put on an actual plane. Invisible equations interface humans with a simulated reality.

Most people grasp the value of hyper-realistic models, even though only experts can be familiar with all the details that go into them. But oddly enough, most people outside science *do not understand the value of simple models*—models that are caricatures of reality and are, in fact, perfect examples of a quote attributed to Einstein: "Everything should be made as simple as possible, but no simpler."

110. Studies exist linking neurophysiological measurements of brain connectivity with the degree of creative reasoning. A recent study (Durante and Duson 2018) suggests that highly creative individuals have significantly more connections between the right and left hemispheres of the brain. These results need careful interpretation. Assuming that brain connectivity is properly measured and quantified, that leaves the rather thorny question of how to measure creative reasoning. There is no general agreement about how to do this. The title of a recent work, "Naming Unrelated Words Predicts Creativity," represents an attempt to address this question (Olson et al. 2021).

Fig 7.7 Picasso's *The Bull (Le Taureau)* shows the evolution of an idea in a series of lithographs the artist completed in little more than a month, beginning December 5, 1945. The entire series includes eleven prints. Here we reproduce eight, in which Picasso reduces the bull to just a few lines: (a) 1st state, (b) 2nd state, (c) 4th state, (d) 5th state, (e) 6th state, (f) 8th state, (g) 10th state, (h) 11th state.

Fig. 7.8 Learn to see simplicity in complexity and complexity in simplicity. From left to the center of the figure, ideas converging into a single concept. From center to right, a simple concept generating multiple possibilities.

Our first example of a simple model is the propagation of fire in a forest. A forest is not a checkerboard, but in this model the trees are represented as randomly occupying a fraction of squares in the board; the fire propagates if trees are adjacent to the face of a square. Fire propagates through these faces—up, down, left, and right, but not diagonally. What is the value of this model? It shows that there is a critical density of trees, above which a fire will propagate through the entire forest; below that the fire remains confined. Will this model tell a forester how many trees to cut or how much vegetation should be removed to avoid forest fires? Of course not. But it gives insight into the underlying phenomenon, something that is called a percolation threshold, and how remarkably dependent this threshold is on the density of trees. It would be hard to get this insight without the assistance of a model.[111]

Our second example models social segregation in cities. In this model (figure 7.11), we have two types of individuals, say oranges and blues who live in a city that is also represented as a checkerboard.[112] The oranges and blues are randomly distributed throughout the city. The number of oranges and blues are equal, but set at less than 50 percent, so that empty spaces are present. The orange people and the blue people get along with each other. But both the oranges and the blues want to live near at least *some* people of their own color. That makes many individuals unhappy since they do not have enough neighbors of the same color. Unhappy individuals move to new locations, tipping the balance of the local population, prompting others to leave. If orange people move into an area, local blue people might leave, and vice versa.

Rearrangements take place and, over time, the number of unhappy individuals decreases, until everybody is happy. What is the insight of the model? That relatively weak individual preferences can lead to significant overall segregation.

When this model was first developed, many were very surprised by this result. For example, in the case where all individuals wanted at least 30 percent of neighbors of the same color, the result would end up (on average) with 70 percent same-color neighbors. "The interplay of individual choices... is a complex system with collective results that bear no close relation to the individual intent," wrote the creator of the model, Thomas Schelling. The title of his book on this topic perfectly captures the insights stemming from the model: *From Micromotives to Macrobehavior* (Schelling 1978; Schelling went on to win the 2005 Nobel Prize in Economics). Can we add more details to these models? Most definitely: different types of trees, different types of housing. But then we may end up missing the forest for the trees: trapped in the details, we may lose sight of the big picture.

These two models are examples of agent-based models (Wilensky and Rand 2015) we saw in chapter 6. and which are central to complex systems theory. They also illustrate a forthcoming lesson: "Be prepared for large consequences stemming from small actions." But most importantly, both examples, forest fire propagation and segregation in

111. The concept of percolation threshold shows up in numerous contexts: flow in porous media, such as oil moving in fractured rock; electrical conductivity of composite materials in materials science; polymerization in chemistry; cell-phone connections; how the fragmentation of an environment may impact animal habitats; and disease transmission, when an infection becomes a pandemic. It is clear that the value of a successful model resides in its power to abstract reality.

112. In the first version of this model, individuals lived on a line, that is a one-dimensional city (Schelling 1971).

AA AA
AA AA
AA AA
AA AA
AAAAAAAAA
AA AA
AA AA
AA AA
AA AA

Healthy brain

Damage to right hemisphere
(only left brain active)

Damage to left hemisphere
(only right brain active)

Fig. 7.9 Brain-damaged patients
were asked to redraw a picture
from memory. The result shown
at left corresponds to patients
with a healthy left hemisphere
(severe damage limited to the right
hemisphere), and the result on
the right corresponds to patients with
a healthy right (and damaged left)
hemisphere (Delis et al. 1988).

cities, exemplify abstraction capturing the essence of the problems, and they encapsulate the lesson of seeing simplicity in complexity. They can be made more complicated (and indeed they have been) but cannot be made simpler.[113]

Embrace Opposites
Develop the habit of seeing the other side.

The virtues of embracing opposites are advocated in the "learn to see simplicity in complexity and complexity in simplicity" lesson. But the "embracing opposites" lesson goes beyond that. It forces us to contemplate the other side or surround ourselves with people (and arguments) who can present the opposite viewpoint.

Opposites often connect in subtle ways. Simplicity and complexity, representing two such extremes, serve to illustrate some key points that apply to many other pairs of opposites. The first is that simplicity/complexity is a false dichotomy. Everything may be complex or simple depending on how we look at it but, more importantly, both may occur at the same time. The study of complex systems, at its root, is the study of the relationship between simplicity and complexity. The arrow connecting simplicity and complexity works in two directions. One direction, simplicity → complexity, is how complex behavior can arise from simple elements and interactions. The other direction, complexity → simplicity, is how complex behavior can be explained (emerges) in terms of simple elements. They are two faces of the same coin. Many such opposites work the same way.

An example comes from design. Good design—of objects, processes, or systems—hides complexity. It takes effort to make things simple. Here we recall a quote from Antoine de Saint-Exupéry (1900–1944): "Perfection is attained not when there is nothing more to add, but when there is nothing more to take away." This means taking features away from an object or process as well as finding the sweet spot on how we interact with the system. An example? The value of Apple can be traced back to its clarity and simplicity: forget about the instruction manual; just take it out of the box, plug it in, and use it. Make the interaction simple and hide the underlying complexity. Perfection is finding the equilibrium.

Always Be on Guard for Unexpected Connections
Think in context; recognize the possibility of hidden connections and being unsurprised by seemingly unexpected linkages.

Once trained, we can find examples of hidden connections everywhere. Ecological networks are examples of how our normal modes of thinking can fail spectacularly because our intuition is not prepared to see faraway connections. Sometimes the effects

113. The plea "understand the value of models" and the statement "simple caricatures of reality yield considerable insight" are appeals for us to benefit from the guidance of science. Which brings to mind a central point of the Nexus argument: there is more analysis in art than perceived by science and more creativity in science than perceived by art. It is appropriate here to quote Leonardo da Vinci: "Those who fall in love with practice without science are like a sailor who enters a ship without a helm or a compass, and who never can be certain whither he is going." Leonardo, the embodiment of a Nexus thinker, was more of a rationalist than most believe. "Good judgment," he said, "is born of clear understanding, and a clear understanding comes of reasons derived from sound rules, and sound rules are the issue of sound experience—the common mother of all the sciences and arts."

Fig. 7.10 Theo van Doesburg
(1883–1931). Studies for the series
Composition (The Cow).

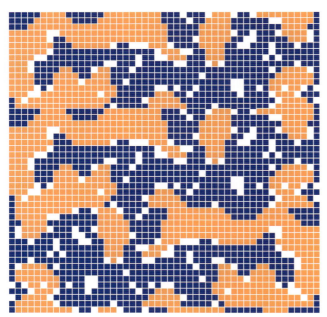

Fig. 7.11 Segregation in cities. The city, represented by a checkerboard, has two kinds of people, orange people and blue people. There are two parameters in the model. In this example an equal number of orange and blue people occupy 90 percent of the city—unoccupied spaces are shown in white—and both groups are happy if 50 percent of their neighbors are of the same color. In the top left figure individuals are placed randomly: the magnified view shows, with crosses, the number of unhappy individuals. The figure on the bottom left shows the city when all individuals have switched locations so that all are happy. A 50 percent tolerance level results in a highly segregated city.

are linear: A implies B and B implies C. But more often, connections are far less visible. For example, an ecological cascade of extinctions may be triggered by many reasons, such as the disappearance of a key top species or the introduction of an invasive species in the ecosystem. Loss of a top predator, for example, may lead main prey to overexploit its own food sources, leading to its own extinction and so on. A classic example is the overhunting of sea otters from the seventeenth to twentieth centuries. The primary food source of the sea otter is the sea urchin, and the main source of food for the sea urchin is kelp. With fewer otters, sea urchins overexploited kelp, and with no kelp, sea urchins became extinct as well. And since kelp forest ecosystems serve as homes to many other species, the loss of the kelp ultimately caused a string of other extinctions. These ecosystems have not yet recovered. The cascade of extinctions along the Pacific Coast continues to the present day.

Recently, bee colonies have been disappearing, with some areas seeing reductions of up to 85 percent of their bee population. Several possible culprits have been named, including pesticides and electromagnetic radiation coming from wireless technology and telecommunication. Why is this significant? Bees pollinate 70 percent of the more than one hundred crop species that feed 90 percent of the world's population. If bees continue to disappear, worldwide food chain supplies will be affected.

Natural disasters also intersect with human networks. The devastating Tōhoku earthquake and tsunami struck the Pacific Coast of Japan in March 2011. This created a nuclear disaster at the Fukushima Daiichi power station, which affected a nearby chemical plant in Onahama owned by Merck KGaA, a German chemical company. That company produced a shiny pigment called Xirallic, which many major auto makers—Ford, Chrysler, Volkswagen, BMW, Toyota, and General Motors—used to give their metallic paints a sparkling appearance. The problem was that this plant was the only one in the world that manufactured the Xirallic pigment. The chain reaction? Major delays in delivering certain car models. Ford, for example, had to tell car dealers that it could no longer take orders for F-150 trucks and other models using "tuxedo black" and three shades of red. A trivial example when compared with loss of ecological diversity. But one that owners of F-150 trucks will understand.

It is only by thinking in context and seeing the ecosystem connections and patterns that we can hope to confront the challenges of the future.

Prepare for Large Consequences Stemming From Small Actions
Be aware of the balance between robustness and fragility.

The famous butterfly effect in chaos theory tells us that two systems with minute differences in initial conditions will end up in two completely different states. Small differences are magnified.[114] Chaos, however, does not mean that prediction is impossible.

Details may not be predictable, but large-scale features of systems are. Coexistence of predictability and unpredictability is another case of coexistence of opposites. This is an area where our mode of thinking must evolve and recognize what we can and cannot predict.

The lesson urging us to "be prepared for large consequences stemming from small actions" appears in *cascade failures* in networks (Motter and Yang 2017). The air travel network, sadly recognizable to anybody traveling in winter, is one example. The effect of travel cancellations is frequently small, but occasionally significant. A volcanic eruption in Eyjafjallajökull, Iceland, in 2010, caused a catastrophic disruption to air travel across western and northern Europe over an initial period of six days from April 14 to 20, 2010. But additional localized disruptions continued into May 2010. About twenty countries closed their airspaces to commercial jet traffic, affecting approximately 10 million travelers.

Another rich source of cascade failures is power grids. On August 15, 2003, four otherwise unremarkable events in the northeast Ohio power grid—the failures of a coal-fired generator and an automated warning system—combined to create a catastrophic situation that darkened the eastern United States and Canada. Sections of New York City were left without electricity for several days. Another example? At 3 a.m. on September 28, 2003, 57 million Italians—the entire country except for Sardinia—found themselves without electricity. The problem was blamed on a series of failures on power lines from Switzerland and France caused by bad weather and a single tree felled by the storms.

Local failures do not have to result in catastrophic results. Failures happen all the time and networks continue to function. Flights get canceled all the time, and air traffic does not come to a halt. Servers constantly fail, and the internet continues working without anybody noticing. Accidents may slow down a supplier, but the entire supply chain adapts. Tolerance to failures is an active area of research. One such area is Highly Optimized Tolerance (HOT) systems, which are "robust" to common perturbations, but especially "fragile" to rare events (Carlson and Doyle 2002). Forest ecosystems, internet traffic, and power systems fall into this category.

Epidemics constitute an even higher level of disruption. Humanity has always faced epidemics, and some have been massive. The Black Death in the mid–1300s wiped out half of Europe's population. In the wake of World War I, the Spanish flu (from 1918 to 1920) killed an estimated 500 million people. Recent epidemics have included Ebola, Zika, and SARS. The worldwide impact of COVID-19 has been massive.

Pandemics are the ultimate complex system. At the simplest level, to predict how a disease will spread, epidemiologists may rely on mathematical models that consider fatality rates and the number of individuals who are susceptible or infected in a given

society (Eubank et al. 2020). More elaborate models may involve teams of physicists, applied mathematicians, computer scientists, statisticians, health sciences professionals, economists, behavioral scientists, public policy experts, and many more. Studies have deployed arrays of computational, statistical, and mathematical modeling tools to capture disease dynamics, pathogen transmission, and the effectiveness and consequences of feasible control intervention strategies, including but not limited to quarantines, school closures, and community and workplace social distancing.

Prediction is the goal. But models can also say if strategies are working. For example, a sub-exponential increase of confirmed cases during the early phase of an epidemic may be a direct consequence of containment policies effectively depleting susceptible populations (Maier and Brockmann 2020). But the predictive ability of models may be hindered by how people change their behavior in response to the disease. This is where complexity comes in, since how people respond affects the system as a whole. The simplest reasoning may be to assume rational behavior—for example, since outings would increase the odds of catching an infection, self-containment may emerge. Or if there is the possibility of medical shortages and lack of access to medical care, people could change their behavior on their own. But models incorporating behavior are not yet there. Smaller scale studies going back to the early 2000s have simulated disease outbreaks in specific cities such as Portland and Chicago (Eubank et al. 2004; Barret et al. 2005; Halloran et al. 2008). Problems are rarely self-contained. The propagation of infections is tied to the worldwide transportation network (Colliza et al. 2006; Chinazzi et al. 2020). The disease ecosystem is the entire world.

There is no shortage of massively complex problems spanning the entire world. Modelling pandemics is challenging but modeling the entire complex food-ag system, to feed ten billon people, may be even more so. Even works that focus primarily on the role of digitalization have to address the numerous factors that influence sustainability in agriculture, land availability, markets, the influence of future climate change, cultural factors, biodiversity, international trade, policies and incentives, and water scarcity (Gerten et al. 2020). A truly complex system indeed.

Learn From the Complexity All around Us
Biology is a prime example.

A few examples of complex systems serve as useful reminders of the complexity that surrounds us. The Roche Biochemical Pathways charts provide an overview of the chemical reactions of cells in various species and organs (figure 7.12). Posters reproducing these charts adorn the walls of biochemistry labs all over the world; the amount of research work they represent is mind-blowing. A small section, connecting just two metabolites, might represent the work of several PhD theses.

Fig. 7.12 Gerhard Michal, Roche
Metabolic Pathways.

These posters serve as a reminder, not only that the world is complex but also that this complexity is within us; we are made of these reactions. Humans have been able to decode some of this complexity, and biochemistry has yielded significant results that impact our lives. The pharmaceutical industry exists because we can work with and within this complexity.

What lessons might biology have for organizations? Let us start with an apology, as it seems unavoidable in the discussion to follow, that we use the word "complexity" in more than one sense. Thus, it is often said than an organization is complex if it has a large number of technologies, products, organizational units, processes of various kinds, geographical locations, input materials, suppliers, and so on. But we will strive for consistency and, as defined in chapter 6, we refer to such organizations as complicated. The more of these components the organizations have, the more complicated they are. We reserve the term "complex" to denote how the organization may link these components and how it may react to inputs or perturbations of various kinds: What happens, for example, if there is a disruption of a supply chain, a supplier suddenly goes out of business, or if there are disruptions in the workforce due to, say, an epidemic taking place somewhere in the world? A picture of the entire organization, like the org chart or the depiction of the supply chain, will tell us if the organization is complicated. To see complexity, we need to see how the organization reacts to disruptions.

It is apparent that simple (as opposed to complicated) organizations may be fragile. Thus, an organization that relies on two products or is run by people with very similar backgrounds may not be able to respond to disruptions or capitalize on opportunities. A single contractor may make economic sense—getting a lower cost in return for giving a vendor 100 percent of the work—but it also creates vulnerabilities in the supply chain. There is no adaptability built into the system, no elasticity, no redundancy.

Having more components brings some advantages. A complicated organization—assuming that all components are needed to produce a product—is a network that is hard to copy because the components and the interactions both need to be copied. But *complicability*, defined here as an antonym to simplicity, has a price. Keeping track of multiple components may be costly and inefficient, and this can lead to unmanageability. More importantly, and well within the realm of complex systems, this can lead to the *emergence* of unexpected behaviors.

In most organizations, complicability emerges organically. This is a problem; rules appear, sometimes driven by the need to respond to the external environment. In time, rules create bureaucracies. If untamed, very much like entropy, complicability always increases. Paradoxically, attempts to reduce complicability—that is, to increase simplicity by reducing components—may backfire, very much like in an ecosystem, where eliminating one species may lead to unforeseen consequences and the extinction of other

What may help reduce these typical behaviors of complex systems? Designing for *modularity* is one possibility, this being the case where components have a controlled degree of interaction. Biology again can serve as an example. Yes, everything within our bodies is connected, and problems in one organ may affect everything else; but to a large extent, organs, while linked, operate in compartments. That is why we can have heart and kidney transplants. In modular systems, failures can be contained. Another way to control for unexpected behaviors is to have *a small number of operating principles*. This is not easy: in response to specific challenges, growing organizations might need to form units that in turn may require completely new processes, things that go outside the existing playbook. But we should remember that it is possible to create a nearly infinite number of things with only a few types of Lego® building blocks. Biology is an even better example. All biology we see, from earthworms to zebras, depends on a remarkable small set of biochemical processes ("small," given the amazing variety of lifeforms on Earth). Another possibility is to mimic biology: successful mutations are favored by natural selection. Constantly look for changes, and do not let things fossilize. Unsupervised dangling parts may lead to unexpected behaviors.

Yes, in complex systems everything is connected, and everything impacts everything, and independence is always a simplifying assumption. But oftentimes the independence assumption works beautifully. The implication of mathematical discussions of complexity is not that everything is connected, and that prediction is hopeless. Complex systems can be managed. We have been doing this, in one way or another, all our lives. Do not make the mistake of taking lessons too far.

We end the chapter by encapsulating three points about complexity: (1) We live surrounded by it, (2) we can make predictions about the behavior of complex systems, and (3) most importantly, we can extract significant lessons from the study of complex systems that translate across domains.

This entire chapter is about lessons. But there is a meta-lesson as well: revealing examples about creative outputs, modes of working and seeing, can come from art, technology, and science— and the lessons emanating from one domain, with minimal tweaking, can yield insights that cut across them all. Absorbing these high-level lessons is essential as we educate ourselves to enrich our thinking and seamlessly navigate across domains.

Christo and Jeanne-Claude's *Running Fence*, completed in 1976, was a massive art installation project, which took more than four years to plan and build. Made of heavy woven white nylon fabric, it was 18 feet height and extended over 24 miles over rolling hills north of San Francisco, before dropping down to the Pacific Ocean at Bodega Bay. Extending over the private properties of 59 ranchers, the project took 18 public hearings, 3 sessions at the Superior Courts of California, and a 450-page Environmental Impact Report. It was designed to be viewed by following 64 kilometers (40 miles) of public roads in Sonoma and Marin Counties. Like other Christo and Jeanne-Claude's projects, *Running Fence* was solely funded through the sale of preparatory drawings, scale models, and original lithographs.

IMPLICATIONS OF THINKING AT THE NEXUS

Tools for organizations and leaders

The only safe prediction is that disruptions lie ahead.

What does it take to lead in a dizzyingly interconnected, interrelated, and permanently chaotic world? It is crucial to have thinking structures and tools that provide guidance and stability. Nexus thinking provides a framework to reconfigure existing categories and thus foster crosslinking, catalyze creativity, and reenergize intellectual output. A combination of map-compass and core-periphery tools can help visualize organizations amid conflicting forces and give leaders a sense of direction.

The Nexus offers a framework to augment thinking. It encapsulates the value that emerges when blurring the boundaries between the analytical and the creative, the rational and the metaphorical, and the convergent and the divergent. The value of this blurring lies not only in having more ideas but also in having a guide for how to execute those ideas. The ultimate goal is reaching complementarity: the ability to contemplate and consider opposites and to ultimately balance creation and execution. This is a tall order for individuals, but remarkably, it may be an easier goal for teams.

We live in a constantly changing world, surrounded by so much change that for some time we believed we could be immune to surprises. The unprecedented reality unleashed in 2020 by the COVID-19 pandemic made it clear that surprises lurk in a complex world. Though pandemics were always a possibility, the danger was considered distant; few had a prepared response.

Now, more than at any point in the recent past, we need a new way of thinking to confront the multitude of problems and unprecedented challenges facing us. In uncertain times, in the midst of constant change and chaos, it is important to have anchors to stabilize us and frameworks to guide our thinking.

How Nexus Thinkers Can Lead in Complex Environments

Managing is guidance in stable environments;
leadership is guidance in complex environments.

There was a time when we could operate in shielded worlds, protected by barriers, insulated from threats, living in cozy isolation. Those days are gone. We all operate in the same hyperconnected interrelated world; a world where perturbations and disruptions propagate worldwide.

Connectivity has a price. Granted, not all problems are present everywhere. But we live in a world touched by the spread of disinformation, a world of tech platforms that magnify hateful speech and propaganda, of xenophobia and nationalism, of anti-immigrant sentiment, of political dysfunction, of lost faith in institutions, of deep failures of sustainability and the accompanying threat of climate change leading to ecological collapses. A taxing picture, indeed.

No organization will simultaneously face all these issues. Some challenges fall on governments. We can look to governments to confront epidemics and pandemics; these are crises that in principle can be "solved" until the next one comes along. But now governments must deal with ever-present background issues of trade battles, racial unrest, addiction and dependence, refugees, and the disproportionate influence of hugely successful multinational tech companies, whose economic and political influence can match or surpass those of traditional nation-states. It is hard to compete, and even

function, in such an environment. Proof of the power of tech in the current political and economic landscape? In 2017, the Danish government elevated technology and digitalization to a foreign and security policy priority. The initiative was named technological diplomacy, and Denmark appointed its first tech ambassador. Germany, France, and others followed suit.

What does leadership entail in this dizzyingly interconnected interrelated world? At the core, the central questions of how to lead successful organizations are always the same: how to make them more efficient, more resilient, more sustainable, more creative, and more innovative. And this has to happen within the world as it is today. A world that it is noisy, nonlinear, and composed of networks intertwined with other networks, where our intuition, formed in simpler times, may be of little use. *Managing alone is not enough. Managing is guidance in slowly changing environments; leadership is guidance in complex, rapidly changing environments.* The paradigm for a well-run business used to be that "it runs like a clock." The new paradigm of a successful adaptable organization should be "it behaves like an ecosystem."

Today's Problems: A Higher Order of Complexity
Networks of networks will be the rule.

We have seen the benefits of approaching the world in terms of networks, which allow us to see hidden connectivities, redundancies, and fragility. An important example of how fragility can change a network is cascade failures that occur when critical nodes of a network are removed: a key species in an ecological network, say, or a single enzyme from a metabolic network, and consequently, its corresponding reaction(s) and the possible "knockout" of several additional ones (Smart et al. 2008). Cascade failures may also occur in computer networks, finance networks, power transmission, water supply networks, transportation systems, and even the human body itself. In a power station, when one part of the system fails, the other parts must then compensate for the failed component. Compared to other spreading processes, cascades are harder to trigger, but they are also harder to stop when they do start spreading (Motter and Lai 2002).

Cascade failures are even more important in the case of networks connected to other networks. A city, for example, can be regarded as a network of transportation, power, services, economic factors, education, and various types of health-related metrics that interact with one another. Although all these systems could be represented as a single network, it is sometimes better to think of them in terms of different layers and regard the system as a network of interacting networks (such networks are often referred to as multilayered and multirelational). Interacting networks raise additional questions, including whether such networks are more susceptible to cascades. The main question: Is coupling to other networks better or worse than operating in isolation? There is no unique answer.

Pandemics too can serve as an example. The focal point of the pandemic is the social-network spreading of the infection itself, but there are multiple ripple effects that can spread through their respective networks: school systems, food processing plants and their supply chains, staffing of health systems, and many more. These effects could linger far longer than the virus itself. On the one hand, we want networks to be connected; it is easier to coordinate activities when they are. Why is it that art galleries and the financial, fashion, and diamond districts congregate in certain areas in cities? On the other hand, the very connections that give a network its functionality can promote the spread of failures that would otherwise remain confined to smaller areas.

The Map-Compass Metaphor

Managers use maps; leaders develop compasses.

Maps show how to go from point A to B to C. Maps work well in stable, well-understood environments, in a world where B and C stay in locked positions, where the map itself does not change. Having a map is like following a steady and trusted playbook. The value of a playbook resides in how well it worked in the past. But in complex, rapidly changing environments, a compass is preferable to a map. A detailed map showing the precise locations of trails and streams in a dense forest is not much use in the middle of a blizzard, where we may not see more than a few feet in front of us. In complex environments, maps, no matter how precisely detailed, are not enough. This is what differentiates managers from leaders: *a manager operates with a map; a leader operates with a compass.*

The map-compass metaphor helps to anchor our thinking. Instilling the sense of a compass—an organization's sense of self, of its larger purposes and values—requires leadership. The role of leadership can be imagined as aligning a group of randomly distributed individual compasses into a single larger compass. In fact, the ability to create a global compass may be the essence of leadership.

To use whole-brain thinking to develop a compass, one must consider the three essential components of leadership:

Vision + Communication + Execution

Vision requires a wide lens to see context and to see simplicity amid complexity. *Communication* requires distilling things to the essence as well as an ability to see simplicity amid complexity. But execution depends on preparing for all possible outcomes—seeing the complexity in simplicity—and having the discipline to stay on a chosen path. Leaders must excel in at least two of these areas. Great leaders, of course, excel in all three since they possess Nexus thinking: vision and communication benefit from right-brain thinking, and execution is greatly helped by left-brain thinking.[115]

115. It is interesting to view various leaders in terms of these components. Take Steve Jobs as one such case. Vision? Galore. Communication? He could have been a religious leader. Execution? Obsessive attention to details, both seen and unseen.

Life-Centered Design

I have been working for several years to move beyond "human-centered design" to what I call "life-centered design." Instead of putting humans at the center of our cosmology, can we imagine a way of living that puts life at the center—all of life. We come to "Life" with reverence, honor, and respect along with all the other living creatures. This is an awareness that has emerged and developed over the last fifteen years through experiences I have had around the world, working with life scientists in Panama, indigenous people in northern Canada, entrepreneurs in Denmark, and more recently with architects in Norway. E. O. Wilson explained in the jungle in Panama that there is only one thing on the planet, life, and it is running an experiment in form, and we are one of the experiments. We do not have a special status. We are simply one of the millions of species, over 99 percent of which have already gone extinct. In Wilson's words, "Rock is slow life, and life is fast rock." Working with the new architecture school in my hometown in northern Canada, which is a tricultural project with French, English, and Indigenous leaders, has helped me to discover the new (old) cosmology that puts life, not humans, at the center. It fundamentally changes everything. It is shocking to discover that we have still not absorbed or accepted the Copernican revolution, that in Western culture we still think the universe revolves around us. The only way out of the mess that we have designed is to extend our empathy beyond other humans, to the rest of life, and develop a practice of life-centered design. To imagine an AI that is dedicated to supporting all of life, not only human life, is to advance the fundamental possibility of creating a world in which we might live and thrive along with the rest of life in the long term. —Bruce Mau

One of the projects that the students at the McEwen School of Architecture undertake is the building of a birch bark canoe, in the way that it has been done for thousands of years. The students work with an indigenous elder, Marcel Labelle. Together they go into the forest, which is part of the school, to find a tree that is "ready to give up its bark." The bark is removed and they return to the studio to build their canoe, culminating in a naming and smudging ceremony, and the launching of their canoe. When that canoe is damaged, or simply wears out, it goes back to the forest floor and becomes food for the next generation of life.

Vision is essential, of course. But communication, it could be argued, is the most essential element in creating a whole-brain organization. These twin mantras should permeate all levels of the organization:

I am part of the whole-brain network.
I enrich the network and the network enriches me.

By internalizing the twin mantras, alignment is possible, and a compass emerges: everyone within the organization will see their individual roles, the value they bring to the interacting network, and how the network helps them.

How does innovation happen in a whole-brain organization? The answer might appear to be deceptively simple: *it is the leader's job to create conditions that allow for successful emergence.* But what about vision and goals? Both are important, but they are not enough. In a whole-brain organization, innovation emerges naturally, not top-down. In the language of complex systems, innovation *is* emergence.

Whole-brain organizations are also better prepared for crises and disruptions. *Crises may alter maps, but they do not disrupt a compass.*

Having a whole-brain view is also important for moving forward when complex issues arise. Disruptions are rarely the result of a single problem, even though that problem may stand out clearly for all to see. Disruptions, and the crises that ensue, are more about root causes; they require organizations to ask the right questions rather than to jump into a solution that magically makes the crises disappear. An analytical mind may be essential to map the landscape of a problem, but overreliance on analytical left-brain thinking and defining a problem too quickly is always a danger. Correctly solving the perceived problem is not of much use if the wrong problem gets solved—it could indeed have a negative impact. An organization's path forward requires having a wide lens and situational awareness, the ability to assess entire landscapes, and the capacity of contemplating possibilities that may often be in opposition with each other. This is why complementarity matters.

Let us next detail how disruptions and opportunities may be seen through the lens of whole-brain thinking. The first disruption, in technology, is artificial intelligence (AI). The second, in academia, is the sudden emergence of massive open online courses (MOOCs). The third example is the emergence of the cloud, as infrastructure can alter the contents of the first and second examples. But the fourth example—though AI, MOOCs, and the cloud feed into it—is an altogether different thing. It is not driven by data or speed. It requires old-fashioned thinking, and it is something that could redefine the entire educational landscape.

Artificial Intelligence and Disruptions

How should we use AI? What can be created with AI? How can we control AI?

Artificial intelligence has the potential to disrupt everything. Consultancies forecast that AI may add between $13 trillion to $16 trillion to the global economy by 2030. AI, in theory, can be useful nearly everywhere, from telemarketing and market research to medicine and law. To a large extent the discovery phase in law practice has already been automated. And AI could assist traditional radiologists and accelerate biomedical research by identifying potential drugs by predicting the bioactivity of candidate molecules. One technology CEO boldly described AI's impact as "more profound than fire or electricity." But AI is hitting limits of various kinds, and these combinations of hype and reality could bring us back to the 1950s, when enthusiastic researchers hoped that computers could reach human-level intelligence. Disappointments followed with so-called AI winters, those periods in which AI interest and funding went into hibernation.

Today is different though. AI is already with us—it follows us in our cell phones. Billions of people use AI, unknowingly, every day. But this does not mean that obstacles ahead are easy to overcome.

The first obstacle is that AI is hard to implement in organizations. It is one thing to train a computer to play chess, where the rules and outcomes are clear: win, lose, or draw. But many real problems are open-ended, and AI struggles with reasoning. Induction is not part of the menu. One can think of AI as a sort of idiot savant who can excel in well-defined domains.

Progress depends on three things: improved algorithms, more powerful computers, and—even though the world is overflowing with data—more access to *usable* data. In typical AI projects, model training takes 10 percent of the time, model tuning 5 percent, and algorithm development 3 percent. The rest? Cleaning up and preparing data.

Research can drive the agenda on the first two. A notable feature of AI is that algorithms are parallelizable. Early on, this fact was exploited by moving computations to graphic processing units (GPUs), which were initially designed for video-game graphics. Some newer chip designs are ten to fifty times more efficient that GPUs. The cost of power, which is massive, has fueled a boom in chip design. Inspiration from biology and the drive toward "neuromorphic" chips, which try to mimic how brains operate, will help. Yet there is a wide gap to overcome. Current systems handling AI processing with the most efficient chips may consume about 15 kilowatts, an amount of energy that could power tens of houses. A human brain consumes a thousand times less. Other possibilities await, quantum computing among them.

The cost of training machines is becoming a problem, and not only because of power consumption. The limits of training can be seen in the self-driving cars and how hard it is to plan for, essentially, everything. Contrast that with the multidimensionality of how humans learn. infants may learn by seeing and hearing, including distinguishing the tone, volume, and modulation of a parent's voice. They learn within a total physical environment—an old AI idea that goes by the name "embodied cognition."

It is undoubtedly true that AI has the potential to disrupt everything—business, research, education, politics, law—but, on the business side, there are indications that most decision-makers are seeing AI in terms of how AI can help them run their *existing business*—helping them make better decisions, run tighter operations, improve customer service, or move ambitiously to develop and advance current strategies. It is also true, that when so much data surrounds us, we may not be able to see patterns, and thus AI may give us insights into the big picture. But these positive potentials seem to be driven by short-term profitability, which is disappointing since AI may change the very process of innovation itself (Cockburn et al. 2019). Technological disruptions are here to be exploited, but few seem to be using their imaginations to think about creating entirely new industries, cultures, or worlds.

Is current AI shaping up into all that it can be? At its root, AI is left-brain paradise: an "intelligence" driven by quantifiable data. But could AI benefit by becoming more right-brain?

Let us pick just one component of AI: the ability to communicate with human beings and help them make decisions. We start by admitting that human decision-making is not rational in the technical sense. "The intuitive mind is a sacred gift, and the rational mind is a faithful servant. We have created a society that honors the servant and has forgotten the gift." This quote is (wrongly) attributed to Einstein, but it serves to make a point. Human decisions are a blend of rational components (left brain) and emotional components (right brain). Behavioral economics demonstrates once again what psychologists, theologians, ethicists, novelists, and philosophers have known for a long time: humans are not rational machines that optimize benefits against costs; we are certainly not mapping out the pros and cons of every decision. Multiple cognitive biases are encoded in our thinking. This blended space maps well onto Nexus thinking.

Thus, one issue in thinking about the future of AI may be recognizing bounded rationality and biases. We humans are far from rational machines when making decisions: for example, we are drawn to details that support our beliefs and tend to find patterns when looking at sparse data, editing and reinforcing some memories after the fact (Bazerman and Moore 2013). The second issue is that many human decisions about complex issues, such as those where technology intersects with societal components, are about systems that we do not understand or understand in a very incomplete way. Could we possibly understand all the components connected with climate change,

sustainability, and energy? Or privacy? Deciding what to optimize in any problem that intersects with society and public policy components cannot be solely based on left-brain thinking.

What is missing from many AI considerations is right-brain thinking. Our responses to issues connected to family, community, and tribe are often far from rational. To put it unkindly, we humans are a collection of heuristics and biases intertwined with a misunderstanding of statistics and a general inability to think beyond linear systems into complex systems and networks. Having systems that can only present ideas as rational arguments will neither help us nor teach us.

As we build out more complex AI systems, we need to focus on having the machine communicate to us in a way we can understand. We need AI machines that not only can appeal to our emotions by responding to the world as if through the eyes of our own experiences, but also, over time, can train us to base decisions on a broader set of ideas.

This is where empathy comes into the picture. The machine needs to be able to express ideas in terms of examples, metaphors, references to experience, analogies, and emotional commitments. Our empathic models may be open to training. In fact, if we look at people's attitude toward issues such as gender and sexual identity or race, we see that they have evolved; humans learn. A properly augmented AI can help with this learning.

The AI systems of the future could make us better by helping us to move away from our own empathy bubbles to look at the world in a less tribal way. Terms and phrases like "human-centered AI," "making AI work for humans," and "humanizing AI" will come up more and more. But, as with many technologies, we must be aware of unintended consequences, things we cannot foresee. Remember the beginning of the web, when we thought we would understand each other and other cultures, but instead one of the results was tribalization?

This is the proposal: We want AI to help us make the best decisions. To do this AI must become more empathetic, creating a two-way street: we understand AI and AI understands us. One direction leads to designing and building AI systems that we can relate to, even build relationships with. The other direction leads to AI systems that can communicate better with us.

Let us assume this two-way understanding happens. Surely it would lead to some industries we have yet to recognize, and some of these ideas will come from places we can barely imagine. But for their own survival, some ideas had better come from the established industries of today, maybe evolving into unrecognizable versions of themselves. Are we seeing enough thinking in this direction?

Academia Capitalizing on Disruptions
Hyper-distributed and hyper-connected modes will coexist.

Compared with most organizations, academia appears stable. All top thirty academic institutions in the United States have been around for more a hundred years, and many far longer than that.

A decade ago, massive open online courses (MOOCs) suddenly appeared, without any central coordination. The ability to teach tens of thousands of students all around the globe took academia and media by storm. Newspapers reported on MOOCs almost daily. Boards of trustees demanded rapid action from university presidents; some were fired. Professors resigned and formed MOOC-delivery companies. No longer would we need multiple versions of courses taught by an array of professors. Indeed, MOOCs were going to make obsolete the traditional classroom where one professor, using a chalkboard or PowerPoint, taught as few as ten or as many as three hundred students. Brick and mortar buildings themselves would become obsolete. University and colleges were going to disappear. MOOCs were going to massively scale up education: only the best professors need apply. And yet this did not happen. Even when COVID-19 entered in the picture. What happened to MOOCs?

Compared with the hype, not much. An individual MOOC has a typical enrollment of 25,000, and some enrollments have reached upward of 200,000. But completion rates are at about 15 percent. Coursera, an online MOOC company, has reported a completion rate of 7 to 9 percent. In fact, MOOCs seem to be yet another example of the dictum that "every revolution goes too far."

When MOOCS appeared, many in academia asked how they should respond. Students on campus started viewing MOOCs delivered by the same professors they could have watched in person. Some professors experimented; "flipped" classrooms flourished, moving activities, including those that may have traditionally been considered homework, into the classroom.[116]

MOOCS may have "emerged," but MOOCS were also a case of "if we build it, they will come." Not exactly command and control, but not a case of emergence on the student side, either. The students were just feeding into a system that existed beyond their control.

Several other things happened, almost concurrently, that changed teaching in a significant way. Campuses saw a tremendous growth in entrepreneurial activities and maker spaces. Team exercises and experiential courses flourished; the more varied the team members and ranges of experiences of the members, the better. And while none of this is antitechnology, we now have courses where no laptops are allowed, and design/studio spaces with Post-it notes and markers everywhere.

116. In flipped classrooms, students watch online lectures, collaborate in online discussions, and/or carry out research at home while engaging in concepts in the classroom with the guidance of a mentor.

So, we went from MOOCs, hyper-distributed courses, to a range of hyper-connected courses, such as design and studio courses, with one instructor for every eight students in actual classrooms. Hyper-distributed now coexists with hyper-connected. Brick and mortar survived.

And then COVID-19 happened, and with it a massive online migration of nearly every course in every university. This was a remarkable forced transition and something that would have been unthinkable fifteen to twenty years ago. If a pandemic had happened then, we would have closed all universities, very much like Cambridge University did in 1665, responding to the Great Plague. One good outcome of that shutdown? The young Isaac Newton left Cambridge, returning to his family farm a safe distance away, where private study led to his development of calculus, optics, and the foundations of mechanics.[117]

A remarkable growth in COVID-19 related research, some of which seems to have affected public policy (Yin et al. 2021), paralleled the massive migration to online teach in 2020. Lessons learned during the pandemic will shape universities for a long time. But the academic enterprise should be looking for big ideas in which both AI and online courses will play a role.[118] Nevertheless, we have the opportunity to go after much bigger ideas that could change the structure of our entire educational system. Virtual reality tools will emerge. Opportunities will open up for those who can leave preconceptions behind.

As the Cloud Becomes Infrastructure
Remember: every revolution goes too far.

In 2020, driven by the COVID-19 lockdown, a staggering number of businesses and people went online: video games and movie streaming exploded, and online shopping became a necessity. Between March 2020 and February 2021, Amazon's market capitalization grew by 77 percent, Zoom by 300 percent. Things that seemed to always be in the future suddenly became the present. Some courses were canceled, but nearly all teaching in universities took place online, delivered by instructors from their own homes. In one university alone, this could be upward of a thousand courses a quarter and five thousand online contacts a day. Multiply this by all the colleges and universities in the world—and all the students consuming information out there in videoconference meetings, and recording lectures often packed with videos—and the result may be about 1 petabyte of information going through the internet a day. This is more than 60 times the content of the US Library of Congress.

Telemedicine came to the forefront. Medical apps coupled with bioelectronic devices emerged to help self-evaluate symptoms. AI tools, aided with contact tracing, informed public policy decisions. The cloud allowed researchers to handle massive

117. There are other examples of isolation resulting in amazing creative outputs. The 1930 cholera-quarantine seclusion of Russia's greatest poet, Alexander Pushkin (1799–1837), was shorter—three months—but resulted in the most productive period of the writer's life.

118. One obvious advantage to merging AI and MOOCs is the potential to offer students feedback that goes beyond reporting grades. Natural language-based AI could provide evaluations along these lines: "You did well in section X of the course, but you seem to have had problems in Y. Next time we are going into topic Z, which relies heavily on Y so it would be useful if..." Having this sort of proto-empathic AI may increase student retention rates. We can also imagine AI assisting instructors in giving feedback to teams. But education may have to prepare itself for much bigger challenges.

amounts of clinical information from around the world in pursuit of therapeutics and vaccines. We discovered that the 2020 internet was much more sophisticated and robust compared with the internet in 2008, when the economy last collapsed. The system was able to handle all the increased demand remarkably well and, except for minor hiccups, the cloud was continuously available.

The lockdown revealed a crucial link between internet infrastructure and energy. Did the online migration consume or save energy? In the first week of April 2020, immediately after the lockdown, US gasoline consumption went down by 30 percent, but overall electric demand was down less than 7 percent. Electricity consumption from factories, shopping malls, and office buildings went down. But with many people working from home, home electric bills went up. The missing component in this balance? The massive energy consumption of data centers. The training of just one AI application can consume more computing energy than ten thousand cars do in a day (Mills 2020b).

But the central issue was the recognition that *the cloud is infrastructure*, and that this infrastructure has to be reliable and resilient. These dual issues—energy consumption and reliability—will reshape future priorities. It was only recently that Microsoft, IBM, Google, Apple, and Facebook were promoting green energy for their operations. Microsoft, in an impressively documented energy manifesto unveiled on January 16, 2020, declared that it "will be carbon negative by 2030." The company also noted that "advances in human prosperity... are inextricably tied to the use of energy." But reliability and resilience—in short, availability—will now move to the top priority. It is, at this moment, prohibitively expensive to provide *high reliability* electricity with solar and wind technologies. The global information infrastructure—counting all its features, from networks and data centers to the energy-intensive fabrication processes—has grown from a nonexistent system several decades ago to one that now uses roughly 2,000 terawatt-hours of electricity a year. That is more than a hundred times the electricity used by the world's 5 million electric cars each year. To put it in terms of individual users: on average the electricity used by all the applications and AI behind a smartphone is more than that used by a typical home refrigerator (Mills 2020b).

More square feet of data centers have been built in the past five years than during the entire prior decade. There is even a new category, "hyperscale," referring to data centers that cover more than a million square feet. Think of these as equivalent to the skyscrapers that emerged a century ago. But while fewer than fifty hyper-tall buildings in the world today are bigger than the Empire State Building, there are already some five hundred hyperscale data centers across the planet. They have a collective energy appetite greater than six thousand skyscrapers (Mills 2020b).

We do not have to guess what will propel growth in cloud traffic. The big drivers at the top of the list are AI, more video, and especially data-intense virtual reality.

Until recently, most news about AI has focused on its potential as a job killer. But it may well be that AI could end up creating jobs.[119] The market for teaching opportunities and training across every sector may have been altered forever.

This is the time when we need the broadest thinking to come into play. Everything will be transformed. And this is when the biggest opportunities appear. But be aware of overshooting: *every revolution goes too far.*

How Nexus Thinking Can Help Redefine Education
Reframe categories to foster crosslinking and reenergize intellectual output.

We are advocating for a unity of knowledge—the benefits of seamlessly traversing science, technology, art, and humanities in general. Sporadic attempts have been made to merge and split these domains, and some of this thinking is etched at the very foundation of some universities. A couple of examples, going back to origins, may be instructive. We encountered earlier the Lunar Society of Birmingham, a group that purposely merged industrial arts, natural philosophers (the scientists of the day), and intellectuals. And it was in Birmingham where a clear position for a split was declared. Josiah Mason was a rag-to-riches, self-taught English industrialist who had made a fortune in pen manufacturing. He founded Mason College in 1875, which later became the University of Birmingham. While delivering the inaugural address of Mason College, Thomas Henry Huxley declared that for "students in physical science to foster industrial progress, literary instruction would be a waste of valuable time."[120]

In 1901 the second president of Johns Hopkins University espoused similar views that also influenced Stanford University founders Leland and Jane Stanford to create an institution where young men and women could "grapple successfully with the practicalities of life." But Leland Stanford, the builder of the first transcontinental railroad, successful businessman, and governor of California who, along with his wife, started from rather modest means, evolved in his thinking. Making a 180-degree turn, he subsequently became an advocate for the broadness of liberal education: "I attach great importance to general literature for the enlargement of the mind and for giving business capacity. I think I have noticed that technically educated boys do not make the most successful businessmen. The imagination needs to be cultivated and developed to assure success in life." The Stanford founders could not possibly have imagined the birth of Silicon Valley, but it is worth mentioning that the terms "fuzzy" and "techie" are still used at Stanford to describe students who study the humanities and social sciences versus those who pursue STEM subjects. The question still is, why not both?

Universities change slowly. And the questions posed above—bifurcation or unity—are still at the center of the debate. Innovation is fueled by creativity, and creativity is

119. It is hard to make predictions regarding the impact of technologies. A simple and classical example is the advent of automatic teller machines (ATMs). It was widely thought that they would reduce the number of bank tellers. In fact, the opposite happened. There are more tellers now than when ATMs were first deployed. ATMs lowered the cost of operating bank branches, and banks increased services by hiring more tellers.

120. Contrast these remarks with what William Barton Rogers said in 1861, upon founding MIT: "The true and only practicable object of a polytechnic school is, as I conceive, the teaching, not of the minute details and manipulations of the arts, which can be done only in the workshop, but the inculcation of those scientific principles which form the basis and explanation of them." Most clearly, he did not wish to establish only a professional school but a combination that contained elements of both professional and liberal education.

Complex Interface between Science and Public Policy

The rapid production of new science during COVID-19 raises key questions about its use in shaping policy during the pandemic. The illustration shows networks of citation relationships among 37,725 COVID-19 policy documents published by government agencies and think tanks from 114 countries and 55 intergovernmental organizations (IGOs) during the period from January 2 to May 26, 2020. Each node represents a COVID-19 policy document, colored by the institution type to which it belongs (IGOs in blue, think tanks in orange, and governments in green). The two big blue circles represent two early documents from the World Health Organization ("Home care for patients with suspected novel coronavirus (nCoV) infection presenting with mild symptoms and management of contacts: interim guidance," from January 20, 2020; and "Infection prevention and control during health care when novel coronavirus (nCoV) infection is suspected: interim guidance," from January 25, 2020). A node's size is proportional to its policy use, meaning the number of policy citations received within this network. A node border (in black) denotes those that draw directly upon science. A link between nodes is curved clockwise to indicate its direction and colored by mixing the source and target nodes' coloring.

Based on Yin et al. 2021.

- 1 citation
- 5 citations
- 10 citations
- 50 citations
- Cites science
- WHO
- Integovernmental organization (other)
- Think tank
- Government

fueled by talent. Since innovation is the competitive edge of the twenty-first century, it is hardly surprising that countries, companies, and all types of organizations are in a war for talent. Talent is the critical element that fuels the creative ecosystem, and talent is fueled by education.

The United States dominates the rankings of the best universities in the world, with some surveys placing thirty US schools among the top fifty ranked worldwide. But the position is far from permanent. Once the United States had a monopoly in attracting talent, talent that fed into an innovation chain—the beginning of an entire creative ecosystem—with labs, high-tech employers, and venture capital, all resting on a foundation of intellectual protection. The monopoly was highly successful. The United States has 388 Nobel Prize winners; 38 percent of those in physics, chemistry, and medicine were born outside the country. Now the talent picture is being altered in significant ways. US immigration policies are shifting, and nation-state players are coming onto the scene. There is powerful competition; the list of top universities is changing, with new entries from Asia.

Forces for change are not solely driven by externalities. Many are internal, and driven by accessibility, diversity, equity, and inclusion. Cost and debt are often mentioned in the press, with figures of $50,000 and up for a year of college representing the norm. But only 150 of the 4,700 higher education schools fall in that category, and they enroll fewer than 600,000 of the 18 million or so undergraduates—with more than half receiving a substantial discount. That leaves, at most, 300,000 students and their families actually paying $50,000 a year, far fewer than media attention suggests. In fact, only about 30 percent of all undergraduates pay the sticker price; the number falls below 15 percent for those attending private four-year colleges and universities (Schapiro and Morson 2015).

Most definitely, administrative costs have increased. For example, between 2001 and 2011, new administrative positions—people managing programs and myriad regulations, all nonclassroom costs—increased 50 percent faster than the number of classroom instructors. But this is hardly a problem restricted to academia. The percentage of the US labor force working in companies with more than five thousand employees is now at 34 percent, from 29 percent in 1987. But the number of administrators and managers more than doubled over that period, while all other jobs increased by less than 50 percent. It thus appear that bureaucracy has been growing everywhere.

Is it time to think about old things in a new way?

Colleges and universities in the United States group together the sciences and humanities for much longer than most other countries, where students quickly converge into law, medicine, engineering, or another specialization. This is true in most of Europe—France, Germany, Switzerland, Italy, Spain—and South America. In the United

Kingdom, specialization begins around the age of fifteen or sixteen. US universities are thus unique in their insistence that all undergraduates receive at least a partial humanistic education. There was no master plan behind this fact, but it may have had tremendous practical implications because it flies in the face of an enemy of innovation: rapid convergence. It is hard to find talents and passions so early in life. Especially now, when lives and careers are getting longer.

Universities are largely structured along the classical lines of art, humanities, and sciences, with the teaching of organizational components and management neatly tucked in business schools. Technology, which has no separate track, resides in engineering, though not exclusively, as large portions of what used to be pure science—chemistry, physics, and biological sciences—have in fact evolved into technology. Technology has always been taught in medical schools, and in art and architecture schools.

Is there a different way to see the landscape of what is covered in universities? Changes have taken place, some departments have disappeared or have been absorbed into new departments; metallurgy, for example, was absorbed by materials science. And new interdisciplinary schools with names that deviate from the norm have been formed. Examples may include the School of Earth and Space Exploration, the School for the Future of Innovation in Society, and the School of Human Evolution and Social Change, at Arizona State University. Centers and Institutes abound. But their primary objective is research, not teaching.

How can we begin to expose people to a broader range of thinking styles? More specifically, how can we increase crosslinking and blur boundaries between silos? In short, how can we produce more people who can be comfortable operating at the Nexus?

But let us agree first on what we may want to stay the same. Large companies are all about creating systems that make people part of a bigger machine. Universities are essentially about setting tenured faculty and their research groups free from the organization, thus empowering them to pursue new ideas, to collaborate and innovate.[121] Tenure is often criticized, but the aspect of reinvention is worth preserving. It gives the system remarkable flexibility and the ability to adapt and evolve. This raises other questions, however: Does the system benefit from this remarkable freedom? Does the system produce enough new ideas? Possibly not. We can imagine higher intellectual outputs. How can we make this happen?

A possible first step is to reorganize what we have in terms of new labels. One option could be to see what is already happening: collaboration in terms of joint research publications.

Another coarser option could be in the objectives of the intellectual domains. Imagine, for example, three broadly defined domains: knowledge, creation, and organization.

121. Let us also agree to avoid the question of whether tenure is a good thing. The tenure system may not change unless the leading universities agree, collectively, to reexamine it.

These divisions are far from clean-cut and others may be imagined. But seeing things in this way forces us to think, and the exercise may result in our awareness (or development) of new horizontal connections. The knowledge domain could include science, history, literature, philosophy, economics, and pure mathematics. The creation domain could encompass all the arts—visual arts, music, creative writing, theater—the playwriting and composing, and film—parts of architecture, and, somewhat more controversially, most of engineering. Creation and doing are linked, and it is hard to draw sharp dividing lines. Criticism could fall under doing, since it is mostly reacting to someone else's creation; writing a novel would fall under creating, though many authors would put it under crafting and doing. There may be clear aspects of creation in performing arts, as well as inset design, for example. Assigning categories is far from easy, but the very difficulties in the exercise may generate interesting intersections. Most disciplines are so used to being where they are that they never think of themselves in terms of the entire landscape of the university.

Engineering (as taught in most universities, though this is rapidly changing) is mostly about knowledge, but the practice of engineering thrives on problem solving and creation (Ferguson 1992). And though science, history, philosophy, economics, and mathematics are placed under knowledge, there are aspects of creation in each of these areas. It takes creativity to do work in the frontiers of history, philosophy, and so on. Science education starts as knowledge, but breakthrough research is rooted in creation, and the generation of new math is arguably one of the most creative human activities of all.

The third domain, organization, is probably the cleanest to define: it is contained in most MBA programs. Components of law, public policy, and government studies could be here as well.

Thus, under this proposal, new names would be needed, and connections would naturally emerge. Big circles may contain wholly different players.[122] (Law and medicine could also be decomposed and placed in this scheme.)

The proposal is to have a structure that would lead naturally to more horizontal enrichment, to educate people who can traverse the cultures driven by knowledge, creation, and organization. There are some hopeful signs. At leading universities, there is increasingly a student population that not only fits the three-culture framework, but more importantly seems comfortable hopping over and between these cultures. What could be a barrier against change? One answer would certainly be backward-looking accreditation programs that prevent flexibility and exploration.

Can this nexus of intersections between art, technology, and science be put to the test? Can artists and engineers come together with loosely defined objectives to find common ground and engage in projects as equals? Several people have experimented

122. Parenthetically, organizations themselves go through similar stages (Greiner 1998). They start with a burst of creativity (creation) but, eventually, the growth becomes hindered by coordination (of knowledge) and finally by organizational issues. The question there is how to periodically go to the origin, freshen things up, and insert creation once again into the mix.

with the concept. Northwestern University tested the idea with self-selected groups and loose objectives. Two different classes combined engineering students and faculty with students and faculty from the School of the Art Institute of Chicago and from Northwestern's Department of Art Theory and Practice. Remarkably, groups of four converged on (and in) a random list of examples: developing new ways of visualizing social inequities in Chicago transit; games to facilitate interaction with autistic individuals; and ways to explore the commonality between sounds of laughter and sadness. These experiments have been going on for several years. The surprising outcome has been the synergistic collision of thought processes between artists and engineers. Evolving culture is making these sorts of interaction more likely. Curated events like *9 Evenings: Theatre and Engineering*, covered in chapter 5, should be common within a university.

Northwestern University's experience provides a case study. Change in an institutional culture depends on designing an initial network, gathering people that embrace a culture of collaboration, and building of programs that crisscross domains, things that create conditions for successful emergence. It is essential to seed the system with people who have the ability to work in teams.

The two-course sequence Design Thinking and Communication (DTC), which has been taught since 1997, is the foundation for educating such people. DTC students learn design thinking skills and the ability to communicate; the communication component is taught in conjunction with faculty from the university's writing program. Teams of four students tackle design problems submitted by individuals, nonprofits, entrepreneurs, and industry. In the first course, projects tend to focus on seemingly unsolvable problems from clients or users with disabilities. Students learn to frame problems from multiple perspectives, to ideate, prototype, and iterate solutions. Tackling these challenges, students gain creative and teamwork skills, as well as empathy, resilience, and humility. This common experience provides a starting point for Nexus thinking.

A network of possibilities is needed to foster subsequent collaboration crisscrossing schools. At Northwestern, bespoke courses on entrepreneurship—on topics such as medicine, energy, the Web, and art—involve students from multiple schools. Teams may range between those with a defined composition—for example, two students each from engineering, medicine, business, and law—to many other courses that also involve students from anthropology, economics, psychology, journalism, communications, and music. In addition, a series of Nexus talks, designed for PhD students, have brought speakers from philosophy, set design, science and economic history, art history, psychology, law, and more. At the other end of the spectrum, a collaboration between business and engineering produces graduates with blended degrees— MBA and technology—and dual degrees, such as an MBA combined with a master's in design and innovation. The network is extensive.

Collaboration among Disciplines

A map of science based on citation patterns showing
6,128 journals connected by 6,434,916 citations (Rosvall
and Bergstrom 2008).

The novel execution of the whole-brain-thinking network was recognized by the National Academy of Engineering with the Bernard M. Gordon Prize. One component of the network, Design for America, was conceived at Northwestern and migrated to forty other campuses before being absorbed into the Watson Foundation. A program with the law school has focused on the intersection of law, computer science, and design. Programs with The Block, the on-campus art museum, have led to collaborations both in terms of contributing to exhibits and bringing artists-at-large to campus. An interdisciplinary space for fledgling student-driven innovations houses a spectrum of disciplines, from psychology to engineering to healthcare and theater.

Northwestern has become a place in which any combination of disciplines is unsurprising. Such crisscrossing, once rare, is now common and part of the culture.

To scale up beyond small, self-selected groups who are often eager to interact with other cultures and organizations may not be trivial. Overcoming stereotypes is essential. At its core science and engineering also thrive on creativity and disruption, yet our educational system does not always foster this. Science and engineering encourage thinking that is logical, rational, analytical, pattern-seeking, and solution-solving. Innovation, however, requires artistry, intuition, divergence, and fantasy, the kind of thinking more closely associated with the arts. Original thinking is demanded earlier in the arts, when students are asked to express opinions, to dissect and criticize.

Both sides—artists, and scientists/engineers—have a romantic, almost cartoonish view of the other. Even though this too may be stereotypical, scientists equate art with creation, beauty, and inspiration, and sometimes with struggle; artists equate science and engineering with cold, methodical logic and a singular moment of inspiration when a great discovery is made. At the same time engineers equate art with paintings, photographs, and sculptures, leaving out conceptual art, installations, and much more, while artists equate engineering with technology, not with the human factors and passions that animate it. But it is precisely in the similarities and opposites where interesting things happen. Learning from each other is part of the goal.

Thankfully, the US academic system is far from monolithic. Different universities evolve independently, exploring and maximizing their positioning and competitive advantages. The rate of change is far from uniform. It is inconceivable to expect a concerted effort guided by some central driver. But guidelines and constraints (or lack thereof) in federal funding can play a major role.

Nearly all undergraduates pay for their education. But most doctoral students in engineering and science are paid to go to school, their salaries generally funded by grants from the National Science Foundation, the National Institutes of Health, and other agencies. These grants support specific research proposed by professors and executed mainly by paid PhD students.

This situation contrasts sharply with the undergraduate experience at top universities, where students customize their education, perhaps by engaging in social entrepreneurship, studying global health in Africa or China, competing in solar car races, working on sustainability in Central America, or collaborating with an art or music major. Undergraduate exploration, creativity, and social entrepreneurship are actively encouraged. Not so at the graduate level.

The demand for (often narrowly defined) research results, the need for myriad compliance mechanisms, and the gravitational pull toward meeting (narrow) program goals that will, if successful, yield follow-on funding, act together to create a closed system within which there is little time or attention for ancillary pursuits, especially idle exploration. This process can yield excellent researchers but does nothing to form—and unintentionally suppresses—whole-brain thinkers. Perhaps worse yet, the process discourages "whole brainers" from even applying.

The US system is still top of class, but the basic organizational structures in academia have remained unaltered for a long time. If the objective is to freshen up intellectual output and increase innovation, big reframings are needed.

Long-lasting consequences can only be seen in retrospect. Has a year of online instruction driven by COVID-19 left a permanent mark?

Lessons from Network Science about the Composition of Teams
Creativity requires divergent thinking; implementation demands convergent thinking.

What further lessons can we draw from the network studies about teams described in chapter 6? One caveat first. In terms of balance, all these studies—Broadway, scientific publishing—involve somewhat homogeneous teams. But right- and left-brain aspects exist in both cases. Most people on the Broadway creative teams, except for the producer, can be thought of as right-brained people. The director may fall in the whole-brain category, given the need to understand and manage a diverse team. Most people in science would conventionally be placed on the left-brain side.

Broadly speaking, creativity requires divergent thinking, and implementation requires convergent thinking. An obvious lesson might follow from this observation: high creative volume and lots of novel ideas can actually hinder innovation by never moving the idea to implementation. Loren Graham, an historian of Russian science and technology, points out a wide range of discoveries and inventions first made in Russia that were never successfully made practical because they were part of a system that was great at divergent thinking but not convergent thinking (Graham 2013). There is a clear vice-versa to this lesson, as well. Moving too quickly to convergence can quench creative output. The best is a team than can operate in both modes.

Another lesson is that diversity, taken to extremes, can be a drawback. It is obvious that increasing team diversity increases the number of different ideas and creativity. But also that too much diversity can increase task conflict and reduce innovation. As Brian Uzzi demonstrated when studying the makeup of Broadway teams, there must be the optimal degree of conflict within the team—no conflict leads to bland ideas; too much conflict can impede innovation.

A final vignette about diversity and adding right-brain components to an organization offers an almost perfect example of whole-brain thinking. At his peak, Edwin Land (1909–1991) was more famous than Steve Jobs. He was certainly more influential since he had the ear of US presidents. Land developed the meticulously precise science behind instant photography and served as the CEO of the Polaroid Corporation. He was an inventor's inventor with many patents to his name. "Nobel Prizes have been given for less," one admiring scientist declared.

But Land was also responsible for something very unusual in his time. Clarence Kennedy (1892–1972), a professor of art history at Smith, an all-women's college in Northampton, Massachusetts, and an artist in his own right, became a consultant to Land and introduced him to the world of contemporary art. He connected Land with Ansel Adams, Andy Warhol, and Chuck Close, who all used Polaroid photography in their work. But more than that, Kennedy persuaded Land to hire art history majors at Polaroid at a time when hiring art majors at a technology company was unthinkable. Moreover, few technical companies were hiring women in the 1940s and 1950s, but Land did precisely that. Land understood that diversity enhanced creativity. It was a good move. Some of these women ended up running major research labs at Polaroid. Mercë Morse (1924–1969) was one such example. Morse became director of the research laboratories, running what was called "black and white" research, a core of Polaroid, and became the first woman to be elected fellow of the Society of Photographic Scientists and Engineers.

Nexus Organizations
Know the value in adopting broader thinking.

Nexus thinking is an important part of the spectrum of world-leading organizations. Existing examples span a wide range. There is an evolutionary aspect as well: businesses evolving into Nexus organizations, and Nexus teams growing into businesses, one extreme being unstructured Nexus-based art practices morphing into structured enterprises.

Nexus thinking manifests itself in two ways. *Surface-level* Nexus thinking is apparent when technology/science visibly blend with arts, or when hard-core engineering emerges in products infused with raw emotion. But Nexus thinking is also present

Art and Science Interfaces
Iñigo Manglano-Ovalle

Iñigo Manglano-Ovalle (b. 1961) is a conceptual artist known for socially oriented sculpture, video, and installations as well as urban community-based projects. His work often combines art with technology and scientific data: research for one of his projects included an aerodynamics test in a hypervelocity wind tunnel; in another installation he created a kinetic array of weathervanes and anemometers in a public park. Two works embodying the art/science interface are *Cloud Prototype* (2003), a titanium-coated mobile shaped like a thundercloud, which was based on scans of real storms; and *Blue Berg* (r11i01), at Cleveland Clinic (2007). He built *Blue Berg* from anodized aircraft aluminum and ABS nylon to reproduce the shape of an actual 460-foot iceberg (identified as # r11|01) in the Labrador Sea by using point cloud data from a Canadian a government laboratory.

when analytical thinking and creative thinking synergistically coexist; when deductive and inductive thinking operate side-by-side to complement each other. This is *embedded-level* Nexus thinking. It is not visible in products per se, but apparent in how the organization thinks and works. In many cases the surface and embedded levels coexist.

Under Steve Jobs, Apple boldly declared that its products are "designed in California," thus moving this integration to the forefront via inspired design and, in the process, creating the most valuable company in human history. Others also occupy this space, many preceding Apple, and new ones have emerged. Tesla and SpaceX are notable current examples; both represent swerves, discontinuities on multiple fronts with the past. Pure engineering drives the SpaceX rocket's designs, but engineering and human-centered design blend seamlessly in Dragon's revolutionary spacecraft designs.

Teaming up with artists may be signifiers of the expanded thinking characterizing some of these organizations. Planet.com, which presents itself as "an AI organization that has deployed the largest constellation of Earth-observing satellites in history," has had artwork laser-etched into the side panels of the more than 150 satellites it has launched to space; technological considerations did not drive this decision.

Many artists seem to be fascinated by doing projects with a space component. And their desires and goals are often reciprocated. Tristan Eaton's artwork *Human Kind*, a series of indestructible paintings made from gold, brass, and aluminum, and Tavares Strachan's homage to the first African American astronaut selected for any national space program—both projects carried into space by SpaceX—are notable examples.

Ferrari has for many years represented a synergistic balance of aesthetics and design with technology and engineering; Porsche and BMW represent this blend as well. Herman Miller captures Nexus balance in many of its products in the office furniture space; Nike brings the technology-design balance in the development and manufacturing of footwear and apparel. Industrial Light & Magic, the visual effects company founded by George Lucas when he began production of the film *Star Wars* and, most definitely, Pixar—linked to both Steve Jobs/Apple and Disney and known for a string of successful feature films powered by its own image-rendering applications—fit in this space as well. Financials illustrate this success: Lucasfilm being sold to Disney for $4 billion; Pixar generating tens of billions, with every one of their fifteen films in the fifty top-grossing animated films of all time.

Some Nexus entrants are in even more select niche categories. Intuitive Surgical is an example; the company makes "The da Vinci Surgical System," a robotic-assisted surgical application whose motto is "pairing human ingenuity with technology." Other examples include Sonus Faber, the Italian manufacturer of handcrafted speakers, headphones, and other high-end audio products; and Teenage Engineering, an advanced

design and engineering firm, which invented new sound and performance synthesizers that not only produce audio but also can program and run entire live shows. Fashion companies and toy companies occupy this space. Visible Nexus thinking is part of the appeal.

There are comparatively few businesses in the hyper-competitive and rarified domain of luxury goods. But there may be lessons to learn regarding the balance of market-driven versus market-driving approaches and the role of artists in shaping such products. An example comes from the French multinational conglomerate Moët Hennessy Louis Vuitton, commonly known as LVMH. The comments made in 2001 by LMVH's CEO Bernard Arnault still resonate today: "Some companies are very marketing driven; they follow the consumer. And they succeed with that strategy. They go out, they test what people want, and then they make it. But that approach has nothing to do with innovation, which is the ultimate driver, we believe, of growth and innovation. You can't charge a premium price for giving people what they expect, and you won't ever have break-out products that way—the kinds of products that people line up around the block for. We have those, but only because we give our artists freedom" (Wetlaufer 2001). LVMH's valuation increased almost fourfold in five years, and in 2020 the company was worth about $315 billion.

Surface and embedded Nexus thinking coexist in many design companies, especially those that have evolved into consulting and organizational design as well as the design of products, services, environments, and digital experiences. Palo Alto–based IDEO started this trend. Most of the big consulting companies have added design to their practices.

We have argued that design thinking bridges analytical, rational, data-driven left-brain thinking and the metaphorical, divergent, artistic right-brain thinking. It may then follow that the more design thinking exists within an organization, the more Nexus-like it becomes. The Design Management Institute (DMI) has a listing of Design-Centric Companies; who makes the list depends on a set of metrics such as "Design holds a prominent place on the company org chart; Experienced executives manage the Design function; Design sees a growing level of investment to support its growing influence." The DMI Design Value Index (DVI), based on a portfolio of sixteen publicly traded stocks from these design-centric companies showed, over the period from 2005 to 2015, a 211 percent return over the S&P 500. Similar metrics may extend to Nexus companies.

At the other extreme from established companies are individuals—a Nexus of one—people with an amazing ability to bridge domains that create Nexus like value and organizations. Brian Eno comes to mind as one of popular music's most influential artists—a musician, record producer, and visual artist who utilized breakthroughs in technology—to produce music and installations combining visuals and sound. He has

without a doubt created an amazing network of consequences that affected all aspect of contemporary music. It is sometimes possible to trace a culture to a single individual. We can see examples where art has been the starting point of massive Nexus practices as well. Olafur Eliasson, for example, has developed one of the most advanced scientific creative practices in the world today; significantly, many of Eliasson's installations using water, light and air temperature are based on scientific insight of such physical phenomena.

Walt Disney Imagineering Research & Development, Inc., the R&D arm of the Walt Disney Company is a seamless blend of art, technology, and science. Imagineering operates an R&D lab that develops the technologies and materials for the theme park installations that have made Disney the most successful creative studio in history. Combining the talents of more than two hundred different disciplines, Imagineering is the contemporary of the Renaissance studio, at a scale beyond anything that period artists and innovators of the sixteenth century could have imagined. The origins of Imagineering can be traced back to the culture created by Walt Disney himself. Walt Disney was the epitome of the NEXUS innovator. He invented the practice of "Imagineering"—the synthesis of engineering and imagination. Beyond his many innovations in cinema and theme park–experience design, at the end of his life he was working on an Experimental Prototype Community of Tomorrow (EPCOT), which was to be a real city, far beyond the scale of the theme park that eventually took its name. It was the design of a new vision for urbanism, integrating all the learning from the experience design of Walt Disney World, including the most advanced science and engineering of the future. Some may argue whether these cartoons were art, but no doubt they served as the launching pad of a massive Nexus organization.

Although the power of NEXUS thinking can be used to create extraordinary social impact and collective equity, it can also be applied to more debatable outcomes. We need only look to the city of Las Vegas to see the advanced integration of science and creativity in the never-ending pursuit to extract wealth from gamblers and tourists. The sophistication of the synthesis of behavioral psychology, neuroscience, entertainment technology, and environmental design has produced one of the most successful commercial enterprises in the world. It is interesting to note that since the turn of the twenty-first century, nongaming revenue has outstripped gambling as the primary source of commercial activity. Organizations like Cirque du Soleil have been emblematic of the NEXUS practice, investing in technological tour de force productions like "O"—the title being a play on *eau*, the French word for water—which took place in and above a 1.5 million gallon swimming pool, engaging over 150 backstage technicians and 85 performers.

Coalescing into a Final Picture: The Compass, the Map, and the Core-Periphery Balance

Concepts rooted in the notion of balance and communication will result in unity; strive for complementarity.

As noted earlier, maps are useful in stable, well-understood environments. In complex, changing environments, a compass is preferable to a map. The compass metaphor conveys both a sense of direction and balance. Every organization can be thought of as a compass. The base is what makes the organization work: its current strengths and identity. The direction is given by its aspirations, its view of the future, and new ventures being explored (figure 8.1).

But while moving into the future, we need to look right and left, balancing the external environment and the various ever-changing constituencies, partners, shareholders, and stakeholders. It is up to us to define what is right and what is left, but we need balance to chart the course. There cannot be only right or only left; there must be tension. Otherwise, like a boat with just one oar, we would not be able to maintain a straight course.[123]

Another way to visualize the content of the compass is by arranging the components to indicate the balance between core and periphery (figure 8.2). The core is the base of the compass, the grounding in fundamentals, the origin of the arrow going into the future; the core contains the existing strengths, the sources of current value, and the areas at which the organization excels. Peripheral strengths are investments, educated bets, today's unique opportunities that could become future areas of strength. To constantly evolve we must monitor the interaction between core and peripheral areas; the core areas of today must be balanced with investments in peripheral areas that represent the future. If all we have is periphery, we lose the center. On the flip side, having all center and no periphery is a sure sign of fragility and problems lurking in the future.

There is yet another type of balance, one central to the thesis of this book: the left-brain / right-brain balance. In fact, it is the basis of another important lesson: "train yourself to look at fields in term of balance." Once this practice is internalized, it can be applied to entire practices. An example? Marketing. The field is nowadays more left-brain and more data-driven than ever. But it is also narrower than ever, which creates a real problem of integration, communication, and community. In practice, it is creating two schools: old school (right-brained—very brand-oriented) and a new school (left-brained—data driven). They do not speak the same language or understand problems the same way. The left-brained school is becoming more powerful (thanks to the influence of Amazon, Facebook, and other corporate behemoths) but clearly struggling without the other half of its brain. A result? Facebook, the company with arguably the most data in the world, has become one of the most hated companies in America because of poor marketing.

123. Important to point out that the content of a SWOT analysis (strengths, weaknesses, opportunities, and threats) can be mapped into a compass. But a compass signals direction; a SWOT analysis does not.

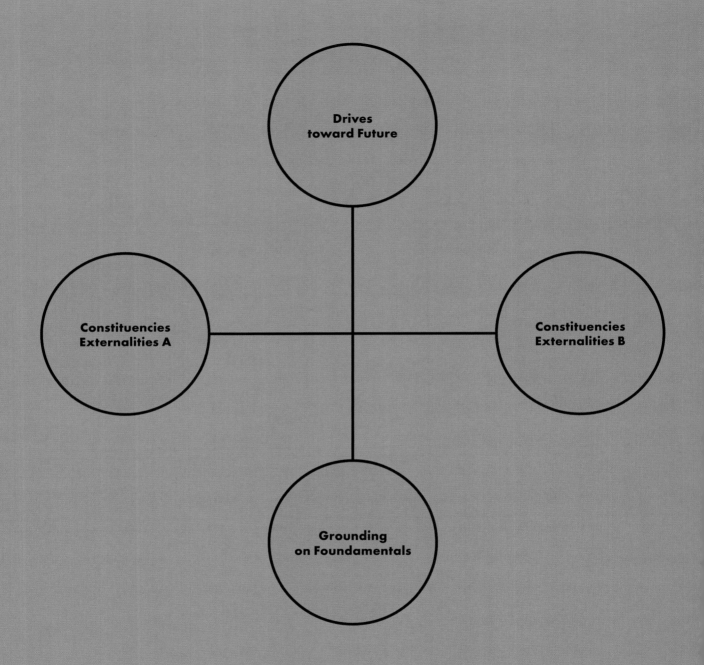

Drives
toward Future

Constituencies
Externalities A

Constituencies
Externalities B

Grounding
on Foundamentals

Fig. 8.1 The compass of an
organization is grounded by its
current strengths and identity;
the forward motion is given by
its aspirations, its view of future,
and new ventures being explored.
The constituencies in tension provide
the balance to chart the course.

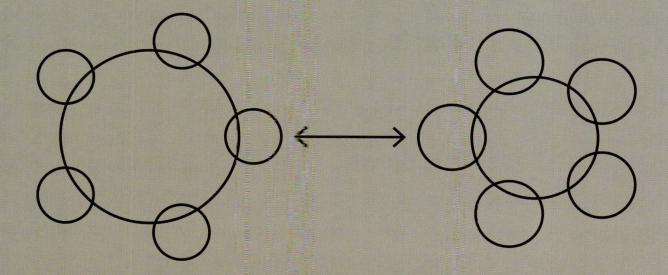

Fig. 8.2 Core strengths must
be balanced with investment
in emerging areas. Constant
interaction between the two allows,
in time, the periphery to redefine
the core.

Tackling complexity goes hand in hand with extracting information from often massive amounts of data. Graduate degrees in analytics are now common, hardly a surprise since we have access to more data than at any point in history. The deluge crosses domains: health, socioeconomical systems, and businesses of all types. It is an unstated belief that having data is good, and that more data is better. "Access to data is the first step toward understanding" is the conviction stemming from science; "if it can be measured, it can be managed" is the refrain from the business world. Knowing what has happened (or what is happening) is the first step in understanding what is going on and, in the case of businesses, how to do things better—the belief in data crosses logistics, customer service, marketing, sales, employee performance, and much more.

Why not simply ask an algorithm to wring understanding from data? A laptop computer that crunches billions of calculations per second could surely examine large datasets from every angle. The key is knowing those angles *in advance*, so that the algorithm can know what patterns to look for. Whole-brain problems are precisely those that require context and human experience that AI algorithms currently lack.

This point can be illustrated with a tiny data set, a mere 8×8 grid of 64 numbers (figure 8.3). How would we program a computer to extract insight from it? We could run basic statistics on the numbers as a whole or ask it to see if there are differences or trends among the rows or columns. But what if there are insights that we cannot predict a priori, and therefore we cannot tell the machine to seek them out? The question, "Tell me what you see?" is easy for a person to answer, not so for a machine.

How can we merge powerful data processing capabilities with the unique knowledge of a human analyst? The best available solution is to load the data into the single largest processor in the human brain: vision. The human visual system occupies around

38	49	79	85	78	91	55	34
30	83	45	41	35	39	90	34
79	32	35	18	20	32	15	87
90	41	89	25	30	95	29	88
82	37	27	21	16	19	18	88
85	23	32	89	91	14	27	87
23	87	43	36	45	44	83	12
33	43	84	96	93	89	51	38

Fig. 8.3 How can we extract information from the 8×8 matrix of numbers on the left? By exploiting visual processing capabilities, as indicated on the right.

40 percent of the human brain (Van Essen et al. 1992) and can process multiple channels of information in parallel including position, size, orientation, and color, across the entire 2D plane of a display. When data are organized into a display that can be read by the visual system, we merge powerful data processing with human insight and contextual understanding. The 8×8 grid on the right in figure 8.3 shows this difference. Suddenly we grasp what was already there: certain symmetries and clustering, something that from a distance resembles an icon of a crude face.

The point of this example is to show the need of balancing processing power with human capabilities to yield knowledge and insight. Data are meaningless unless they can be converted to insight. Numerous organizations, both commercial and research, are attacking this problem. Many terms are associated with these efforts: data mining, correlation analysis, machine learning, recommendation engines—anything that people can think will translate data into understanding or to inform decision-making and transform business practices. Visualization—those efforts that go way beyond a supporting role for analysis—can be part of the solution, transforming data into prose via artificial intelligence, for example. The key is assessing the balance within the organization: weighing the reliance on data for data's sake versus the desire and ability to get insight from the data. Facebook has lots of data but not enough insight into how that data can be useful to its image.

We are seeing how the whole-brain concept coalesces into a simple final picture and how it relates to a central concept from complex systems theory. The concept is emergence, and emergence in our case—the Nexus case—is the augmentation of thinking space.

Emergence is a central concept in complex systems theory, and the main point of emergence is that it is *not* top-down. A successful organization (and a successful leader) is one that creates the condition for successful emergence: the seemingly spontaneous surge of creative ideas and the successful execution of those ideas; of teams that seem to form and create output without imposed scripts; of encouraging people who grasp things that are in the air, who are aware of the sense of mission of the organization. Possibly the most important balance within organizations is the one between complicated and complex; how much or the organization is designed with a blueprint (as in complicated systems) versus how much of the organization is designed to foster successful emergence (as in complex systems) – a Nexus balance between creators and implementors that would foster execution, resilience, adaptability, and innovation.

But all this depends on setting the underlying conditions for emergence: *the alignment of individual compasses within the organization.* This is the job of the leader, to set the culture of the place, the compass of the organization. Once this occurs, seemingly magical things can happen.

124. These ideas resemble those of Jane Jacobs's highly influential city planning book, *The Death and Life of Great American Cities* (Jacobs 1961).

True innovation is the result of a compass that drives a culture, not of a dictum from above. It is the result of a complex set of interactions by talented people who link and reinforce each other in unpredictable ways; individuals who think of themselves as part of a whole-brain system, who understand that ideas do not stay in restricted neighborhoods. Ideas are placed "out there" so that they can connect with others and form better, more complete ideas.[124]

We mentioned earlier in the chapter that simple models can sharpen our thinking. Using the example of forest fires and percolation thresholds, we also referred briefly to phase transitions, a concept stemming from physics. In phase transitions, the properties of a system change discontinuously because of some change in external conditions, such as temperature. An example is the transition between solid and liquid states: freezing in one direction, melting in the other. The Ising model, a mathematical model of ferromagnetism—a caricature of magnetization—is a model of phase transitions in general (Domb 1974).

The model consists of a lattice, such as a checkerboard, where each of the sites has a spin, something that can be either up or down, say +1 or −1. Sites interact with their neighbors, and neighboring spins that agree lead to a lower energy than those that disagree. Lowest energy is preferred, but thermal agitation (temperature) disturbs this tendency. Depending on the temperature, the system can go from a state where the spins are randomly distributed over the lattice to a rich array of morphologies, intertwined regions where spins are aligned in +1 or −1 directions.

It is possible to imagine higher order models where the interactions take place in a network rather than in a lattice. A key difference here is that the sites in the network may have varying numbers of neighbors, with some elements in the network being more influential than others. Imagine also what would happen if the overall connectivity of the network were to increase or decrease. An extreme example could be when a subset is cut off from the main network. In such a case, alignment between parts would be lost. Or imagine that alignment could be more complex than just up or down states; it could be a set of positions on various issues, with the degree of alignment quantified by suitable metrics, possibly ranking the importance of the issues themselves. In fact, it is possible that the "overall" position of the individuals on these various issues could be represented by an individual compass, a sense of direction about their values and priorities. It would then be possible to quantify, by some suitable metric, the degree of alignment of the individual compasses in the entire network. Thus, by imagining these scenarios, we went in an abstract way from a model of magnetization to a model that could represent the degree of alignment of individual compasses within an organization. When posed in this way, we can visualize the overall compass of the organization and understand why connectivity, the structure of the network, is important. This highlights the importance of the network and, in turn, requires us to pay attention to formation and the rules of attachment.

Many networks grow by what is called "preferential attachment," or "like attracts like." The more connected a node is—think of a website with lots of traffic—the more likely it is that other websites would want to link to it; "like attracts like" means, for example, that people with similar backgrounds or interests are likely to connect with each other. The key issue is to augment the definition of "like." "Like" may not just be people with similar backgrounds, it could be people who share an appetite for ambiguity. This will more often lead to teams that may include at least some people who feel comfortable with Nexus thinking. Thus, augmenting our thinking space is the first step, which brings us back to the starting point. Is innovation the result of a compass that drives a culture, or is it the culture that creates the compass? The answer: it is both.

Modern art is an encapsulation of the kind of thinking that may enrich the thinking space of left-brain individuals. What does "thinking like an artist" bring to the table? Artists bring other components besides the usually perceived elements of creativity. Artistic thinking brings resilience. "Artists, more than anyone I know, are capable of making something out of nothing... They find things on the street, they beg, they borrow, or create brand-new colors, brand-new objects, or brand-new ways of looking at the world. They have with them what I would call a resilient spirit that... infuses everything they do," proclaimed a New York arts organization director after Hurricane

Fig. 8.4 The elements of continual innovation.

Sandy destroyed many Brooklyn art studios (Wolff 2013). Though the storm ruined pieces and transformed others in unexpected ways, many artists embraced these random accidents and regarded Sandy as a collaborator. Artistic thinking can augment the thinking space; its expanded form of creativity is the first component of continual innovation (figure 8.4).

The second crucial component is to equip people with the ability to operate in complex environments. This is important now more than ever. They must be prepared to recognize and exploit emergence, to be on the lookout for hidden connections, and to be comfortable operating in chaotic environments. The third component—and this is something that goes well outside expanding creative spaces, embracing complex systems concepts, and guiding execution—is having people who have a bias toward action, and an ingrained motivation to act. Bias toward action must be accompanied by tolerance of failure and the ability to act in challenging and possibly hostile environments. This is hard to teach. But how to deal with setbacks is one of the most reliable indicators and predictors of true leadership. The skills required to conquer adversity and emerge stronger and more committed than ever are the same ones that make for extraordinary leaders.

The fundamental goal is to nurture a new generation of people who have not only the functional technical skills but also the broader contextual and collaborative abilities to truly innovate. The work in front of us is to map a model that attracts the right people, build programs to inform them, and then make it impossible for them not to apply that thinking to the mainstream of their work. Traditional leaders are map-driven, hierarchical, analytical, methodical, and evolutionary. New leaders are compass-driven, collaborative whole-brain thinkers who can establish a culture of values while creating the conditions for constant reinvention.

How can we lead in a chaotic and interconnected world? Maps work in stable, well-understood environments. Crises may alter maps; crises do not disrupt a compass. The ability to instill the sense of a compass in a complex organization may, in fact, be the essence of leadership. A successful organization is one that creates the right conditions for emergence.

Image of super typhoon Maysak
taken by European Space Agency
astronaut Samantha Cristoforetti
as the International Space Station
passed near the storm on March
31, 2015.

EPILOGUE

Stepping back to look at the entire picture

Big challenges will drive us:
we need to be prepared.

At no point in history has there been such a universal agreement as to the existential problems facing the entire planet in energy and sustainability. At no point have we had a pandemic that shut down entire countries and paralyzed their economies. A recognition that we live in a finite Earth will shape much of our future, but many other problems that we cannot possibly imagine will emerge as well. To better understand, we must look both forward and backward.

Predictions

There is difficulty in escaping the present.

How many of us would imagine that predicting five years ahead could be as hard as predicting fifty or a hundred years into the future? Yet that is exactly what annual forecasts from the *Economist* seem to suggest: every November the magazine publishes what it calls "future-gazing coverage" with a list of predictions; then it reports back in a year's time to see how accurate those predictions were. Producing a scorecard is far from easy. Roughly half the predictions turn out to be correct, and the pandemic did not appear on any list. How might the *Economist's* recent track record compare to predictions from the *Ladies' Home Journal* at the turn of the twentieth century?

John Elfreth Watkins Jr. (1852–1903) attempted a bolder challenge in the December 1900 issue of that venerable magazine (figure 9.1) by gathering predictions that leapt forward not one but one hundred years. He announced his objective at the beginning: "To the wisest and most careful men in our greatest institutions of science and learning I have gone, asking each in his turn to forecast for me what, in his opinion, will have been wrought in his own field of investigation before the dawn of 2001—a century from now. These opinions I have carefully transcribed." Watkins listed twenty-eight predictions in his piece titled "What May Happen in the Next Hundred Years."

Watkins's predictions spanned several categories. Only one could be forecast with contemporaneous tools: "There will probably be from 350,000,000 to 500,000,000 people in America and its possessions by the lapse of another century." The starting point of the prediction, the US population in 1900, was 76 million; in 2000 it was 282 million and rose to 331 million in 2020. Thus the 350-million estimate was even a bit too optimistic, despite waves of immigration, since it could not factor in the staggering death tolls resulting from two world wars and massive economics crises. Maybe "its possessions," a specified component of the prediction, accounted for the gap. Today, demographics is an advanced discipline, and we can precisely predict populations shifts worldwide

Some predictions were off the mark: "Nicaragua will ask for admission to our Union after the completion of the great canal. Mexico will be next." And "There will be No C, X or Q in our every-day alphabet. ... English will be a language of condensed words expressing condensed ideas and will be more extensively spoken than any other. Russian will rank second." Of course, Russian did not become the second most-spoken language in the world; it is now eighth. German is between tenth and thirteenth worldwide, but it was popular in the United States in 1901. In fact, Watkins's article in the *Ladies' Home Journal* article was translated into German for the *Milwaukee Herold und Seebote*, a newspaper that ran daily, except Sundays, from 1898 to 1912. As late as 1910, an estimated one in ten people in the United States still spoke German as their mother tongue. Few spoke Spanish.

WHAT MAY HAPPEN IN THE NEXT HUNDRED YEARS

By JOHN ELFRETH WATKINS, Jr.

THESE prophecies will seem strange, almost impossible. Yet they have come from the most learned and conservative minds in America. To the wisest and most careful men in our greatest institutions of science and learning I have gone, asking each in his turn to forecast for me what, in his opinion, will have been wrought in his own field of investigation before the dawn of 2001—a century from now. These opinions I have carefully transcribed.

Five Hundred Million People. There will probably be from 350,000,000 to 500,000,000 people in America and its possessions by the lapse of another century. Nicaragua will ask for admission to our Union after the completion of the great canal. Mexico will be next. Europe, seeking more territory to the south of us, will cause many of the South and Central American republics to be voted into the Union by their own people.

The American will be Taller by from one to two inches. His increase of stature will result from better health, due to vast reforms in medicine, sanitation, food and athletics. He will live fifty years instead of thirty-five as at present—for he will reside in the suburbs. The city house will practically be no more. Building in blocks will be illegal. The trip from suburban home to office will require a few minutes only. A penny will pay the fare.

There will be No C, X or Q in our every-day alphabet. They will be abandoned because unnecessary. Spelling by sound will have been adopted, first by the newspapers. English will be a language of condensed words expressing condensed ideas, and will be more extensively spoken than any other. Russian will rank second.

Hot and Cold Air from Spigots. Hot or cold air will be turned on from spigots to regulate the temperature of a house as we now turn on hot or cold water from spigots to regulate the temperature of the bath. Central plants will supply this cool air and heat to city houses in the same way as now our gas or electricity is furnished. Rising early to build the furnace fire will be a task of the olden times. Homes will have no chimneys, because no smoke will be created within their walls.

No Mosquitoes nor Flies. Insect screens will be unnecessary. Mosquitoes, house-flies and roaches will have been practically exterminated. Boards of health will have destroyed all mosquito haunts and breeding-grounds, drained all stagnant pools, filled in all swamp-lands, and chemically treated all still-water streams. The extermination of the horse and its stable will reduce the house-fly.

Ready-Cooked Meals will be Bought from establishments similar to our bakeries of to-day. They will purchase materials in tremendous wholesale quantities and sell the cooked foods at a price much lower than the cost of individual cooking. Food will be served hot or cold to private houses in pneumatic tubes or automobile wagons. The meal being over, the dishes used will be packed and returned to the cooking establishments where they will be washed. Such wholesale cookery will be done in electric laboratories rather than in kitchens. These laboratories will be equipped with electric stoves, and all sorts of electric devices, such as coffee-grinders, egg-beaters, stirrers, shakers, parers, meat-choppers, meat-saws, potato-mashers, lemon-squeezers, dish-washers, dish-dryers and the like. All such utensils will be washed in chemicals fatal to disease microbes. Having one's own cook and purchasing one's own food will be an extravagance.

No Foods will be Exposed. Storekeepers who expose food to air breathed out by patrons or to the atmosphere of the busy streets will be arrested with those who sell stale or adulterated produce. Liquid-air refrigerators will keep great quantities of food fresh for long intervals.

Coal will Not be Used for Heating or Cooking. It will be scarce, but not entirely exhausted. The earth's hard coal will last until the year 2050 or 2100; its soft-coal mines until 2200 or 2300. Meanwhile both kinds of coal will have become more and more expensive. Man will have found electricity manufactured by water-power to be much cheaper. Every river or creek with any suitable fall will have been equipped with water-motors, turning dynamos, making electricity. Along the seacoast will be numerous reservoirs continually filled by waves and tides washing in. Out of these the water will be constantly falling over revolving wheels. All of our restless waters, fresh and salt, will thus be harnessed to do the work which Niagara is doing to-day: making electricity for heat, light and fuel.

There will be No Street Cars in Our Large Cities. All hurry traffic will be below or high above ground when brought within city limits. In most cities it will be confined to broad subways or tunnels, well lighted and well ventilated, or to high trestles with "moving-sidewalk" stairways leading to the top. These underground or overhead streets will teem with capacious automobile passenger coaches and freight wagons, with cushioned wheels. Subways or trestles will be reserved for express trains. Cities, therefore, will be free from all noises.

Photographs will be Telegraphed from any distance. If there be a battle in China a hundred years hence snapshots of its most striking events will be published in the newspapers an hour later. Even to-day photographs are being telegraphed over short distances. Photographs will reproduce all of Nature's colors.

Trains One Hundred and Fifty Miles an Hour. Trains will run two miles a minute, normally; express trains one hundred and fifty miles an hour. To go from New York to San Francisco will take a day and a night by fast express. There will be cigar-shaped electric locomotives hauling long trains of cars. Cars will, like houses, be artificially cooled. Along the railroads there will be no smoke, no cinders, because coal will be neither carried nor burned. There will be no stops for water. Passengers will travel through hot or dusty country regions with windows down.

Automobiles will be Cheaper than Horses are to-day. Farmers will own automobile hay-wagons, automobile truck-wagons, plows, harrows and hay-rakes. A one-pound motor in one of these vehicles will do the work of a pair of horses or more. Children will ride in automobile sleighs in winter. Automobiles will have been substituted for every horse vehicle now known. There will be, as already exist to-day, automobile hearses, automobile police patrols, automobile ambulances, automobile street sweepers. The horse in harness will be as scarce, it, indeed, not even scarcer, then as the yoked ox is to-day.

Everybody will Walk Ten Miles. Gymnastics will begin in the nursery, where toys and games will be designed to strengthen the muscles. Exercise will be compulsory in the schools. Every school, college and community will have a complete gymnasium. All cities will have public gymnasiums. A man or woman unable to walk ten miles at a stretch will be regarded as a weakling.

To England in Two Days. Fast electric ships, crossing the ocean at more than a mile a minute, will go from New York to Liverpool in two days. The bodies of these ships will be built above the waves. They will be supported upon runners, somewhat like those of the sleigh. These runners will be very buoyant. Upon their under sides will be apertures expelling jets of air. In this way a film of air will be kept between them and the water's surface. This film, together with the small surface of the runners, will reduce friction against the waves to the smallest possible degree. Propellers turned by electricity will screw themselves through both the water beneath and the air above. Ships with cabins artificially cooled will be entirely fire-proof. In storm they will dive below the water and there await fair weather.

There will be Air-Ships, but they will not successfully compete with surface cars and water vessels for passenger or freight traffic. They will be maintained as deadly war-vessels by all military nations. Some will transport men and goods. Others will be used by scientists making observations at great heights above the earth.

Aërial War-Ships and Forts on Wheels. Giant guns will shoot twenty-five miles or more, and will hurl anywhere within such a radius shells exploding and destroying whole cities. Such guns will be aimed by aid of compasses when used on land or sea, and telescopes when directed from great heights. Fleets of air-ships, hiding themselves with dense, smoky mists, thrown off by themselves as they move, will float over cities, fortifications, camps or fleets. They will surprise foes below by hurling upon them deadly thunderbolts. These aërial war-ships will necessitate bomb-proof forts, protected by great steel plates over their tops as well as at their sides. Huge forts on wheels will dash across open spaces at the speed of express trains of to-day. They will make what are now known as cavalry charges. Great automobile plows will dig deep intrenchments as fast as soldiers can occupy them. Rifles will use silent cartridges. Submarine boats submerged for days will be capable of wiping a whole navy off the face of the deep. Balloons and flying machines will carry telescopes of one-hundred-mile vision with camera attachments, photographing an enemy within that radius. These photographs, as distinct and large as if taken from across the street, will be lowered to the commanding officer in charge of troops below.

There will be No Wild Animals except in menageries. Rats and mice will have become practically extinct. The horse will have become practically extinct. A few of high breed will be kept by the rich for racing, hunting and exercise. The automobile will have driven out the horse. Cattle and sheep will have no horns. They will be unable to run faster than the fattened hog of to-day. A century ago the wild hog could outrun a horse. Food animals will be bred to expend practically all of their life energy in producing meat, milk, wool and other by-products. Horns, bones, muscles and lungs will have been neglected.

Man will See Around the World. Persons and things of all kinds will be brought within focus of cameras connected electrically with screens at opposite ends of circuits, thousands of miles at a span. American audiences in their theatres will view upon huge curtains before them the coronations of kings in Europe or the progress of battles in the Orient. The instrument bringing these distant scenes to the very doors of people will be connected with a giant telephone apparatus transmitting each incidental sound in its appropriate place. Thus the guns of a distant battle will be heard to boom when seen to blaze, and thus the lips of a remote actor or singer will be heard to utter words or music when seen to move.

Telephones Around the World. Wireless telephone and telegraph circuits will span the world. A husband in the middle of the Atlantic will be able to converse with his wife sitting in her boudoir in Chicago. We will be able to telephone to China quite as readily as we now talk from New York to Brooklyn. By an automatic signal they will connect with any circuit in their locality without the intervention of a "hello girl."

Grand Opera will be Telephoned to private homes, and will sound as harmonious as though enjoyed from a theatre box. Automatic instruments reproducing original airs exactly will bring the best music to the families of the untalented. Great musicians gathered in one inclosure in New York will, by manipulating electric keys, produce at the same time music from instruments arranged in theatres or halls in San Francisco or New Orleans, for instance. Thus will great bands and orchestras give long-distance concerts. In great cities there will be public opera-houses whose singers and musicians are paid from funds endowed by philanthropists and by the government. The piano will be capable of changing its tone from cheerful to sad. Many devices will add to the emotional effect of music.

How Children will be Taught. A university education will be free to every man and woman. Several great national universities will have been established. Children will study a simple English grammar adapted to simplified English, and not copied after the Latin. Time will be saved by grouping like studies. Poor students will be given free board, free clothing and free books if ambitious and actually unable to meet their school and college expenses. Medical inspectors regularly visiting the public schools will furnish poor children free eyeglasses, free dentistry and free medical attention of every kind. The very poor will, when necessary, get free rides to and from school and free lunches between sessions. In vacation time poor children will be taken on trips to various parts of the world. Etiquette and housekeeping will be important studies in the public schools.

Store Purchases by Tube. Pneumatic tubes, instead of store wagons, will deliver packages and bundles. These tubes will collect, deliver and transport mail over certain distances, perhaps for hundreds of miles. They will at first connect with the private houses of the wealthy; then with all homes. Great business establishments will extend them to stations, similar to our branch post-offices of to-day, whence fast automobile vehicles will distribute purchases from house to house.

Vegetables Grown by Electricity. Winter will be turned into summer and night into day by the farmer. In cold weather he will place heat-conducting electric wires under the soil of his garden and thus warm his growing plants. He will also grow large gardens under glass. At night his vegetables will be bathed in powerful electric light, serving, like sunlight, to hasten their growth. Electric currents applied to the soil will make valuable plants grow larger and faster, and will kill troublesome weeds. Rays of colored light will hasten the growth of many plants. Electricity applied to garden seeds will make them sprout and develop unusually early.

Oranges will Grow in Philadelphia. Fast-flying refrigerators on land and sea will bring delicious fruits from the tropics and southern temperate zone within a few days. The farmers of South America, South Africa, Australia and the South Sea Islands, whose seasons are directly opposite to ours, will thus supply us in winter with fresh summer foods which cannot be grown here. Scientists will have discovered how to raise here many fruits now confined to much hotter or colder climates. Delicious oranges will be grown in the suburbs of Philadelphia. Cantaloupe and other summer fruits will be of such a hardy nature that they can be stored through the winter as potatoes are now.

Strawberries as Large as Apples will be eaten by our great-great-grandchildren for their Christmas dinners a hundred years hence. Raspberries and blackberries will be as large. One will suffice for the fruit course of each person. Strawberries and cranberries will be grown upon tall bushes. Cranberries, gooseberries and currants will be as large as oranges. One cantaloup will supply an entire family. Melons, cherries, grapes, plums, apples, pears, peaches and all berries will be seedless. Figs will be cultivated over the entire United States.

Peas as Large as Beets. Peas and beans will be as large as beets are to-day. Sugar cane will produce twice as much sugar as the sugar beet now does. Cane will once more be the chief source of our sugar supply. The milkweed will have been developed into a rubber plant. Cheap native rubber will be harvested by machinery all over this country. Plants will be made proof against disease microbes just as readily as man is to-day against smallpox. The soil will be kept enriched by plants which take their nutrition from the air and give fertility to the earth.

Black, Blue and Green Roses. Roses will be as large as cabbage heads. Violets will grow to the size of orchids. A pansy will be as large in diameter as a sunflower. A century ago the pansy measured but half an inch across its face. There will be black, blue and green roses. It will be possible to grow any flower in any color and to transfer the perfume of a scented flower to another which is odorless. Then may the pansy be given the perfume of the violet.

Few Drugs will be Swallowed or taken into the stomach unless needed for the direct treatment of that organ itself. Drugs needed by the lungs, for instance, will be applied directly to those organs through the skin and flesh. They will be carried with the electric current applied without pain to the outside skin of the body. Microscopes will lay bare the vital organs, through the living flesh, of men and animals. The living body will to all medical purposes be transparent. Not only will it be possible for a physician to actually see a living, throbbing heart inside the chest, but he will be able to magnify and photograph any part of it. This work will be done with rays of invisible light.

Fig. 9.1 John Elfreth Watkins, "What May Happen in the Next Hundred Years," from *Ladies' Home Journal,* December 1900.

Some predictions did bet or technologies that quickly plateaued: "Pneumatic tubes, instead of store wagons, will deliver packages and bundles." Some were too grounded on the themes of the day: "Vegetables Grown by Electricity. Electricity applied to garden seeds will make them sprout and develop." In 1900, electricity was all the rage.

And a few other predictions extrapolated from what was already in the air: "Automobiles will be cheaper than horses are today." The Ford Model T, the first affordable automobile, was to be launched in 1908 (car production in the United States was 11,000 in 1900; 461,000 in 1913; 3,625,000 in 1923; half of these were Fords). But other predictions could not foresee what was about to happen: "There will be air-ships, but they will not successfully compete with surface cars and water vessels for passenger or freight traffic." If the air-ship category was restricted to the zeppelin, the prediction was right. But likely this prediction did not foresee the birth of airplanes; the Wright brothers were around the corner. By World War I, airplanes would be in full production.

But some predictions were closer to the mark: "The American will be taller by from one to two inches. … [The] increase of stature will result from better health, due to vast reforms in medicine, sanitation, food and athletics." And another: "Hot and Cold Air from Spigots. Hot or cold air will be turned on from spigots to regulate the temperature of a house. … Rising early to build the furnace fire will be a task of the olden times."

Sadly, some predictions did not come to pass: "There Will Be No Street Cars in Our Large Cities. All hurry traffic will be below or high above ground when brought within city limits… Cities, therefore, will be free from all noises." This was in 1900!

But others were remarkably prescient: The prediction that "Grand Opera will be telephoned to private homes and will sound as harmonious as though enjoyed from a theatre box" mixed the old and the new. "Photographs will be telegraphed from any distance. … Photographs will reproduce all of Nature's colors." And the most remarkable of all: "Man will See Around the World. Persons and things of all kinds will be brought within focus of cameras connected electrically with screens at opposite ends of circuits, thousands of miles at a span," something that could be regarded as a presage of the internet. But the prediction also states: "American audiences in their theatres will view upon huge curtains before them the coronations of kings in Europe or the progress of battles in the Orient." There were battles in East Asia after 1900, but far fewer coronations of kings in Europe than one could have anticipated based on the world of the 1900s.

Perspective helps: What was going on in 1900? The workforce in the United States in 1900 was vastly different than in 2000. In 1900, 44 percent of the population worked in agriculture and mining, 36 percent in services, and 20 percent in manufacturing; by 2000 those numbers changed to 3 percent, 80 percent, and 17 percent, with manufacturing having peaks nearing 30 percent in 1920 and 1970. But momentous changes

were in the air. In 1897, Guglielmo Marconi had sent the first-ever wireless communication over open sea. Flight had not taken place; the first successful airplane, making the first controlled, powered, and sustained heavier-than-air human flight, would take place in December 1903. The first oil well was drilled in the United States in 1859, and Alexander Graham Bell and the telephone could be pinned down to 1879. The beginnings of color photography had been invented by Auguste and Louis Lumière. Electricity made outdoor arc lighting possible in 1879, but it was only later in the nineteenth century that electricity had been put to industrial and residential use. In 1900, George Claude invented the neon light; in 1903, William Coolidge invented the ductile tungsten used in light bulbs, and Leo Baekeland invented the first synthetic plastic called Bakelite.

And then, change accelerated. In 1905, the publication of Albert Einstein's papers on the theory of relativity and the famous the equation $E = mc^2$ transformed physics. Quantum mechanics came into the picture. And, although the distinction between pure and applied science was less sharp before 1900, around that time a greater distinction began to appear between pure mathematics and applied mathematics, pure physics and applied physics. For example, Irving Langmuir (1881–1957), an American chemist and physicist who worked at GE from 1909 to 1950, won the 1932 Nobel Prize in Chemistry for the fundamental work in surface chemistry he did while there—making him the first to receive a Nobel Prize while working in a corporation. Langmuir did applied work as well; he invented the gas-filled incandescent lamp. Technology exploded. But the word itself was barely on the horizon, even in the early 1930s.

In fact, no US president used the word "technology" (or a form of it) in a State of the Union speech until Franklin D. Roosevelt spoke of technological improvements in 1939 and Harry Truman invoked the need for technical power and technical know-how in 1952. The word "innovation" provides another way to measure change: Ronald Regan called for an innovative program to monitor government accountability in his 1982 State of the Union speech; Barak Obama used the word and variations of it—"out-innovate," for example—a total sixteen times in 2011. Everything is about innovation now.

A recent lesson on the utility of forecasts and forecasters comes from the book *After Shock*, a 2020 tome timed to mark the fiftieth anniversary of *Future Shock*, Alvin Toffler's 1970 megahit. This collection of essays promises the "extraordinary insights of the world's foremost thought leaders." In this sense the book is less of a retrospective on what Toffler got right or wrong and more of what 116 futurists say will happen in the next fifty years (Mills 2020a).

In a perceptive review of the book, Mark Mills notes that given its publication date, only several weeks into COVID-19 lockdown, *After Shock* had a lot to say about pre-pandemic problems, from climate change and energy to transportation, and an

array of digital and social issues that have occupied the popular media in recent years. This may not seem surprising, as Mills points out: "Forecasters extrapolate, in effect, on yesterday's technologies or on what they think should happen to address today's troubles." With that in mind, he notices that barely a half-dozen of those 116 contributors had anything to say about health care, never mind pandemics.

Going back to assess the technologies mentioned by Toffler in 1970, we learn that the word "computer" appears 54 times in *Future Shock*, and the word "software" only once. The term "artificial intelligence" never appears. It is worth mentioning that by the time Future Shock was published, AI had been around for fifteen years, and four years had passed since the ideas that launched Arpanet, the precursor to the internet, had been framed (Mills 2020a). Indeed, when forecasters extrapolate based on existing, visible technologies, they miss technologies that are not-yet-visible, not-yet-named, but which may be just around the corner.

Some of the best visions of the future have come from outside science and technology; fiction writers have had a better track record in anticipating the future. Aldous Huxley (1894–1963), author of *Brave New World*, presented a dystopian future that anticipated chemical birth control, television and video conferencing, mood stabilizers, and genetic engineering. H. G. Wells (1866–1946) foresaw the advent of aircraft, air combat, tanks, air conditioning, television, space travel, nuclear weapons, and something resembling the internet and the World Wide Web. He imagined alien invasions, biological engineering, invisibility, and time travel. Wells was obviously aware of Jules G. Verne (1828–1905), the other "father of science fiction"—he was twenty-five when Verne was sixty-three—but they portrayed science and technology in different lights: Verne championed new technologies as instruments of progress, a time when Romantic writers were inspired by the scientific discoveries of the day. Wells, on the other hand, saw some of the negative consequences of science and technology. Wells's military science-fiction work *War in the Air*, which was serialized in four magazine installments in 1908, anticipated the strategic importance of air power in World War I.

In a different class are predictions of possible science and technology informed by solid technical knowledge. Vannevar Bush's "As We May Think," the highly influential 1945 *Atlantic* piece mentioned in chapter 6, is a tour de force in forecasting the future. Bush envisioned the ability to post and retrieve articles, and the possibility that people would be able create links between articles. "Wholly new forms of encyclopedias will appear, ready-made with a mesh of associative trails running through them," he wrote. One of his goals was to create a trail of thinking, what he called a *Memex*, enabling others to see the thought process of each user. His goal was to make knowledge more accessible; even though the amount of information in 1945 was a fraction of the information we have today, he wanted to convert what he saw as an information explosion into a knowledge explosion. Remarkably, this vision was grounded on technologies that existed before digital computers did. But this was not science fiction.

Fig. 9.2 Vannevar Bush's differential analyzer at MIT, merging the electrical and mechanical worlds.

In hindsight we can see the strands of technical knowledge that gave rise to Bush's 1945 vision. Between 1928 and 1931, Bush built what was regarded as the first practical general-purpose differential analyzer, a device that could solve differential equations. Earlier designs of differential analyzers existed, but those were purely mechanical. Bush's version had both mechanical and electrical components (figure 9.2). In 1936 Claude Shannon, who we encountered earlier as well, began his graduate studies with Bush working on the differential analyzer. And, in 1937, the twenty-year-old Shannon wrote a master's thesis that became the foundation of practical digital circuit design.

Thus, important strands converged: Bush's differential analyzer merging the mechanical and electrical worlds, and Shannon's merging the electrical and logical worlds. The first electronic general-purpose computer, the ENIAC, was just around the corner; it was completed at the end of 1945. We could say that this convergence signaled the beginning of the digital world, but in and of itself did not produce a picture of the future. Remarkable imagination was needed to create the vision articulated by Bush.

Our goal, the Nexus goal, s to put forward a thinking framework that will prepare us for what is yet to come. The previous examples show that we should be humble in tackling anything that deals with future.

Choices
What should we include? What can we leave out?

There are many ways to build an argument for the Nexus and the benefits that come from Nexus thinking. Writing a book requires making choices about how to make a case: what to use, what to leave out. Let us justify a few of them.

Many of the examples in this book are drawn from exceptional individuals and organizations. It is good to connect names to ideas to serve as inspiration. We recognize, however, that some of these achievements and ideas may look unreachable. Nevertheless, we believe that Nexus thinking is attainable to all who believe in the concept. Ultimately, this will be a self-selected group: those who want to enrich and expand their thinking and those who are willing to be subsumed in teams and collaborations, blending their talents and skills with others, to tackle big problems and to be part of goals that may transcend individuals.

We acknowledge, however that stereotypes conspire in the opposite direction. Artists, who want to express their own unique viewpoints, may want to receive credit as a sole author. Scientists, though now often part of teams, typically expect to receive credit for discoveries. And technologists, a broad group who could be part of large corporate teams or the lead drivers of entrepreneurial ventures, may range from those who know they may never be recognized as authors of complex technologies they help devise,

Fig. 9.3 Exploring the limits of art. Marina Abramović has been using the body as medium, pushing past perceived limits of the body and mind, often involving considerable pain, exploring the relationship between artist and audience. In 2010, at the Museum of Modern Art in New York City, Abramović performed *The Artist Is Present*, an over 700-hour static, silent piece, where she sat immobile while spectators waiting in line were invited to sit individually across from her while she maintained eye contact with them.

to entrepreneurs who are, or want to be, indistinguishable from the products they conceive. The people who will function at the Nexus are people who derive satisfaction from seeing their thinking spaces augmented by others, and their ideas reaching other domains.

We want to move from the narrow thinking that equates creative output with products: writers with novels, scientists with some unique discovery, architects with buildings, and so on. In each of these examples, the process that leads to the product is more important than the product; *learning how others think is the main lesson.*

For example, a *Chronicle of Higher Education* article about building bridges between engineering and the humanities argues that the domains differ not just in subject matter but in the very kinds of thinking they encourage (Ottino and Morson 2016). The thinking that *underlies* different domains is where the focus should be. Basic literature courses do not teach mastery of a body of material—not just because it is hard to agree on what such a body may be, but also because it is unclear what "mastery of the material" would mean. The *Chronicle* authors invoke the Russian literary theorist Viktor Shklovsky, who argued that art demands us to reverse the usual process of learning. When we acquire a skill, we normally practice it until it is automatic. Learning, in this sense, is a process of familiarization. But sometimes it is important to experience something familiar as if experiencing it for the first time. Or, as Shklovsky explains, we need to "defamiliarize the familiar." Acquiring the habit of overcoming habitual perception is one process that brings engineering and the arts together. It is how great writers impart human experience in new ways, and it is how engineers innovate, seeing something that many others have seen, but seeing it in a completely different way. Like literature, engineering sometimes works not by satisfying recognized needs but by creating the needs it satisfies.

A couple of our content choices deserve justification. One is focusing on a relatively small body of modern and contemporary art to represent art, the domain that is more chaotic than technology or science.[125] Why? Because we need to learn how to be comfortable with exploration and chaos (figure 9.3). We use modern art as a metaphor for speed, chaos, and complexity. If there is one thing that will characterize the world going forward, the one safe prediction we can make, it is that chaos and complexity will increase.

Out of all the possible rising fields in science and technology, we decided to highlight synthetic biology. Why? Because it bridges the world of classical engineering (of designs with parts that fulfill a role) with the world of biological systems (where parts can adapt). Synthetic biology enables cells to perform specialized tasks in response to specific stimuli; the goal is to conceive a desired function, then design and build an engineered system with tools and parts. The idea is to make biology the equivalent of one the amazingly successful ideas of the twentieth century: the programmable integrated circuit. The expectation is that things will work as predicted, but it is a mild expectation. Synthetic biologists know this may not happen. They are prepared to analyze and learn from the results, then go back to and redesign.

125. It is certainly possible to imagine a somewhat parallel book using music, writing, or any other art form as the reference point, instead of visual arts.

Reframing the Past
Tavares Strachan

Tavares Strachan (b. 1979) is a contemporary, conceptual Bahamian artist whose multimedia installations investigate science, technology, mythology, history, and exploration. His work is at the intersection of art, science, and the environment, and has blended aeronautical engineering and astronomy, deep-sea exploration, and climatology/exploration. His works defy characterization, and many resemble scientific experiments or feats of engineering. The work *The Distance Between What We Have and What We Want* involved a journey to northern Alaska that resulted in a 4.5-ton block of ice being transported to the Bahamas and displayed in a solar-powered freezer in the courtyard of his childhood elementary school. *Orthostatic Tolerance*, a work focused on the physiological stress of exiting and reentering Earth, involved photography, video, drawing, sculpture, and documentation of Strachan's experience while training as cosmonaut at the Yuri Gagarin Training Center in Star City, Russia. *ENOCH*, a project in collaboration with the Los Angeles County Museum of Art (LACMA) and SpaceX, involved a golden urn with the likeness of Robert Henry Lawrence Jr., the first African American astronaut selected for any national space program. In December 2019, the urn was placed in low orbit by a SpaceX Falcon 9 rocket. The urn will continue to circle Earth for seven years in a sun-synchronous orbit.

ENOCH (Display Unit), 2015–2017. 11 13/16 × 3 15/16in (30 × 10 × 10 cm). Bronze, 24k gold, sand, steel, aluminum, sacred air blessed by Shinto priest. Isolated Labs, and Digital rendering, Isolated Labs, created in collaboration with LACMA as part of the Art+Technology Lab initiative.

Reframing Reality
Xu Bing

Xu Bing (b. 1955) is part of the group of artists that emerged after China's Cultural Revolution. Growing up in Beijing, he was relocated for two years to the countryside as part of China's "re-education" policy. Returning to Beijing in 1977, he studied printmaking at the Central Academy of Fine Arts, where he received an MFA. *The Book from the Sky*, one of his first independent works and produced over four years, is a four-volume treatise that uses four thousand characters—roughly the number of characters in common usage in modern written Chinese—that, in terms of density of strokes and other metrics, look like ancient Chinese characters. Many early viewers obsessively looked for real characters, but none can be found. The meticulous attention Xu Bing gives to the work invites reading, but its text cannot be read. We can thus see the work as a subversion of language that calls into question our implicit faith in the written word and the authority conveyed in books. The initial critical reactions were dismissive. When later the work was perceived as a critique of the Chinese government, Xu Bing moved to the United States. In 2008, he returned to Beijing.

It would indeed be incredible if we could design organizations in the same manner: put components in place, wire them in the right way, and reap the consequences and rewards. But, as in synthetic biology, we know that this is not possible. Context matters: performances change with different cell types or under different laboratory conditions. Same with people. We picked synthetic biology because it is a powerful metaphor. There is value in contrasting engineering systems with biological systems.

Curiosity as a Must-Have, and the Willingness to Go against Training

There is danger in single-lens thinking.

The book is also about lessons, especially those that cross domains, like the lessons we list in chapter 7. Let us pick one—"Learn to see simplicity in complexity and complexity in simplicity"—and re-elaborate on its importance. First, though, we point out that it is possible to train for any of the lessons we have presented. Training for this one may involve resisting the temptation to ask questions about details before trying to get a sense of the big picture. Many overtrained people face this temptation; they function like computers, seeking to understand sequentially, processing details one by one, fitting ideas to a well-internalized template. We see this happen at academic presentations, where someone questions a speaker about a particular point, giving the impression that without clarification, it is impossible to proceed. But it may well be—in fact it is not uncommon—that after following all the steps the outcome is neither interesting nor important. This recalls a remark the theoretical physicist Wolfgang Pauli (1900–1958) made when one of his colleagues showed him a paper by young physicist. His colleague suspected that the work did not have great value and wanted Pauli's views. Pauli remarked, "It is not even wrong." That may be indeed be the conclusion after reaching the end of many presentations. Or books. Thus, we could reframe the lesson as "Try to grasp the big picture first, and then the details." It may not be worth asking questions in between.

Which brings us to the issue of training and the balance of "automated" versus "controlled" processing. Once a function becomes trained, it becomes an unconscious competence. There is no need to "think," to consciously control the actions required for the function. This may be good, since it may free up resources for other functions. But negative consequences are possible as well. For example, it may be very hard to break habitual patterns. We can apply this to everything, from sports, to playing musical instruments, to learning languages. Importantly, it applies also to thinking modes. We could consider aspects of education, especially professional education, as another form of training. The danger? Preventing us from considering alternative viewpoints by focusing only on the details we were trained to see.

New research blending neuroscience, network science, and information theory illustrates the balance of details/whole picture beautifully (Lynn et al. 2020). We do know that the human brain is adept at uncovering abstract associations—humans, for

example, are skilled at recognizing patterns from complex networks, such as languages, without any formal instruction. But how this happens, and what the underlying mechanisms are, is imperfectly understood. Research is nevertheless advancing a rapid pace and new research suggests that the detection of patterns in complex networks by the human brain is the result of a delicate, seemingly concurrent balancing of opposites, of details and big picture. The brain's ability to detect patterns stems in part from its goal to represent things in the simplest way possible. The conceptual model depicts the brain as constantly balancing accuracy with simplicity when making decisions, built upon the idea that people make mistakes while trying to make sense of patterns, but that these errors are in fact essential to capturing the bigger picture. The brain can pick up on certain statistics between elements without being aware of what those statistics are. Thus, the model sees the brain in sort of a dynamic equilibrium, seeing simultaneously simplicity and complexity—which is in fact, the essence of complementarity. It is worth noting that training may alter this balance. No one should dispute the value of training, but over-reliance on training may force us to see the work through a single lens. It is important to be aware that most often the lens, like a microscope, focuses on details.

A painting analogy helps: "If you look at a pointillist painting up close, you can correctly identify every dot. If you step back 20 feet, the details get fuzzy but you'll gain a better sense of the overall structure" (Lynn et al. 2020). It seems that being able to look at complex systems more broadly, like stepping away from a pointillist painting or a Chuck Close painting (figure 9.4), gives the brain a better idea of overall relationships.

Too much detail clouds the picture. There are many examples of this, but Irineo Funes, the eponymous character in "Funes the Memorious," a short story by Jorge Luis Borges, serves as an extreme example. Funes lives in Fray Bentos, Uruguay, and has a prodigious memory—even more so than Cyrus the Great, the founder of the first Persian Empire, who purportedly remembered all the names of the soldiers in his armies. Funes could remember the shapes of all the clouds he had seen; he could remember an entire day, but it took him an entire day to reconstruct it. A running horse now, and an instant afterward, were for him two different horses. Funes was unable to discover essences or rules. He could not grasp the concept of tree; he could not grasp the concept of Picasso's bull series we saw in chapter 7, how the images relate to one another.

The other point we make is to be open, to look broad and wide. Why is this so critical? Because although many things can be taught—even how to be more creative—it is difficult, if not impossible, to teach someone how to be curious. We can, however, teach the value of being curious. "I have no special talent. I am only passionately curious," Albert Einstein said. That curiosity took him far.

We can also describe the essence of being curious: It is the ability to transcend details and not to filter everything based on past knowledge. It is the ability to not only

Fig. 9.4 Chuck Close, *Self-Portrait*, 2004–2005. With the detail on the right it illustrates seeing the parts and seeing the whole.

remove the standard labels but also to see beyond the need for labels. It is what frees us to see connections. This requires effort, but once we are trained to see connections, we can see them everywhere, even in unexpected places.

An example from a faraway domain? The following words come from the introduction to a book published in the 1830s: "We propose to consider first the single elements of our subject, then each branch or part, and, last of all, the whole, in all of its relations—therefore to advance from the *simple to the complex* [italics added]. But it is necessary for us to commence with a glance at the nature of the whole, because it is particularly necessary that in the consideration of any of the parts their relation to the whole should be kept constantly in view." We could have used some of these ideas and words in our introduction as well. But the book they come from does not fit the narrative of art, technology, and science. Both influential and controversial, the book is one of the most important treatises in military strategy ever written: Carl von Clausewitz's *On War*.[126] The lesson in our comparison here? Yes, we want to address the future, but there is a lot of inspiration to be mined from the past, even in faraway domains.

Another example off the beaten path? The 1977 Luis Buñuel film *That Obscure Object of Desire (Cet obscur objet du désir; Ese oscuro objeto del deseo).* The film takes place in Spain and France and recounts through flashbacks the story of Mathieu, a mature distinguished Frenchman (played by Fernando Rey) who recounts falling in love with a beautiful young Spanish flamenco dancer, Conchita. What makes this an example of complementarity? Conchita's character is played by two different actresses: Carole Bouquet and Ángela Molina. They appear, seemingly randomly, in different scenes. They are not only physically different (although not too much, which is initially baffling to the viewer) but temperamentally different, as well. Yet it was the whole Conchita that Mathieu experienced (figure 9.5).

Curiosity will prepare us for massive shifts. Disruptions in the last few years have included online versus traditional print media, Facebook versus traditional media, Uber versus taxis, Airbnb versus world hoteliers, Skype/WeChat versus AT&T, Alibaba/Amazon versus Walmart, Netflix versus movie theater companies, cloud computing versus hardware/software companies—and AI disrupting everything. There is no sign that disruptions will abate. In fact, the trend will continue to accelerate. COVID-19 put everything in overdrive. Planned transitions that would have taken years took place in a few months. It will be increasingly hard to be a leader for long during a period of such rapid change. Having our antennae up is essential. Curiosity is a must.

126. On War, *which remained unfinished at Clausewitz's death in 1831, was published posthumously in 1832. We quote from the first of many English translations of the book, this one done by J. J. Graham (published by Nicholas Trübner, London, 1873). Compare the translation of the same passage by Michael Howard and Peter Paret (1976; revised 1984): "I propose to consider first the various elements of the subject, next its various parts or sections, and finally the whole in its internal structure. In other words, I shall proceed from the simple to the complex. But in war more than in any other subject we must begin by looking at the nature of the whole; for here more than elsewhere the part and the whole must always be thought of together."*

Fig. 9.5 *That Obscure Object of Desire*, the last film directed by Luis Buñuel, involves a character played interchangeably by Carole Bouquet (on the left in the photo showing them together) and Ángela Molina (on the right).

Striking a Nexus Balance

Reaching complementarity, right-brain thinking and left-brain thinking work together.

Nexus thinking is about balance: understanding when deta ls matter and when they do not, knowing when to go into action and when to hold on. Nexus thinking is about reaching complementarity: the coexistence of fast and slow, of action and inaction.

The temptation and drawbacks of fast action are represented in chapter 7 as the lesson "Do not converge too quickly. Step back and look at the big picture." The rise of analytics, machine learning, and AI—and people with advanced degrees in all these areas—is tilting the balance toward left-brain skills. We now have highly trained people who are very good at solving quantitatively demanding and complex but often highly structured problems. The challenge, however, is that many important problems—especially novel ones—are highly unstructured. Structuring requires making assumptions about context and constraints. Too much structuring, or structuring problems too quickly, is dangerous. Often this is the result of cleaning up the problem too much, so that context gets eliminated It is not hard to imagine that too much structuring can result in framing problems that can be solved rather than the problems that must be solved. The key issue is who does the structuring. Who identifies or decides what problems must be solved? This, more than ever, is the danger stemming from left-brain-dominated thinking. Conversely, we face the opposite problem, and we cannot emphasize it enough: the danger of infinite contemplation of every detail and thus losing sight of the big picture; the danger in not being able to abstract central issues amid a sea of complexity.

Left- and right-brained perspectives see problems in different lights. The appetite for structuring is one, a second concerns how we balance modes of thinking, the balance of induction and deduction. Left-brain thinkers favor deduction, whereas right-brain thinkers are more comfortable with induction. Creating a Nexus perspective requires addressing these fundamental differences. The key is to reach a balance: to achieve complementarity we need deduction and induction. Process and creativity can coexist. It is about replacing the word *versus* by the word *and*. This is the very essence of operating at the Nexus.

Developing solutions to many of today's problems requires whole-brain solutions and whole-brain teams. But we recognize there are key issues—within the teams themselves or between teams within an organization—that may pit one camp against the other. This makes even more crucial the role of Nexus thinkers, individuals who are adroit at navigating both camps. This schism can be seen in various areas. Marketing is one example. A huge internet-driven transition from traditional media (print advertising, television commercials, billboards, and so on) to new media (targeting audience through social media, paid online adds, and influencers) has generated massive amounts of data that can be mined in numerous ways. This has

created an old- and new-school divide. New-school analytical approaches make assumptions about consumers, assessing demand by deduction. But consumers behave using induction. They learn through experience. Throwing analytics at the problem may miss this. Currently, the analytical left-brain-leaning new school is winning (for the most part), though as we saw in chapter 8, Facebook is an example of a new-school loser and LVMH exemplifies old-school winners.[127]

An even more visible battle pits old-fashioned journalism (right-brain leaning) against new media, AI-driven writing bots, and the like. There are big and important words associated with all these changes; in marketing it is privacy; in journalism it is truth and ethics. But in fact, both worlds are converging. All traditional newspapers offer "digital editions." Online advertising allows news websites to show curated ads based on a visitor's interests. There is a clear danger in delivering targeted context, that is, in marketing the news. An important element of traditional journalism is relevance (or context); old print media provided this in the form of op-ed pages or long-form articles that explored various angles of a story and pieces that offered contrasting points of view. It was a way for a reader to learn about the issue at hand while reading neighboring information and views relevant to it. Technology could do this in principle, but it is much easier to have technology to do something else: to exploit *similarity*, which gives users more of what they have seen before. It is no exaggeration to say that similarity leads to a reinforcement of viewpoints and to myopia, which has played a significant role in the polarization of society.

The left brain/right brain battle appears in almost all business contexts. Aspects of financial analysis is yet another example, with the influx of extremely analytical talent ("quant jocks"), people who may be amazing with numbers but may have limited understanding of the business as a whole. Naturally, there are people with exactly the opposite perspective. More than ever a holistic approach is required to be an effective leader.

We can see left brain/right brain battles in the need to satisfy multiple, often contradictory, requirements. Firms are pressed to be both big and small, both efficient and effective, and to operate in multiple timeframes. These requirements may contain examples of irreconcilable logic and contradiction. One such example is balancing *exploitation and exploration*.

Exploitation builds on an organization's past; exploration is about creating a future that may be quite different from anything the organization has done before. Too much exploitation drives inertia; exploitation may crowd out exploration. At the same, too much exploration could drive out efficiencies and prevent economies of scale. Yet without exploration, firms die. We argue that sustained performance rests in doing both: *exploitation and exploration*.

127. Greg Carpenter, a marketing expert from Northwestern University's Kellogg School of Management, put it this way in conversation with JMO): "Facebook appears to focus on short-term financial gain. These decisions place customers second to Facebook. ... Consumers often put Facebook high on the list of most hated companies. LVMH, on the other hand, focuses on long-term brand building. Consumers love the brand, and its market cap has reached $250 billion, more than Intel, Pfizer, or Toyota. These two approaches represent modern 'performance' marketing (often very digitally driven and short-term focus) and old-school 'brand' marketing (focused on communications and long-term value)."

Another example of irreconcilable logic? Being *market-driven and market-driving* at the same time. Apple, Tesla and Starbucks can be seen as market-driving. Ferrari is also market-driving, but it is also a Nexus example of being two things at the same time, and how those things synergize. Ferrari is a place where the *art of form and the science of function*—where design and engineering—coexist. More than that, these two realms continuously challenge and inspire each other.

There are several other good consequences of Nexus thinking. It is important to recap them here.

The first is avoiding the trap of *time-driven forced convergence*, in problems that suddenly materialize as crises. Crises come with urgency, and urgency has the imperative of an endpoint, something which—if we could only find it!—would be a clean solution. A sufficiently sanitized problem can be solved; but the cleaning may have eliminated crucial context. The result? What we have done is solve an incomplete representation of the total situation. We have solved a problem, but it is the wrong problem.

A second consequence of whole-brain thinking resides in the word *whole*. "Domain expertise" used to be an advantage, but a heavy reliance on a single perspective may hinder the ability to successfully navigate vague situations. It is the equivalent of being equipped with one tool instead of a variety. Deep knowledge goes with expertise and experts, but expertise itself carries hidden dangers. It tempts us to think that we can fix any new problem with the tool we already own.

Specialists, of course, can be part of our diverse teams. There will always be a place for people who go deeply into one discipline and create new knowledge at the frontiers of their field. But specialists see the world through a single lens. That is not enough for maximum impact. The Nexus advantage allows broad thinkers who can merge skills from different fields to mesh differing perspectives in the face of conflicting data. More and more, the truly revolutionary ideas now come from connecting disciplines and connecting different modes of thinking.

Another issue is *adaptation*. Nexus thinkers can transition because they operate in an expanded thinking space. Their ideas are not solely anchored in one domain: having feet in two or more increases the number of ideas and possibilities.

On a more practical level, adaptability may be the need to transcend specific aspects of our education. Older alumni with degrees in electrical engineering were educated in the world of vacuum tubes, just before the advent of solid-state electronics. Did this hinder their progress? No, the best of them adapted. The technology was at surface level. The key value of a real engineering education lies underneath, in skills that resist obsolescence: the ability to think quantitatively, have a systems view, and possess the skill to frame and solve problems.

What about confronting lurking dangers, like jobs and the future? AI-enabled programs can analyze massive amounts of data—text and numbers—and construct stories at par with human ability. This "skill" was tested slowly with AI-generated baseball game articles that matched those of sports journalists, and it was afterward expanded to produce corporate documents such as earnings reports for publicly traded companies. AI-authored reports are now everywhere. So are debates about the potential of computer-generated narratives to amplify biases: and there lies the danger, since these narratives can proliferate at greater speed and far wider scale than anything written by humans.

But AI will not take over every job. Those that merge technical and creative thinking will resist automation. Such "hybrid jobs" merge skills not normally found together. Many forward-looking companies look for multifunctional experience when hiring. This flexibility is essential in large organizations, where employees jump from team to team and from role to role, as well as in startups that do not have the luxury of hiring specialists. This is not a passing fad.

One final point: leadership. In chapter 8 we discussed the skills necessary for becoming a leader: Vision + Communication + Execution. These components bear repeating. The first two depend on seeing a world that does not yet exist and having the ability to convey it to others. We also addressed, even if somewhat tangentially, the connection between the latter two components: communication and execution.

In closing we stress once again that complex systems thinking needs to be part of the equation and that achieving complementarity—the ability to reconcile opposing viewpoints—is an essential skill for a leader in dealing with the future. More than ever, we will be required to balance opposites. The synthesis and resolution of opposites may be the central issue of the twenty-first century.

We believe our book will help its readers to better understand why the vision component of the equation is so crucial for the future. Vision needs a wide lens. And the broader our thinking spaces, the more likely it is that a successful vision might emerge. Ultimately, reaching the Nexus, and embracing Nexus thinking, is about expanding our thinking spaces. But, like acquiring wisdom, this does not magically happen. It requires considerable effort. Our hope is that readers internalize a thought inspired by Albert Einstein, one that both of us have always kept in mind: wisdom is the product of a lifelong attempt to acquire it.

ACKNOWLEDGMENTS

The two of us, JMO and BM, share the view that the most interesting things happen at intersections. And that there are benefits from the broadenings of thinking that come from connecting with people who bring perspectives different than our own. This book encompasses many such inputs, collected over the years, crossing many disciplines, fields of study, and practices. It is impossible to acknowledge all the influences received and blend them into a seamless whole of indebtedness and gratitude.

The list encompasses colleagues from within and outside academia who span a range of areas (art, physics, complex systems, computer science and computational social science, engineering, synthetic biology, economics, history of science and history of art, humanities, neuroscience, and psychology) and backgrounds (innovators and leaders representing a broad range of business and artistic domains in aerospace, healthcare, software, architecture and design, manufacturing, consulting, law, and many more). Several wrote books themselves. Our gratitude for either providing comments or materials goes to Adilson Motter, Adrian Randolph, A-László Barabási, Ben Russell, Bill Baker, Bruce Grenville, Daniel Diermeier. Dashun Wang, Bill White, Brian Uzzi, Caterina Gratton, Dan Mote, Dario Robleto, Dirk Brockman, Francesca Casadio, Greg Carpenter, Greg Holderfield, Guy Metcalfe, Harry Kraemer, Iñigo Manglano-Ovalle, Jesus Mantas, Jim Plummer, Joel Mokyr. John Seinfeld, John Tracy, Joseph Gal, Josh Leonard, Ken Alder, Ken Porrello, Kris Hammond, Larry Booth, Lisa Corrin, Lloyd Shefsky. Luis Amaral, Mark Beeman, Mark Mills, Matt Levatich, Michael Rakowitz, Pete McNerney, Phil Gilbert, Rich Padula, Sanford Kwinter, Saul Morson, and Steve Franconeri. It is due to the topics listed above that our gratitude goes to the three reviewers selected by MIT Press, who understood the essence of the idea, and gave a solid go ahead to the project when the manuscript was only an approximation of what we envisioned the end product would look like.

Special recognition must be paid to Vašek Nunnelly Kokeš, who collaborated on the detailed design and typography for the book; Cheryl Dubois at Lumina Datamatics for her painstaking and patient image research, Tina Rayyan, who managed the creative and production process for Massive Change Network, to Amy Pokrass and Kyle Delaney, for innumerable ways of support, and to Emily Ayshford for the reading the very early drafts of this work. At MIT Press, Jermey Matthews, Jim Mitchell, Judy Feldmann and Haley Biermann helped shepherd the project from first draft through to the final delivery. As dean of Northwestern University's McCormick School of Engineering and Applied Science, JMO wants to stress that this book could not have been done in any other place than Northwestern University. And that he never imagined copyediting would have been as enjoyable as when working with Mary Bagg. Our thanks go to MIT Press for believing in a project that was an augmentation of current practices.

REFERENCES

Adams, G. S., B. A. Converse, A. H. Hales, and L. E. Klotz. 2021. "People Systematically Overlook Subtractive Changes." *Nature* 592, no. 7853: 258–261.

Albert, R., H. Jeong, and A.-L. Barabási. 1999. "Diameter of the World Wide Web." *Nature* 401, no. 9: 130–131.

Amaral, L. A. N., and J. M. Ottino. 2004. "Complex Networks: Completing the Framework for the Study of Complex Systems." *European Physics Journal* 38: 147–162.

Anderson, P. 1972. "More Is Different." *Science* 177, no. 4047: 393–396.

Ball, P. 2004. *Critical Mass: How One Thing Leads to Another*. New York: Farrar, Straus and Giroux.

Barabási, A.-L. 2002. *Linked: The New Science of Networks*. New York: Perseus Books Group.

Barabási, A.-L., and E. Bonabeau. 2003. "Scale-Free Networks." *Scientific American* 288, no. 5: 60–69.

Bardi, J. S. 2006. *The Calculus Wars: Newton, Leibniz, and the Greatest Mathematical Clash of All Time*. New York: Thunder Mouth.

Barrett, C. L., S. G. Eubank, and J. P. Smith. 2005. "If Smallpox Strikes Portland." *Scientific American* 292, no. 3: 54–61.

Barrow-Green, J. 1997. *Poincaré and the Three Body Problem. Vol. 11 of History of Mathematics*. Washington, DC: American Mathematical Society.

Bassett, D. S., N. F. Wymbs, M. A. Porter, P. J. Mucha, J. M. Carlson, and S. T. Grafton. 2011. "Dynamic Reconfiguration of Human Brain Networks during Learning." *Proceedings of the National Academy of Sciences* 108, no.18: 7641–7646.

Bazerman, M. H., and D. A. Moore. 2013. *Judgment in Managerial Decision Making*. 8th ed. Hoboken, NJ: John Wiley & Sons.

Beaty, R. E., Y. N. Kenett, A. P. Christensen, M. D. Rosenberg, M. Benedek, Q. Chen, A. Fink, et al. 2018. "Robust Prediction of Individual Creative Ability from Brain Functional Connectivity." *Proceedings of the National Academy of Sciences* 115, no. 5: 1087–1092.

Becker, H. S. 1982. *Art Worlds*. Berkeley: University of California Press.

Bigelow, J. 1831. *Elements of Technology* [based on a course given at Harvard between 1819 and 1829, titled "Application of the Sciences to the Useful Arts"]. Boston: Hilliard, Gray, Little and Wilkins.

Borges, J. L. 1970. *El Informe de Brodie*. Buenos Aires: Emecé.

Bradbury, R. 1952. "A Sound of Thunder." *Collier's*, June 28, 1952.

Brandt, A., and D. Eagleman. 2017. *The Runaway Species: How Human Creativity Remakes the World*. New York: Catapult.

Brodetsky, S. 1942. "Newton: Scientist and Man." *Nature* 150: 698–699.

Bronowski, J. 1958. "The Creative Process." *Scientific American*, September 1958.

Buchanan, M. 2002. *Nexus: Small Worlds and the Groundbreaking Theory of Networks*. New York: Norton.

Bush, V. 1945a. "As We May Think." *The Atlantic Monthly*, July 1945, 101–108; LIFE, September 1945, 112–124.

Bush, V. 1945b. *Science, The Endless Frontier*. A Report to the President. Washington, DC: US Government Printing Office.

Carlson, J. M., and J. Doyle. 2002. "Complexity and Robustness." *Proceeding of the National Academy of Sciences* 99 (suppl. 1): 2538–2545.

Chandrasekhar, S. 1987. *Truth and Beauty: Aesthetics and Motivations in Science*. Chicago: University of Chicago Press.

Chinazzi, M., J. T. Davis, M. Ajelli, C. Gioannini, M. Livinova, S. Merler, A. Pionti, et al. 2020. "The Effect of Travel Restrictions on the Spread of the 2019 Novel Coronavirus (COVID-19) Outbreak." *Science* 368, no. 6489: 395–400.

Churchman, C. W. 1967. "Wicked Problems." *Management Science* 14, no. 4: B-141–B-146.

Cockburn, I. M., R. Henderson, and S. Stern. 2019. "The Impact of Artificial Intelligence on Innovation: An Exploratory Analysis." In *The Economics of Artificial Intelligence: An Agenda*, edited by A, Agrawal, J. Gans, and A. Goldfarb. Chicago: University of Chicago Press.

Colliza, V., A. Barrat, M. Barthelemy, and A. Vespignani. 2006. "The Role of the Airline Transportation Network in the Prediction and Predictability of Global Epidemics." *Proceedings of the National Academy of Sciences* 103, no. 7: 2015–2020.

Cowles, H. M. 2020. *The Scientific Method: An Evolution of Thinking from Darwin to Dewey*. Cambridge, MA: Harvard University Press.

Csikszentmihalyi, M. 1996. *Creativity: Flow and the Psychology of Discovery and Invention*. New York: Harper Perennial.

Csiszar, A. 2018. *The Scientific Journal: Authorship and the Politics of Knowledge in the Nineteenth Century*. Chicago: University of Chicago Press.

Currey, M. 2013. *Daily Rituals*. New York: Knopf.

Dance, A. 2021. "How the Arts Can Help You to Craft a Successful Research Career." *Nature* 590, no. 7845: 351–353.

Danto, A. 1997. *After the End of Art: Contemporary Art and the Pale of History*. Princeton, NJ: Princeton University Press.

Delis, D. C., M. G. Kiefner, and A. J. Fridlund. 1988. "Visuospatial Dysfunction Following Unilateral Brain Damage: Dissociations in Hierarchical and Hemispatial Analysis." *Journal of Clinical and Experimental Neuropsychology* 10, no. 4: 421–431.

de Selincourt, E. ed. 1969. William Wordsworth, "Letter to Lady Beaumont, 21 May 1807." In *Letters of William and Dorothy Wordsworth*. Vol. 2. Oxford: Oxford University Press.

Domb, C. 1974. "The Ising Model." In *Phase Transitions and Critical Phenomena*. Edited by C. Domb and H. S. Green. Vol. 3, 357–484. New York: Academic Press.

Durante, D., and D. B. Duson. 2018. "Bayesian Inference and Testing of Group Differences in Brain Networks." *Bayesian Analysis* 13, no. 1: 29–58.

Eames Official Site. n.d. Video clip from *Design Q&A*, 1972. https://www.eamesoffice.com/the-work/design-q-a/.

Eckhardt, B., E. Ott, S. H. Strogatz, D. M. Abrams, and A. McRobie 2007. "Modeling Walker Synchronization on the Millennium Bridge." *Physical Review* E 75: 021110.

Edgerton, S. Y. 1984. "Galileo, Florentine 'Disegno' and the 'Strange Spottednesse' of the Moon." *Art Journal* 44, no. 3, 225–248.

Eubank, S., I. Eckstrand, B. Lewis, S. Venkatramanan, M. Marathe, and C. L. Barrett. 2020. "Commentary on Ferguson, et al., "Impact of Non-pharmaceutical Interventions (NPIs) to Reduce COVID-19 Mortality and Healthcare Demand." *Bulletin of Mathematical Biology* 82, no. 4: 52.

Eubank, S., H. Guclu, V. S. Kumar, M. V. Marathe, A. Srinivasan, Z. Toroczkai, and N. Wang. 2004. "Modelling Disease Outbreaks in Realistic Urban Social Networks." *Nature* 429, no. 6988: 180–184.

Fara, P. 2009. *Science: A Four Thousand Year History*. Oxford: Oxford University Press.

Ferguson, E. 1992. *Engineering and the Mind's Eye*. Cambridge, MA: MIT Press.

Feynman, R. P., R. B. Leighton, and M. Sand. 1964. *The Feynman Lectures on Physics*. Vol 1. Boston: Addison-Wesley.

Fraiberger S. P., R. Sinatra, M. Resch, C. Riedl, and A-László Barabási. 2018. "Quantifying Reputation and Success in Art." *Science* 362, no. 6416: 825–829.

Gal, J. 2011. "Louis Pasteur, Language, and Molecular Chirality. I. Background and Dissymmetry." Contribution to the *Proceedings of the 21st International Symposium on Chirality* 23, no. 1: 1–16.

Gal, J., 2017. "Pasteur and the Art of Chirality." *Nature Chemistry* 9, no. 7: 604–605.

Galenson, D. W. 2007. *Masters and Young Geniuses: The Two Life Cycles of Artistic Creativity*. Princeton, NJ: Princeton University Press.

Gardner, H. 1983. *Frames of Mind: The Theory of Multiple Intelligences*. New York: Basic Books.

Gerten, D., V. Heck, J. Jägermeyr, B.L. Bodirsky, I. Fetzer, M. Jalava, et al. 2020. Feeding ten billion people is possible within four terrestrial planetary boundaries, *Nature Sustainability*, 3, 200–208.

Gladwell, M. 2008a. "In the Air." *New Yorker*, May 12, 2008.

Gladwell, M. 2008b. *Outliers: The Story of Success*. New York: Little, Brown.

Goldenfeld, N., and L. P. Kadanoff. 1999. "Simple Lessons from Complexity." *Science* 284, no. 5411: 87–89.

Graham, L. 2013. *Lonely Ideas: Can Russia Compete?* Cambridge, MA: MIT Press.

Greenblatt, S. 2011. *The Swerve: How the World Become Modern*. New York: Norton.

Greiner, L. E. 1998. "Evolution and Revolution as Organizations Grow." *Harvard Business Review*, May–June 1998 [originally published July–August 1972].

Guimerà, R., B. Uzzi, J. Spiro, and L. A. N. Amaral. 2005. "Team Assembly Mechanisms Determine Collaboration Network Structure and Team Performance." *Science* 308, no. 5722: 697–702.

Hadamard, J. 1945. *The Psychology of Invention in the Mathematical Field*. Princeton, NJ: Princeton University Press [1954 Dover edition].

Halloran, M. E., N. M. Ferguson, S. Eubank, I. M. Longini Jr. D. Cummings, B. Lewis, S. Xu, et al. 2008. "Modeling Targeted Layered Containment of an Influenza Pandemic in the United States." *Proceedings of the National Academy of Sciences* 105, no, 12: 4639–4644.

Halloun, I., and D. Hestenes. 1985. "The Initial Knowledge State of College Physics Students." *American Journal of Physics* 53, no. 11: 1043–1055.

Hardy, G. H. 1940. *A Mathematician's Apology* (with a foreword by C. P. Snow). Cambridge: Cambridge University Press.

Henderson, L. 2013. *The Fourth Dimension and Non-Euclidean Geometry in Modern Art*. Cambridge, MA: MIT Press.

Holmes, R. 2009. *The Age of Wonder*. New York: Harper Press.

Holmes, R. 2014. "In Retrospect: *On the Connexion of the Physical Sciences*." Nature 514, no. 7523: 432–433.

Holton, G. 1996. "On the Art of Scientific Imagination." *Daedalus* 125, no. 2: 183–208.

Holton, G. 2001. "Henry Poincaré, Marcel Duchamp, and Innovation in Science and Art." *Leonardo* 34, no. 2: 127–134.

Holtzman, H. 1952. Mission Statement for the Journal *trans\formation 1*, no. 1.

Jacobs, J. 1961. *The Death and Life of Great American Cities*. New York: Random House.

Jansen, T. 2017. *The Great Pretender*. Rotterdam: nai010 Publisher.

Jinek, M., K. Chylinski, I. Fonfara, M. Hauer, J. A. Doudna, and E. Charpentier. 2012. "A Programmable Dual-RNA–Guided DNA Endonuclease in Adaptive Bacterial Immunity." *Science* 337, no. 6096: 816–821.

Johnson, S. 2010. *Where do Good Ideas Come from? The Natural History of Innovation*. New York: Riverhead Books.

Jones, B. F., and B. A. Weinberg. 2011. "Age Dynamics in Scientific Creativity." *Proceedings of the National Academy of Sciences* 108, no. 47: 18910–18914.

Jung-Beeman M., E. M. Bowden, J. Haberman, J. L. Frymiare, S. Arambel-Liu, R. Greenblatt R, et al. 2004. "Neural Activity When People Solve Verbal Problems with Insight." *PLoS Biol* 2(4), 500-510.

Kahneman, D. 2011. *Thinking, Fast and Slow*. New York: Farrar, Straus and Giroux.

Kaufman, S. 1995. *At Home in the Universe: The Search for the Laws of Self-Organization and Complexity*. Oxford: Oxford University Press.

Kounios, J., and M. Beeman. 2009. "The *Aha!* Moment: The Cognitive Neuroscience of Insight." *Current Directions in Psychological Science* 18, no. 4: 201–216.

Kounios, J., and M. Beeman. 2015. *The Eureka Factor: Aha Moments, Creative Insight, and the Brain*. New York: Random House.

Kuhn, T. S. 1962. *The Structure of Scientific Revolutions*, 2nd ed. Chicago: University of Chicago Press.

Lavigne, D. M. 2003. "Marine Mammals and Fisheries: The Role of Science in the Culling Debate." Chapter 2 in *Marine Mammals: Fisheries, Tourism and Management Issues*, 31–47. Edited by N. Gales, M. Hindell, and R. Kirkwood. Collingwood, VIC, Australia: CSIRO.

Lorenz, E. N. 1960. "Deterministic Nonperiodic Flow." *Journal of the Atmospheric Sciences* 20: 130–141.

Lynn, C. W., A. E. Kahn, N. Nyema, and D. S. Bassett. 2020. "Abstract Representations of Events Arise from Mental Errors in Learning and Memory." *Nature Communications* 11, art. no. 2313.

Maier, B. F., and D. Brockmann. 2020. "Effective Containment Explains Sub-Exponential Growth in Confirmed Cases of Recent COVID-19 Outbreak in Mainland China." *Science* 368, no. 6492: 742–746.

Mair, R. 2018. *Sophie Taeuber-Arp and the Avant-Garde: A Biography*. Chicago: University of Chicago Press.

Malmgren, R. D., J. M. Ottino, L. A. N. Amaral. 2010. "The Role of Mentorship in Protégé Performance." *Nature* 465, no. 7298: 622–626.

Merton, R. K. 1961. "Singletons and Multiples in Scientific Discovery: A Chapter in the Sociology of Science." *Proceedings of the American Philosophical Society* 105, no. 5: 470–486.

Merton, R. K. 1973. *The Sociology of Science: Theoretical and Empirical Investigations*. Chicago: University of Chicago Press.

Michaud, E. 2020. *The Barbarian Invasions: A Genealogy of the History of Art*. Translated by N. Huckle. Cambridge, MA: MIT Press.

Miller, A. 2001. *Einstein, Picasso: Space, Time, and the Beauty That Causes Havoc*. New York: Basic Books (Perseus).

Miller, E. K., and J. D. Cohen. 2001. "An Integrative Theory of Prefrontal Cortex Function." *Annual Review of Neuroscience* 24, no. 1: 167–202.

Miller, J. H., and S. E. Page. 2009. *Complex Adaptive Systems* (Princeton Studies in Complexity, Book 17). Princeton, NJ: Princeton University Press.

Mills, M. P. 2020a. "The Future of Forecasting. Review of After Shock." *Wall Street Journal*, April 2, 2020.

Mills, M.P., 2020b. *Digital Cathedrals*. New York: Encounter Books.

Mokyr, J. 2016. *A Culture of Growth: The Origins of the Modern Economy*. Princeton, NJ: Princeton University Press.

Molnar, F., T. Nishikawa, and A. E. Motter. 2020. "Network Experiment Demonstrates Converse Symmetry Breaking." *Nature Physics* 16: 351–356.

Motter, A. E., and Y.-C. Lai. 2002. "Cascade-Based Attacks on Complex Networks." *Physical Review* E 66: 065102.

Motter, A. E., S. A. Myers, M. Anghel, and T. Nishikawa. 2013. "Spontaneous Synchrony in Power-Grid Networks." *Nature Physics* 9, no. 3: 191–197.

Motter, A. E., and Y. Yang. 2017. "The Unfolding and Control of Network Cascades." *Physics Today* 70, no. 1: 32–39.

National Science Board. 2020. *Science and Engineering Indicators—2020*. Arlington, VA: National Science Foundation.

Navon, D. 1977. "Forest Before the Trees: The Precedence of Global Features in Visual Perception." *Cognitive Psychology* 9: 353–383.

Newman, M. E. J. 2010. *Networks: An Introduction*. Oxford: Oxford University Press.

Nishikawa, T., and A. E. Motter. 2016. "Symmetric States Requiring System Asymmetry." *Physical Review Letters* 117: 114101.

Nye, D. E. 2006. *Technology Matters: Questions to Live With*. Cambridge, MA: MIT Press.

Olson, J. A., J. Nahas, D. Chmoulevitch, S. J. Cropper, M. E. Webb. 2021. "Naming unrelated words predicts creativity." *Proceedings of the National Academy of Sciences* 118 (25) e2022340118

Ottino, J. M. 2003a. "Complex Systems." *American Institute of Chemical Engineers Journal* 49, no. 2: 292–299.

Ottino, J. M. 2003b. "Is a Picture Worth 1,000 Words? Exciting New Illustration Techniques Should Be Used with Care." *Nature* 421, no. 6922: 474–476.

Ottino, J. M. 2004. "Engineering Complex Systems." *Nature* 427, no. 6973: 399.

Ottino, J. M., and G. S. Morson. 2016. "Building a Bridge between Engineering and the Humanities." *The Chronicle of Higher Education*, February 14, 2016.

Pasteur, L. 1848. "Sur les relations qui peuvent exister entre la forme cristalline, la composition chimique et le sens de la polarisation rotatoire." *Annales de Chimie et de Physique*, 3rd series, 24, no. 6: 442–459.

Pinker, S. 2018. *Enlightenment Now: The Case for Reason, Science, Humanism, and Progress*. New York: Penguin Books/Viking.

Polya, G. 1954. *Induction and Analogy in Mathematics* (Vol. I) and Mathematics and Plausible Reasoning (Vol. II). Princeton, NJ: Princeton University Press.

Prose, F. 2010. "As Darkness Falls. *Review of The Death of the Adversary and Comedy in a Minor Key*, by Hans Keilson." New York Times, August 5, 2010.

Quammen, Q. 2019. *The Tangled Tree: A Radical New History of Life*. New York: Simon & Shuster.

Root-Bernstein, R., L. Allen, L. Beach, R. Bhadula, J. Fast. C. Hosnea, W. B. Kremko, et al. 2008. "Arts Foster Success: Comparison of Nobel Prizewinners, Royal Society, National Academy, and Sigma Xi Members." *Journal of Psychology of Science and Technology* 1, no. 2: 51–63.

Ross, A. 2019. "Antonio Salieri's Revenge." *New Yorker*, June 3, 2019.

Rosvall, M., and C. T. Bergstrom. 2008. "Maps of Random Walks on Complex Networks Reveal Community Structure." *Proceedings of the National Academy of Sciences* 105, no. 4: 1118 –1123.

Rothenberg, A., 1971. "The Process of Janusian Thinking in Creativity." *Archives of General Psychiatry* 24, no. 3: 195–205.

Rothenberg, A. 1979. *The Emerging Goddess: The Creative Process in Art, Science and Other Fields*. Chicago: University of Chicago Press

Rozental, S., 1967. *Niels Bohr: His Life and Work as Seen by His Friends and Colleagues*. Amsterdam: North-Holland Publishing Company.

Russell, B. 2014. *James Watt: Making the World Anew*. Chicago: University of Chicago Press.

Schapiro, M., and G. S. Morson, eds. 2015. *The Fabulous Future?: America and the World in 2040*. Evanston, IL: Northwestern University Press.

Schelling, T. 1971. "Dynamic Models of Segregation." *Journal of Mathematical Sociology* 1, no. 2: 143–186.

Schelling, T. 1978. *From Micromotives to Macrobehavior*. New York: Norton.

Simon, H. H. 1983. "Discovery, Invention, and Development: Human Creative Thinking." *Proceedings of the National Academy of Sciences* 80, no. 14: 4569–4571.

Smart, A. G., L. A. N. Amaral, and J. M. Ottino. 2008. "Cascading Failure and Robustness in Metabolic Networks." *Proceedings of the National Academy of Sciences* 105, no. 36: 13223–13228.

Somerville, M. F. 1834. *On the Connexion of the Physical Sciences*. London: John Murray.

Stigler, S. M. 1980. *In Festschrift for Robert K. Merton*. Edited by F. Gieryn. "Stigler's Law of Eponymy." Transactions of the New York Academy of Sciences 39: 147–58.

Stokes, D. E. 1997. *Pasteur's Quadrant: Basic Science and Technological Innovation*. Washington, DC: The Brookings Institution.

Strogatz, S. H. 2003. *Sync: The Emerging Science of Spontaneous Order*. Westport, CT: Hyperion Press.

Szell, M., Y. Ma, and R. Sinatra. 2018. "A Nobel Opportunity for Interdisciplinarity." *Nature Physics* 14, no. 11: 1075–1078.

Tallman, S. 2020. "Who Decides What's Beautiful?" *New York Review of Books* 67, no. 14: 16–20.

Teachout, T. 2008, "Importantitis, Enemy of Art: How to Wreck a Career in One Easy Lesson." *Wall Street Journal*, February 16, 2008,

Uzzi, B., S. Mukherjee, M. Stringer, and B. Jones. 2013. "Atypical Combinations and Scientific Impact. *Science* 342, no. 6157: 468–472.

Uzzi, B., and J. Spiro. 2005. "Collaboration and Creativity: The Small World Problem." *American Journal of Sociology* 111, no. 2: 447–504.

Van Essen, D. C., C. H. Anderson, and D. J. Felleman. 1992. "Information Processing in the Primate Visual System: An Integrated Systems Perspective." *Science* 255, no. 5043: 419–423.

von Békésy, G. 1961. "Concerning the Pleasures of Observing, and the Mechanics of the Inner Ear: Trying to Do Science in an Unscientific Way." Nobel Lecture, December 11, 1961, https://www.nobelprize.org/uploads/2018/06/bekesy-lecture.pdf.

Wallace, W. E. 2020. *Michelangelo, God's Architect: The Story of His Final Years and Greatest Masterpieces*. Princeton, NJ: Princeton University Press.

Wang D. and A.-L. Barabási 2021. *The Science of Science*, Cambridge: Cambridge University Press.

Watkins, J. E. 1900. "What May Happen in the Next Hundred Years." *The Ladies Home Journal*, December 1900.

Watson, J. D., and F. H. C. Crick. 1953. "Molecular Structure of Nucleic Acids: A Structure for Deoxyribose Nucleic Acid." *Nature* 171, no. 4356: 737–738.

Watts, D. J., and S. H. Strogatz. 1998. "Collective Dynamics of 'Small-World' Networks." *Nature* 393, no. 6684: 440–442.

Wetlaufer, S. 2001. "The Perfect Paradox of Star Brands." *Harvard Business Review* 79, no. 9: 116–122.

Weyl, H. 1952. *Symmetry*. Princeton, NJ: Princeton University Press.

Wilensky, U., and W. Rand. 2015. *An Introduction to Agent-Based Modelling*. Cambridge, MA: MIT Press.

Woods, C. S. 2020. *A History of Art History*. Princeton, NJ: Princeton University Press.

Wolff, R. 2013. "When Storm Is Collaborator," quoting Michael Royce. ARTnews, April 22 https://www.artnews.com/art-news/news/art-inspired-by-sandy-2204/.

Wu, L., D. Wang, and J. A. Evans. 2019. "Large Teams Develop and Small Teams Disrupt Science and Technology." *Nature* 566, no. 7744: 378–382.

Yin, Y., J. Gao, B. F. Jones, and D. Wang. 2021. "Coevolution of Policy and Science during the Pandemic." *Science* 371, no. 6525: 128–130.

Zee, A. 2016. *Fearful Symmetry: The Search for Beauty in Modern Physics*. Princeton, NJ: Princeton University Press.

IMAGE SOURCES AND PERMISSIONS

Cover - Loris Cecchini and Galleria Continua

Front Endpaper - Photo by Shiinoki Shunsuke. Courtesy of the artist and AMKK.

Page 001 - Smithsonian Institution Archives, Record Unit 31, Image No. SIA2013-09131

Page 002–003 - The Archives of Rudolf and Leopold Blaschka and the Ware Collection of Blaschka Glass Models of Plants, Harvard University Herbaria © President and Fellows of Harvard College

Page 004–005 - Julia Koerner, Setae Jacket for Chro-Morpho Collection by Stratasys, 2019, Photography Ger Ger

Page 006–007 - Andrew Balet https://creativecommons.org/licenses/by-sa/2.5/deed.en

Page 008–009 - Alessandro Grassani/The New York Times/Redux

Page 010–011 - Celine Ramoni Lee/Getty Images

Page 012–013 - Robert R. McElroy/Archive Photos/Getty Images

Page 014–015 - SpaceX

Page 020 (t) - Public Domain

Page 020 (b) - Kenneth G. Libbrecht

Page 022 - Roche

Page 023 - NASA/MSFC/David Higginbotham

Page 024 (t) - MyLoupe/Universal Images Group/Getty Images

Page 024 (b) - AP Photo/Noah Berger

Page 026 - Loris Cecchini and Galleria Continua

Page 028 (t) -Image courtesy Tom Sachs Studio

Page 028 (b) - Courtesy to the artist, David O'Reilly

Page 032 - squidish on Flickr https://creativecommons.org/licenses/by/2.0/

Page 034 - Jose Fuste RAGA/Getty Images

Page 038 (t) - William Miller

Page 038 (b) - NASA/NOAA/GSFC/Suomi NPP/VIIRS/Norman Kuring

Page 040 - Courtesy of the artist and Danziger Gallery

Page 042–043 - Owen Humphreys/Alamy Stock Photo

Page 054–055 - Stringer/Getty Images

Page 066–067 - NASA

Page 072 (t) Fig 02.02 - Image by danhenncpa from Pixabay

Page 072 (b) Fig 02.02 - Scala/Art Resource, NY

Page 075 (l) Fig 02.03 - Max Alexander/Lord Egremont/Science Source

Page 075 (r) Fig 02.03 - Scala/Art Resource, NY

Page 076 - Scala/Art Resource, NY

Page 077 (t) - PAINTING/Alamy Stock Photo

Page 077 (bl) - The Picture Art Collection/Alamy Stock Photo

Page 077 (br) - https://digi.ub.uni-heidelberg.de/diglit/alberti1726/0004

Page 078–079 - FineArt/Alamy Stock Photo

Page 082 (t) Fig 02.04 - Institut Pasteur/Musée Pasteur

Page 082 (b) Fig 02.05 - Annales de Chimie et de Physique

Page 082–083 Fig 02.05 - Institut Pasteur/Musée Pasteur

Page 086–087 - Cajal Legacy. Instituto Cajal (CSIC), Madrid

Page 088 (l) Fig 02.06 - © 2021 Artists Rights Society (ARS), New York/ADAGP, Paris. Photo: akg-images

Page 088 (r) Fig 02.06 - Niels Bohr Archive, Copenhagen

Page 096 - Courtesy of Carl Solway Gallery, Cincinnati

Page 098-099 - Bruce Mau

Page 102 Fig 03.01 - Musee d'Orsay, Paris, France/Bridgeman Images

Page 104 (tl) Fig 03.02 - Lounge chair and ottoman. 1956. Molded rosewood plywood; black leather cushions with foam, down and feather filling; and black and polished aluminum base. Chair: 33" h. x 33 3 /4" w. x 33" d. Gift of Herman Miller Furniture Co. Digital Image © The Museum of Modern Art/Licensed by SCALA/Art Resource, NY

Page 104 (tr) Fig 03.02 - Glass, Henry (1911–2003). Cylindra Plywood Chair. 1966. Walnut, plywood and artificial leather, 99 x 48 x 48 cm (39 x 19 x 19 in.). Gift of Michael Jefferson and Heidi Mucha (2019.1222). The Art Institute of Chicago, Chicago, U.S.A. Photo Credit: The Art Institute of Chicago/Art Resource, NY

Page 104 (cl) Fig 03.02 - Bertoia, Harry (1915–1978) © ARS, NY. Armchair, 1967. White vinyl-covered steel mesh, 77.4 x 85.8 x 71.1 cm (30 1/2 x 33 3/4 x 28 in.). Gift of Malcolm, Kay, Kim, and Kyle Kamin, 1986.38. Photo Credit: The Art Institute of Chicago/Art Resource, NY

Page 104 (cr) Fig 03.02 - Bartolucci, Edgar (1918–2014). and Waldheim, Jack (American, 1920–2002): Barwa Lounge Chair. 1946. Aluminum and upholstery, 106.7 x 53.3 x 129.5 cm (42 x 21 x 51 in.) (approx.). Gift of Marisa Bartolucci (2014.999). The Art Institute of Chicago, Chicago, U.S.A. Photo Credit: The Art Institute of Chicago/Art Resource, NY

Page 104 (bl) Fig 03.02 - Adjaye, David (b. 1966) © Copyright. Washington Skin Nylon Side Chair. 2013. Manufactured by Knoll, Inc. (American, founded 1938). Injection-molded, glass-reinforced nylon, aluminum and stainless steel, 83 x 46 x 51 cm (32 1/2 x 18 x 20 1/4 in.). Gift of Knoll, Inc. (2016.198.2). The Art Institute of Chicago, Chicago, U.S.A. Photo Credit: The Art Institute of Chicago/Art Resource, NY

Page 104 (br) Fig 03.02 - Gehry, Frank (b. 1929). Wiggle Side Chair. 1972. Corrugated cardboard and Masonite, 85 x 39 x 57 cm (33 1/2 x 15 1/2 x 22 1/2 in.). Gift of David Teiger Trust (2017.529). The Art Institute of Chicago, Chicago, U.S.A. Photo Credit: The Art Institute of Chicago/Art Resource, NY

Page 105 (tl) Fig 03.02 - Mies van der Rohe, Ludwig (1886–1969) © ARS, NY. MR 20 Armchair. Designed and manufactured 1926/27. Bent tubular chromium-plated steel, with banded and sewn dark green leather spanning seat and back, 80 x 54.3 x 85.1 cm (31 1/2 x 21 3/8 x 33 1/2 in.). Restricted gift of the Graham Foundation for Advanced Studies in the Fine Arts (1970.403). The Art Institute of Chicago, Chicago, U.S.A. Photo Credit: The Art Institute of Chicago/Art Resource, NY

Page 105 (tc) Fig 03.02 - Albers, Josef (1888-1976) © ARS, NY. Armchair. Ca. 1927. Producer: Bauhaus Workshop, Germany, 1919–1933. Wood,

Page 138 Fig 04.03 - Album/Alamy Stock Photo

Page 140–141 - Fraiberger et al. 2018

Page 144–145 Fig 04.04 - Used with permission of the Harley-Davidson Archives

Page 148 Fig 04.05 - The British Library

Page 150 Fig 04.06 - elisevonwinkle/Alamy Stock Photo

Page 152-153 - Courtesy of the artist

Page 156-157 - Courtesy birforms gallery, New York

Page 160-161 - Science Museum/Science and Society Picture Library

Page 164 (t) Fig 05.01 - BR49.458 Schmidt, Joost, Pamphlet for City of Dessau, Harvard Art Museums/Busch-Reisinger Museum, Gift of Josef Albers. Photo: © President and Fellows of Harvard College. © 2021 Artists Rights Society (ARS), New York

Page 164 (b) Fig 05.01 - BR48.94 Bayer, Herbert, Research in Development of Universal Type, Harvard Art Museums/Busch-Reisinger Museum, Gift of the artist © 2021 Artists Rights Society (ARS), New York/ VG Bild-Kunst, Bonn

Page 165 Fig 05.02 - Image by Moonglow from Pixabay

Page 166 (t) Fig 05.03 - Photographer Unknown, The Studies Building, Black Mountain College, architect Lawrence Kocher, c. 1940s. Courtesy of the Black Mountain College Museum + Arts Center

Page 166 (b) Fig 05.03 - Josef Albers, Black Mountain College seal, 1933-34. Courtesy of the Black Mountain College Museum + Arts Center

Page 168 Fig 05.04 - Michael Moran/OTTO

Page 172 Fig 05.05 - Photos by Bruce Mau

Page 173 Fig 05.05 - Photos by Bruce Mau

Page 176 Fig 05.06 - Courtesy of the artist and James Cohan, New York

Page 178 Fig 05.07 - Dario Robleto

Page 180 (l) Fig 05.08 - Robert Rauschenberg Poster for 9 Evenings: Theatre & Engineering, 1966 Offset lithograph, 36 1/2 x 24 1/4 inches (92.7 x 61.6 cm) From an edition of 90 © Robert Rauschenberg Foundation

Page 180 (r) Fig 05.08 - Robert R. McElroy/Archive Photos/Getty Images

Page 182-184 - Design Q & A is a film by Charles and Ray Eames, © 1972 Eames Office, LLC

Page 186 - SpaceX

Page 187 - NASA

Page 188 Fig 05.10 - Photo: Terra Foundation for American Art, Chicago/ Art Resource, NY

Page 190 (t) Fig 05.11 - The United States Patent and Trademark Office

Page 190 (b) Fig 05.11 - Public Domain

Page 192-193 - Photos by Bruce Mau

Page 194-195 - Bartlomiej K. Wroblewski/Shutterstock

Page 202 (t) Fig 06.02 - Picture by dfettel on Pixabay

Page 202 (tc) Fig 06.02 - Handout/Getty Images

Page 202 (bc) Fig 06.02 - Image by adueck on Pixabay

Page 202 (b) Fig 06.02 - Image by Candid_Shots on Pixabay

Page 203 (t) Fig 06.02 - iStockphoto.com/armiblue

Page 203 (tc) Fig 06.02 - R.H. Koenig/Shutterstock

Page 203 (bc) Fig 06.02 - iStockphoto.com/enot-poloskun

Page 203 (b) Fig 06.02 - Photo by Pexels on Pixabay

Page 206 Fig 06.03 - Copyright David Lavigne, Used with permission

Page 208 Fig 06.04 - Dirk Brockmann, Humboldt-University of Berlin

Page 214-215 Fig 06.05 - Interactive diagram created for the exhibition "Inventing Abstraction: 1910–1925." December 23, 2012 through April 15, 2013. The Museum of Modem Art, New York. Digital Image © The Museum of Modern Art/Licensed by SCALA/Art Resource, NY

Page 216 (t) Fig 06.06 - Science Museum/Science & Society Picture Library

Page 216 (b) Fig 06.06 - GL Archive/Alamy Stock Photo

Page 218-219 Fig 06.07 - Theo Jansen

Page 222–223 - © Philips Company Archives

Page 226–227 - Yale Joel/The LIFE Picture Collection/Getty Images

Page 227 - Science History Images/Alamy Stock Photo

Page 230–231 - © Mariko Mori Photography: Richard Learoyd Courtesy: Sean Kelly, New York

Page 234 (t) Fig 07.01 - © 2021 The Willem de Kooning Foundation/Artists Rights Society (ARS), New York. Photo: The Art Institute of Chicago, IL, USA/ Mr. and Mrs. Frank G. Logan Purchase Prize Fund; restricted gifts of Edgar J. Kaufmann, Jr., and Mr. and Mrs. Noah Goldowsky/Bridgeman Images

Page 234 (b) Fig 07.01 - © 2021 The Willem de Kooning Foundation/ Artists Rights Society (ARS), New York

Page 236 (tl) Fig 07.02 - Tretyakov Gallery, Moscow, Russia/Bridgeman Images

Page 236 (tr) Fig 07.02 - Stedelijk Museum, Amsterdam, The Netherlands/ Bridgeman Images

Page 236 (bl) Fig 07.02 - Malevich, Kazimir (1878–1935). Suprematist Composition: Airplane Flying. 1915 (dated on reverse 1914). Oil on canvas, 22 7/8 x 19" (58.1 x 48.3 cm). 1935 Acquisition confirmed in 1999 by agreement with the Estate of Kazimir Malevich and made possible with funds from the Mrs. John Hay Whitney Bequest (by exchange). Digital Image © The Museum of Modern Art/Licensed by SCALA/Art Resource, NY

Page 236 (br) Fig 07.02 - Malevich, Kazimir {1878–1935}. Woman with Water Pails: Dynamic Arrangement. 1912-13; dated 1912. Oil on canvas, 31 5/8 x 31 5/8". Acquisition confirmed in 1999 by agreement with the Estate of Kazimir Malevich and made possible with funds from the Mrs. John Hay Whitney Bequest (by exchange). Digital Image © The Museum of Modern Art/Licensed by SCALA/Art Resource, NY

Page 237 Fig 07.02 - Tretyakov Gallery, Moscow, Russia/Sputnik/ Bridgeman Images

Page 238 Fig 07.03 - Picasso, Pablo (1881–1973) © 2021 Estate of Pablo Picasso/Artists Rights Society (ARS), New York. Baboon and Young. Vallauris, October 1951 (cast 1955). Bronze, 21x 13 1/4 x 20 3/4" (53.3 x 33.3 x 52.7 cm). Mrs. Simon Guggenheim Fund. Digital Image © The Museum of Modern Art/Licensed by SCALA/Art Resource, NY

Page 240 Fig 07.04 - © 2021 Frank Lloyd Wright Foundation. All Rights Reserved. Licensed by Artist Rights Society. Photo: dbimages/Alamy Stock Photo

Page 242 Fig 07.05 - Picasso, Pablo (1881–1973) © 2021 Estate of Pablo Picasso/Artists Rights Society (ARS), New York. Mother and Child. 1921. Composite image with fragment added. Oil on canvas. Gift of Pablo Picasso, 1968.100. The Art Institute of Chicago, Chicago, U.S.A. Photo Credit: The Art Institute of Chicago/Art Resource, NY

Page 244 (t) Fig 07.06 - © 2021 Succession H. Matisse/Artists Rights Society (ARS), New York. The State Hermitage Museum, St. Petersburg. Photograph © The State Hermitage Museum /photo by Vladimir Terebenin

Page 244 (b) Fig 07.06 - © 2021 Succession H. Matisse/Artists Rights Society (ARS), New York. From the collection of The Pushkin State Museum of Fine Arts

Page 250 (t) - Taeuber-Arp, Sophie (1889–1943) © 2021 Stiftung Arp e.V., Berlin/Rolandswerth/Artists Rights Society (ARS), New York. Composition of Circles and Overlapping Angles. 1930. Oil on canvas, 19 1/2 × 25 1/4". The Riklis Collection of the McCrory Corporation. The Museum of Modern Art, New York, NY, U.S.A. Digital Image © The Museum of Modern Art/Licensed by SCALA /Art Resource, NY

Page 250 (b) - © 2021 Stiftung Arp e.V., Berlin/Rolandswerth/Artists Rights Society (ARS), New York. Photo: Fondazione Marguerite Arp, Locarno. Foto Nic Aluf.

Page 251 - © 2021 Stiftung Arp e.V., Berlin/Rolandswerth/Artists Rights Society (ARS), New York. Photo: © Zürcher Hochschule der Künste/ Museum für Gestaltung Zürich/Kunstgewerbesammlung

Page 254–255 Fig 07.07 - © 2021 Estate of Pablo Picasso/Artists Rights Society (ARS), New York. Photo: RMN-Grand Palais/Art Resource, NY

Page 260 (tl) Fig 07.10 - Doesburg, Theo van (1883–1931). Study for Composition (The Cow). 1917. Pencil, 4 1/8 × 5 3/4". Gift of Nelly van Doesburg. (25.1969) Digital Image © The Museum of Modern Art/ Licensed by SCALA/Art Resource, NY

Page 260 (tr) Fig 07.10 - Doesburg, Theo van (1883–1931). Study for Composition (The Cow). 1917. Pencil on paper, 4 5/8 × 6 1/4". Purchase (227.1948.6) Digital Image © The Museum of Modern Art/Licensed by SCALA/Art Resource, NY

Page 260 (cl) Fig 07.10 - Doesburg, Theo van (1883–1931). Study for Composition VIII (The Cow). Ca. 1917. Pencil on paper, 4 5/8 × 6 1/4" (11.7 × 15.9 cm). Purchase. The Museum of Modern Art, New York, NY, U.S.A. Digital Image © The Museum of Modern Art/Licensed by SCALA/ Art Resource, NY

Page 260 (cr) Fig 07.10 - Digital Image © The Museum of Modern Art/ Licensed by SCALA/Art Resource, NY

Page 260 (bl) Fig 07.10 - Doesburg, Theo van (1883–1931). Study for Composition VIII (The Cow). Ca. 1917. Pencil on paper, 4 3/8 × 5 1/8" (11.1x 15.6 cm). Purchase. The Museum of Modern Art, New York, NY, U.S.A. Digital Image © The Museum of Modern Art/Licensed by SCALA /Art Resource, NY

Page 260 (br) Fig 07.10 - Doesburg, Theo van (1883–1931). Composition (The Cow). (Ca. 1917). Gouache, oil, and charcoal on paper, 15 5/8 × 22 3/4" (39.7 × 57.7 cm). Purchase. Digital Image © The Museum of Modern Art/Licensed by SCALA/Art Resource, NY

Page 261 Fig 07.10 - Doesburg, Theo van (1883–1931). Composition (The Cow). (Ca. 1917). Pencil on paper, 4 5/8 × 6 1/4" (11.7 × 15.9

cm). Purchase. Digital Image © The Museum of Modern Art/Licensed by SCALA/Art Resource, NY

Page 266 Fig 07.12 - Roche

Page 270–271 - © 2021 Artists Rights Society (ARS), New York/ADAGP, Paris. Digital Image © CNAC/MNAM. Dist. RMN-Grand Palais/Art Resource, NY

Page 276–277 - Courtesy of the McEwen School of Architecture

Page 287 - Courtesy Dashun Wang

Page 292 - Maps of random walks on complex networks reveal community structure, Martin Rosvall, Carl T. Bergstrom, Proceedings of the National Academy of Sciences 105 (4) 1118–1123. Copyright (2008) National Academy of Sciences, U.S.A.

Page 296–297 - Images courtesy of the artist

Page 310–311 - Photo provided by ESA/NASA, taken by ESA astronaut Samantha Cristoforetti. Caption by Adam Voiland.

Page 314 Fig 09.01 - The Ladies' Home Journal (1889-1907); Dec 1900; Vol. XVIII,, No. 1; pg. 8

Page 318 Fig 09.02 - Courtesy MIT Museum

Page 320 Fig 09.03 - Andrew H. Walker/Getty Images

Page 322–323 - Courtest of the artist and Marian Goodman Gallery

Page 324–325 - Xu Bing Studio

Page 328 Fig 09.04 - © Chuck Close, courtesy Pace Gallery

Page 330 (t) Fig 09.05 - Allan Tannenbaum/Getty Images

Page 330 (c) Fig 09.05 - Album/Alamy Stock Photo

Page 330 (b) Fig 09.05 - Collection Christophel/Alamy Stock Photo

Page 346–347 - teamLab, Exhibition view of "Every Wall is a Door," 2021, Superblue Miami, Florida © teamLab, courtesy Pace Gallery

Page 348–349 - Bloomberg/Getty Images

Page 350–351 - Ann Hamilton, the event of a thread. Commissioned by Park Avenue Armory, New York, New York, December 5, 2012 - January 6, 2013, Courtesy of Ann Hamilton Studio, Photo credit: Thibault Jeanson

Page 352–353 - © Anish Kapoor. All Rights Reserved, DACS, London/ ARS, NY 2021. Photo: Visual/ZUMAPRESS.com

Page 354–355 - Richard Hunt

Page 356–357 - Michelle Devereaux, Wired (c) Condé Nast

Page 358–359 - Brian Jungen, Cetology. 2002, plastic chairs, 161.54 × 1260.40 × 168.66 cm, Collection of the Vancouver Art Gallery, Purchased with the financial support of the Canada Council for the Arts Acquisition Assistance Program and the Vancouver Art Gallery Acquisition Fund, VAG 2003.8 a-z, Photo: Trevor Mills, Vancouver Art Gallery

Page 360–361 - © R. Hamilton. All Rights Reserved, DACS and ARS 2021. Photo: Photographic Archives Museo Nacional Centro de Arte Reina Sofia

Back Endpaper - Bruce Mau. Massive Change Network. Photo courtesy Robert Harshman

INDEX

Art as non-repeatable change. *Flowers and People, Cannot be Controlled but Live Together– Transcending Boundaries, A Whole Year per Hour.* teamLab, 2017, Interactive Digital Installation. Rendered in real time by a computer program, this work was created by international art collective teamLab, a team composed of artists, programmers, engineers, computer graphics animators, architects, and mathematicians, the interaction between the viewer and the installation causes continuous change in the artwork; flowers are born, grow, bloom, and eventually scatter and die. The work is not completed until observers interact with it.

The Brooklyn Bridge Waterfall, one
four New York City Waterfalls, by
artist Olafur Eliasson in collaboration
with the Public Art Fund, deployed
in 2008. Construction involved the
work of more than one hundred
different people, including two
environmental consultants. The
project was designed to be
ecologically-friendly including
filters used to keep aquatic life from
being suck up by the waterfall,
use of electricity generated from
renewable resources, and lighting
with LED lights.

THE NEXUS

Ann Hamilton's 2012 installation
at the Park Avenue Armory in New
York City features an immense,
delicate silk white curtain strung
across the center of the armory's
cavernous hall. The piece exists
when any or all of 42 large wooden
swings, which can accommodate up
to two or three adults, are in use. The
swings are connected to the curtain
by an elaborate rope-and-pulley
system which make the curtain flutter
and move, therefore making the
audience part of the piece.

"Fittingly, one of its best parts is a
kind of fiber performance-art piece
conducted high overhead:
the movements of the elaborately
rigged and intersecting ropes and
chains of the swings and curtain,
which crisscross the upper third of
the space."

Philip Greenberg
for the New York Times

THE NEXUS

Anish Kapoor's *Leviathan* was produced for the 2011 Monumenta exhibition of contemporary art held in the massively large 13,000 square meter nave of the Grand Palais in Paris. Kapoor's sculpture is a giant inflated artwork that occupies the entire nave. Visitors inside the Leviathan, made of translucent red PVC, which appears organic and flexible, feel that they are inside a living and breathing organism. This contrasts with the rigid roof of the nave, at the top of the Leviathan, constructed from iron, steel, and glass.

THE NEXUS

Richard Hunt's studio. The number of artists who work with found objects is legion. One example is Richard Hunt, one of the most important African American sculptors of the 20th-century, rare among artists because he largely spent all his career in Chicago, the place of his birth and artistic training. In the 1960s and 1970s, Hunt transformed materials from car junkyards, welding bumpers and fenders into abstract sculptures. In 1971 Hunt acquired a deactivated electrical substation, with 40-foot ceilings and a bridge crane, suited for moving large metal sculpture pieces, and converted it into his studio.

It all started with a band of rebels who wanted to help a farmboy follow his dream. Three decades later, the *Star Wars* empire has grown into one of the most fertile incubators of talent in the worlds of movies (Lucasfilm), visual effects (Industrial Light & Magic), sound (Skywalker Sound), and videogames (LucasArts). Along the way, some of the original Lucas crew has gone on to become his biggest competitors. This chart maps the people, companies, and technologies touched by the Force. – Michelle Devereaux

People | Companies | Technologies | Film / TV / Games

LUCASARTS [1982]

Hal Barwood — game designer, writer, producer
Scumm — point-and-click game int
Insane — game engine

THX — TAP — theater system

SKYWALKER SOUND [1977]

Bob Doris — president
Gary Rydstrom — sound designer

Ron Howard — actor, director
Richard Dreyfuss — actor
Steven Spielberg — writer, director
American Graffiti [1973]
Jaws [1975]

More American Graffiti [1979] — Caleb Deschanel — cinematographer
Close Encounters of the Third Kind [1977]
Raiders of the Lost Ark [1981]
Dragonslayer [1981]

Harrison Ford — actor
Ralph McQuarrie — illustrator

GEORGE LUCAS — LUCASFILM (1971) — STAR WARS (1977) — EMPIRE STRIKES BACK (1980)

Ben Burtt — sound designer, editor, director
Gary Kurtz — producer
Peter Kuran — animation
Frank Oz — voice of Yoda, puppeteer

THX 1138 [1971]
Marcia Lucas — editor
Walter Murch — writer, sound designer, editor
Robert Duvall — actor
Francis Ford Coppola — producer, director, writer

animatics — storyboard technique

The Dark Crystal [1982]
The Muppet Movie [1979]
Visual Concept Entertainment [1982]
Apocalypse Now [1979]

Phil Tippett — visual effects
Scott Squires — visual effects
Commotion — effects software
stained-glass knight — first CG character
Dennis Muren — visual effects

INDUSTRIAL LIGHT & MAGIC [1975]

Computer Division [1979]
Dan O'Bannon — visual effects, writer
Scott Ross — general manager
MARS — object motion analysis software
virtual sets

John Lasseter — animator, director
Ed Catmull — visual effects, vice president
The Genesis Effect — first all-CG film sequence
Star Trek II: The Wrath of Khan [1982]
EditDroid — nonlinear video editing system
ALIEN [1979]

John Dykstra — visual effects
Richard Edlund — visual effects
Dykstraflex — camera process
motion control — camera process
Battlestar Galactica [1978]
Ken Ralston — visual effects
blue-screen matting — background effects process

Star Wars. The remarkable string of companies, games, films, generated after the first film in the *Star Wars* franchise through 2005. Released in 1977, 'A New Hope' had a production cost of 11 million U.S. dollars, achieving worldwide box office revenues of around 775 million U.S. dollars. Disney acquired Lucasfilm in 2012 for $4 billion. With the anchoring value of a great story, innovative marketing, and targeting of many demographics, there seems to little doubt that the *Star Wars* franchise was well worth the $4 billion-plus purchase price.

Brian Jungen, 2003, Cetology.
A whale made of inexpensive white
polypropylene plastic patio chairs.

Richard Hamilton's *Man, Machine and Motion*. The work is made up of 176 black and white photographs and reproductions of drawings showing vehicles and equipment that 'extend the powers of the human body', enabling motion in aquatic, terrestrial, aerial, and interplanetary environments. The work was first mounted in 1955 in the Hatton Gallery, in Newcastle. Revolutionary for its time, images were arranged in a modular steel grid with clips of Hamilton's design, so that viewers moving through the exhibit could see images below and above them.

THE NEXUS